PRAISE FOR

THE LIGHT YEARS

"Rush is a fantastically vivid writer, whether he's remembering a New Jersey of 'meatballs and Windex and hairspray' or the dappled, dangerous beauty of Northern California, where 'rock stars lurked like lemurs in the trees.' Read if you loved . . . *Just Kids* by Patti Smith."

—Leah Greenblatt, *Entertainment Weekly*

"Chris Rush . . . not only has one hell of a story, he also has the talent to bring it to life. You can open his gorgeous new memoir, *The Light Years*, to any page and the prose will leap out. It's funny, charming and effortlessly descriptive." —Aaron Hicklin, *The Observer*

"What's most surprising . . . is the grace that can emerge from brutality. It's a relief to read someone who's waited long enough to not only document his rather extraordinary experience, but most importantly to have the wisdom to understand it . . . It's hard to fathom how [Rush] got out alive. But thank goodness he did." —Minju Pak, *T Magazine*

"[A] vibrant memoir . . . Rush's storytelling shines as he travels across the country and back again, searching for truth, love, UFOs in New Mexico, peace, something that feels like God, and a place to call home. This is a mesmerizing record of his journey through adolescence."

—*Publishers Weekly* (starred review)

"In sparkling, lucid prose that perfectly captures the joy, depression, anger, and wonder that characterized his adventures, [Rush] recounts the seemingly endless hills and valleys of his unique tale . . . Readers will wish for more from this talented writer." —*Kirkus Reviews* (starred review)

"Brace yourself: To enter *The Light Years* you must be willing to be changed. It is, in the end, about the one question we all must ask ourselves—How does one live? In the end the answer is, always, love. You could wait until you are ready to read this radiant book, though how will you know when that moment arrives?"

—Nick Flynn, author of *Another Bullshit Night in Suck City*

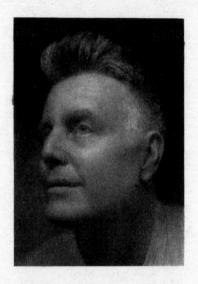

A NOTE ABOUT THE AUTHOR

CHRIS RUSH is an award-winning artist and designer whose work is held in numerous museum collections. *The Light Years* is his first book.

THE LIGHT YEARS

THE LIGHT YEARS

A MEMOIR

CHRIS RUSH

PICADOR

FARRAR, STRAUS AND GIROUX

New York

Picador
120 Broadway, New York 10271

Printed in the United States of America
First published in 2019 by Farrar, Straus and Giroux
First Picador paperback edition, March 2020

Photographs of clouds by Richard Oriolo.

The Library of Congress has cataloged the Farrar, Straus and Giroux
hardcover edtion as follows:
Names: Rush, Chris, [date] author.
Title: The light years : a memoir / Chris Rush.
Description: First edition. | New York : Farrar, Straus and Giroux, 2019.
Identifiers: LCCN 2018020669 | ISBN 9780374294410 (hardcover)
Subjects: LCSH: Rush, Chris, [date] | Artists—United States—Biography.
Classification: LCC N6537.R873 A2 2019 | DDC 700.92 [B]—dc23
LC record available at https://lccn.loc.gov/2018020669

Picador Paperback ISBN 978-1-250-25119-0

Designed by Abby Kagan

Our books may be purchased in bulk for promotional, educational, or
business use. Please contact your local bookseller or the Macmillan
Corporate and Premium Sales Department at 1-800-221-7945, extension
5442, or by e-mail at MacmillanSpecialMarkets@macmillan.com.

Picador® is a U.S. registered trademark and is used by
Macmillan Publishing Group, LLC, under license from
Pan Books Limited.

For book club information, please visit facebook.com/picadorbookclub
or e-mail marketing@picadorusa.com.

picadorusa.com • instagram.com/picador
twitter.com/picadorusa • facebook.com/picadorusa

1 3 5 7 9 10 8 6 4 2

In this memoir, some names and identifying details have been
changed. The dialogue is based on my recollection; some dialogue is
reconstructed, with a clear knowledge of what transpired. The timeline
is occasionally compressed or reordered for clarity. To simplify the
narrative, I have created several composite characters. Certain byways
were omitted, along with a few people I dearly miss.

For my mother
And for Victor

Never make friends with the Devil, a monkey, or a boy.

—RUDYARD KIPLING

THE LIGHT YEARS

WHEN I THINK BACK ON my childhood, there's always a speeding car. Sometimes it's a white pickup, sometimes a red Jeep. As the world rushes by outside the window, I can feel the old familiar sick.

From one of these cars I jump; from one I am pushed. But they're connected somehow, and I try to understand the line from one to the other.

There are other cars, too—other wrecks. Some of this is not my story, but my father's. There is a man with no head, though this doesn't seem possible, or real.

I need to go back to see *how* this is possible. I have to remind myself how sweet it was at the beginning. Which is where I'll start. From the place most journeys begin.

From home.

PART I

MY EDUCATION

I.

Flower Boy

IT'S AUGUST.

We're in the basement, hiding from the heat. I'm in a sweaty heap with my little brothers, Mike and Steve, and two neighbor kids, Becky and Jimmy. We lie on the floor, silent, just the sound of our breathing.

Then I say it: *Let's play poison.*

The game is my invention and I'm prepared. From my shorts I produce a roll of Life Savers, carefully unspooling the foil wrapper. Slipping a cherry into my mouth, I hand out sublime flavors to my companions: *watermelon, pineapple, orange, lime.* They suck their candy, serious as cyanide.

We all wait for the inevitable—it won't be long.

It's the summer of '67 and I've just turned eleven. Thin as a matchstick, with a big dollop of blond hair across my brow, I close my eyes, preparing to die. As usual, Becky will be the first to feel the symptoms. Becky is excitable. She's twelve and a half, with flaming red hair and new boobs.

Becky doesn't know how to whisper. In perfect agony, she calls out, "Help me! Something's terribly wrong!"

I say, "What is it, my darling?"

She places my hand on her chest. "Can you feel it? I'm burning up!" she screams. And it's true: her breasts are surprisingly warm. "I-I can't breathe," she stutters. "Our food was poisoned!"

Taking my hand back from her hot bra, I tremble. "I feel strange, too. But who would do such an awful thing?"

"The Russians," Mike says.

"Or the Red Chinese!" Steven cries.

My brothers are endearingly bad actors—I'm proud of them for remembering their lines. In the half-light of the basement, I watch them grimace and grin.

"There must be an antidote!" I call out, as I clank through my father's liquor cabinet.

"It's too late for that. *Uhhhhh!*" Becky becomes hysterical. It's contagious. The five of us drool and twitch and run about, each suffering in our own special way. Steven, at eight, perishes in a torrent of blubbery tears. Michael, a brute at ten, keels over with a maximum of movie violence, convulsing and kicking the table as if drilled by machine-gun fire. Becky's little brother, Jimmy (strawberry curls and good manners), is wistful and understated. He coughs once and joins my brothers on the floor.

Becky and I are the final act. I embrace her as she goes limp in my arms.

"My darling. Please don't leave me!"

But Becky gurgles and spits and collapses in slow motion. With her last bit of strength, she grabs my Bermuda shorts and pulls them down. In one grand gesture, buxom Becky is gone.

Standing in my underwear, I consider my audience. They sprawl on the floor, eyes pretend-closed, awaiting my soliloquy. Since I'm already half-dead, I decide to risk a Calvary motif (I'm a good Catholic boy and know my New Testament). Stretching out my skinny arms, I ask, "Lord, Lord, why hast Thou forsaken us?"

My high voice echoes against the concrete. I improvise: "Dear God, why would You poison Your own children?" Standing in my underwear, beseeching heaven, I get a baby boner. Before I can pull up my shorts, the lights flick on and, instantly, my parents materialize, their mouths open in horror. Somehow Father Dempsey, pastor of our church, is standing between them. He turns a redder shade than usual.

Dad says, "For Christ's sake, Chris, pull up your pants."

"We were just playing."

"At what?"

"Dying."

Dad says, "Oh, I can help you with that."

Father Dempsey winks at me as I tug up my shorts.

Mom sighs—she understands the nature of drama.

Mother is *very* dramatic. Her clothes often veer toward costume. Today, she's wearing her gold *I Dream of Jeannie* slippers and a chiffon blouse that blooms like a giant orchid. Her hair flips upward, defying gravity—her lips pout, a shade of pumpkin pie.

As the other kids scurry upstairs, Mom pulls me aside.

"Fainting not enough?"

I'm *thrilled* she remembers.

I'D BEEN TEACHING myself how to faint—deeming it, in addition to dying, an important life skill. The trick was getting the little sigh right just before your knees gave out. After perfecting my technique, I'd run to show Mom, the one person who'd understand. She was in the kitchen, cooking dinner, and when I asked if she wanted to see me faint, she put down her wooden spoon and said, "Fainting is not a joke. Do you know I fainted in Spain once from too much

garlic? I had to be hospitalized. If your father hadn't caught me, who knows what would have happened?"

Mom's story went on for quite a while. There was a handsome doctor ("I considered running away with him") and smelling salts ("a diabolic invention!"). My mother was famous for her monologues. I waited patiently, and when she was finished, I said, "So can I faint now?"

"I'm busy. Go faint for your brothers." And then: "We have guests coming tonight." She pointed a lacquered fingernail at me. "I don't want you fainting for any of them."

THE HOUSE OF RUSH was booming.

My parents' cocktail parties careened through the fifties and sixties like a great drunken circus. The whole town came and went. I remember a pastel sea of summer dresses; waiters flying by in black and white, carrying trays of martinis, ten at a time. Booze filled the world with excitement. Everyone danced and laughed, fell over and got up. If ladies landed in the pool, the men jumped in after them. There were sing-alongs and fistfights, bloody noses and slow cigars. And at the end of the night, as Dad helped the last of the guests out to their cars, Mom would get a flashlight and sweep the yard for bodies.

Sometimes, members of the fallen were local priests—men I respected and looked up to—so it was odd to find a cleric facedown in the daffodils. I knew that priests weren't like cops, they were never "off duty," but in our house they could let their hair down, as my mother liked to say.

"And their balls," as my father once added.

OF THE SEVEN Rush children, I was in the middle. I grew up when my parents were most fabulous—and most happy. They still believed that the past was firmly behind them. The past was always referred to with some suspicion—and I associated it with a phrase my mother often used: *good riddance to bad rubbish.* We rarely saw members of

my mother's or father's family. I knew that *bad rubbish* had some-thing to do with *white trash*.

By 1967, my two oldest siblings, Chuck and Kathy, were already married with kids. The next person in line was my sister Donna—a contagiously happy sixteen-year-old, leading us all to a better, brighter future. I adored her Vidal Sassoon blunt cut and artful mascara—and she had her priorities straight: after a star turn as captain of the cheer-leading squad, she planned to become a professional model.

She'd already done summer training at the Barbizon Modeling School. For the two months of the program, Donna and I had taken a bus to New York City every Saturday. Though I was five years younger than my sister, Mom dubbed me Donna's chaperone. Preparing our outfits took the better part of Friday night. There is a photo of Donna in a peach cashmere wrap, with a taupe fedora and white eye shadow; I'm standing beside her in a glimmer-blue suit and yellow ascot.

Together, we'd prance up Fifth Avenue to Barbizon, to the little door where all the girls zoomed in. I'd wave goodbye as Donna disap-peared into a world of *poise, posture, and panty hose.* I was captivated.

On my own, I walked around town in my miniature man-suit, window-shopping. I'd study all the stylish women walking into Saks. Style was a bid for happiness, a kind of hope.

On the bus home, Donna and I would page through fashion mags, searching for cool.

Frosted lips—*yes.*

Leopard leotards—*yes.*

Sputnik earrings—*of course, of course!*

I watched my sister closely, aped her every move—slowly sepa-rating myself from my younger brothers Michael and Steven, who were barbarians, and my baby brother, Danny, just a pet in diapers.

IN THE MIDDLE, I floated about freely, yapping to everyone. Once I'd exhausted Donna and my other siblings, I'd start on any adults hang-ing about. For a long time, I assumed adults knew much more than

they actually did. But when I asked them about vampires or continental drift, they looked at me like they had no idea what I was talking about.

The time I asked Father Dempsey if he spoke with God, he pretended not to hear me. When I told him I talked to God all the time, he leaned in to whisper. "Maybe that's something you should keep to yourself."

Mom, at least, was fun. If I asked her a question, she always answered. She had *lots* of opinions. In that way, we were similar.

"MOM, ARE PAPER FLOWERS PRETTY?"

I knew it was a dumb question, but she took the bait.

"When your father and I were in Acapulco, children chased us around with paper flowers. Paper flowers and Chiclets! Or they just begged. It was very sad, all their little hands sticking out. Your father got quite teary, said he wanted to adopt every one of them. As if we could just scoop a brown baby off the street! I had to put my foot down. So, no, dear, paper flowers are not pretty. They're cheap."

"Oh, because I thought I might make some."

"I can't stop you, can I? Please don't make a mess."

WITH TISSUE PAPER, coat hangers, and floral tape, I methodically followed the directions in *Family Circle* magazine. Soon, a jungle of pink and purple pom-poms overtook my room. Cheerful as an elf, I carried out the two biggest for my mother.

Just in from golf, she wore white culottes and a buttercup visor. Before she even got off her sunglasses, I screamed, "Mom, Mom, look—flowers for you!"

"That's so sweet. Maybe keep them in your room for now, okay?"

After I'd assembled a dozen or two, I decided I should sell them. At my parents' next bridge party, I strolled from table to table showing off my wares. I wore my black Andy Warhol turtleneck to

accentuate the merchandise. Flowers flopped about in various radio-active colors. The adults went quiet.

Then old Miss Chester spoke up. "Young man, what on earth are you doing?" She had a voice deeper than dirt. A cigarette dangled in her diamond claw. I smelled whiskey.

"I'm selling paper flowers, ma'am—five dollars each. I made them."

"Well, good for you." She grabbed her purse.

When I got excited as a kid, one of two things happened: I threw up or my voice got very high. At that moment, my voice filled the room like a dentist's drill. "Do you want red, yellow, or pink? I think yellow is best. But this is a fantastic pink! I'm not sure about red, though. It might be too much." My mother had told me that red was questionable after forty.

"Yellow is fine." Miss Chester handed me a ten-dollar bill.

"It's just *so* lovely doing business with you," I effused.

My father, at a corner table in shirt and tie, looked, for some reason, displeased.

"Norma!" he shouted across the room.

Mom took charge. "Chris, you're interrupting. Go watch TV."

"I have to make change," I said.

My client winked. "Keep it, honey-pants."

I handed her a flower and ran off with my tip.

WITHIN A WEEK, I'd made thirty-five bucks selling to every person who dared walk in our door. My sister Donna ordered two in school colors—blue and white. I was a factory; fake flowers spread to every corner of the house. In a fit of inspiration, I started adding perfume. Three spritzes per flower. I was using Mom's expensive stuff—Shalimar and Arpège. My brothers, though, acted like my flowers were poisonous. Dad, too.

I didn't understand.

Mom did. "Honey, how about I buy all your flowers? Every single one."

"Really?"

"Yes, then let's say enough for a while. You need to go outside and get some air. You smell like a lady of the evening. Why don't you jump in the pool?"

"Okay, Mom. Thanks!"

I LOVED OUR POOL.

It was huge—bluer than heaven. Around it, the trees strutted, the roses roared.

Finished in '56, our house was my father's midcentury master-piece. Featured in newspapers and fashion shoots, our house was new, new, new!—no attic, no heirlooms, no trace of the past.

Every detail was carefully managed by Norma Farrow Rush, the pale-skinned daughter of a taxidermist. She no longer had to do any dirty work for her father; the house was her shining rebuke.

The kitchen was immaculate, wrapped in Formica, smooth as snow. And though Mom had dined all over the world, she seemed happiest in her own kitchen, performing for twenty guests in a snug apron and high heels. By some Catholic miracle, her figure improved with each child. Babies, she said, were her beauty secret.

Sometimes when Dad was out late at a meeting, I'd sit with Mom at the kitchen table and watch her play cards. She taught me how to win at solitaire—by cheating. She placed each card down with a de-cisive snap, saying: *If you don't cheat, you lose—and what fun is that?*

Past her makeup and her jewelry, I could always spot the glim-mer of sadness. I think she could see me seeing it. She called me "the sensitive one."

There were days when Mom was particularly manic, when there was nothing left to cook or clean, no fund-raiser or bridge party. I'd come home from school and she'd say, "Let's go for a spin." Often it was simply a run to the grocery store—but sometimes we'd drive out to an old cemetery in the woods off Route 9, to look at headstones.

The names on the stones were not Rush or Farrow.

"Who are these people?" I asked my mother.

THE LIGHT YEARS 15

"Old families, long gone," she said. "I love how peaceful it is out here."

I recall my shock, seeing a marker in which the year of birth and the year of death were the same. The stone read: BORN INTO THE ARMS OF ANGELS. There was no name. Only the word *Baby*.

My mother told me not to mention where we'd been.

"What would your father think?"

ON THE WAY HOME, Mom would drive past the place she grew up. It wasn't much, just a small apartment over a run-down store. Red neon still flashed above the door: BAIT AND TACKLE. Out front was a life-sized concrete brontosaurus—a New Jersey landmark. I longed for a closer look, but no matter how many times I asked, Mom would never stop.

Her father was still living there. Sometimes, I could glimpse him standing behind the counter. Mom, eyes on the road, never once looked toward the shop.

I didn't ask about him. Questions of that sort were not encouraged. To Mom, the past was something you sped by—and best to do it at ten miles over the speed limit, in a brand-new white Cadillac.

Whoosh! Good riddance to bad rubbish.

MOM WAS DEMANDING when it came to other people—and especially hard on the help. Our most recent nanny had been let go for body odor. Her room downstairs had been empty all summer while Mother tried to air out *the smell of poverty*.

One afternoon, I went down and sat cross-legged on the black linoleum. It was quiet in the basement, and it smelled fine to me. A square of light fell from the high window, landing on the floor like a magic doorway. I thought it was poetic.

I was sharing a bedroom with my brother Michael, who was not poetic. I asked Mom if I could move downstairs, claiming I needed greater privacy.

"You're eleven," she said. "You don't need privacy. You need supervision."

From whom, I wondered.

Mom was not much of a supervisor. She regarded her children as her audience—and once we'd applauded, we could do as we wished.

DAD WAS MORE of a mystery—a dark planet, exerting only vague astrological influence on his offspring. He walked with a limp, a steel brace on one leg from the car crash of '64. He was still strong, though, and steady. He could be quite charming, always ready to amuse guests with a story or a joke. But to a child, to a son, he had nothing to say. He seemed unsure around kids, uncomfortable, even guilty. I knew something bad had happened to him, something that couldn't be talked about.

There was always silence in his wake.

Every Sunday, our family went to church, but Dad went during the week, as well. He went to confession often and took Communion every day. I was intrigued by the idea of his soul—and even more intrigued by the idea of his sin. What could it be?

WHEN AGAIN I BROUGHT UP the idea of my taking the maid's quarters, Mother had already moved on. She was on the phone, talking about Dotty Doone, the golf pro who dressed like a man. As she gossiped, I carried my clothes and records downstairs right in front of her.

Once I'd settled in, I asked my mother about *décor*.

It was the exact right word. Instantly, she came alive. "You know, I always meant to do something down there. Make a statement. I don't know why the girls we hire don't make more of an effort. Why live in squalor?"

When I suggested we paint, Mom smiled. "How about a wild yellow? Maybe a *marigold*—the kind of yellow that wants to be orange."

"That's me—I'm a yellow who wants to be orange!"

"Yes, I know that about you."

Soon we were downtown, looking at swatches—and the next day

the basement was reborn. Against black linoleum, marigold was a rocket launch, a flower-power explosion. Inspired by photos of hippie crash pads in *Life* magazine, I went on to strangle my bookcase with Christmas lights. I taped tinfoil to the ceiling and threw fake fur on the floor. From a ratty record store in town, I'd procured a black light and the necessary posters; now Jimi and Janis flickered on my wall. When Donna came down, she nodded in approval. She gave me incense and a 45 of Donovan's "Mellow Yellow"—which I played a thousand times.

One night, I took off my clothes and danced naked, wiggling in the mirror, a daub of Day-Glo on my teenie-weenie. Then, from out of nowhere, there was the sound of static and a God-like voice: *What is that horrible odor?*

I'd forgotten about the intercom, by which Mother sent commands into the maid's quarters. I pressed the call button. "It's frankincense and myrrh, Mom." I reminded her these rare fragrances had been gifts to the Baby Jesus.

"Don't be smart. It smells worse than Nanny's underarms. Open your window. And turn down that screeching."

AS TIME WENT ON, Mom tended to forget I was in the basement, burning things and growing up. She never visited and only occasionally intruded by intercom. In the fragrant gloom, I was free to become a weirdo. By day I was a Catholic boy in a plaid uniform. By night I was a freak in a fuzzy vest.

Having grown up in a spotless space-age home, I developed an unwholesome desire for all things vine-choked and Victorian. On weekends, I searched yard sales and junk stores for buried treasure. I found mad crystals and silk tassels, tintypes and diaries. I carried home a case of butterflies—each one stabbed through the heart with a pin.

It all belonged in my room.

In a moment of good cheer, Father Dempsey let me have a life-sized statue of the Virgin Mary I'd found moldering in the church basement. Delivered by two of Dad's workers, Mary seemed content

as my roommate. Glass-eyed and gilt—I thought she was beautiful. I played records for her, explained that rock music was a kind of prayer.

My search for treasure continued. One Saturday, I walked to Polly's Bric-a-Brac and Fine Furnishings, a disaster of pointless merchandise in an unheated barn. Cupboards and crutches, Bibles and toilets—it was a kind of perfect chaos. Hoping for gold, I opened an old leather trunk and pulled at a tangle of frilly underwear and faded neckties.

Then it flashed: a cape—*a pink satin cape!*

I ran to a cracked mirror and tried it on. Draped across my shoulders, the fabric was blinding, the color obscene. The label said *Pucci*—the lining a riot of rainbow colors. It was a fashion miracle. I gave old Polly a rumpled dollar and ran.

FOR A WEEK, I wandered the neighborhood in my cape, feeling potent and magical, a vampire-saint prowling the earth. In a Transylvanian accent, I asked people: *Do you like my Pucci?* Neighbor Becky, my partner in poison, refused to answer when I rang her doorbell. My brothers all but disowned me. To other children, my delirious face, emerging from a magenta flame, may have indicated mental illness or clown school. Girls gaped. Boys spit. I carried on.

Until Dad spotted me.

He stopped his new Thunderbird and put down the electric window. "*No fucking way.* Get it off."

"Dad, I'm Pope John—the Twenty-Third!"

"You heard me. Get it off. *Now.*"

The Pucci was banned. Dad wouldn't explain, but later, during an argument with my mother, I heard him use a new phrase.

"The boy is a goddamn *queer*, Norma—it's obvious."

"Charlie, don't say that, he just needs a challenge." Mom suggested piano lessons, or archery. "Why don't we call Father Dempsey—or one of the younger priests? Maybe they'll know what to do with him."

Lying on my bed, I thought: *What's a goddamn queer?*

2.

Eviction

MY FATHER'S COMPANY, Charles Rush Construction, built office buildings and town halls, waterworks and missile silos—but Dad was most proud of the churches and schools he built for the Diocese of Trenton. Dad made a fortune serving Our Lord.

To show his gratitude, my father entertained the clergy in style.

On summer Sundays, a gang of priests could always be found sipping cocktails by the pool (they always stayed for dinner). Father Dempsey, our pastor, was considered "family" and regularly joined my parents on vacation. I'm told that besides gambling and golf, Dad sometimes introduced Father Dempsey to the fairer sex. Charles Rush Inc. won all the church contracts.

At St. Ignatius, Father D's church, my parents were high-profile parishioners, an example for all to see. Charlie and Norma Rush marched up for Holy Communion as if collecting a prize. Dad was strong-jawed and blond, handsome as a movie star, and his wife—the brunette bombshell—swung at his side. Down the fashion runway, my siblings and I followed them—hands folded, eyes down. God watching.

At school, the nuns had explained God to me—heaven and hell, miracles and martyrdom. I loved every juicy bit, both the glory and the terror. Sometimes, I spent lunchtime in the dark church, alone, waiting for God to finally appear. I tried to feel His Holiness, penetrating me like atomic radiation. Closing my eyes, I meditated.

God-rays are entering my soul.

I could feel their warmth inside me.

In church I felt safe. It was the one place where everything moved slowly, and in that slowness there was peace. "Your mind is always racing," my mother used to say—and it was true. But in church I was better, I was calmer. When the nuns saw my piety, I heard them whisper: *Maybe God wants this one for Himself* . . .

My dad, born of Irish immigrants, would have been happy to hand over one of his sons to the Church. But my mother, a convert to Catholicism, was descended from Connecticut Puritans. She was much less inclined to give things away.

IT WAS SISTER Theresa Ann, a hunchbacked Puerto Rican, who instigated *God's Peculiar Plan for Chris.* Sister Theresa was no fan of mine. In her sixth-grade classroom, she found my metaphysical enthusiasms difficult to contain. When she called my house to schedule a private consultation with my parents, it was I who picked up—shocked to learn that nuns used telephones.

"Am I in trouble, Sister?"

"Let me speak to your mother, please."

A few days later, when my parents returned from a meeting with

the hunchback, they seemed a bit perturbed. I was escorted into the living room for a talk. Dad lit a cigarette.

Mother explained the bad news. "Sister Theresa received your IQ results this week and she's a little concerned."

I tried to defend myself, saying how nervous I got during tests.

"Stop," my mother said, holding up her hand. "Sister Theresa says the numbers are inappropriately high. She thinks you'll need some sort of special help." I didn't understand.

"Sister Theresa says you're an excellent student, but that you constantly interrupt."

"How do I—"

"You ask too many goddamned questions," my father chimed in.

"Calm down, Charlie." Mother turned to me, bland as the moon. "It's just that other children need a chance to learn, Chris—not just you."

I tried to defend myself. "I can't help it that other kids are dumb."

"Darling, what did I tell you? No one likes a conceited child."

"I'm not conceited. I'm just saying—"

"Boy, listen to your mother!"

I bit my lip, trying not to cry. My parents *hated* crying.

"Chris, this is serious—the test results are really alarming. But your father and I have discussed the problem and we've come up with a great idea."

I felt my stomach turn.

"The idea is . . ." The fact that my normally direct mother was dragging this out was a bad sign. Her hands fluttered—another indicator of doom. "We're going to send you away to school."

I opened my mouth, but before I could speak, my father told me to shut it up.

Mother continued: "Sister thinks a Catholic boarding school would be best for you. For your *development*. And Father Dempsey agrees."

"But I live here. I don't want to leave." I explained that I'd just bought some throw pillows. "I'm redecorating my room. And I'm planning a dance party!" I could hear my voice rising into hysteria.

"Calm yourself." Father's face was hard. "It's time for you to grow

up, buster. Your mother has made it too easy for you—lying around, making funny flowers. No more."

I tried to explain that I was done with the flowers.

Dad turned away. "Norma, finish this." He disliked parenting even more than Mom. He got up to mix a drink.

Mom grabbed my hand. "Honey, we just want what's best for you. We're proud that you're smart, we really are—but you're different. I think you know that."

"I haven't done anything wrong. Why do I have to go?"

"You won't go until September. You'll have the whole summer with us. We can still have a party."

As she leaned in to comfort me, I could smell her perfume—but I pulled away.

TWO WEEKS LATER, I'm miserable.

We're driving to St. John's—*a monastery*—for my interview. As we pull up the long driveway, I'm thinking I'll die of sadness. I don't want to leave home.

Then, at the top of the hill I see it—a castle rising from the fog. Stone walls, dark towers, windows like squinting eyes. It's pure monster movie. I'm sort of impressed. I take a deep breath—and though I keep some sourness in reserve, I decide not to throw a tantrum—not yet, anyway.

A young crew-cut priest greets us at the castle's huge wooden doors. Behind him is a long stone staircase, leading to a heaven of stained glass. The priest smiles and quickly removes me from my parents, who are shown to a lounge to meet with the headmaster. I walk down a dark passageway with the handsome priest, and we enter a tiny office—no windows. The door is shut.

"I'm Father Karl," he says, finally introducing himself. I wonder if he's an albino, he's that pale—his crew cut like a bed of white needles. He pulls up a chair for me, and when he speaks it's very softly. He asks about my family, my grades. He knows about the infamous IQ test. "Impressive."

Like my mother, I'm easily flattered. I feel the sudden need to shine. When he asks about my hobbies, I tell him I like to sketch. "I can draw anything."

"What are you working on now?" he asks me.

"Well, I'm doing a series of drawings of paramecia. Do you know what they are?"

He says he does.

"Okay, so I do a whole page with lots of them, and if you color them in, it looks sort of like paisley."

"Oh, really. And what sports do you like?"

When I tell him I'm not interested in sports, he frowns.

I don't want to disappoint him.

"I used to sail."

He studies my face, a concerned adult.

Embarrassed, I look at the stone walls, which seem to be sweating. But the office is actually freezing. My hands are shaking.

"I like God, too," I blurt. "I mean, I really like Him. I'm just not a hundred percent sure I want to be a priest."

"Okay, well, that's not a requirement."

I'm confused. I'd assumed St. John's was a kind of Barbizon school for priesting.

"Isn't this like a—what do you call it—a seminary?" I say it quietly; it sounds like a dirty word.

"Yes, there's a seminary here for men, but that's separate. You'd be here in the boys' school. That is, if you're accepted."

There's a long pause, which feels like a test—maybe to see if silence freaked me out. I fold my hands on my lap and close my eyes halfway, like a saint on a mass card.

"Are you sleepy, Chris?"

"No, I was just—" Blushing, I tell him that, actually, I haven't slept well for a few days. "I'm kind of a nervous person. And sometimes I have bad dreams."

"The Lord is my light and my salvation; whom shall I fear? The Lord is the stronghold of my life; of whom shall I be afraid?"

I nod, knowing he's quoting scripture, but part of me wishes

Father Karl were really asking what scared me. About a trillion things, I would have told him.

When he stands and offers me his white hand, I shake it firmly like my older brother had taught me. "Like you're packing a snowball," was how he explained it—but Father Karl's hand is warm as could be.

Outside the building, my parents are waiting. My mother kisses my cheek. "Good job."

"Who knows?" I say.

"We know. We heard the whole thing."

"Through the walls?" I say sarcastically.

"No, silly. Through an intercom. Quite a setup."

"What?" I'm aghast, worried about what I said.

"Paisley?" My father rolls his eyes. "Really?"

When I look at him, he laughs—and it doesn't seem like he's making fun of me, because my mother laughs, too. They're holding hands, pine trees and stone towers rising behind them. They look beautiful, like a postcard. So I laugh, as well—and miracle of miracles, my father pats me on the back. "We'll stop at that steakhouse," he says. "The one we saw on the way up."

My mother says she could go for a petite sirloin.

To have my parents to myself was a triumph.

ON THE INTERCOM: my mother's voice.

"Chris, come to the table. Father Dempsey is waiting."

Sunday dinner—always a performance. Table set, candles lit, silverware shining like new money. Rushes ran from all directions, assembling behind our assigned seats, ready to play our part.

To my right, Dad stood with our honored guest, waiting for the signal. When Mother made her entrance, she took her throne and nodded. Then we all sat, grabbing our napkins and bowing our bony heads. On cue, Father Dempsey recited grace like a radio jingle.

"Bless us O Lord and these Thy gifts we are about to receive . . .

"Amen," he said, but then held up his hand, signaling he had more to say. "Charlie, Norma, I have some good news. Headmaster

O'Conner informs me that your son has been accepted at St. John's." Lifting his whiskey, Father Dempsey winked at me. "Congratulations, my boy. One day, I hope you'll go on to take your holy vows." He downed his drink in a single swig.

Mother, representing the clan, responded judiciously. "Thank you, Father. But let's not rush ahead to the vows. The boy is still very young."

Dad said nothing, but my brothers turned to me, confused. Michael seemed slightly hostile. "You're going to a new school?"

Donna patted my arm. "Very clever."

I looked down at my meal. Everything was white: filet of sole, mashed potatoes, cauliflower, and a big glass of milk. It was as if my mother were making an appeal to heaven, to purity—to creamy perfection.

WHEN I TOLD MOM I was nervous about going away, I meant nervous about leaving her. Maybe she knew. Instead of a hug or a pep talk, she offered to take me clothes shopping—a full day together at the Short Hills Mall. She understood exactly how to seduce me. For hours, I posed in department store mirrors, multiplying myself, trying to find the future me, the right look for St. John's. I tried on jackets and ties, sweaters and suits.

Watching all this activity, Mother became a bit wistful. "Eleven years old and already a little man."

"I'm a size-ten shoe."

"You know, I might miss you, Chris." She batted her eyes, as if it were a game. "I haven't decided."

It was too late to risk sadness. I changed the subject.

"So, can I have both sweaters, the mint *and* the blue?"

Mom regained her poise. "Boys do not wear mint."

UNLIKE MY MOTHER, Donna was very emotional, saying twice a day how much she'd miss me. "Who will I talk to in this house once you're gone?"

Being in my sister's room was thrilling, especially when she locked

the door. The room smelled like Doublemint. Green garlands made from gum wrappers hung from her canopy bed.

One night, she spit her Wrigley's into a Kleenex and said she needed a cigarette.

"A what?" It was inconceivable to me that Donna would smoke. I watched in awe as she opened the window and lit a Tareyton.

"Are you still a cheerleader?"

"What?" she said. "Cheerleaders can't smoke?" She exhaled, said *Fuck it*, and told me the rest.

"Cheerleaders do lots of things. Did you know I have sex? I smoke pot and have sex. With *Derrick*."

I felt my whole body tingle and go red; I looked toward the locked door and then back at her. How was it possible that she could even say things like this out loud? Did she think I was already a priest? Was this a confession?

"So, who is Derrick?"

Donna explained that Derrick was her twenty-two-year-old boyfriend.

I had some understanding of "teen pregnancy." At sixteen, my older brother Chuck had been forced to marry his hillbilly girlfriend. Only a few years later, my sister Kathy had dropped out of high school, pregnant by a sailor. I asked Donna if she was being careful.

"Chris, I'm on the pill."

"Oh, okay." Not exactly sure what the pill did, I changed the subject. "I can't believe you smoke pot."

"Everybody does." She dragged thoughtfully on her Tareyton. "Pot makes everything more intense."

I crossed my legs, not letting on how shocked I was. "Are you a hippie then?"

She shook her head: *Uh-huh.* "Just don't tell Mom."

I couldn't believe it. Just as things were getting interesting at home, Mom and Dad were planning to lock me up in a priest prison.

I was amazed by Donna's ability to lead a double life. I wanted to have a secret life, too. Perhaps I already had one, somewhere inside me, but couldn't yet see its shape. I spent hours at my desk drawing

pictures and making art—maybe *that* was it. To me, drawing was as calming as prayer.

Within a week of Donna's confession, I became her all-purpose alibi—ready to lie for her at any moment. She didn't want to upset my parents, who expected much from their not-yet-pregnant daughter.

"Mom, Chris and I are going shopping for school clothes," Donna would say—and then we'd disappear for hours to her boyfriend's bungalow on the beach.

Boyfriend Derrick was a high-strung college kid who'd failed out and was about to be drafted. Donna admired *his ideals*. He was a pacifist, ranting against the Vietnam War. He was also very handsome, with pale green eyes. He called me by my full name, Christopher; this made me feel like a grown-up.

Derrick gave me a notepad to draw in while he fucked my sister in the bedroom. The walls were thin. Even with the stereo on, I heard far too much. I hated it when they made animal sounds. When they came out, Donna would be sheepish, her makeup a raspberry mess, as she watched Derrick roll a joint. The smell of pot was wonderful, like a deep forest, but I didn't like it when Derrick started laughing for no reason. I was afraid he was laughing at me.

ONE SUNNY AFTERNOON, I rode my bike to Woolworth's, meandering home with pockets full of candy. Gliding toward the back door, I saw cars in our driveway I'd never seen before, and strange people wandering about. Two girls were picking Mom's flowers! I jumped off my bike, speechless, struck dumb by the gob of Dubble Bubble wedged in my mouth.

I spit out the gum and ran inside. A blond guy sat in my dad's recliner, a joint dangling from his dainty fingers. Calm as a caterpillar, he exhaled a blue cloud, asking, *Who are you?*

I ran into the kitchen.

My parents were 757 miles away, golfing in Bermuda. My brothers had been shipped off to relatives, but my sister and I were allowed to stay home, by virtue of our *maturity*. I found Donna at the fridge,

talking to a cowboy with red sideburns and a turquoise belt buckle—both of them swigging bottles of my dad's special beer.

When Donna saw me, she practically did a cheer. "We're having a party! Chris, this is Buffalo. He's from Taos."

"Howdy," he said, crushing my hand.

The house was overrun: girls in gauze, boys in boots, people splashing in the pool—*naked!* I was freaking out. I ran down to the basement, where it was safe. Looking at Mary in her golden gown, I suddenly knew what to do.

I went to the closet and opened the box where I'd hidden my shame. After months in my room, it smelled a bit like incense—like a holy garment. I unfurled the pink cape and put it on, and slowly walked upstairs, feeling a bit like Joan of Arc headed to the stake.

Or was I a butterfly, emerging in my true colors?

When I entered the kitchen everyone stopped talking. I saw the cowboy put down his beer and knew I'd made a terrible mistake.

But then there was something new: the sound of clapping. Everyone cheered, "Right on!" The room felt like it was a thousand degrees and I had the sense of something beginning to break. It was a smile, a big grin across my face. People were still clapping. Donna, too. Something was clearly expected of me.

What would my mother do?

Twirl. I executed a double twirl to better show off my splendid Pucci.

I was blushing but didn't care. Smiling, everyone went back to their drinks, their smokes. A boy in a pink cape—a minor diversion, a laugh.

When I walked into the den, the blond guy waved me over.

"Donna says you're her brother. Join me. I'm Valentine."

I took a space on the floor in front of him. I wrapped my cape around me for safety, my head floating above the mound of pink satin. I was slightly afraid of this Valentine.

My sister had already told me all about him. A Russian boy from the city, sleeping with her best friend Jo. Though Jo was blonde and pretty, Valentine was something way past pretty. His features fell

exactly between male and female, his long hair a perfect shade of platinum. As if to signal gender, a pale mustache floated on his lip.

Valentine was too beautiful somehow; it caused a kind of pain in my chest.

He was also a drug dealer, wanted by the police. And implausibly, he was sitting in my father's easy chair, my mother's Hummels like a blond army behind him.

I felt dizzy.

Wearing black silk pajamas, Valentine casually crossed his legs as my sister brought him a cold bottle of Coke. He took a long swig and handed it back. From behind his ear he pulled out what I knew was another joint. He lit it and passed it—to Donna.

"So, your brother is cool with this?"

Donna smiled, as smoke drifted from her mouth. "Oh yeah."

Strolling back to the kitchen, she left me with Valentine. I thought I should say something. Trying to sound scientific, I asked him what his intentions were, in regard to drugs.

He held up his hand. The gesture was stern. "Please don't call them drugs. Call them what they are—*sacraments*. Given to us by the Creator for our spiritual evolution."

With his doll eyes flashing, he added in a whisper: "I'm looking for God, not a hand job."

What's a hand job?

"So, brother, you need some sacrament?"

Donna yelled from the kitchen, "Valentine! He's only eleven."

"But I have an abnormally high IQ," I said. "I'm not bragging. It's actually a problem."

Valentine said, "There are no problems, man. Only questions."

3.

Johnnies

SUMMER ENDED, LIKE A SHADOW across the sun.

Mom and I left for St. John's. As usual, she was speeding, passing every car on the highway.

"Mom, I'm worried. I won't know anyone."

"You'll be fine. Soon you'll be Mr. Popularity."

The scene at the castle was chaos: cars everywhere, boys running about, mothers weeping, fathers dragging trunks like coffins up the castle steps.

Mother, in a red dress and pearls, pushed to the front. "Where do we go, Father?"

"Is that your boy, ma'am?"

"Yes, it is."

"Wrong building, I'm afraid." He pointed back down the hill.

No castle for me. Younger boys were sheltered in an old farm-house, just a stone's throw from the sewage treatment facilities. A fat Father Jerry greeted us there, offering to help me with my luggage. The building was run-down; the whole structure leaned to the left like it was trying to dodge a bullet. My room was grim—metal bunk beds on brown linoleum, dishrag curtains.

Mom helped me unpack and then administered a cautious kiss. "Goodbye, darling." We both knew not to cry.

"You don't have to leave yet," I said. "I think there's like a dinner or something."

"I can't. I have to meet your father in the city."

Without a second glance, she disappeared.

Father Jerry—his hands too tiny for his enormous body—introduced me to my new roommates, who'd just walked in and were, for some reason, in their underwear.

"Anthony, Stewart, I want you to meet Christopher."

Father Jerry left me there, in my gold ascot and blue blazer, to sort out the arrangements. When I asked which bunk was mine, Tony (the shorter one, with chest hair) said, "Will you look at his goddamn outfit?"

Stew (blond and Polish) had skinny arms with prominent lumps of bicep; they looked like snakes that had just swallowed gerbils. He put one of his deadly arms around me and asked if I gave good head.

Thinking it was drug slang, I said, "No, but I'd like to."

THE NEXT MORNING, I peed in a trough with six other boys, as if group urination were the latest thing. And waiting my turn at the sinks, I noted that some boys brushed their teeth in the nude, and with great vigor. There was spitting and gargling, farting on com-mand. Having nothing to contribute, I combed my hair, tied my tie, and found my way to breakfast.

The cafeteria, in a basement below the church, echoed with the sounds of several hundred very rowdy boys. As I waited in line with my plastic tray, I began to worry. Nearly everyone was bigger and older than me. At the seventh graders' table, even my loudmouth roommates seemed uneasy.

We were the runts—and we were surrounded.

I'd never seen so many jocks. St. John's School, carved from a huge private estate in the 1930s, was a fervently Catholic institution, with a famous athletic program. Golden trophies lined the halls. The students, known as Johnnies, were, for the most part, clean-cut and wide-shouldered. I understood now why Father Karl had asked me about sports during my interview.

Watching grown-up boys wolf down their food, I was both frightened and excited. Was it really possible I was going to spend the next six years here—until I was eighteen?

I felt my own arms: there were no gerbils.

On second glance around the room, I was relieved to spot a few other skinny boys, as well as a few fat ones, off in the shadows. Maybe their plan was similar to mine: study, survive, graduate. But first I had to get through seventh grade.

EACH DAY at St. John's was dependably the same, and slowly I began to adjust. With the other thirty boys of Low House, I woke at seven to a clanging bell, frantically got dressed, and made my bed. Dress code was nonnegotiable: short combed hair, dress shoes, school blazer, white shirt, and dark tie. Pastels of any sort were highly illegal. When I'd done my mad rush of clothes shopping with Mom, I had no idea of how regimented everything would be.

Classes were much harder than at St. Ignatius. I barely had time to sketch (or to feel homesick). I sang at mass, cheered at football games, and slogged through hours of homework in study hall. The schedule was relentless. When the last bell announced *lights-out*, I collapsed.

From dawn to dark, the monks were always watching, their

silhouettes embedded in each and every scene. All wore black woolen cassocks, the fabric coarse and somber. Some monks were ancient, having spent their whole lives on the mountain. Others were fresh from college. Though many were not ordained as priests (*Brothers* rather than *Fathers*), all the monks of St. John's were teachers by trade.

Above everything stood the church, a concrete fortress, harsh and modern. Beyond that, the monastery skulked closer to the ground, windowless, revealing nothing to the outside world. My teachers ate and slept up there, traversed the secret tunnels connecting the church and the castle.

Johnnies were forbidden to even visit the monastery.

I wondered what the monks did at night. Did they fry pork chops, smoke cigars, watch *Bonanza* in their underwear? I'd heard that they'd all taken a vow of poverty. That sounded dreadful.

Most of them, though, were quite pleasant. I think they liked their lives. My religion teacher, Father Peter, was a loquacious elderly monk with a sizable mole on the tip of his nose. Some of the nastier boys called him Mickey Mouse.

You ask too many goddamn questions, Dad had told me—but in Father Peter's class my questions were encouraged.

"Father, if God knows everything, then there's no free will. If He knows what I'm going to say, then I'm just a robot."

Father Peter smiled. "Who knows, maybe we amuse God with all our jabbering? You amuse me, Mr. Rush. And you seem to have no shortage of free will."

Within a short time, I was at the top of my class.

I wished I could tell Mom in person. Even though home was several hours away, I assumed I'd be going back most weekends. But on the phone, Mom suggested I stay for the first month or two, *to get adjusted*.

I wasn't the only boy stranded. There were lots of kids who didn't go home on Fridays. A few parents showed up to visit on Sundays, but they never stayed long.

I could hear kids crying from inside the phone booth on the second

floor. Sometimes, even a jock would emerge from the box, sniffling and rubbing his eyes. I refused to do that. Whenever I called home, my routine was consistent: I bragged and chattered, even as my heart was sinking. I was my mother's son—and I refused to humiliate myself.

If I spoke with Donna, she always said, "You're lucky to escape."

I tried to feel lucky, tried to imagine I was a boy in a fairy tale. Surrounded by a thousand acres of forest and ravine, St. John's was miles from the nearest town.

The woods were a tangle, a dark dream.

AT NIGHT, I usually slipped into bed early, to avoid the kids crashing about in the hallway. In the minutes before lights-out, all the boys went a little wild.

Luckily, there was supervision. Father Jerry had his quarters at Low House—he was our own personal priest. I thought of him as an old man, but he was probably only in his forties. He had a perfectly round face and slicked-back hair, too black, like something painted on a mannequin. His cologne smelled like whiskey and roses, filling the air as he made his rounds. While my roommates relished their last moments of freedom, Father Jerry would always visit me— sit on the edge of my bed. He was kind, always asking me how I was.

Once it had been my mother who had bid me good night. Often there was a dinner party or bridge game waiting—and she'd only have a moment. But that moment was all mine, her kiss a ray of light falling, landing on my lips.

Now it was Father Jerry who offered me kindness. There was so little tenderness at St. John's that I looked forward to his visits—the way he smiled at me and called me *sleepyhead*.

"Good night, baby," he would whisper in my ear, while with one efficient gesture he'd slip his hand under the covers to pet my skinny legs and caress my balls. Then, with a sigh, he'd stand and leave for another room, another boy.

As the year went on, Father Jerry grew bolder. His hands began to stray. He would find my anus and massage it with his finger.

Sometimes, he'd lean in to kiss me—and I'd smell the booze. Then, before anyone could notice a thing, he'd say *good night, baby* and be off. The bell would ring, the lights would shut, and I'd fall asleep, confused.

The next day, in a noisy classroom, I'd blush, thinking: *He'll visit again tonight.*

THE FIRST MONTHS: a blur of boys, trees, darkness. I can still smell the roses in whiskey, wet stone, rain on wool coats. The sweet smell of candles and frankincense.

Often, I sat in church, in the flickering half-light, listening to the sound of monks walking past. It was always safe there, and serene.

Sometimes I thought, *Maybe I'll give myself to God.* Did that mean giving myself to Father Jerry? At twelve, I could not do the math of love and sacrifice—but God understood everything. I asked Him to help me.

I thought of my real father, how he went to confession, day after day.

I prayed and I studied—and in my notebooks I began to draw the dark trees of St. John's, witchy and half-human, faces in the bark like the apple-throwing trees from *The Wizard of Oz.* I can still see those drawings, can still walk through that living forest.

IN THE CHURCH, sometimes I saw an older boy—a fat kid lighting candles and muttering prayers. One Saturday morning, I watched him creep in by the side door. I went and knelt down beside him. He lit a candle and turned to me. "I'm praying my nana dies and goes to hell. Then I'll inherit her money and her house. Why are you here so early?"

I opened my mouth but nothing came out.

He asked me, "What are you praying for?"

I didn't have a good answer. I told him I wanted to become a priest.

"Why would you want to do that?" He asked me to give him one example of God actually helping anyone. "You can't depend on Him," the boy said, with shocking conviction.

"Then why are you praying to Him?" I asked.

"I'm not. I'm praying to Lucifer, my prince."

PAULY PINUCCI—*LUCIFERIAN*—lived upstairs at Low House. He was fifteen and on the wrong side of average: too short, too chubby, too big a nose. He wasn't much of a Johnny—but his voice was deep, his hands long and lovely.

And he played the piano like a genius.

In the castle, in a practice room, Pauly performed a Mozart sonata for me—from memory. It was extraordinary. He became another person when he played—his big body swaying fluidly about the keys. At the baby grand, he was beautiful.

I liked Pauly—liked listening to his big ambitions. "I'm going to be rich and famous. I'll make *brilliant* music. The fact that I'm ugly doesn't matter a bit."

"You aren't ugly."

"You don't have to lie. Luckily, concert pianists don't have to be sexy. The best are almost always unattractive. Horowitz is hideous, farting as he plays . . ."

I risked a question. "Do guys ever mock you?"

"What do you mean?"

I told him I couldn't take showers anymore—that every time I tried, some of the older boys made fun of my body, my little dick. I told him that two of them peed on me, on my butt.

"They what?"

"They've done it *twice*."

"Is that what you were praying about?"

"Not exactly."

PAULY, TOO, WAS MOCKED in the showers. So we began to do our showering together, at the gymnasium. We did it during dinner

hour, when the building was deserted. We never dared turn on the lights.

In the gloom of the shower room, our bodies slowly materialized. The water was hot and delicious, and as we washed ourselves, we snuck glances toward each other. Pauly was pale and pudgy, and through the steam I saw a shadow of pubic hair above his dick. He looked at me, smooth as a baby, but I didn't feel embarrassed at all.

Pauly became my guide and protector. It was his third year at St. John's. On weekends he took me to the secret spots on campus—the fields and forests, the ancient barn, the abandoned swimming pool filled with leaves and bones. One could easily get lost on the huge estate, and there were afternoons we wandered without seeing another soul. I imagined us as the only two boys left on Earth, waiting for Paradise to begin.

Pauly talked about Mozart and Goethe, about Hesse and Horowitz, and, of course, about God and the Fallen Angel. And he told me about his crazy clan. Pauly came from a wealthy Italian family in Boston, the only boy. His mother was obsessed with him. He had to call her several times a week and report all his activities in detail. "I hate being interrogated every time I call home. 'Pauly, are you studying? Pauly, are you regular?' She never shuts up. I know it's the pills. She takes them because she's fat."

"Pauly, your mother sounds nice. At least she cares. Mine is always too busy to talk. And I think my dad hates me."

"Chris, that's what fathers do. Do you think my father doesn't hate me? Our fathers went through World War Two. They're all psycho."

I asked him what his father did for a living.

"He's a surgeon. He just operated on the Bishop. He shoots vitamins into the Bishop's ass—he really does. He does it in our house, in my bathroom. I saw the ass. Completely gross."

"My dad throws big parties for the priests," I said. "They put their hands up ladies' skirts. That's grosser. And my dad says I'm the bad one."

"Bad at what?"

"He says I'm a *queer*. I'm not, you know."

"Doesn't matter to me. The Devil likes everything."

I was about to bring up Father Jerry, but a deer had appeared in front of us, like a miracle. She seemed to say: *Silence.*

FATHER KARL, the crew-cut football coach, mussed my hair, then told me I needed a haircut. That Saturday, I took the school van to the little town of Morton. The barbershop was packed and stunk of cigars and old men, but just up the street was a place called Marta's, a salon. An hour later, after a surgically precise haircut and a fluff under a space-age dryer, I appeared to be wearing a cap of yellow feathers on my head.

The young hairdresser seemed pleased. She said, "Pixie cut."

My return to the dorm caused a small riot. Every kid in Low House came by to laugh at my hair.

"*Rosemary's Baby!*" someone shouted.

"It's Mia Farrow!" came next.

Even Pauly had to laugh.

Word of my hairdo spread quickly. By Monday morning, the dean of discipline, Father Boniface, had me in his office. Bonny's punishments were famously harsh, but I liked him—his manicure, his stylish black glasses. He was also an art teacher, known for his calligraphy. Each day, he'd handwrite the list of boys for detention in a gleeful frenzy, posting the text on his door like a demented wedding invitation.

I sat down in a huge butt-dented leather chair, facing his desk.

"Mr. Rush, what is the meaning of your coiffure?"

"Father, it's just a haircut."

"Young man, I'm quite certain that is a *girl's* haircut. Is it supposed to be some kind of joke?"

"No. The woman just *gave* it to me. All I said was make it *short*."

Bonny told me to be quiet. "You have detention all this week, Mr. Rush. And I'll be watching you very closely. Very closely!"

Leaving the office, I swore I'd never cut my hair again.

For seven years, I kept that promise.

FOR THE WHOLE WEEK of detention, Pauly selflessly joined me and did his homework—a silent vigil that sealed our friendship. Afterward, we ran to our favorite spot in the apple orchard, relishing the fact that we could speak again. The hour of silence only served to increase the needy nerdishness of our conversations.

"Pauly, just assume with me that God exists."

"I do not deny this fact."

"Okay, so would you say that God is all-encompassing?"

"It depends on what you mean."

"I speak of totality."

"Then no. We must include the shadow . . ."

If I brought up God, Pauly brought up Satan.

One evening, as we walked toward the cafeteria after Vespers, Pauly asked me if I was hungry.

"Of course," I said. "I'm starved."

"Well, look what I have." From his shirt pocket, he pulled out a Host, waving the little white wafer in front of me. "At Communion, I only pretended to swallow."

In all of Christendom there were few sins as grave as desecrating a Consecrated Host. If anyone saw it in his hand, we'd be expelled—*and* excommunicated.

Pauly nibbled on the holy disc. "Wanna bite?"

Piously, I declined.

Saturday morning, a few weeks later, Pauly sat at breakfast, shoving a powdered donut into his mouth. Sugar dusted the book in front of him: *A Compendium of Black Magic.* I gasped and put my napkin over the title.

"Relax, *Christ*-o-pher."

But I couldn't relax.

When I was little, I'd often dreamt of demons. In my nightmares, they dragged me away into darkness, into a terrible crater. I'd inherited

this propensity for bad dreams from my father, who often woke up screaming.

I didn't like the Devil. I told Pauly to get rid of the book.

"I just need you to do me one favor," he said.

"What?"

"Just come to the woods with me later? You trust me, right?"

Pauly was not just my friend—he was my only friend. He'd spent a week with me in detention; played Mozart just for me.

"Fine," I said. "I'll come."

THAT EVENING, in the beam of our flashlight, I saw Randy, an older friend of Pauly's. He had on a varsity jacket and, implausibly, goggles. He carried a huge book bag.

I whispered to Pauly, "Why is he here?"

"Don't worry. You'll see."

He gave the flashlight to Randy. We had arrived near the ruins of an old stone house, deep in the woods. Pushing leaves away from the ground, Pauly drew a circle in the dirt with the long willow wand he carried at his side. Outside the circle, he traced a triangle, where I was told to sit. When Pauly pulled out a homemade white gown from his pack and struggled to get it on over his clothes, Randy and I started laughing.

Pauly told us to *shut the fuck up*.

"Randy—get into the magic circle with me. Chris, you stay in the triangle."

We laughed once more and Pauly snapped. "Do as I fucking say!"

I took my place, heart pounding, and, as instructed, lit the three candles stuck in the dirt in front of me. Pauly held a piece of parchment in one hand and his willow stick in the other. He read some words in Latin, and then he said, "Randy, get the rat."

From his book bag, the other boy lifted a silver cage containing a white rat—stolen, I assumed, from the biology lab. Pauly, speaking English now, offered the rat's life to Satan. Randy pulled out a pearl-handled letter opener. Its first plunge into the animal produced only a tiny squeak.

"Stop," I said—but Randy downed the blade again, this time producing a ruby of blood.

"Kill the goddamn thing!" Pauly hissed.

Randy, eyes squinting behind goggles, strangled the rat to death, then placed the corpse at Pauly's feet.

I felt ill.

Pauly called out to the demons. He named all their terrible names, one after another. He said, "I give to you a virgin." He crouched down and touched my shoulder, the candles throwing shadows across his face.

Part of me wanted to run, but a nightmare feeling of helplessness overtook me. I went limp. I thought to myself: *Am I hypnotized?* I could feel myself far away, a shivering body. And then suddenly Pauly struck me with his stick.

I tasted blood. And then—no pain, nothing. In a trance, I dreamt of my father, in the woods with me, a deer carcass at his feet. I remember my father shouting.

Then Pauly shaking me, screaming, *Come back! Come back!*

When I opened my eyes, the other boy was gone. Pauly's eyes were wet, glittering. "It worked. It worked," he said. "I have no soul."

I saw the dead rat on the ground.

I began to shiver. Pauly took me in his arms. And then he told me that we could never leave each other. "Do you understand, Chris? Not ever."

4.

Napalm

WHEN I CAME HOME for the summer, I had flawless grades, but it meant nothing. I was still condemned to childhood—puberty would not arrive for almost a year. But somehow, my younger brothers already looked and acted like little men, following my father around the yard, doing their chores like soldiers.

It was cookout season—and my father was getting ready.

Dad's barbecue was a monument, a brick ziggurat crowned with an iron *R*. He could cook for a hundred people, if need be. Dad was a pro.

That summer, he decided to use napalm.

Napalm, a form of jellied gasoline, was invented to melt people during the Vietnam War. In 1969, billed as the perfect accelerant, it was briefly available to home chefs. My dad bought cans of it at the hardware store and used it to start the barbecue. It was a real crowd-pleaser. *Whoosh!* A wall of flame.

AFTER A YEAR away, it was strange to be home. I fussed with my room, decided it was time to get rid of my toys and stuffed animals. I torched them with napalm in the sandbox, thinking of Pauly and the fires of hell.

I saw my brothers Michael and Steve watching from the distance. Mike, a pyro like me, smiled at the flames. He was a brain, as well, a twelve-year-old who liked to dismember stereos in his junky room, then put them back together. He favored noise and chaos. Steve, a year younger, was a nervous child (he'd been given tranquilizers to get through first grade). Staring now at the fiery mayhem, he looked worried. After a few minutes, the boys drove off together on their bikes. Secretly I wanted to get on my ten-speed and race ahead of them. Once I'd been their leader, but my going off to boarding school was a kind of betrayal.

Now brotherless, I hung out with Donna.

In my sister's locked bedroom, she snuck not only Tareytons but quick hits of pot. I begged her to let me try some. "Valentine said it's good for me—it's from God. It's a *sacrament*."

Donna rolled her eyes, but I gave her my laser stare and tried to sound tough. "Or would you prefer I get it on the streets?"

Finally, she gave in to my high-pitched begging.

One night, after everyone was asleep, Donna and I smoked a joint in her bedroom. As I pulled the smoke into my greedy lungs, it burned, but I was too proud to cough. After a few more puffs, my hands began to feel like catcher's mitts. And I couldn't stop smiling.

Donna took the joint away. "That's enough."

I looked around the room. Every detail was leering and hilarious.

My sister's chiffon curtains seemed like they might start to sing and dance.

"Chris, are you okay?"

I nodded, unable to speak.

Eventually, we drifted downstairs to the rec room. Everything I saw—the poker table, the wet bar, the gun racks—was transformed. The stuffed deer heads, killed by Dad, seemed undead but not unhappy. I studied their glass eyes, set like glowing jewels. I sang "Silent Night" to them in German, as I'd learned in the choir at St. John's.

Stille Nacht! Heil'ge Nacht!
Alles schläft; einsam wacht

Suddenly the deer's eyes were my father's eyes, telling me to be quiet. But the pot made me fearless and I sang even louder, Donna laughing at every silly note.

IN JULY, Mom invited her relatives over—a rare occurrence. While strange kids swam in the pool, the adults congregated in the living room, curtains drawn, AC set on freeze. Mom's relations were poor people, with crooked teeth and ugly clothes. I barely knew who most of them were. What I did understand was that Mom was not quite herself—serving drinks in plastic cups instead of crystal.

I listened to Grandma Loey chat on the couch with her sister Peggy. Old as dragons, they sipped cocktails, their eyes swimming behind enormous glasses. Not three in the afternoon, and already they'd begun to drift.

Loey was proud of her daughter's well-appointed home. "Look, look," she kept saying to her sister. "My Norma collects turtles! Aren't they something?" She picked up one from the coffee table and pushed it in Peggy's face. The turtle was a pill case, and as Loey held it aloft, hundreds of saccharins fell like flakes of snow.

Neither noticed a thing.

The sisters drank, toasted, and kissed, smearing their lipstick like jam. I didn't know that they'd once been fabulous flappers, gorgeous girls with terrible luck. Both married men who beat them silly. No one ever told me how rough their lives had been, how tough they had to be.

My parents, of course, explained nothing.

MY SISTER HAD graduated with honors from St. Ignatius High. Her graduation gift had been a Mustang convertible, in forest green. Once she had the keys, she was hardly home. I missed her terribly.

But it seemed she could still read my mind. One morning, she came down to the basement. "Chris, there's a be-in at the park today. Wanna come?"

In five minutes, I was dressed: maxi-fringe moccasins, Peter Max pajamas, and a strand of baby-blue beads. When I came upstairs, Mom thought I looked darling in my *costume* and took a picture. Then, in another, quieter voice, she said she was concerned about Donna, who was still primping in her room. "Chris, I think some of Donna's friends may smoke marijuana. Keep an eye out, will you?"

AT THE COUNTY PARK, there were a couple of hundred kids stretched out on the lawn. There were puffy pants and ostrich feathers, face paint and attempted beards. Under the shade of a giant maple, we found Donna's friends. On an Indian blanket, we sat beside Valentine and Jo. Valentine was shirtless and tanned, his blond head on Jo's lap.

He said, "The angels have arrived."

I'd forgotten how pretty he was, boyish even, but so confident, with his sexy girlfriend and adoring friends.

Some dude nearby tapped on a drum and hummed. No one spoke, though, or danced. The crowd was strangely reserved. Donna whispered to me, "They're all tripping. Valentine doses everyone. That's his thing."

Soon, he sat up and spoke to his disciples, in the kind of cooing

tones one uses with toddlers. "People, are you with me? Do you feel the breeze? It's *sooooo* fulfilling. Do you feel it? Do you feel the earth vibrating? *Yeaaaaah*—let's ride it, people . . . ride . . ."

From inside his own movie, Valentine swayed back and forth.

It was a Sunday afternoon. At home, the adults would be mixing cocktails, maybe playing cards. Someone would be trying to sing along with Perry Como or Robert Goulet.

From Valentine's girlish hand appeared a little sheet of folded paper. Carefully, he undid the puzzle. Inside was a tangerine-colored tablet. With his fingernail, he chipped it, holding up a tiny sunny shard. "Take this," he said to me.

"I don't think that's a good idea," said Jo.

But when I looked at my sister she shrugged, and Valentine put the LSD on my tongue—like a priest giving Communion. He bowed his head, and I bowed mine. Instantly, the drug dissolved. Valentine handed the rest of the tablet to Donna.

"Orange Sunshine," he said.

In silence, everyone stared out across the lawn. Soon, an agitation began to flutter inside me. Or was it outside? As the breeze moved across the park, the shuddering of the trees was mesmerizing; the lawn rippled like the surface of a lake.

I thought: *God's here.*

I had not yet been drunk, but like a drunk I found that everything around me was moving to and fro. But rather than falling overboard, I stayed safely on the red blanket. It was a boat and on it we were slowly carried away . . .

My sister said, "Let's take a stroll," and, like Jesus, we were able to walk across the waters of the lawn. Against my bare feet, each blade of grass felt profound and singular. When my sister bought me an ice cream, I began to cry. I wanted to scream: *I love you so much!*

Love was not a word that was ever said in our house. It suddenly felt like a great secret, rediscovered. Why hadn't anyone told me about it before? And how had it arrived inside a piece of dust placed on my tongue?

"Are you okay?" Donna asked.

When we went back to the blanket, Valentine put his hand on my shoulder. He understood everything. "Love is making him cry."

I looked up into his impossibly beautiful face.

"You're one of us now," he said—and then, "You're one of mine."

I closed my eyes and saw stars, paisley, jellyfish.

BEFORE GOING HOME, Valentine slips me a folded piece of paper, another tiny pill. The next night I can't sleep, thinking about it. At midnight, I take a chip. When I wander upstairs at four, I'm peaking. In the kitchen my father is making his eggs. I watch him from the doorway. Like an X-ray, I can see inside him. Can see his heart, like an octopus.

Ten minutes later—*an hour?*—I see him out the window, walking around the yard. As the light grows, I see he has a gun in his hand—a spray nozzle attached to a bottle of pesticide. He's at war with the dandelions. In his other hand, there's a glass of scotch. As he sprays each flower, he's saying: *Die, die.*

The sun is rising, yellow on his yellow hair.

I need to tell him that *everything is okay.*

But he disappears behind a curtain of sunlight sweeping the world.

A FEW WEEKS LATER, Donna drove me out to Valentine's stash house in the Pine Barrens. Up a long dirt drive sat a shack on the edge of a mossy spring. Inside, our leader was sleeping on a bare mattress, blond head on a paisley pillow. We stood there for a moment, watching him breathe.

The house was dark and sweet, like cinnamon.

Valentine opened his eyes and said: *Peace.*

Jo came from the kitchen and kissed us hello. She and Donna went off to chat, leaving me alone with Valentine. I sat on the floor next to the bed as he rolled a joint. He lit it and only after five or six hits did he pass it to me. It was wickedly strong. I handed it back, coughing, already far too stoned.

It took all my nerve to say, "Valentine?"

"Yes?"

"I'd like to take some acid back to school."

"You want to buy some?"

I swallowed, said, "Yes."

Valentine did not take his eyes off me. "Have you been saying your prayers?"

I bowed my head, embarrassed by the question, wondering if he was making fun of me.

"How much?" he asked.

"Like five."

He opened a suitcase, pulled out a dusty plastic bag, then poured a mound of pink pills onto a silver tray. He thought I meant five hundred. I didn't know what to do.

"I just want to share some with a friend. We're in the choir," I added stupidly.

"Sacrament belongs in a church. Take a thousand."

"I really just want five." I could hear my voice going up. "And I don't have that much money."

"You will. Go ahead, count 'em out. I'll get a baggie from the kitchen." When he left the room, I felt dizzy. I wanted Donna's advice but she was busy with Jo.

Fingers coated with pink dust, I counted out a thousand hits.

Valentine, walking back in with a jar of baby food, licked goo from a tiny spoon. "I love this stuff. Especially the vanilla." He poured the pills into a baggie. I didn't want to disappoint him. I asked what I should charge.

"You get them for a buck a tab. Sell them for three." He smiled. "When you have the cash, have your sister call me. It's all for the Glory of God."

I SAW EVERYTHING but understood nothing.

At home, something was going very wrong. Dad was drinking too much. And Mom was spinning like a top. I asked myself: *Have they always been this strange?*

The anchor of my childhood, the thing that kept our house from drifting out to sea, was the love between my parents. Being ignored was not so terrible, because Mom and Dad had put on such a great show for everyone to see.

I loved my parents because of how much they loved each other. They were showing us what was possible if we were good and patient. I also understood that love made people selfish. But now they seemed selfish not only toward their kids but toward each other.

I spent little time with either of them that summer. Mom was a blur, coming and going, shopping like crazy. She came home with a car full of bags and boxes, although every closet was stuffed with clothes she'd already forgotten. Plus, her turtle collection was growing. It was an infestation. She'd bought hundreds more.

My father said less than ever, but every night at dinner, he said, "Chris will say Grace. He's almost a priest." I could never tell if he was mocking me or honoring me. But it always made my brothers laugh.

Mom, too, was strange when she spoke to me, almost petulant, as if I'd abandoned her by going away to school. I followed her around the house trying to tell her how glad I was to be home, but we had no adventures that summer. No trips to the stores or the cemetery.

She seemed to be looking over some cliff, her eyes far-off. But the night before I went back, she made the simple effort of doing my laundry while I watched her in silence. I remember her dark hair, stiff with hair spray—her apron, white with green piping. In the kitchen, she ironed my clothes and folded them, a perfect pyramid, crowned with a pair of socks.

5.

Virgin in Ruins

AFTER A RAINY SUMMER, Low House was dank and moldy. It smelled like a stable; even with the windows open, there was no getting rid of the scent of thirty boys stacked to the ceiling on spermy mattresses.

When I first saw Pauly, I was worried; neither of us said a word.

He looked older, a vampire in cashmere, greasy black hair across his eyes. He seemed tired, a little sad. I reached for his hand, and soon we fell back into our old rhythms. The murdered rat was never mentioned.

It was comforting, hearing Pauly ramble on, telling me about his

summer. Apparently, he never left the house. "I was held hostage! My mother never stopped feeding me!" He opened his coat to show me how fat he'd gotten. "Feel it."

"Pauly, can we go to the orchard?" Halfway there, I squealed. "I smoked pot with my sister!"

"That's expected. You're an artist."

"And I took acid!"

"*Really?* I assume you're speaking of lysergic acid diethylamide and not hydrochloric, which would mean you tried to commit suicide."

"Pauly, stop—look." I knelt down and opened my pack and pulled out the plastic bag.

"What the hell is that? You're shaking like a leaf!"

"It's called the Pink. It's LSD."

"Are you out of your fucking mind? Put that away!"

I went to stuff it back in my pocket, but Pauly said, "No. You can't take that to your room!" He searched and found a tree with a hobbit-hole. "Put it in there."

"What if someone steals it?"

"No one comes out here but us, dickweed. Give it to me."

As he lodged the baggie in the hole, I asked, "Shouldn't we take a couple out for later?"

"What, you're a drug addict now?"

I was too embarrassed to say it wasn't a drug, it was a *sacrament.* Besides, that wouldn't have been a selling point for a Luciferian.

NO LONGER A FIRST-YEAR, I'd graduated to a room on the second floor of Low House. I had a view of smoky hills and wizened trees that pelted my window with nuts. Father Jerry did not stop by the first night—nor the next. I recall the combination of relief and disappointment in my gut.

But I didn't think about him for long. I had other things to worry about. Bringing a thousand hits of acid to St. John's was preposterous—enough LSD for every person on campus *and* their families.

As if to make up for my mad crime, I threw myself into my

schoolwork. I wrote essays on Mary Shelley and mortal sin, on Conrad and the war in Vietnam. My sister's boyfriend was on his way there.

I got As on everything.

In art class, I boldly used the largest sheets of paper to draw fantastic landscapes, with elves hiding behind the foliage. I drew the creatures' faces and bodies to blend in with the branches and the rocks. Of course, I believed firmly in both elves *and* the Lord Our God.

I desperately wanted to share the Pink with Pauly—I thought it might be good for him. *Angel food*, I thought. Finally, a few weeks before Christmas, I took a pill from my blazer pocket and pushed it into Pauly's hand. I smiled.

"Okay," he said. "Let's do it."

IN THE CHURCH, feeling very high, we listen to one of the monks on the pipe organ, the music a vine growing inside us—beautiful, complicated knots, like ancient code unraveling. Then we are two boys running in the woods, the forest a fantastic blur of color, glitter, and fire. We climb a tree in a windstorm and sway, as if held in the arms of a giant.

I'm a giant, too. Looking down at myself, I notice how small my clothes are, how tight. I've grown six inches in the past year—and no shopping trips with Mom.

"I'm huge," I tell Pauly.

But he can't stop staring at the sky.

Maybe he can see God. I stop talking, leave him to his own trip.

"SUBLIME," PAULY SAYS the next day, and, being Pauly, he can't help blabbing about it. And not just to me. He's bragging to all the other boys.

"Shut up," I whisper.

He takes me aside. "Isn't that why you brought it? You're supposed to sell this stuff, right?"

"Yes," I say back. "But only to people who are ready for it."

"Everybody's ready—believe me."

And they were. Word spread quickly.

Pauly walked around campus in his long black coat and pinky ring, like some kind of Gothic door-to-door salesman. He told the older kids where to find me—and in the afternoons I'd go to the quarry past the pond and wait. That was my office. I kept the pills stashed under a rock—the cash, too. We used film containers scrounged from Camera Club to distribute the product.

In their St. John's blazers, our customers were excited, their hands trembling as they gave me their money. My hands shook, as well. I tried to remember what Valentine had said: *You're helping people evolve.*

There was a strange elation, giving out LSD to upperclassmen who'd once bullied me. Even a couple of jocks got in line. As thrilled as I was, part of me was terrified. I warned everyone to be careful. "These pills are really strong."

It took only two weeks to sell everything. Suddenly I had thousands of dollars. Part of it would have to go to Valentine, but the rest was mine.

IN ART CLASS, while working on some elfish fantasy, I was told that Father Boniface wanted to see me. Father Bonny had punished me harshly for my girly haircut. The punishment for selling acid would probably be *death*.

Bonny's office, full of art books and paintings, always had a box of tissues on the teak desktop, ready for boy tears. I took my seat.

Leaning back in his leatherette, Bonny lit a cigarette, his lighter boldly monogrammed with a gothic *B*. He blew smoke in my face. "So I'm told you're quite the little artist."

"Yes." I swallowed. "I like to draw."

"Yet you spend all your time in the woods with the older boys." A puff, a pause. "I wonder if you could tell me what that's all about?"

"I don't know. They like me, I guess."

"Evidently, Mr. Rush." He took another puff and then leaned forward. "Christopher, I'm speaking to you as a friend. These boys are toying with you. From this moment on, you are forbidden to talk to any boy older than yourself, under *any* circumstances. I need to end this nonsense, before the stain is too great."

I was confused. *Was this about the acid?*

"I don't understand, Father."

"Just do what I say. I'm watching you."

PAULY SAID, "We just have to be more careful . . ."

I saw him speaking but had no idea what he was saying, because I was watching flowers grow out of his head. We were tripping—again.

At thirteen, I took LSD as often as possible. Taking acid was like entering a painting or a storybook—a glowing dream world, lush and lovely. I felt no conflict between the real and the unreal. It was so easy to slip in between.

And why not? Acid always told me: *Everything will be okay.*

Plus, the way Valentine explained it, LSD was a kind of brain vitamin.

In the winter orchard, Pauly and I lay on wet leaves in our good coats.

After a while, he turned to me. "Who are you?"

"What?" I said. "I'm Chris!"

Am I Chris? The question confused me. Nameless amoebas floated in my brain—galaxies multiplying in all directions.

Pauly was hovering above me now, staring at my galaxies, breathing hard. I asked him if he was all right.

He said, "You look like a girl."

"Why are you saying that?"

"Because I love you."

"Shut up." I pointed at the trees rustling in the wind.

"I love trees," whispered Pauly.

When I glanced at my friend, I could see his bulging hard-on.

I had one, too. I sighed. "Yes, trees are very sexy."
We kissed.

I CALLED DONNA. She was in college now. We talked nonsense; we talked about Mom and Dad. I changed the subject, telling her how I'd been selling Valentine's stuff.

"Me, too," she said. "Glory to God." I repeated the words back to her. It sounded silly. We were quiet for a bit, and then she told me that Derrick, her boyfriend who'd been drafted, was now missing.

That night, I couldn't sleep. My mind was racing, thinking about the war, the weirdness of life. I got out of bed and walked around Low House in the dark, trying not to make a sound. I crept by Father Jerry's room. His light was on, his door ajar. He was sitting in his rocking chair, reading with half-frame glasses. His room, tiny as a closet, contained little—a bookshelf, a bed, a small desk.

A vow of poverty.

He owned even less than I did.

AS FOR ME, I had a pile of money. All the acid was gone.

But across the campus, the Pink was still very much in use. Every day, I saw boys goofing about—their pupils like big black dots. I knew I was doomed. Then, in March, two seniors were busted. Both were football stars, with prestigious college scholarships. It was a school scandal.

Ten weeks before graduation, Bonny had them both vigorously expelled. To my amazement, neither boy revealed who'd given him the acid.

NOT LONG AFTER THAT, on a foggy night, I snuck off to the woods with Pauly to get stoned. Sounds were amplified, perhaps by the watery mist in the air. I thought I could hear people talking miles away. Then something moved in a nearby bush.

Quietly, Pauly said, "Who's there?"

A black figure flickered in the mist. It did not seem real. I said, "Dracula?" and started to laugh—but then the dark form moved closer.

Pauly said, "Run!" As I ran, I heard the words *Mr. Rush! Come back here immediately!*

Fuck—it was Bonny. And though I escaped into the thicket, there was no hope. He'd seen me with Pauly, a forbidden older boy.

After lights-out, Father Jerry came to my bunk. It was the first time he'd been in my room that year. He did not touch me—only told me to get out of bed, after which I followed him to a room in the basement. Bonny was there, waiting. He locked the door and told me to sit down.

The room was freezing. All I had on was my underwear.

Bonny sat opposite me, watching me shiver. After a long time, he said, "Mr. Rush, you know why you're here. Tell me what you were doing out there in the dark with Mr. Pinucci."

"Nothing, Father. Pauly and I were just having a conversation."

"Oh, a conversation? About what, I wonder."

"Music," I blurted.

Father Bonny shook his head. "So why were you hiding in the dark then?"

"We weren't hiding."

A sudden shout: "I saw you kiss him!"

"No, Father!"

Bonny's face went red with fury. "You are a liar. What else do you do with him?"

"Nothing!"

After ten minutes of interrogation, I fell apart. I began sobbing, shaking. Bonny, in black cassock, watched me blubber. He lit a cigarette, snapped his lighter shut. "Your crying disgusts me. Go to bed."

A FEW DAYS LATER, I was taken from class and sent into one of the elegant lounges in the castle, off-limits to students. I was shocked to

discover Bonny and my father, whispering together on a couch. Their meeting had obviously begun well before my arrival. I said nothing. Dad, in a silvery suit, refused to look in my direction. I sat down, frightened.

Father Bonny was speaking, but it took me a moment to understand what was going on.

". . . in spite of his behavior, we've already determined that a number of military academies, such as Valley Forge, would be willing to accept your son on such short notice."

My dad paused, took his time, inhaled on his cigarette.

"Father, are any of the institutions you've contacted Catholic schools?"

Bonny shook his head. "No, sir."

"Well, I've always thought a Catholic education is essential, certainly for my children." My father gestured toward me, still no eye contact. "If I recall correctly, I've paid for Christopher to attend St. John's through the end of May. Perhaps the simplest solution to the situation you've described would be patience. I'm sure that you can handle a thirteen-year-old for a few more months. It would make my life much simpler if the boy stayed put, for now."

"I've explained the situation in detail." Bonny lowered his voice. "Sir, it is intolerable. He must leave."

My dad rose, not to exit but to overpower. "Father Boniface, it is your job to keep my son busy until May. Then he'll leave. And at that point, I'll decide if my donations to the monastery will terminate or not."

The meeting ended, and my father took me out for an early dinner. At an empty steak house, we ate our T-bones in absolute silence. Under the table, I kept folding and unfolding my napkin, terrified to imagine what Bonny had told my father.

Dad had three Manhattans. I had three Cokes. Our silence was a kind of endless falling, but by dessert I calmed down a bit, eating ice cream while my father smoked.

I loved him for saving me.

In the car, he said, "We will not speak of this again, to anyone. I'll tell your mother you were caught shoplifting."

FOR THE REST of the school year, I was placed in permanent detention. Every afternoon, after classes, I sat in a cold stone room, alone. Pauly was not permitted to visit.

When I finally told him that I wouldn't be coming back to St. John's, he looked away.

"Pauly, we'll still be friends."

We both knew that was impossible (two boys in separate schools, likely several states away). When Pauly got up from the log we were sitting on, I told him not to leave. So we sat together, suffering in silence, holding back our tears.

FATHER PETER, my religion teacher, saw me one afternoon as I was walking past the formal gardens. He grabbed my arm and took me inside. Late May: flowers in full bloom. We walked gravel pathways, past beds of yellow and pink hydrangeas, through decaying colonnades, under trellises of red rose. At a stone grotto against the hillside, we stopped. In the shadows was a worn marble statue of Pan dancing, lute to the sky—a forgotten wild boy covered with moss.

"Italian, sixteenth century, a copy of something much older. Do you like it?"

"Yes." It was beautiful, unbearable.

"Chris, don't forget all this. And don't forget God. He loves you. It upsets me that you're leaving. You were one of our best."

Among the ruins, I began to weep.

6.

The Help

"SHOPLIFTING?" MY MOTHER SAID. "When we give you everything?"

I was relieved to see her so invested in my father's lie.

She frowned and then dropped the indignation. Businesslike, she rearranged her turtles, a legion across the coffee table.

When I asked her if I should stay home for good now, she pretended not to hear me. There were brochures for new schools on her desk—fortunately no monasteries or military academies. Mom asked if I was still interested in archery.

I'd never mentioned archery once in my life.

I didn't bother to remind her who I was. She was jittering around at that point, sorting papers, writing checks. Dressed in tennis whites, like a vaudeville nurse—slim as ever. I wondered if she was on diet pills, like Pauly's mom.

"I have to go," she said, suddenly grabbing the car keys. "There's tuna salad in the fridge. Stay out of trouble."

THAT SUMMER, my whole family came and went, always on the move: golfing, sailing, trips to the beach.

For my baby brother, there was a new nanny. A pretty girl with rosy cheeks and long brown hair. Oonagh Brady, imported from Ireland through an agency. It was her first time away from home, the Rushes her first job.

She was nineteen, and tiny as a child. Like me, she blushed easily—and she was sad, too; I could tell. We chatted and she told me about Ireland, about her big Catholic family, the little grocery shop her father ran. She wore barrettes in her hair, shaped like blue butterflies.

Sometimes, when we were talking, my father would come in and say, "Leave the girl alone."

Shouldn't he have been happy to see me sitting on the couch with a girl?

Then I have a new thought: maybe he wants her for himself.

WHEN I MET with Valentine to give him his money, he seemed pleased, even surprised. With the profit I'd made selling the acid, he suggested I buy a jar of mescaline. "It's about six hundred doses," he said, "if you put the powder in capsules. You could make some money."

"I'm not at that school anymore."

"Yeah, your sister told me. Take it anyway," he says. "You'll make new friends."

But that summer, there was only Oonagh.

. . .

WHAT I USUALLY did was put a spoonful of mescaline in some OJ and watch TV, timing the drug to come on just as everyone went to bed. Everyone except Oonagh. At ten, she would join me on the couch.

The first night, I asked her if she wanted some Tastykakes. "They're really good," I said.

"No. But a wee taste of your father's whiskey would be fine."

My parents were asleep, so I obliged her. And, like God, I overpoured.

Soon, Oonagh was drunk, and I was tripping. In the middle of *The Tonight Show*, she kissed me, her mouth like booze and cigarettes. I sat half-frozen while she did all the work—placing my hand under her blouse and onto her breasts. As she moaned and groaned, I tried not to laugh—she seemed terribly serious about the whole situation.

Did she know I'd only just turned fourteen? Puberty had arrived only a month before, when I woke up from a wet dream. Since then, I'd gotten pretty good at masturbation. It hadn't yet occurred to me that I needed any help.

A few nights later, Oonagh and I ended up in the yard, wandering around after midnight. I told her about St. John's—I could hear myself bragging—and without warning, Oonagh took off her clothes and waded into the pool.

I could see her pubic hair, wavering in the blue.

She said, "I'm waiting, you fool."

"Very funny," I said, splashing her with my foot.

THE NEXT NIGHT, I got into the water with her, wrapped my long arms around her tiny body. It was thrilling, to feel her warmth in the cool water. She pushed her belly against my hard-on. It felt good, but when we got out I was trembling, maybe even afraid.

"Come to my room," she said.

"That used to be my room, when I was little," I told her. "Now I'm downstairs."

"I know. I like your statue," Oonagh said, with a wink. "The Virgin. I also want to sleep with a virgin."

"Ha, ha," I said.

I went to her room, but she passed out before we could do anything.

WHEN DONNA CAME home from college, it was a relief.

My sister was excited, telling me about her new life, her new boyfriend, Vinnie. "He's so great," she said. "Very spiritual. We're sharing an apartment. Don't tell Mom!"

She paused, then went off on a tangent. "Vinnie thinks Mom and Dad use their money to control me. Which makes sense. They think money is everything. I love them, but all Mom cares about is what other people think—and Dad is just a workaholic who has never faced his grief. That's what Vinnie says."

"What grief?"

"You know, his dead brothers and everything."

No, I didn't know. Dad never even said their names. My uncles had died a long time ago. I was about to ask my sister more when she leaned toward me. "Is that lipstick?"

"What? No," I lied, rubbing my hand across my mouth. I'd stolen it from Donna's bedroom, curious to see how it would look. It looked good.

"Chris, don't get too weird, okay? Hey, listen, Vinnie and I are going to Powder Ridge—it's this rock festival in Connecticut. Do you wanna come with us?"

"Yes!" I screamed.

When Donna asked Mom if I could go, unbelievably Mom said yes. I heard her tell Donna, "Your brother does nothing but sleep all day. Get him out of here, please!" Mom thought it would be good for me to spend some time with my collegiate sister.

Donna's new boyfriend arrived in his dad's Buick Regal. With carefully trimmed beard and brooding blue eyes, Vinnie looked like a modern-day Jesus. He was very polite to my mom; sweet and soft-spoken. What impressed me most was that he had on an embroidered white smock that matched my sister's perfectly.

Vinnie and Donna: decorated with daisies and drippy with love.

The Powder Ridge ski resort—now rock festival—was a long drive. By dark, we were either lost or close. Then we saw *the freaks*. After parking the car on the side of some road, we followed a mob of kids marching in the dark. It was hard to understand what was going on.

Then, at the top of the hill, we saw the madness. From off the road and out of the woods, thousands of bodies were swarming toward a floodlit valley below. We ran to join them, stumbling down a dusty ski trail. On either side, flashlights wobbled, bonfires burned. I heard drums pounding and people yelling—it was the Island of King Kong. Civilization—canceled in Connecticut.

Vinnie dropped the gear in the middle of the trail and we put up our tent—a big white canvas box. He carefully unrolled his sleeping bag as Donna lit a cinnamon-scented candle. Then they just sat there, staring at each other.

Vinnie said he was sleepy. Donna fake-yawned in agreement.

Oh. I understand.

I told them I was going for a stroll.

In a surge of bodies, I was swept down the mountain toward the stage. All along the way were makeshift pharmacies laid out on blankets and hunks of cardboard. By lantern light, all kinds of drugs were seductively displayed. "Speed! Temple balls! Chocolate mescaline!"

A blond boy in the doorway of a tent pointed at me—with a long silver spoon. Calmly, he stated the facts. "Purple psilocybin. Two bucks a dose."

I gave him my money and he dipped the spoon into a glass jar.

"Open up," he said, and moondust flew into my mouth.

DOWN AT THE STAGE, under fierce electric light, the kids looked stunned. Their eyes were huge, trying to take in the End of Our Parents' World. I joined my peers, sitting in the dirt—endless joints passing from hand to hand. On a small screen at the back of the

stage, an out-of-focus cartoon shimmered. It was Disney's *Alice in Wonderland*.

Everyone cheered her on—Alice was our hero.

As the cartoon ended, a young man in glasses took the stage. From a rumpled paper, he read announcements into a mike. Some mother had lost her kid. Someone else had lost car keys. Then, as if to be funny, the man gave us a little advice. "All you space cadets out there, we know some of you might be getting a little high."

The audience roared in response.

"Well, we love you, too," the man said, "but whatever you do, don't eat the green acid. It's strychnine, and it's poison."

The word *poison* swept through the crowd. There was screaming and confusion. The girl next to me threw up what looked like miniature hot dogs. I got up to leave. Suddenly, the psilocybin was merciless. Moving against the crowd was like fighting an octopus. People touched me and I could read their minds: *hungry, high, horny* . . .

After a long time, I found our tent, found Donna and Vinnie sound asleep, naked on top of their sleeping bag. I stared at them, watching them breathe by cinnamon candlelight. My sister's thigh was wet. I turned away.

Too high to sleep, I got out my sketchbook, and by the flickering candle I drew trees, monkeys, castles on fire. I sketched till dawn.

DONNA AND VINNIE were up early and before long had stacked a pile of liverwurst sandwiches on the cooler. They were wound up, talking excitedly about all the music we were about to hear: Sly and Zeppelin, Melanie and more.

I got up, got dressed, had a Fresca for breakfast.

With liverwurst and reefer stowed in Donna's purse, the three of us headed out for the show. As the white-smocked lovers held hands, I lagged behind them in red bell-bottoms, purple sneakers, and a dash of Donna's perfume. The ski trail was full of new arrivals, shiny and clean, but the area in front of the stage was a mess of unconscious kids, garbage, and gear, with a faint whiff of poo.

It was August 1, burning hot by ten in the morning. The three of us stood there sweating in the sun.

I said, "I wonder which band will come on first?"

A black kid in a bathrobe explained the situation, "The pigs cut the juice. No electricity. No music. It's a total fucking rip-off."

We didn't quite believe it until an amplified voice came over the speakers. "People, I know most of you have heard the bad news. The festival has been canceled. The roads are blocked and we have no electricity, just this one little generator. We're really sorry. There's a court order. Apparently Connecticut is scared of its own children. I'm supposed to tell you all to go home. We're really sorry."

The crowd screamed, *"No! No! No!"*

Kids raised their tickets in the air, screaming, "Thirty bucks, motherfucker!"

I said to Donna, "People don't need electricity to sing. Or roads. Zeppelin could parachute in or take a helicopter."

She looked at Vinnie. Vinnie shrugged. "Fuck this. Let's get out of here."

My heart sank. I told them I'd catch up.

Not far from the stage, under a beat-up tree I found a girl selling LSD. She stood behind a homemade sign that might have said LEMONADE. That day it said CALIFORNIA'S BEST ACID. Orange hair and freckles, the girl was maybe twelve or thirteen. She gushed, "These tabs are from Berkeley, handmade with gold glitter by my friend Gregory, who is super interesting. One dollar, or three for two. I took one this morning to stay clear. It's really fresh."

I smiled at her, in love with love.

Freckles said, "Let me show you the product."

She poured a hundred hits from her *Man from U.N.C.L.E.* thermos. I bought three. Without the benefit of lemonade, I swallowed the tabs and wandered back toward the tent.

Who needs rock 'n' roll when you have rock 'n' roll pills?

Thirty-five thousand kids agreed. There were flags and fires on the mountain, tanks of nitrous hissing like bombs. Topless girls

smoked hookahs and sipped warm beer. Amphetamine Eagle Scouts built lean-tos from underwear and lost maps. There were dogs and babies, whistles and flutes.

DONNA GAVE ME a motherly look. "Chris, I can't believe you dropped acid—again!"

She knew I'd been tripping all summer.

"You can't take it every day!" She shook her head at the little monster she'd created. I asked her if we could *please* stay a little while longer—that I didn't want to trip in the car. My head rolled around as I smiled at her.

"Well, I can't deliver you to Mom like this. She'll blame *me*."

So we all went outside and watched guys playing Frisbee and drinking Bud. One dude wore nothing but an American flag around his waist. Each time he threw the Frisbee, it fell off. Everyone laughed.

American Flag had a crew cut, which pretty much meant Vietnam. I thought of Donna's missing boyfriend while watching the boy in front of us—who seemed like the happiest person in the world, throwing a Frisbee, wrapping his wang in red, white, and blue. He was so handsome—I hoped he wouldn't have to die. Or kill. As he caught the pink saucer, stroboscopic trails followed him, frame by frame by frame. I began to think of the awfulness of the war, of dead bodies piled in the sun. Maybe the glitter-acid was coming on a little too strong . . .

Then, the weird noises began, stopping and starting, *eeek*, *oook*, *blech*, *argggh*. It took me a while to realize they were coming from my mouth. It seemed like someone else was talking. Donna said, "Chris, what's wrong?"

"I feel sick or something." I lay down in the dirt.

"Vinnie, get him some water."

Donna held me, and Vinnie put a cup to my lips. Rocked by a pair of daisy angels, I calmed down, pretending I was their baby. After a while, the worst feelings passed. But I felt so incredibly tired.

Later, Vinnie walked me to the Port-O-Sans so I could shit. With his arm around me, he said, "Shitting always helps."

AT HOME, I decided I should fuck the nanny—*for the experience.*

At Thrift Drugs, I looked for protection. I spotted the condoms behind the counter. The shop clerk was staring at me, an old lady in a fuzzy sweater. "Can I help you, young man?"

I could never have said the word *condom* to an old lady. Instead, I shoplifted a package of contraceptive foam from one of the shelves. The box informed me that foam was "the Modern Contraceptive."

That evening, I handed Oonagh the package, telling her that if we were going to have sex, we needed to be careful. Drunk, she laughed at me, saying: *But you're a child.* I informed her that I was also a person who manufactured *sperm.*

Oonagh agreed to apply the foam.

Suddenly modest, she asked me to leave the room.

In a few moments, I heard a scream.

When I ran back in, Oonagh was in tears. The can was defective—the nozzle had come loose. Her crotch was a science fiction mess of yellow foam; a huge blob crept across the sofa. I gave her my T-shirt to wipe herself off.

"Don't worry, Oonagh. I'll just tell Mom I threw up."

AFTER POWDER RIDGE, Donna was never around.

Then, one afternoon, she stayed home and helped Mom make spaghetti and meatballs for dinner. Donna used too much red pepper and my brother Danny spit up at the table. I remember all of us laughing at the commotion—such a small thing, but in my mind it's like this little shred of light before a shadow falls.

After supper, Donna knocked on my door to tell me she was running away with Vinnie. "He's coming by at eleven. Don't tell Mom and Dad. I'm leaving them a note."

My heart sank. "But why? And where are you going?"

"I don't know, we're not sure. Somewhere better. Maybe out west."

"Why not tell Mom and Dad so they can help you?"

"I told you, I don't want any of their money. Vinnie will take care of me. And God."

She gave me a hug. Told me to cool it with the mescaline.

WHEN I GOT UP the next day, Donna was gone. Apparently, the note she'd left for my parents was quite hurtful. Mom was still crying.

She asked, "Do you know where Donna went?"

I shook my head.

In the afternoon, my sister Kathy stopped by to comfort my mother. Kathy chain-smoked but never drank or did drugs. Though she'd once been a wild child, my older sister was now a fastidious homemaker, loyal to her new husband and little girl. She seemed more like an adult than my mother. During a crisis, Kathy could always calm things down.

Once all the tears had dried, my parents went about their business, like everything was normal. But I could see it was an act. Their favorite child had fled. For days, no one really talked, not even my little brothers. Donna had deliberately left the Mustang my parents had given her for graduation. Sitting there in the driveway, it reminded everyone that Donna was gone, that she was done with us. Finally, Dad had it towed. The empty space was somehow worse than the empty car.

I went to Donna's room and breathed in the minty, gum-scented air.

I didn't cool it with the mescaline.

I'M IN THE TV ROOM, bugging out in the dark. It's really late. Ten feet away, my father walks into the kitchen and turns on every single light. *Fuck.* He fills the coffeepot, pours juice, gets out pots and pans. The noise is excruciating. It's four in the morning and he's making himself a manly breakfast.

I need to go back to my room, but the stairway is past the kitchen.

I walk into blinding light. The kitchen wobbles with weird energy. Dad is turned toward the stove, frying meat in his boxer shorts. He's shrinking—his body too small, his legs too skinny. Without a suit, without his sunglasses and gold watch, he looks awful. He's not wearing his brace; I see his ruined leg.

I can hear my mother's voice—*All those accidents.*

His grief—my sister's voice now.

And why is he so tiny? I want my other father back, the man in the tux, with my mother on his arm. I don't understand him alone in the kitchen in his underwear. I only recognize him when he's walking away, leaving us kids behind, flying off to Paris or Rome.

He turns to me and smiles. Maybe he's forgotten who I am, forgotten the war between us, forgotten that his brothers are dead. "What are you doing up, Chris?"

Why is he speaking to me?

I can barely breathe. The room is disintegrating. Dad's head starts to throb like some undersea protoplasm.

"I'm making pork chops. Do you want one?"

The creases in his neck crack and shatter.

"Boy," he says. "Did you hear me?"

SUMMER ENDS in confusion.

Donna's long gone. Oonagh's fired for stealing booze. She'll be sent back to Ireland the day after I leave for my new school. Locked in her bedroom, she won't come out to say goodbye to me. I stand by her door, telling her I love her, that I won't forget her. So much misplaced emotion—I'm in tears.

Mother says, "Leave the poor girl alone."

7.

Star Farms

OFF IN THE WEEDS, the sign reads STAR FARMS ACADEMY.

Predictably, I'm ready to throw up out the car window. Mom cruises up the driveway, oblivious to my distress. "Come home for Thanksgiving if you want, dear, but you might get a better offer. You're going to meet such interesting people! I envy you. I really do."

Maybe she does. I'd heard her bragging at a cocktail party about my new boarding school. "It's an art school, very chic. The staff is top-drawer. That actress who won the Academy Award—she went there."

But when we pull into the parking lot, the scene is less than glamorous. Sweaty men drag luggage across cracked pavement,

followed by grim adolescents and frantic wives in silk scarves and insensible footwear.

I don't want to get out of the car. I'm nauseous and feel like I'm being punished. I ask a simple question. "Mom, why didn't you send Michael and Steven away to school?"

She pauses—adjusts her wedding band—then lobs a couple of unconvincing compliments at me. "Your brothers are nothing like you—not nearly as smart or as creative. You're a special case, Chris. The nice thing is that there'll be other people like you here. *Artistic.*"

When I finally vomit in the bushes, Mom asks if I'd like a mint.

The headmaster is in the parking lot, yapping like a used-car salesman. He's a short man in a seersucker suit, too much grease in his hair.

He zeros in on a few well-dressed mothers, including my own. "Ladies, did you know Star Farms grows over two hundred acres of corn and alfalfa? It's real country out here, a very healthy life. And though our classes are small, our goals are big as all outdoors. *Big, big, big!*"

Avoiding spittle, my mother leans back.

"My son Christopher is an *artist,*" she says—and the headmaster nods. I sense they're communicating in code.

"Mrs. Rush, right? Well, as I mentioned to you on the phone, our art department is just fantastic. The studios are run by Zelda Ping— one of today's leading ceramic artists. No boundaries. And the studios are open twenty-four hours a day."

"That seems excessive. I don't want my son up all night with a bunch of clay."

"Of course, Mrs. Rush. We'll keep an eye out for him."

Though she was not personally attracted to art or alfalfa, Mom decided I'd be better off at Star Farms than at a religious school. She'd heard nice things about the Farm from parents at the country club. Plus, my mother liked the price ("Expensive, and that means something"), as well as the institution's stationery ("Cream linen—fifty pound!").

. . .

PAST THE PARKING LOT, the grounds were picturesque. There were fat trees and lush lawns—a couple of cows standing around for effect. As Mom and I strolled past whitewashed fences and old stone buildings, Star Farms was a dream of wholesomeness. The smell of tea roses and fresh hay.

In my room: the smell of rotting flesh.

Mother scowled. "I know that smell." She reminded me that her father had been a taxidermist. ("Sometimes he made me glue in the eyes . . .") She sniffed. "Possum, or maybe raccoon. Open a window before we *both* vomit."

I smiled, imagining us throwing up together.

AFTER MOM LEFT, I wandered the campus looking for my peers. The brochure had shown a clutch of smartly dressed teens, conversing under a map of Europe. Instead, I found a bunch of losers, passed out in the weeds.

One girl roused and told me to sit. She offered me a bottle of brandy. She was already quite drunk.

"Are you people stupid?" she said to the fallen kids around her. "Prep school isn't for *us*, it's for *them*."

A boy turned to her. "Well, actually—"

"Shut up, I'm talking. This is my third school, so I *know*. Prep school is simply a socially acceptable way to get rid of a problem child."

The boy mumbled, "I'm not a problem child."

"Did I not tell you to *shut the fuck up*?"

BACK IN my possum-scented room, I considered my fate. Though my cell was tiny and the floor sticky—it was to be all mine, no roommates.

No curfew or dress code either.

Trying to relax, I unpacked things to put on my desk, familiar things: a cloisonné turtle (stolen from Mom), a tin full of brushes and pens, a bottle of India ink Father Bonny had given me—and, of

course, my sketchpad. On a scrap of old paisley, I carefully arranged my books—*Steppenwolf* on top, Bible on the bottom. I stared at all of these objects, my talismans, and felt better. Despite everything, part of me was excited to be here, to have the chance to draw and paint and find out what was waiting inside my brain.

In the bottom of a bureau, I put my almost-empty jar of mescaline—to remind me of Valentine. He'd just married his girlfriend, Jo, in a church built by my father. Afterward, the two of them had driven off to Tucson to smuggle Mexican weed.

As for my sister: neither my parents nor I had heard from her since she'd taken off with Vinnie. Every night I prayed for her.

I got out an X-Acto blade to carve my initials on the desk. I did it carefully—artfully—so that my initials just looked like part of the scratches on the wood. Maybe, I thought, that could be a project. Writing letters and words that no one could see.

Secrets hidden in broad daylight—to a child, the idea seemed profound.

HEADMASTER STEVENS SPOKE at our first assembly, held in a converted barn.

"People, you are now part of the Star Farms Experiment, on five hundred acres of God's own front lawn. Milk a cow! Knit a hat! Read a book! Anything is possible. Maybe this year we'll finally make preserves." He had changed out of his seersucker suit and now wore overalls and a bow tie. "I want you kids to watch out for each other. And our two main rules: kindness and respect. Let's be proud of who we are!"

I felt a small thrill. Maybe this wouldn't be so bad.

Then the boy next to me said: "I wonder how many suicides we'll have this year."

MY TEACHERS WERE a change from the monks of St. John's.

The man who taught science at Star Farms was blind and managed

the room with a kind of bat sonar. In geometry class, we were made to do jumping jacks. To wake the brain, our teacher said. He wore lederhosen and often yodeled.

Cove Callahan taught first-year composition. Suave and gray, he let us know right off he was ex-OSS-CIA. Said he was tight with Marshal Tito.

Twice a week, there was hatha yoga in the gym. Karma Kay, the teacher, was a frail reed, swaying in a black leotard. At the end of each class, she'd light a Lucky, reminding us to fear nothing—*not even cigarettes.*

Art class was a dream.

Zelda Ping, master potter, was more than serious about clay. Zelda was a firm, silver-haired woman—a matron dipped in mud. The first day, she dumped a hunk of clay in front of each one of us.

She said, "Touch it—touch your mother!"

There were no assignments in Zelda's class, just music and mayhem, kids making a mess. Over the coming weeks, I made figurines and monster heads, hash pipes and Roman urns. Late one night, alone in the studio, I made what turned out to resemble a surreal volcano. The slimy mouth was open and ready to erupt.

When Zelda found it the next day, under a sheet of plastic, she yelled, "Who is responsible for this luscious vaginal representation? Come on, don't be shy. It's a stupendous piece."

In front of the whole class, I raised my filthy paw.

"Chris, this is good, very good. The feminine aspect—it's very alive. But go deeper. Get yourself—inside! Like this. *Ooooh . . .*" In front of everyone, she put her hand in my vagina.

I was flattered.

THE ONLY TEACHER who was neither hip nor funny was Mrs. Galdi, who taught history. I immediately liked her, and, after art, hers was my favorite class.

Always formal, like a schoolteacher in a black-and-white movie, she wore tailored dresses the color of bark, her hair always in a tight knot. Serious cheekbones cut into her round face, her eyes narrow

and green and unafraid. She had a way of staring at you when you spoke as if she was actually *listening*. Someone said that Mrs. Galdi had been in a concentration camp. I wanted to ask her about it, but didn't dare.

Her Hungarian accent was pure Dracula. "Gilgamesh, exhausted by hiz many defeats, sought immortality, sought the jewel-laden tree. He defeated za scorpion men, and in turn, negotiated with za evil vitch."

I had always loved books, but no one had ever read to me. In Mrs. Galdi's tremendous voice, Gilgamesh came alive, fighting the forces of darkness.

I read more books at Star Farms than I had in the previous fourteen years of my life. Inspired, I wrote notes in the margins, pompous juvenilia: *This is the same dilemma I raised in my essay on* The Scarlet Letter*!*

A SUNNY DAY in late October. Parents strolling the lawns, bluegrass music drifting from the gymnasium. The Star Farms Art Show was on—with displays of paintings and sculptures by me and my fellow Farmers.

My vagina, fired and glazed, did not win a prize but received an honorable mention. I stood beside the special table, waiting for my parents—late as usual.

I chatted a bit with Terry Bopp, who'd won first prize for a rustic urn the size of a five-year-old. It was wobbly and purple, like a mutant eggplant.

"Very cool," I said.

"Thanks, Chris. Hey, meet my parents."

I shook their hands and when they asked to see my piece, I pointed it out. "That's something," the mother said. "Is it a mountain?" the father said. "Don't be stupid, guys," Terry hissed. "It's a vaginal representation."

Maybe it was good my parents never showed.

. . .

OCCASIONALLY, AT STAR FARMS, I could hear some of the kids talking about college and *the future*, like it was all planned out. Other kids seemed to do nothing but sleep and get stoned. I'd not yet joined either camp. Was I a futurist or a somnambulist?

Eventually, I set my sights on T Bopp—the boy who'd won first place at the Art Fair. I assumed he was a futurist. Shy, I didn't talk to Terry directly, but rather followed him around—always a few paces behind, like some Hindu bride.

Terry was often with Nicky Bloom. One day they turned and stared at me. "Can we help you?"

They were both older than me—Terry a strapping New England Wasp, and Nicky a homely Jewish kid from New York.

"I just wanted to say hi."

"You're the vagina kid, right?" said Nicky. "Do you want to get stoned?"

I joined them for a joint in the woods. Quickly I understood that Nicky was the boss. He had superior taste (Diane Arbus, the Velvet Underground) and very rich parents. Under a storm of black hair and bad skin, he scowled at everything bourgeois. Though impressed by his assessment of Star Farms ("This is where the East Coast trust-trash is dumped"), I was shocked by his vocal unhappiness ("I hate it here—I'm the next suicide").

Terry played air drums and made rhymes for the word *hate*.

"Hate! Fate! Mastur-bate!"

The three of us got high quite a lot after that—but I think we liked dope far more than we liked one another. Glad not to be alone, we formed a company of losers: Bopp, Bloom, and Rush. We talked about nothing, a subject I'd not previously realized could be discussed for *days*. (I missed my conversations with Pauly, missed talking about God and the Devil, the nature of existence.)

"My last school was very strict," I said. "Star Farms is more *Lord of the Flies*."

"Who is he?" asked Terry.

I explained the reference—the book by Golding.

"What's that, Goldilocks?" Nicky said, playing dumb.

"We're just fucking with you," Bopp said, bopping me on the head before passing the joint.

Hanging out with Nicky and Terry, I soon met all the Star Farms zombies. I was offered barbiturates, angel dust, speed, and cocaine, but I declined. I wanted to stay true to my sister, wherever she was, and take only God-approved substances. Donna, like Valentine, believed only in sacrament, only in psychedelics. Everything else was *unclean*.

Of course, I still got stoned, skipped classes, stayed up all night talking. Dope was the main topic of conversation. Bragging, I said I knew a smuggler in Arizona.

HISTORY WAS THE ONE CLASS I never skipped. Drifting into Galdi's room one morning, I was hoping she'd spend the whole period reading out loud to us. Instead, class began with a question.

"Students, has one of you lost your text?"

At that moment, I was naked, the only student without a book.

"I found one yesterday, after class," Mrs. Galdi said. "Never would I pry into your affairs. You are young men and women. Your private lives are none of my business. However, the book had no name, only a letter inside. I only read za letter, hoping to discover za owner's identity."

She did not look in my direction.

"I was shocked by what I read, and saddened. The letter described Star Farms Academy as a drug *emporium*. The writer lists all za drugs that can be consumed. Apparently zis school is a joke to zis person. No schoolwork, he says in the letter, only just the 'getting high' is cared for."

A few kids laughed.

"Is this true?" Mrs. Galdi asked. "Do you children live this way? Do you hold such a debauched view of life? That the opportunities of learning should be squandered—this upsets me very much. It is tragic."

She shook her head and was quiet for a while. "These books we read—are they not important?"

Then: "The letter is unsigned. I would like to return it to its rightful owner. Please come see me after class to retrieve it. Now let us go to page one hundred eleven."

She began to read, but my shame rang like a bell. I could barely hear her.

Afterward, waiting until the room was empty, I crept up to Mrs. Galdi's desk. I planned to explain everything—that she'd misunderstood the letter, that I was exaggerating, showing off. I would tell her I took a lot of drugs *last* year, but now I was barely doing anything.

Maybe she'd have some sympathy. Maybe she'd explain things to me. I felt sure she was a much wiser person than my own mother.

I was shaking when I got to her desk. "I'm sorry, Mrs. Galdi. I really am."

"I don't understand, Mr. Rush. Are you in some kind of pain?"

"No, not at all." Strangely, I was smiling, the way my mother did when someone asked her a difficult question.

"What is the meaning of this, then?" She held up the letter.

"I'm trying to find God. Like Gilgamesh."

"That is nonsense!" It was the first time I heard anger in her voice. "I will not discuss such foolishness with you. I teach you history and that is all. We will not speak of this again. Take your book. And please do not take drugs in my class."

I left in tears. In the woods, I burned the letter. It was addressed to Pauly Pinucci. I never wrote to him again.

AFTER THE ENCOUNTER with Galdi, a terrible melancholy overtook me. I called my mother and told her I wanted to come home, just for a visit.

She said it wasn't a good time—that she and Dad were going to Spain.

"You've already been to Spain," I said—and then I shouted: "Are you lying? I bet you're not going anywhere!"

"What has gotten into you? We are *absolutely* going to Spain—and you'll be coming back for Christmas, for God's sake."

To spite Mom, I went home anyway. I got Max, a handsome senior, to drive me, bribing him with some weed. When we arrived, my brothers were watching *The Partridge Family* and eating TV dinners.

"What are you doing here?" Michael said. "Are you in trouble again?"

"Where's Mom?"

"Away," said Steven. "Gramma Loey is babysitting—but she's asleep."

"Who's that?" Michael asked, pointing to Max. "Your *boyfriend*?"

When Loey finally limped into the kitchen, Max and I were eating frozen pizza. I kissed my grandmother hello. She looked terrible, nearly bald, her frail legs sticking out from a too-short pink nightgown.

Old and fat, she sat down beside us, sipping a vanilla milkshake through a straw.

"The only thing I can keep down now, I'm afraid."

Soon she headed back to bed—her steps slow and agonizing. With Max there, I was too embarrassed to get up and help her.

My grandmother was dying; that weekend would be the last time I'd ever see her. I didn't know any of that, of course—but I wondered why Mom would leave a sick person to watch my brothers. They seemed oblivious; I could hear them laughing in the TV room.

None of us really knew this woman, our grandmother, our mother's mother.

Later, feeling guilty, I peeked inside my parents' room and saw Loey sleeping. I wanted to wake her, crawl into the bed with her and say: Tell me about your life, about my mother. Tell me everything. But I just stood there, frightened by the sound of her breathing.

What would she have said?

My boy, it's all so sad. My first child died as he was born. He would have been your uncle! But the doctor killed him, crushed his skull with those awful forceps. Your mother was next, a year later, but my husband, Bill—

*your grandfather—was still heartbroken and raised her as a boy. He was
too tough on her, kept her hair short, allowed her only boys' clothing. When
your mother's pets would die, he'd stuff them for the shop! She even had to
go to the zoos with him, to shoot the old lions. In high school, you know,
she had to testify against her father in court, tell the world that he was
beating me. Such terrible memories! My darling, I'm so glad you're here
next to me. It really does help . . .*

MAYBE MOM COULDN'T face her mother failing, maybe that's why she
left for Spain. Sickness was frowned upon in our family—any sort
of weakness.

"In the woods," my father had once told me. "An animal goes off
to die alone."

I let Loey sleep and went downstairs to find Max.

He was already passed out on my bed, dimly lit by a strand of
blinking lights. When I lay down beside him, I touched his hand as
if by accident.

He bolted awake. "What the fuck are you doing?"

"Nothing," I said. "Uh, maybe I should sleep on the floor."

I put some blankets next to the statue of Mary. In the middle of
the night I jerked off. Max snored through, but the Virgin saw
everything.

ART CLASS became my refuge at Star Farms. From lumps of pos-
sibility, flowers and towers were pushed into being. I molded a fist
thrust into the air. I pretended I was some kind of revolutionary,
but I had nothing to revolt against—except my own unhappiness.

In a dormitory full of boys, I was dizzy with desire. Finally, I un-
derstood what Pauly had wanted. That I wanted it too both thrilled
and horrified me. Sometimes, when no one was around, I'd fuck a
slippery piece of clay—then smash it to pieces.

I could hear my mother's voice: *Nobody likes a strange boy.*

But there were already rumors. Max, the senior who'd driven me

home, had told other kids that I'd tried to blow him. Outside my room, I heard two boys having a loud conversation for my benefit.

What's a blow job, Gramma?

Well, dear, a blow job is when one person sucks on another person's penis. They say it feels wonderful.

Really? I wonder if anyone around here knows how to do that?

Mortified, I tried to figure out what to do, how to redeem my reputation.

Then Funky Dude popped into my head.

Funky was a tiny kid up the hall, curly hair and glasses—a child really. Everyone called him Funky Dude because he was not *in any way* funky. He was just uncool, wearing velvet slippers and a shawl to class—nodding to secret thoughts, singing to himself. The only thing that was clear to me, at the time, was that he was the one boy at Star Farms more fem than me.

One night, I suggested to Bopp and Bloom that we play a joke on Funky Dude.

They asked why.

"No reason."

"*So*, what did you have in mind?"

We got right to it—pooling our urine in a pail. We added some paint, some dirt, a splash of cologne. We walked into the boy's room after dark; he was sound asleep.

I hesitated, but Bloom had the bucket—and a moment later the contents were poured over Funky Dude's face. It took him a few seconds to wake, but then he was choking, blinded by the muck, screaming in terror.

As I watched him suffer, my own horror was not without a feeling of triumph—because his suffering was not my own. It was sick, but we all laughed as Funky Dude whimpered, *Why, why, why?*

DEAR MR. AND MRS. RUSH, April 20, 1971

I am writing to inform you of an incident that took place Monday, April 4, which involved your son Chris. In the

freshman dormitory, a boy was attacked by your son and several other students. The boy was temporarily blinded.

The actions of your son impede our attempts to create an environment respectful of all students. I have decided that Chris must rake leaves this weekend and next as punishment.

While we have no specific evidence, both faculty and student informants alike feel that Chris is one of Star Farms' most committed drug users. I do hope that you will discuss this issue with him. He must begin to see the damage he is doing to himself and his future. In all frankness, many of us believe he has great abilities and would succeed if and when he matures.

Enclosed is our registration agreement for next year. Please sign it and return with your check.

Feel free to contact me if you have any questions.

Sincerely,

Wendall S. Stevens, Ph.D.

Headmaster

My mother did not show me this letter for forty years. When she received it, she read it once and put it away—never confronting me about the attack or my drug use.

But, a few days after the incident, when I was told I had a telephone call, I was certain it was her. I approached the phone in dread.

"Chris! Hi, it's Donna!"

"Where are you?" I almost started crying. "I thought you were dead."

"Don't be dramatic. I was hanging with Vinnie—we're back in New Jersey now—and guess what? We're getting married!"

"Does Mom know?"

"She's paying for the wedding."

I asked Donna if she planned to finish college.

"No, after the wedding we're moving to Tucson."

"To work with Valentine?"

"Chris," she scolded me, "not on the phone!"

. . .

THINGS WEREN'T GREAT at school. Now I wasn't just a fag; the attack on Funky made me seem like I was a sadist, too. I didn't want people to think of me as a bad person, and often I tried to change the subject by bragging about my great drug connections out west: *Mexican gold bud—fifty bucks a kilo!* The stoners shrugged, having heard it all before.

Finally, one day, handsome, hawklike Kurt Vogel interrupted me. "If—I'm saying if—you're telling the truth, why wouldn't we drive to Tucson, score cheap weed, and sell it here? Make some real money."

"Oh," I said, panicking, "my guy won't sell in small quantities."

"I'm not talking small. At least twenty kilos."

Bloom and Bopp looked at me. "Faggot is full of shit. Faggot lie."

"I'm not lying. I just have to make sure I can trust you."

Kurt opened his arms as if allowing me to perform an examination.

"Fine," I said. "I'll make some calls."

DONNA AND VINNIE were already in Tucson on their honeymoon. I couldn't ask my sister about buying pot on the phone, so I mentioned *a summer visit* and the word *product*.

She understood, told me to come out. "It'll be fun!"

When I told Mom that a visit to the Southwest would be educational, and that my friend Kurt was willing to drive, she said, "Well, we can't have another summer like last year, with you moping around this house. And who is this Kurt fellow?"

"His dad is a brain surgeon."

"Really?"

After calling the brain surgeon and his wife, Mom was impressed. "Nice people. Austrian, I think. They feel very strongly about their son's independence. The sort of people I hoped you'd meet at Star Farms."

The trip was on.

· · ·

HOME FROM SCHOOL, I assembled my new backpack, poncho, sleeping bag, and canteen—but there was one thing missing. Money. I had a little saved, though not enough to buy a bunch of pot. Kurt and I were supposed to be partners.

When Dad wandered in half-drunk, his timing was impeccable. I was trying on my poncho. The plastic hood was over my head.

"Are you going somewhere?" he mumbled.

"Yes, I'm—"

"Norma!" he shouted. "Get my good blue suit from the cleaners. I'm meeting with clients tonight. I'm taking a nap now."

In our home, Dad's afternoon nap was a time for family reflection, a time for calm and quiet voices—and the best time to rob him.

Sneaking into the darkened bedroom, I saw him on the bed, asleep in his boxers. As usual, Dad's clothes were laid out beside him. I slipped the wallet from his trousers and opened it—reverently—as if it were a prayer book. I pulled out a fan of hundred-dollar bills and bowed my head.

Thank You, Father.

WHEN KURT'S NEW VW van glided into our driveway the next day, I ran out to greet him. Mom followed close behind. I could tell she liked Kurt, with his clear blue eyes and short dark hair. They chatted and laughed while I loaded my stuff. Having just come home, it was strange to be leaving again.

"You're both so young!" Mom exclaimed, kissing me, and then Kurt. I watched her slip her arms around his waist. He smiled at her and flirted—but as we drove away, his mirth instantly disappeared.

"Your mom wants to fuck me. Too late, Mrs. Bitch!"

He lit a cig, continued. "Listen closely. Here are the rules. You pay for the gasoline and I drive. You sleep outside and I sleep in the van. You buy your own food and I'll take care of mine. As for the radio, I control it at all times. Do not touch it, *ever*. Understand? Never touch *any* of my shit."

I gulped, nodded.

"Verbal confirmation, please."

"Yes," I said. "I understand."

I'd just turned fifteen. For my birthday, I'd received camping gear, a new pair of Wallabees, and the book *Be Here Now*. I felt prepared—and nervous. I buckled the seat belt. When I asked Kurt if I could roll down the window, he told me, "It's a free country," and suddenly we both burst into laughter.

PART II

GIVE ME A HOME

8.

Peter Pan

KURT WAS VERY ORGANIZED. Tire pressure checked each morning. Sixteen cigarettes a day, at one-hour intervals. Everything he ate or drank was nutritionally sound and methodically shoplifted. Kurt said it was immoral to spend money on food that could be spent on drugs. While grocery clerks followed long-haired me around the store, clean-cut Kurt stuffed prime rib in his shorts.

Grilled to perfection on his Coleman stove, each of Kurt's steaks was carefully timed—two and a half minutes per side, with a five-minute rest before consumption.

He said: *It's the blood that nourishes.*

He never offered me a single bite, but I made do with my purple jelly sandwiches. On the sides of superhighways, preparing for sleep, I watched Kurt inside the van. It reminded me of the way I used to look in at my parents when I was playing in the yard after dark: watching from the lawn, seeing them kiss or shout at each other. They could have been anyone's parents, or actors in a play. I wondered if Kurt, too, was performing for me when he slowly took off his shirt and yawned. But then, a moment later, the interior light would click off.

At five each morning, he kicked my sleeping bag and we'd drive till dark. The whole country flew by, unexplored. Kurt said Middle America was a waste of gasoline.

His plan was to go to Boulder *for the pussy*, then Tucson *for the pot*.

Sometimes we stopped by some lonesome river, to wash and swim. I'd steal glances at Kurt. He wore his naked body without apology. He knew he was a man, just as I knew I was not. I never loved Kurt, but I loved looking at his beautiful dick—even as I tried to look away.

THE WINDSHIELD of a '71 VW microbus was like a movie screen. Sitting in the front row, I watched the world fly by. When I saw snow-caps on the horizon, I started to yell. Kurt was excited, too. He pushed the van as fast as it would go. At the bottom of those celestial peaks was famed Boulder, Colorado.

Kurt pulled over on a tree-lined street, and we walked to the town park. There seemed to be a thousand kids sprawled on the lawn— smiling faces, blond guitars, various kinds of smoke. I took off my shoes and wandered around barefoot. People waved at me as if they knew me. When I turned to tell Kurt how great Boulder was, he wasn't there.

I retraced my steps but couldn't find him. And then I started to run in circles, like a demented dog, calling his name.

Freaking out, I headed back to the van. It was gone, with all my gear inside. I tried to stay calm, standing like an idiot in the empty parking space.

Kurt had ditched me.

I sat on the curb, angry. My anger grew to include Mom. Why had she let me leave in the first place? Why weren't we all on a family vacation, heading out to see Donna?

I went back to the park and sat on the dandelion lawn. From a nearby blanket, a tiny boy, with the quietest voice, spoke up. "Hi. I'm Peter. From Florida."

Blond and blue-eyed, pale and girlish, he was a miniature version of me, both of us with hair past our shoulders. "Do you want to go down by the water?" he asked me.

I joined him by the roaring river that split the park in two. Twice we saw guys try to swim in the water and almost drown. Peter explained that the river was snowmelt, fast-moving and dangerous.

We talked for a while—I mostly rambled on about Kurt, nothing about my family. Peter was a bit more forthcoming.

"When I first ran away, I didn't have anything either," he said. "Not even fifty cents."

"I'm not a runaway," I said. "My friend's coming back."

"From what you just told me, he doesn't sound like a friend. But I know a safe place you can stay."

By dark, it had started to rain. It was cold, and all I had on was a T-shirt. Peter escorted me to a shelter at a church, not far from the park. He coached me on what to say. In the office, the two counselors asked me a lot of questions. I was nervous. They made me call home.

Mom was not pleased to get a collect call at one in the morning. "Just a little mix-up with Kurt. I'm sorry, Mom. Just tell them it's okay for me to stay here."

Once approved, Peter and I were sent to the dormitory—a large room full of twenty or thirty metal beds, all of them occupied—more a jail than a church. It smelled of sweat and disinfectant. There were no windows at all, a single flickering bulb.

In the half-dark, an excited kid ran up to us, talking at high speed. He followed us into the bathroom. "Did you see my guitar? It's cracked and shit but it still works fine. I can't believe someone gave

this as a *donation*. I'm going to play guitar and drums. Do you guys play anything?" He said he was from a town I'd never heard of. "It's in Alaska. But I had to leave because my brother beat the shit out of me, every day of my life."

Alaska told us he'd hitched a thousand miles and, like me, had gotten to Boulder only that day. The three of us snuck outside, walking past a big black sign—NO DRUGS OR LEAVE NOW!—to smoke a joint in the courtyard.

Alaska wore no shirt, the cold rain dripping on his muscles. He just stood there, rambling on about his life, showing us scars on his back where someone had whipped him, over and over. Peter gently patted the boy's arm.

Inside, we watched TV, the three of us laughing at nothing. My brothers had probably watched the same stupid show—a couple of hours before. The concept of time zones suddenly seemed so strange. I barely knew where I was.

After lights-out, two men came into the room with flashlights to check the premises. I pretended I was asleep.

In the morning, Alaska was gone.

THE SHELTER GAVE all of us breakfast and then a Jesus talk. As the minister lectured, Peter and I wolfed down everything we could get our hands on: spoons of jelly, cream cheese, cereal, donuts. Afterward, we walked back to the park.

Kurt was nowhere to be found.

Peter told me not to worry. "Forget about him. They let you stay at the shelter for up to a week. And then if you spend a week somewhere else, you can go back."

I didn't want to say *I'm not a runaway*, so I just said, "I don't think I'll be staying that long." It amazes me now that I didn't just call my mother or my sister immediately. Maybe I didn't want Peter to think I was a baby.

He took me to meet some of his friends, ragtag teens bumming cigarettes and change. He told everyone my name and that I was good

people, to trust me. *How does he know I'm good?* I had barely told him anything about my life.

A girl in pink pajamas and a bridal veil handed us blotter acid, saying "Prepare yourselves." It was a powerful dose, my hands trembling as it came on.

Peter and I sat on the grass, tripping hard, laughing like kids on a playground. By late afternoon, we were saucer-eyed and quiet.

I asked Peter why he'd run away.

"Oh, my stepdad found pot in my room. He already hated my guts, but now he had an excuse. He made my mom choose between him and me. Otherwise, he said he'd call the cops. My mom took his side but I'm not mad at her. She has to take care of my baby brothers. And she needs the asshole's money to survive."

I could hear the bravado, the false tenor of his voice. Still, it amazed me that he could just come out and say these things—that he knew so clearly what his story was.

When I considered it, I suppose my mother would have made the same choice. Still, my own position wasn't as clear-cut as Peter's.

What was obvious, though, was that Peter was a soft boy, like me.

"It was just best for everyone if I disappeared," Peter added.

Before going back to the shelter, we climbed a peak above town to watch the sunset. Walking over red rock and sage, I wondered if the story of my life was just beginning. But what kind of story would it be? *Romance? Mystery? Horror?* From the mountain peak, I could see Dorothy's Kansas to the east, black with tornados. The wind from the Rockies was icy. I felt rain again.

Peter put his arm around me. Not sex, just kindness.

"I hope you don't leave," he said. "I like you."

I was thrilled, but at the same time I was surprised he could like me; I didn't think I was a likable person.

That night, in the cot next to his, my acid brain went on for hours, trying to figure it out: *If Kurt is gone, what should I do? Peter from Florida is nice—maybe I could hang out with him for a while, stay in Boulder. Maybe I'd never go home.*

It was a brilliant, shocking idea.

But then I remembered Donna—waiting for me in Tucson.

Maybe I could hitchhike to Tucson, take Peter with me? I still have a bunch of money in my wallet.

THE NEXT MORNING we strolled to the park, and there was Kurt—plaid shorts, mirror sunglasses, all fake-glad to see me. "Chris, where have you been? I looked everywhere for you."

"That's such bullshit, you never looked for me. I was here the whole time." I pressed my lips together, afraid I would start crying.

"I met a chick," he said, and began to enumerate the charms of pussy. "Anyway, it doesn't matter. I've got some excellent coke."

I ignored that comment. Coke was not on the Jesus-approved list of drugs. In fact, I remember watching my sister actually *flushing* cocaine down the toilet.

"Kurt, this is my friend Peter. Who *took care of me* when you split."

"Cool. Peter, you want to do some coke with us?"

"Sure," said Peter, looking at me to see if it was all right.

He looked like an elf, a happy elf.

"Okay then," I said. I just wouldn't tell Donna.

We got in the van, and Kurt drove us into the mountains. I was intoxicated by the sharp smell of pine, the prehistoric rocks balanced above our heads. Kurt parked, and the three of us hiked through some scrub toward a foaming brook.

From his shirt pocket, Kurt got out a syringe.

"What are you doing?" I said.

"Chris, it's the only way to do cocaine. No waste."

"No, I just want to snort it."

"My father's a fucking doctor. I know what I'm doing."

Peter spoke up. "Chris, he's right. It's the best way."

Tipping a bag of powder into a spoon of stream water, Kurt boiled the mixture with a match. Removing all the fluid with the needle, he squirted a few test drops from the silver tip. Kurt handed Peter the needle, and I watched as my new friend stuck out his little-boy

arm and how calmly—how expertly—he plunged the needle into the whitest part of his flesh. Instantly, he was rubber, neck falling back, mouth breaking into a huge smile. Peter moaned a little, then reached for my hand. "Go now," he said. "It's *sooo* good."

How could that smile come from the Devil?

"*Sooo* good," he repeated.

I let Kurt administer my medicine. Instantly, something like a huge orgasm swept through my body, the menthol-metal taste of coke flooding my blood with pleasure.

I leaned back, in love with the candy-blue sky.

Even Kurt was transformed. He couldn't stop gushing. "I needed to share this with you, Chris. I just had to. I mean, I just . . . I feel so normal now, don't you? My dad does lobotomies on people and he's always saying there's no such thing as the soul. Well, he's wrong. We're proving it right now. He is so fucking wrong."

Peter and I nodded vigorously, as Kurt rambled on. "I mean, cocaine's not even a drug, really. This is, like, who we really are."

IN THIRTY MINUTES, after three more rounds with the needle, the powder was *gone*. This fact was profoundly unpleasant. Kurt stared at the empty plastic bag as if waiting for it to replenish itself. I felt dull, sad, lost. No trace of the magic remained—the opposite, in fact. As we sat by the bounding brook, nature suddenly seemed hollow and annoying.

On the way down the mountain, no one talked, as if something terrible had just occurred. Kurt was driving badly. He got angry when I asked him to please slow down.

At the park, the crowd was lazy, the afternoon hot. Peter walked away to bum a cigarette. Before he left, he gently touched my arm.

Kurt shook his head in disgust.

"What's wrong?" I said.

"Your friend's a fag."

"No he's not."

"He's just another hippie faggot bum. Look at them. Bunch of pathetic losers."

"But Kurt, you're a hippie."

"No, I'm not. Fuck this. Fuck Boulder. I'm leaving."

"No. I'm not ready."

"It's not up to you. *My* van! Come with me or not. I don't give a shit."

I had no choice. The truth was, I was too afraid to leave Kurt—and I wanted to see my sister. But there was something about these kids on the lawn that suddenly seemed like *the real world*. But if I stayed here, maybe I wouldn't be able to find my way back to the world I came from.

I found my new friend to say goodbye. Surrounded by other lost boys, he lounged on a green blanket with his sneakers off, wiggling his toes.

He saw me and got up. "Are you okay?"

"I'm leaving—in five minutes. Kurt's going. I can't stay. But I want to. I don't know what to do."

"You can stay. I told you—I'll watch out for you."

"No, I have to go to Tucson. My sister's waiting for me."

It was the first time I'd mentioned my sister to Peter. His face changed. "If you have someone, you should go. That's better. This place sucks."

When I asked if he was mad at me, he said, "No. I'll just miss you."

He hugged me, whispered, "Be careful, okay? I don't trust that guy."

I walked away, teary. Then Peter screamed, "Wait!"

From a girl in a baby-doll dress, he got a pen and wrote out his mother's address on a scrap of paper. I did the same and left.

A YEAR LATER, Peter sent me a tab of Orange Sunshine and told me he'd made it back to his mom's. *I still miss you*, he wrote. *I wish someone had taken a picture of us.*

We never saw each other again.

9.

You Don't Belong Here

KURT LIKED TO PICK UP hitchhikers. I took it personally, as if he was bored with my company. Of course, Kurt wasn't very nice to the hitchhikers either. He seemed to relish his superior position—saving kids from the side of the road and then kicking them out of the car as soon as they'd ceased to amuse him.

South of Denver, he stopped for two rough-looking guys—not kids. They got in the back with their duffel bags, smoking, while Kurt talked and talked, telling them how dull the scene in Boulder was. "I'm just driving around looking for something authentic, you know what I mean?"

It was obvious he was trying to show off.

"Yeah, man," one of the guys said. "Us, too."

The other one said if we drove them to Albuquerque, they could offer us a place to stay. When Kurt said that sounded cool, I tried to get his attention, mouthing the word *Tucson*.

"Albuquerque's on the way to Tucson, retard," Kurt replied, and the guys in the backseat laughed.

I was surprised Kurt was so comfortable around them—but I guess it made sense. Like Kurt, the guys were twitchy, boastful.

Roy and Bill—one dark-haired, one blond.

As soon as my bag was out of the van in Albuquerque, Kurt left with the guys to score some dope. I was told to wait inside.

The men's house was tiny, with almost no signs of habitation except for rotting food in the fridge. In the living room was an old couch, dirty ashtrays, an army blanket nailed across a window. The bedrooms had mattresses and little else. The disgusting bathroom, which I didn't want to use, was spotted with dead cockroaches and dried blood.

I looked around for a phone, but there didn't seem to be one. Dusk was coming on. I decided to roll out my bag and sleep in the backyard.

I woke later, hearing the van roll in. I went in the back door. Kurt sat with Roy and Bill at the kitchen table. No smiles.

Roy asked me if I wanted to get high. He held up a tiny bag of brown powder.

"No, thanks."

"Your loss," said Kurt.

I asked why it was dirty.

"What?" said Kurt.

"The coke."

Roy laughed. "It's not coke."

"Uh, *how old is he*?" asked Bill.

Kurt shrugged, already fingering the bag of dirt.

I sat down at the table, half-asleep, trying to understand what was happening. Why wasn't I in school? I felt the heat and remembered: Summer. New Mexico.

Equipment was assembled on the table. I thought of science class at St. John's, Brother Gregory holding up a test tube full of chemicals. I watched Bill tip heroin from the glassine bag into a spoonful of water. Using a lighter, he heated the mixture until it boiled and spit. In his shaking hand, the syringe slowly withdrew the fluid from the spoon. Roy tied up Bill's arm with a length of rubber tube, his movements sure and steady.

A moment later, as Bill sunk the needle into his arm, a wave of gravity passed through the room. The walls contracted, the air was heavy. Bill's eyes grew dull and distant as the syringe emptied into his vein.

Roy took care of himself with the same slow-motion intensity, extending the moment of injection as long as possible. Both men were now altered, eyes fixed, unwilling to focus. Kurt was fidgeting like a child, anxious for his chance. "Is it good?"

"*Right-chuuussss*," Roy said in a slur.

A few moments later, the men roused—Kurt's arm was tied off. With quivering fingertips, both men searched for a suitable vein, petting and coaxing Kurt's skin like feeble vampires. When the syringe went in, Kurt looked terrified. Then his face melted into an idiotic mask.

The needle slid out bright red.

Roy and Bill smiled: another soul initiated into Dark Life.

The three of them moved to the couch in the living room, silent, fumbling to light cigarettes in the gloom. I thought of my father, the way he sometimes smoked in the dark, saying nothing.

Suddenly Kurt ran to the bathroom, the sound of his retching echoing through the house. I sat on the floor, frightened. "Is he all right?"

Roy mumbled something about it being normal, the first time.

Then Kurt came out of the bathroom, bleary, announcing the news: "Amazing."

Over the next few days, I observed a way of life.

On the clock of heroin, each day repeated itself. At the kitchen table, the three men injected, three times a day—a simple diet, without the nuisance of food. Leaving the house only to score and to buy

cigarettes; no additional effort was made to do anything. Roy and Bill never left for work. No meals were prepared. Sometimes a radio played in the bedroom while the men slept or smoked.

I continued to sleep outside, the heat of the desert sun making it impossible to lie there much past dawn. By six thirty each morning, I had peed in the bushes and started walking. I wandered the neighborhood, passing shabby houses, highways, and shopping centers, trying not to get lost. Behind barbed wire were stretches of desert trapped by the city.

Walking through garbage and cactus one morning, I saw an army of red ants dragging a grasshopper across the sand. The grasshopper was taken into the ground to be eaten alive.

I had no idea where I was.

I found a restaurant and ordered huevos rancheros, glad to be in the bright little room, with holy pictures on the wall and the smell of greasy food. Without asking, the waitress poured me coffee, the first I'd ever had.

When I got back to the house, Kurt said, "Give me a hundred bucks. I know you've got money."

"No," I said. I told him I wanted to leave.

"We'll leave when I'm fucking ready."

That night, I hid my wallet in the yard.

THE NEXT DAY, I heard a firecracker—then lots of them.

It was the Fourth of July. I'd been in Albuquerque a week.

Later, Bill bought two cases of Coors, and the four of us drove into the night, as fireworks lit up the sky. The men opened their beers and cheered.

We ended up in Taos, looking for some friend of Roy's, who was nowhere to be found. It didn't matter. The dudes just bought another case of Coors. Ten miles out of town, Roy told Kurt to stop on the Taos Bridge.

Roy got out and walked to the guardrail. We all followed.

The view was breathtakingly unreal. Balanced on a tiny ribbon of steel, we stood a thousand feet above the Rio Grande. The canyon

was huge, a hollow world beneath us, the river hissing and turning in the dark. It sounded like the ocean.

"This is America," Roy said. "Fought the gooks for this shit!"

"Fucking-A, brother!" shouted Bill.

I understood now—they were Vietnam vets.

Leaning over the guardrail, drunk on beer—a thousand feet in the air—I tried to understand what it meant to be there with those crazy men who'd probably killed people. I thought of the dead—my grandmother, my father's brothers, the suicides of Star Farms.

The river is time, I thought. *Time before me, time after I'm gone . . .*

Kurt was less reflective. He went to the van and grabbed the five-gallon can of gasoline he kept for emergencies. Taking off his T-shirt, he doused it with gas, stuffed it back in the can.

Roy and Bill started screaming, "Fucking Fourth of Joo-lie!"

Kurt balanced the gas can on the railing and lit the cloth. As he pushed the Molotov cocktail over the edge, its flame seemed to disappear. But a few moments later there was a terrifying explosion, turning the canyon a hellish red. It was insane.

"Motherfucker!" Roy screamed.

"Fuck yeah!" answered Bill.

Kurt made a sudden move like he was going to push me off the bridge, too, and when I gasped, everyone laughed, too hard.

IN THE MORNING, I didn't feel well. Everyone else seemed fine.

Roy and Bill were getting ready for a party, and by late afternoon the house was full of people. Finally, there were women—and food. I ate a hamburger by myself in a corner of the yard. One woman came over to me and asked who I was. She introduced herself as Roy's ex-wife. I was shy at first but she kept asking me questions, and eventually I opened up a bit. It was a relief to speak to someone who wasn't a zombie. She had big hair, long fingernails, and a skinny cigar.

Her name was Cheryl—from Texas.

She told me she and Roy had a little girl, which was hard to imagine.

I asked how old her baby was.

"Not a baby anymore. Just turned four. She's a little doll, though. And how old are you, sweetie?"

"Fifteen."

She said I looked younger. "And your parents? Do they know you're here?"

I told her yes, I had their permission.

She took the skinny cigar out of her mouth and spit. "Listen to me. You don't really know these guys. Okay? Roy can be great, but he came back from Vietnam with some very big problems, including Bill, who is retarded."

"Is he really?"

The woman laughed. "I exaggerate. A little."

"But you still like Roy?"

Cheryl puffed. "He's the father of my kid. And I have my own reasons for coming around." She asked if I'd *partaken* with Roy and Bill. I knew what she meant and said no.

"Well, good. Then listen to me. It's not really safe here. It's okay tonight while I'm around, but . . ." She asked if I had anywhere to go.

I told her about my sister in Tucson.

"Good—go see your sister. You don't belong here. You're a good kid, I can tell. I'm a mother and it's my job to say it—you need to go home. You hear me?"

KURT CORNERED ME. "What did you say to that bitch last night?"

"Nothing."

"Get in the van," he said. "Get in the fucking van!"

We weren't going anywhere—Kurt just wanted a private place to bully me. Inside, he pushed me against the door and said he needed some of my money—*Now.*

"No," I said—but when he pushed me harder, I said, "Okay, stop." I gave him one of my dad's hundred-dollar bills.

"Will you at least give me a ride to the highway?"

"Fuck you."

. . .

I CALLED MY SISTER from a pay phone and told her things had changed. I was hitchhiking to Tucson.

"Hitching's really easy," she said. "It shouldn't take more than a day. Call me as soon as you get here. We'll have tamales!"

10.

Blackout

STANDING AT THE ON-RAMP to Interstate 25, I held up my shaky little sign.

In blue magic marker: TUCSON!

Three hundred miles to go.

At ten in the morning, it was already a hundred degrees, but I felt energized, full of coffee from my little restaurant. Also, I hadn't done any dope, even a puff of pot, for nearly two weeks. The cars and trucks zoomed by quickly; the sixteen-wheelers made me nervous—the way the ground shook beneath my feet. But in less than five minutes a white pickup pulled over. The two guys in front didn't smile

when I approached the window. Both had black hair and identical mustaches. Maybe they were brothers.

In my most cheerful voice, I said, "I'm headed to Tucson!"

Without a word, the guy in the passenger seat pointed to the back with his thumb. The bed of the old Chevy was loaded with engine parts. I climbed up and crouched against the cab with my backpack, trying not to get grease on my clothes. I had on my best T-shirt, white with flowers on the front.

The smell of motor oil was intense.

We lurched onto the interstate. It was very windy in the back but the hot air was fresh, and the mountains were beautiful. I watched a black bird soar across the sky.

That's the last thing I remember.

II.

Marjorie

FOR A LONG TIME, I'm tied up in the dark, screaming.

When the lights come on, I see that I'm in an empty room. A man in white clothing tells me to calm down. But I start screaming again.

The darkness returns.

WHEN I WAKE, my throat is raw—and coursing through the rest of my body is the most remarkable pain. But even more remarkable is the fact that my mother is there in the room, whispering to me.

After some consideration, I decide she is real. "Chris," she says, "everything is okay. You're safe now."

When I look down, I see that I'm naked and that there's a tube in my dick. Leather straps are holding me down. The tiles in the room are gleaming like water. I see blood and bandages.

Then my mother's gone. I'm screaming again.

I fall into a hole I spend the rest of the night trying to climb out of.

"WHERE AM I?" I say when the light returns.

Plainly, my mother says, "Albuquerque."

I thought I left Albuquerque.

Mom explains that the hospital had called her the day before. She got on a plane. "I just arrived last night. Chris, I don't understand what happened. Do you?" Doctors come in and examine me. They, too, ask me if I remember anything.

Nothing.

They shine a light in my eyes. When they touch my body, I cry. They take my mother into the hallway. I'm gone again.

THE NEXT DAY, I wake up in another room—blindingly bright, high above the city. I can see the upper floors of office buildings outside my window. It's frightening to be so high up, but at least there are no longer straps on my bed. I can move my arms and legs—though just barely.

Mom says, "Good morning, darling. How do you feel?"

She gives me some water. I drink it with a straw and croak, "I'm awake."

A doctor removes my catheter. It hurts like nothing I've ever experienced. Afterward, Mom helps me walk to the bathroom and holds me up so I can pee. Again, the unreal pain. But the worst thing is seeing myself in the mirror. Everything is ruined. I do not understand my face.

Tired. I'm so tired. Back in bed, I only want to sleep, but Mom can't help herself. "Why in God's name did you hitchhike? Donna told me. And I looked in your wallet. It's full of money!"

Is Mom mad at me? I close my eyes.

I'M CONFUSED. There's an old woman in the room. At first, I think it's Loey, my grandmother. But she's dead and the face is wrong. This woman looks like a person who's lived a hundred years in the sun. She has dark skin, elaborately wrinkled, and pale blue eyes.

"Chris, hello, I'm Marjorie Forsyth. I'm the one who found you in the desert. I'm so glad you're all right. You scared my sister and me to death. We've been so concerned, haven't slept a wink for days."

She touches my hand and I apologize. "I don't remember you."

Mom is suddenly there. She takes over. "Thank you for coming by, Ms. Forsyth. I'm sorry to put you to so much trouble. But can you please explain what happened?"

A dark look comes over Marjorie's face. She hesitates a long time before speaking.

"Mrs. Rush, maybe we should do this later?" She looks at me, concerned.

But Mother is impatient. "Please, just tell me."

"All right," Marjorie says, pausing as my mother gets her a chair.

"We live in the area—my sister Kate and I—and we were driving home from our shopping day in town. County Road Six, about twenty miles from the freeway. Not a lot of traffic out there, just locals. Well, we saw a white pickup truck moving quite fast, and there was a boy in the back of the truck, standing up and—"

She turns to me at this point; I can feel my lips quivering.

"You were waving your arms and yelling, though we couldn't hear you. Kate thought maybe you were calling out to us. We knew something was terribly wrong. You threw your bag out of the truck."

Marjorie is crying now; she takes a moment to compose herself. "And then we saw the truck speed up, it was just flying—and oh my Lord, you jumped, you just . . . such a horrible thing to see!"

She dabs at her eyes with a tissue. "The truck took off as fast as it could. And we pulled over, we found you in the dirt, just covered with blood. At first, we thought you were dead, but then you started moaning. I stayed with you the whole time while my sister went to call an ambulance . . ."

My mother is crying now, too.

"I was just soaked in your blood," Marjorie says. "And, of course, we stayed at the hospital as long as we could. The doctor promised us you would live, praise God. We were so grateful. You're just a baby."

For some reason, I feel ashamed. I want to hide my head under the blanket.

"Thank you for coming," my mother says—a dismal tone in her voice.

"Of course," Marjorie says, standing. "Please know that I've given a whole report to the police. They'll try to find those men."

"Why don't I walk you to your car?" Mother suggests.

Before she goes, Marjorie takes my hand. She asks me if I know how to pray.

I tell her yes, and she says, "You keep on praying."

WHEN MOTHER COMES back into the room, she sits in the chair where Marjorie told her story. She's quiet for a long time.

"You were doing drugs, weren't you?" she finally says.

"No," I tell her.

"Don't deny it. We found marijuana in your bedroom."

"Mom, I haven't had any drugs in weeks."

"Oh, in *weeks*!"

"Mom, really, I wasn't on anything when this happened."

"Well, why else would you jump from the back of a truck?"

I open my mouth to say something, but Mother holds up her hand.

"You should rest, Chris." And then: "We'll send that woman some roses."

∙ ∙ ∙

FIVE DAYS LATER, I was released with a severe concussion, lacerations, but no broken bones. *A miracle*, the doctors said. Seeing my bent backpack and bloody clothes by the door of our motel, I couldn't stop crying.

Mom threw it all away. She ordered us grilled cheese sandwiches from the motel café and we ate them in our room, watching soap operas. There were two beds, but that night Mom let me sleep next to her, as if I were still her baby.

The next day, wearing new jeans and a white oxford, I sat beside my mother on a plane to Tucson. It was a great relief to be leaving Albuquerque, but even from ten thousand feet I could see the gray dirt where I'd been left for dead.

At the gate in Tucson, my sister and Vinnie were waiting, unprepared for the horror show of my face. When Donna saw me, she ran into my mother's arms, hysterical.

Once everyone calmed down, Vinnie whispered to me, "You are *fucked up*, man. Here." He slipped me a joint.

THOUGH WE SAW Donna every day, Mom had no interest in staying at my sister's tiny bungalow. We took a room at a luxury resort near the University of Arizona. There was a big swimming pool and a fancy restaurant.

I was in pain, but was glad to be with Mom. But whenever we were alone, she could only talk about Donna.

"Your poor sister. She could have had anything in the world and this is where she ends up—*the Inferno*. And Vinnie—pretending he's Jesus. What he needs is a job."

"Mom, he's a Catholic, like us. Don't be mean."

My head was throbbing from the concussion. "Mom, did you ever send flowers to Ms. Forsyth?"

"I did. I sent her a mountain."

Seeing my opportunity, I said, "Mom, why do you think that truck went faster after I stood up?"

"What are you talking about?"

I reminded her of all Marjorie had told us.

"Who?"

"Ms. Forsyth. It's just totally bizarre," I continued. "If someone stands up in a truck, you slow down. You don't go eighty miles an hour. I mean, I must have had a reason to jump."

"I think you're all mixed up, honey. The doctors told me you were delirious when you were brought in."

"Yeah, that's called *a head injury*."

LATER, AFTER I'D GONE to bed, I overheard her talking to Donna on the phone: "I spoke to the police. Evidently, your brother went a little crazy. 'A psychotic episode brought on by drugs' is what the police told me. Best not to bring it up and upset him again. He's a bit unstable right now." I couldn't understand why she was making things up.

I was so mad that she kept insisting I'd been "on drugs" that I refused to have breakfast with her the following morning. Instead, I went outside and smoked the joint Vinnie had given me.

ON A BLINDINGLY bright morning, Mom and I drove out to the San Xavier Mission, a Tucson tourist attraction. The church, hundreds of years old, was a sort of haunted house, the interior encrusted with centuries of soot and wax. Worm-eaten statues, dead as fence posts, loomed above Indian women mumbling rosaries in the dark. In a corner, I found a statue of San Xavier, his cloak covered with handwritten prayers. I read the ones in English. *Please, San Xavier, let me walk again! San Xavier, heal my husband! San Xavier, my son is at war. Please protect him!*

Pinned to a ratty blanket below the saint's feet were hundreds of tiny metal charms—arms and legs and eyes, even donkeys and pigs. People prayed for so many different reasons.

My amnesia after the accident frightened me—so I prayed to have my memory restored. As soon as I asked, I knew it was a mistake. I prayed again, telling San Xavier that I'd rather not know.

Just make me better. Make the headaches go away.

In the gloom, I watched my mother lighting a candle and imagined it was for me. On her head was a silk scarf and big black sunglasses to hide any tears. Her piety made me feel safe. I loved her again—the glamorous woman praying in pink.

I understood why she had to believe that drugs had caused the accident. She didn't want anyone to blame her for what had happened—to think that she'd put a child in danger by letting him go off alone with a stranger. It was better to say I'd gone crazy.

I walked across the church and took her hand.

She said, "Your brothers will wring my neck if I don't bring them souvenirs."

At a curio shop downtown, Mom and I wandered past endless Arizona clichés: bolo ties, cowboy hats, kachina dolls floating like spacemen across the wall. In wooden cases, silver jewelry was stacked up, cheap as candy.

"I have no idea what to get your brothers. Who knows what they like."

I knew exactly, and knowing made me miss them. I told Mom what she needed: *A drum for Mike. A geode for Steve. A tomahawk for Danny.*

We gathered up the loot.

"Mom, I want a tomahawk, too."

"Why?"

"To defend myself." Shaking one of the axes, I growled—perhaps a bit too loudly. Mom frowned, and I put down the toy. Instead, she bought me turquoise beads, slipping them over my head like a halo. "That's better."

She bought a matching strand for Donna, as if we were twins.

That afternoon my sister joined us, and we all went to the corner store for ice cream. Slurping our cones in the sun, she said, "Faster, before everything melts."

Still emerging from shock, I didn't want to be alone for more than a few minutes. Without Mom and Donna, I worried I might fade away forever.

. . .

BY SEEMINGLY MIRACULOUS means, my bruises and cuts began to heal. I walked with a slight limp, but at least I could find my face again in the mirror. The headaches came less frequently.

After two weeks in Tucson, Mom said it was time to leave.

I asked her if I could stay with Donna a little longer.

"You've just spent two weeks with your sister."

"I still miss her."

"And you don't miss me?"

I told her, of course I did.

"Then fine, you can stay."

12.

Sixteen Kilos

DONNA AND VINNIE'S BUNGALOW had one bedroom and one bathroom. It was the size of a doghouse. But I was overjoyed to sleep on the lumpy couch, to never be more than a few feet from Donna's door.

I started having nightmares. I'd had bad dreams my whole life—but these were worse. No longer just monsters and devils, but now a new kind of dread—humans. I was running from people who were somehow more frightening, and more plausible, than monsters.

Always, I was running.

Before she left, Mother had set an appointment for me with a

Tucson neurologist, but somehow Donna and I spaced out on the date. My sister said she'd take me to see her chiropractor instead.

"What about my stitches?"

"Oh, Vinnie can do it."

One morning, after breakfast, I asked Donna if we could visit Valentine and Jo. Donna said, "Sure, I have an errand out there anyway. Gotta pick up product for my next run."

ON A HUNDRED-DEGREE afternoon, my sister and I drove through saguaro forests, down miles of dirt roads into the deep desert. I thought of the gray dirt of Albuquerque and started to feel uneasy. A metal gate blocked our path—then opened magically just as we approached. On a small rise, a white building came into view, gleaming like a crystal in the sun. A pregnant Jo was waiting for us outside. She kissed me gently on my Frankenstein face. "Oh, Chris." I knew she wanted to cry, but I laughed to show her I was all right.

We went inside through an air-conditioned garage stacked with hundreds of huge candles—red, purple, and green. Jo explained, "We manufacture these. Aren't they fantastic? We use essential oils, mostly patchouli."

I whispered to Donna, "They sell candles?"

She winked at me. "Uh-huh."

As we walked past a huge indoor pool under a glass dome, I wondered if Valentine was now richer than my father. Jo led us through a maze of rooms and terraces until we found Valentine, standing before a wall of windows. A desert moonscape rose up behind him. It was like a scene in a science-fiction movie.

From across galaxies: *A reunion!*

Valentine kissed my sister and shook my hand. In the stark light, he appraised my injuries. "Next time, pick a fight you can win, okay? You upset your sister very much."

After waiting all summer to see him, I was too shy to speak. Valentine was as handsome as ever, in a white shirt and jeans, a silver

concho belt strung on his thin waist. All around him was product, being readied for shipment. Slabs of hash, bricks of reefer, yellow pills in plastic bags . . .

He saw me staring. "People gotta get high—right, brother?"

"Yeah, for sure."

Donna and Jo floated away in their gauzy dresses, arm in arm. They'd known each other since they were little girls in New Jersey— and now they were women, living on the moon.

Valentine said, "Did you know I used to sell fireworks when I was a kid?"

It was my chance to tell him about Kurt—about Roy and Bill, heroin, and the Fourth of July. But I was ashamed of all that had happened.

He picked up a bag of pills and laughed. "And now God is using me to sell sacrament. We all do our part in His plan." His voice trailed off. We were quiet for a few moments. He reached over and touched my face.

I flinched.

"Sorry," he said. "Didn't mean to scare you."

He lit a joint. "So, Chris, you came to Tucson, just like I told you. Was I right or not? Is this not Paradise?"

"Yes," I said, wanting to say something smart. "The light here is very white . . . *very pure.*"

"If you want," he said, "you can hang out with me while I pack some stuff. Big shipment going out, some of it with your sister. She's important to us, you know. America needs hope right now, with this fucking war—and that's what I'm doing, man, I'm selling hope. And what about you? You interested in hope?"

Hope? I wasn't sure. "I'm at this cool new school now—I'm doing a lot of art." Somehow, I couldn't lie. "Actually, it's hard to figure out what matters."

He nodded, staring at me.

"I don't know, I just thought if I could bring back—I don't know, not too much, but just . . ." I fumbled for the words. "Maybe a little weed."

"Of course," Valentine said. "We'll take care of you. I'll talk to my partner Lu."

I wanted to say more, ask important questions, but Valentine was distracted.

"Why don't you go see the girls? Jo's making cookies."

"I'M SO GLAD you know what I'm doing," Donna said as we were driving home. "It's nice to have someone who I can tell, who understands. Because this is such a great opportunity." She was gushing. "I fly product all over the country. It's really easy and everyone is *so* nice to me. I'm not even nervous anymore. Vinnie and I always pray before I leave. In fact, do you want to pray right now?"

"Sure," I said.

Donna talked to Jesus like He was in the car. For her, Jesus had become a fact of life, like a Coke or a sandwich.

I prayed with Donna, word for word.

In the trunk of our car, in a blue Samsonite suitcase, was a hundred thousand hits of LSD. Donna would travel alone to the East Coast to deliver it. "A few days away," she said. "And then I fly home with the cash."

"When are you leaving?" I asked.

Maybe she heard the anxiety in my voice. "You'll have a good time with Vinnie. And he'll introduce you to Lu and Jingle." She smiled. "Valentine said you're doing a little business. That's great! I'm really proud of you, Chris."

"I'm proud of you, too," I said. "You're brave."

"So are you."

She kept her hand on my arm, driving with the other—a professional now, her long hair swimming in the wind.

ON RIVER ROAD, Vinnie pointed to a rock so far away it was just a blue blur. "Valentine's partner lives out there, on the mountain. Lu's pretty cool. His real name's Luigi. He's a Sicilian, like me."

"Valentine said Lu would get me whatever pot I needed."

"Hey, you're family—you're covered. But I should warn you about one thing before we get out there." Vinnie slowed down the car. "Lu's sort of deformed."

I nodded, trying to be businesslike. "That's cool."

Soon we were on a dirt driveway, approaching a wooden house on a black cliff. I saw a bent figure, four feet high, with long, black hair—a man. As we got closer, I could see the shriveled legs and steel crutches.

The man waved and shouted, his voice pure New York. "Hey, guys!"

As soon as I was out of the car, Lu grabbed my hand. "Chris, brother, so nice to meet you. Vinnie, man, come on inside."

In the kitchen, a woman in an apron and cowboy boots held a huge carrot.

"This is my wife, Jingle. Honey, this is Donna's little brother, Christopher."

She kissed me, once on each cheek. "*Christ*-opher," she said—just like Pauly used to say—except Jingle didn't seem to be making fun of me. She asked me if I liked carrot juice.

"I don't know."

She turned on a machine, loud as a lawn mower, and liquefied various roots. Jingle was tall and blonde—gorgeous, maybe twenty-five.

She's married to Lu? The math was far-fetched.

As I sipped my carrot juice (dirty and sweet), I noticed the saguaros out the window, leaning like monsters trying to get in. Though beautiful, the desert was still a little scary to me. As the adults chatted, I studied the landscape. Above the house were craggy slopes and various types of alien vegetation.

"Pretty, isn't it?" Jingle said. "Why don't you go outside, take it in?"

"Go ahead, run up the mountain!" Lu cried, smacking my butt with his crutch.

Everyone was smiling at me—"Okay," I said. "I guess I'll check it out."

Even at seven in the evening, the heat was still fierce. Pulling

myself up burning black boulders, I was alone for the first time since my accident. Everything seemed strange, especially my own body, climbing up a mountain.

Then I heard it, shaking like a husk of seeds. Inches from my leg, a fat yellow snake, mouth open, was ready to strike. It lunged, fangs flying at me, and I tumbled down the rock, screaming.

I'm okay I'm okay I'm okay—the words raced through my head. I was trembling, ready to run back, but then I remembered my sister, telling me I was brave. I made myself hike to the top, from where I could see the whole valley. There were huge thunderheads, drifting like jellyfish across the sky, turning from pink to violet as the sun disappeared. I prayed: *Thank you, God. Thank you for not killing me.*

I wasn't thinking of the snake, but of the men in the truck. Some things were coming back to me. I'd remembered the gun pointed at my head. Like the one my father had in the drawer beside his bed.

By the time I got back, it was nearly dark. The house was quiet. The adults sat at the table, bleary-eyed, holding hands. Candles burning, the smell of hashish. As I joined the circle, Jingle sang a delirious hymn in a shockingly beautiful voice.

"*Grazie, mia amore*," said Lu—after which he thanked the Holy Spirit for our dinner. Everyone mumbled *Amen*, and we ate our enchiladas.

Later, after dinner, I asked Vinnie what I should say to Lu about getting some product. Vinnie said, "It's taken care of. We'll pick it up before you leave town."

On the ride home, Vinnie explained that Lu's place was a stash house. "Tons of pot goes through there. Lu and Val supply Boston, Philly, and New York. They've got stash houses back there, too."

I asked why Lu's legs were so small.

"Polio," said Vinnie. "The man's a saint."

THREE DAYS LATER, when Donna walked in the house, I ran to her. "You made it!"

"Of course. I told you, it's really easy."

That night, to celebrate, she invited a guest to dinner—a

Neanderthal named Flow Bear, an old friend from college, who now did a little business with Donna on the side.

"Chris, Flow Bear is a nudist. I hope that doesn't bother you."

"Not at all."

Flow Bear lay naked in the yard, on a towel. He remained unclothed during dinner and dessert, while I tried to find a polite way to stare at his dick.

The next day, when Donna told me that Flow Bear would drive me back to New Jersey, I didn't understand. I'd almost forgotten that this was just a vacation—that I'd have to go home, go to high school.

"Didn't Mom say I was supposed to fly home?"

"Chris, your hair's way too long to fly with pot. Just call Mom and tell her you're coming back with a friend of mine."

When I called Mom and explained the new plan—that I was driving home with Flow Bear, she said, "Honey, I believe Flaubert is dead."

"No, Mom, it's a different one. It's Flow *Bear*. He's a friend of Donna's. From *college*," I emphasized.

"I wish your sister would go back to school," Mother said. "What's happened to my children?"

"So I can drive with him?"

"Fine," Mom said.

She didn't ask me how I was feeling after the accident. Maybe she had amnesia, too.

THERE WAS ONLY one thing left to do.

In a supermarket parking lot, we met Lu. Vinnie removed a suitcase from the trunk of Lu's VW bug and threw it in his own. I handed Lu an envelope of cash, a bit over five hundred dollars—what was left of my theft from Dad. It wasn't quite enough for the product, but Lu said, "Pay me later. Your sister will be back east soon. You can send it with her."

Donna looked at me sadly. "Or you'll come back to visit."

. . .

FLOW BEAR'S '48 Chevy was a shining blue ship, big as a bedroom. With thirty-two pounds of pot stashed under the backseat, the car was further equipped with beer, bread, and peanut butter.

The trip was a wander; Flow Bear was in no rush. Driving the back roads, we listened to the hick radio stations. The music sounded hollow and tinny, like it had been broadcast in 1920 and bounced back from outer space.

In Oklahoma, we stopped for the night on a bluff above a lake. I crashed early, dragging my bedding to a big flat rock. The moon was high overhead, the earth colorless, the lake a sheet of dull metal. The air was still and warm. Lying naked on my blankets, I couldn't sleep.

Much later, I heard the car door open. Flow Bear emerged nude and began to walk in my direction. Closing my eyes, I pretended to be asleep. His footsteps on the gravel moved closer and closer. He stopped to pee. Then he walked over, stood right next to me. Eyes pressed shut, I tried not to move a muscle. I could feel him staring at my body. My heart was pounding with a mixture of fear and desire. After a while, he walked off, and I listened, footstep by footstep, until I heard the car door close.

I remember thinking, *Why would he want to look at me? Can't he see the scars?*

FARTHER EAST, the weather thickened. Hot and humid; the only relief was the air rushing in the windows. Flow Bear stripped raw for the ride. Truckers honked at his nuts. Shy and sweaty, I kept my clothes on, drowsed on the backseat.

Flow Bear's driving was a bit broad, and somewhere in Missouri sirens went off. "We are creatures of calm," Flow Bear said, as he glided to the side of the road. "Nothing to worry about."

Still buck-naked, Flow Bear unfolded the Rand McNally to cover himself.

The sheriff requested license and registration.

Flow Bear asked, "Officer, was I driving too slowly?"

He answered, "Son, you are driving a very fine automobile. Is this a 1948 Chevy?"

"Yes, sir—'48 Streamliner Coupe."

"Well, I just needed to get a better look. My daddy drove one in cherry red. The blue ain't too bad, though. I see you have the wheel skirts. Very classy."

"Yes, sir—got the rear wipers, map light, and original tissue dispenser."

"Well, she sure is pretty. The boy in the backseat, is he a minor?"

"Yes, sir, he is. His mama asked me to take him home."

"Boy, are you all right driving around with this nude man?"

"Yes, sir. I am." Under my butt, the smell of Mexican pot was unmistakable. I knew that I was headed to prison.

The sheriff handed Flow Bear back his papers. "May I suggest that you boys exit the state of Missouri at the maximum legal speed limit? *For your own safety.* Am I understood?"

"Yes, Officer, perfectly."

"And take care of this beautiful car, will ya?" The sheriff patted the blue bonnet. "You boys have a good afternoon."

Two days later, Flow Bear and I were sneaking behind my parents' house, stashing bricks of pot in the pool house. I gave him a kilo to thank him for the ride. He reminded me he only lived an hour away. "I'll see you again." He shook my hand and left.

I ran inside, screaming, "I'm home—I'm home!"

But the house was empty.

13.

The Bermuda Triangle

I CALLED MY SISTER KATHY. "Where is everyone?"

"Bermuda. They'll be back on Tuesday."

"*Bermuda?*" I could hear my voice going up an octave.

"Yeah, on a cruise."

There was no note—and not much in the fridge. Though I hadn't told Mom the exact day of my arrival, she knew I'd be home that week. I sat in the kitchen, eating Kraft Singles, thinking: *I have six days alone in the house.* The idea was half-exciting. Thinking of Flow Bear, I swam nude in the pool.

Later, obsessing about my thirty-two pounds of pot, I moved it

from the pool house to my closet, and sealed it in a large cardboard box labeled ART SUPPLIES. Of course, I often unsealed the box, sampling my supplies.

Soon, I was bored. I made coffee and read *The New York Times*.

ASTRONAUTS END 12-DAY MOON TRIP

I scanned the gallery listings. Yoko Ono was having a one-woman show. Maybe I could get Mom to take me, some weekend when I was home from Star Farms.

I went into my parents' bedroom and looked at myself in the big mirror. The wounds on my face had become red splotches, my right eyebrow now interrupted by a jagged scar. I marveled at my ugliness. I took off all my clothes to survey the damage. It was pretty bad. My knees and elbows were still raw, my ass and back marked with scrapes.

To hide my sins, I put on my mother's chinchilla, the satin lining cool against my skin. I fell asleep on my parents' bed, then woke from a nightmare, startled, not knowing where I was or why I was naked in a fur coat.

The next night, I dropped some acid from Valentine, trying to synchronize my peak with the moment of moonrise. It seemed scientific—like I was part of some great experiment. The experiment was *hope*.

A DAY LATER, I'm in the kitchen, tripping out again, marveling at how the molecules of the air have become visible. I reach up my hand to catch one when my father walks in. He thinks I'm waving to him.

"Hello to you, too," he says. "So you're home?"

Am I?

It takes me a moment to find my voice. "I thought you were in Bermuda."

He scowls. "No. Your mother and brothers."

Dad's eyes are like mine; they have trouble focusing. I wonder if he's high, too. He sits for a moment in the chair beside me. "I hear you almost got yourself killed out there?"

The molecules of air become planets.

When I don't reply, Dad says he's going to bed. He gets up and limps out of the kitchen. As he passes me, I can smell perfume.

Stray molecules enter my nose, and my brain computes:

Not my mother's perfume.

ON TUESDAY, as scheduled, my mother and brothers returned.

"We just needed to get away," my mother said brightly. "I see you got back safely. You've been here with your father all week?"

I nodded, deciding not to tell her that he'd only just showed up.

My brothers stared at my wrecked face.

"Cool," said Michael.

Steven smiled at me sadly.

Little Danny said, "*Eww.*"

Mom opened the freezer and stared inside. "I'm tired, boys. Okay if we just have hamburgers?"

I said, "Oh, I'm a vegetarian now."

"Since when?"

"Since Donna and Vinnie became vegetarian."

"Well, I think we need to talk to Dr. Footer about this. I'll make an appointment."

"Mom, I'm fine."

Dr. Footer was our pediatrician. He was also the county coroner. By day he ministered to children, by night he ripped the lungs out of corpses.

AFTER THREE DAYS of my limping around the house in bib overalls, Mom said to me, "Let's go out and get you some new clothes."

I told her I liked my wardrobe. "Besides," I said. "There's no dress code at Star Farms. No one cares."

"Oh." She tilted her head and frowned.

"What?"

"Honey, I thought I told you. You're not going back to Star Farms."

"What do you mean?"

"Well, it was your idea. Don't you remember all those hysterical phone calls? 'Mommy, I hate boarding school. Mommy, I want to come home.' Well, now you're home. I enrolled you in public school."

"When were you going to tell me?"

"I just did."

A wave of confusion broke over me. It wasn't just the horror of a new school. I had thirty-two pounds of pot to unload—and Star Farms was my only market. I'd told Valentine and Lu I'd pay them the rest of the money by the end of September.

"What's the matter, honey? You're perspiring."

AT NIGHT, I kept going back to Albuquerque.

A white truck, a mustached man pointing a gun at me . . .

It wasn't just me, though. The whole house was having a nightmare.

Dad was drunk, drunk every day, more drunk than sober. Maybe I wouldn't have noticed how wasted he was but for my mother—who always noticed, and who always made a scene. She was *very* disappointed in my father.

"It's a small town, Charlie. People are talking!"

"As far as I can see, Norma, you're the only person who won't shut up."

Mom sniffed and circled my father every time he came in. Her favorite time to demand that he stop drinking was when he was shit-faced—a strategy even *I* recognized as hopeless. Their arguments moved across the house like storms, from porch to kitchen to bedroom.

My brothers and I ran outside, hid in the trees like monkeys.

Stupid monkeys, who went in for dinner.

MEALTIMES, everyone was on edge. Dad, smash-o, not saying a single word. Disdainful, he'd stare off into space, chewing in slow motion. Mother often tried to start fake conversations with me or my brothers.

"Boys, tell me about your new teachers."

I was wary, but my younger brothers always took the bait. One night Steven, in the middle of some dumb story about math class, knocked over his glass. Milk inundated corn and casserole, poured off the table. It was an epic mess.

"Not again!" Mother said. She stood and got a roll of paper towels, which she unfurled across the carpet—her flag of surrender. As she sopped up the milk under the table, she began to weep, howling like some dying creature. None of us dared move.

Then Dad flicked his silver lighter—the signal that *he'd had enough.* Lighting a Winston, he puffed, as if bored by Mom's performance. In a trail of smoke, like the Devil, he went off to his den.

My brothers, too, ran to various hiding places in the house.

I stayed on, worried about my mother's mental health. Climbing back into her chair, abandoned paper towels on the floor, she looked deranged. There were drops of milk in her hair and mascara running down her cheeks. Her strange smile terrified me, her hands fluttering in the air, dismissing the drama.

She put three biscuits on her plate and reached for the gravy.

"Honey," she said. "Tell me some good news. I could use some good news for a change." She stared at me, grinning, but I had nothing to offer.

AT RIVERWOOD PUBLIC HIGH SCHOOL, I was one of the tallest students, but I spent most days shrinking, looking down, trying to ignore the jibes about my face and girly hair. Under the influence of art supplies, I remained in a trance.

One rainy afternoon, on the bus home, the kids started to chant. *Go Red! Go Red!*—and then *Ci-ba! Ci-ba! Ci-ba!*

Blazingly insecure, I tried to figure out what those words had to do with me, but when I put my head up, everyone was watching the river as we drove by. The water was bloodred. It was terrifying. The girl beside me explained.

"Oh, that's just Ciba-Geigy—the chemical plant—dumping in the river again." She yanked a wad of gum from her mouth and stuck

it under her seat. "I don't know, I think it's kind of pretty—don't you? And red *is* our school color!"

AROUND THIS TIME, my sister sent me a mysterious cookbook called *The Ten Talents*. In addition to recipes, there were photographs of women in braids stirring nutritious goo with large wooden spatulas. The book's authors argued for "the Bible Diet," claiming that cashew milk could revive our godless world. Pulverized nutmeat energized and congealed all the dishes in the miraculous cookbook, from ice cream to casseroles.

Donna wrote that the recipes were *very evolved*.

I wanted to be evolved. After baking a surprisingly delicious cashew-pumpkin pie, it was clear to me that the Bible was right about snacks. With enough cashews, I, too, could grow strong and spiritual. Soon I was baking bread and fermenting my own yogurt, which Mom said smelled like dirty laundry.

"ANOTHER PACKAGE for you from Donna," my mother said when I got home from school. Every month or so, my sister and Vinnie sent me religious items—a votive candle or a small statue of Jesus.

"Isn't that charming?" Mother would say. "I didn't realize how devoted they were."

What Mom didn't know was that in the gift box, under a false bottom, there'd always be a bag of product—a couple of hundred hits of acid, a slab of hash.

On the phone, Sis said: "Just some stuff we had lying around. It would be great if you could sell it and mail us the cash."

Luckily, I'd found a few people to sell to at public school, including my old buddy Sean Carney. Sean had been my best friend in fourth grade. Back then, we were inseparable, two boys with our arms around each other, yapping on the playground of St. Ignatius. Sean had a big bristly head of black hair, blue eyes, and the truest smile. *I love you*, we'd say to each other unabashedly. Then, one day he was gone—transferred to public school.

Now, years later, we met again in detention. I'd been busted for skipping gym, and Sean had committed multiple dress-code violations. That day, he had on maroon harem pants, bracelets, and a fez. Though Sean was now a broad-shouldered fellow with long hair and sideburns, I recognized him immediately. We couldn't stop talking. When he said "You heard about the UFOs, right?" I didn't hesitate. I repeated what Lu's wife, Jingle, had told me the summer before. "They're kind of like angels, from Mars and Venus, here to help us through the current crisis."

"Oh my God," Sean screeched. "That's exactly what I heard!"

Sean was enthusiastic about drugs, too. He bought some of my pot, as well as twenty hits of acid.

But I still had a lot of product to unload. I decided to call Star Farms.

THE PAY PHONE rang and rang—far away, a bell in outer space.

When someone finally picked up, it was Betsy Chang, a junior. I'd always liked her. "Hi!" she said. "Who's this?"

"Betsy, it's Chris Rush. I used to go there. Remember, we used to get high in the tree house?"

"Oh, yeah. The gay kid, right?"

My heart sank. *Is that all that anyone remembered?*

She asked why I wasn't there anymore.

"Oh," I said. "My mom's sick. I need to help her."

Betsy, always competitive, said, "My mom's *dead.*"

I asked if Kurt Vogel was still around.

"Yeah, but he's in class. He told everyone you ran away from him this summer. Plus, worse shit."

"Well, I have some stuff he might be very interested in. Tell him I'm taking a train to the Farm this weekend. I'll call him when I have my schedule."

On Saturday morning, before my mom got up, I snuck off with a suitcase full of pot. I caught a bus to New York City, then a train north. Five hours later, I sat outside a tiny depot waiting for Kurt to show up.

An hour late, the familiar white van materialized. Kurt and I barely spoke. He was only interested in the weed. Returning to my old school felt very weird. I smiled and waved at a few people as I walked across campus to Kurt's room. Nicky Bloom dropped by to snoop. "So you're back?"

"No, man, just delivering product from Tucson."

"Oh—*how working-class.*"

"Nicky, not now," Kurt said. "I have business to do."

When we were alone, I took the kilo bricks out of their paper wrappers and checked the weight on a scale Kurt had stolen from the science lab. My thirty-two pounds of Mexican Gold had already dwindled to twenty-nine.

Kurt and I sampled a very nice joint, but he refused to smile.

"Obviously, excellent pot," I said. It was hard to look at Kurt's stupid face; I still hated him. "I think two-fifty a pound is a fair price." This was nearly ten times more than the price I'd paid.

"Fuck two-fifty," he growled. "Two hundred—or keep it."

I frowned, pretended it was a terrible dilemma. After a long pause, I said, "Okay, man, I guess it's a deal. You can have the suitcase, too."

Kurt got the money from a padlocked closet and put the suitcase away. Then, like it was nothing, he said, "Oh, did I tell you Roy OD'd? Remember—those guys we picked up?"

"I know who Roy is." I thought of his wife, Cheryl, and their little kid. "I have to go," I said suddenly.

Outside, I saw Zelda, the art teacher, and hid behind a tree.

When the coast was clear, I ran—three miles to the train station.

AS A CONSOLATION PRIZE for all the nastiness at home, Mom offered to take my brothers and me to New York City one Saturday. I was the only one who wanted to go.

There's a photo of the two of us from that day, taken on a ship in New York Harbor. We're waving from the rails. Mom looks terrific, her hair in a wild flip, plastic wraparound coat with fake fur cuffs and a rope belt. Her white knee-length go-go boots are just hilarious.

She's trying to be young and hip—grinning like a teenybopper on a big date. I'm in blue jeans and a denim jacket, my hair tangled in the wind. Next to Mom, I'm just a goofy blur.

After the ship, we hit the galleries. I recall abstract paintings—lots of blue and yellow stripes. On the street I saw a man in a mink coat walking a cat.

Late in the afternoon, we wandered over to Mom's favorite Italian place in the Village. She had a few daiquiris—but the good cheer was fading fast. I drank my Coke, trying to explain how hard it was to make new friends at school. "I have to start all over again."

It was too late. Mom had gone off; she couldn't listen. All she wanted to talk about now was *the bastard*. "You should know what's going on, darling. It's not just the drinking or the money problems. Last week, your father said he was going to a meeting. But he put on too much cologne. I followed him. He went to the Cedarwood. I waited outside a bit and then went in. The bartender says, 'Oh no, we haven't seen him, Mrs. Rush.' Then, there he is, strolling from the back with Rita Rooney, telling me, 'Norma, they have a drywall problem in the basement.' Do you understand what I'm saying, Chris? Your father in the basement with a waitress!"

She stared at me, waiting. What did she want me to do? I had no idea how to console her, how to be supportive and loyal. These were not qualities that had been instilled in me.

As her teardrops fell, all I could say was, "Please don't."

AT HOME, Mom began to ambush me. She wanted to talk about her childhood, go through the old photo albums. I'd never heard any of it before. It sounded like a fantasy: pony rides and lemonade, dance parties and sing-alongs. She spoke of her doting grandmother Teresa, elocutionist and photographer. Teresa entertained Mom after school, performing fairy tales for her delight.

She rarely mentioned her father—bootlegger, bandleader, wife beater—a man who ran a side business as a traffic judge. Only years later would I hear the whole story. How the cops on Route 9 would

nab motorists on their way to Atlantic City and drag them over to Farrow's Bait and Tackle, where my grandfather had turned one of his storage areas into a faux courtroom. If the "speeder" couldn't pay the fine, Granddad and the cops would confiscate whatever they could find in the car.

I also learned, much later, how he would beat my grandmother Loey. And how my mom would hide her head under a pillow so she couldn't hear the screams. When finally, after years of brutality, Loey divorced Bill, my mother was forced to testify against her father in court. She was sixteen.

Now, at forty-six, my unhappy mother tried to explain how wonderful her childhood had been.

14.

Five Gunshots, Maybe Six

MOM AT BREAKFAST—NO MAKEUP, scribble hair, bathrobe.

"Look at this paper. This is terrible. Now everyone knows our business!"

Next to her coffee was a copy of the *Daily News*, the largest-circulation paper in the tristate area. Mom snapped it open to page two.

There it was: NJ BUILDER BUSTED IN BRIBERY STING.

Reading over my mother's shoulder, I discovered that a "Charles Rush" had been pulled over in Atlantic City for drunken driving only a few months earlier. The officer had invited the builder to pay a

thousand-dollar bribe or spend the night in jail. Mr. Rush cordially agreed to come back the next day with cash. As it turned out, that particular officer was under surveillance for mob activities and Mr. Rush was filmed handing off an envelope. The article stated that New Jersey prosecutors were now forcing this Mr. Rush to testify.

Half a million copies of the story had been distributed. Mom was freaking.

When Dad came home early that day, it was not for his usual alcoholic nap. Instead he had a serious heart-to-heart with Mom. As the two of them whispered in the living room, I eavesdropped from the hall.

"If I don't testify, I go to prison. But I got a call from Richie. He says if I testify—I'm a dead man. Maybe I better leave town for a while."

"What does Richie know?" my mother snapped. "His restaurant is awful."

My father said Richie was in the mob. "Norma, this is serious!"

Mom started to cry—it was more like *howling*. Still, she managed to make demands. "Why do you always have to drag us backward? Charlie, I cannot live with any more shame. You had better clean this up!"

I went to the basement and lit a joint. I zoned a bit, wondered what would happen next. Then five gunshots rang out, maybe six.

Oh my God, Dad's been shot! Then I thought, *That was quick!*

I hid under the bed. Then I heard a door slam and my father's voice in the kitchen.

When I crept upstairs, he was sitting in a chair with a revolver.

"What happened?"

"Target practice," he slurred. "Gotta protect myself."

And then he said, "Tree," and pointed the pistol at my head.

A FEW NIGHTS later, during dinner, a truck went by with several violent backfires. In an instant, Dad was under the table. I looked at him there, tiny and sad, cowering beneath the tablecloth. When he

THE LIGHT YEARS 135

got up and lit a cigarette, his hands were trembling; his face was white.

"What's so funny?" he hissed.

But none of us were laughing.

Later, I heard mumbling and peeked into his room. I saw him on his knees, praying to the crucifix, tears in his eyes.

MY MOTHER'S ABSURD PLAN: Dad should get out of town for a while—and take his boys hunting! She said something to my father about lying low, and something about *the bond between fathers and sons*. Maybe she wanted to keep my father away from Rita Rooney. Or maybe she just wanted to be alone.

It worked, I guess—the hunting trip was on.

My brothers Michael and Steven got a little overexcited, preparing for the expedition. My mother was manic, too. She went on a cleaning jag. I heard her shouting from down the hall. "Moths! We have moths!"

Dad said, "What's going on?"

"Look at this." Mom was pulling clothes out of Michael's closet. There were little holes everywhere. "Charlie, call the exterminator." She handed my father a tattered sweater.

"This is shot," he said.

"That's what I *just* said," my mother hissed.

"No, Norma. It's not moths. It's *buckshot*."

It turned out that in the commotion my brother had accidentally fired a shotgun into his bedroom closet.

My mother started screaming, "I want you animals out of this house!"

Everyone, except five-year-old Danny, was expelled.

DAD'S HUNTING LODGE was on the Chesapeake. There he hunted geese. Deer he usually killed up north.

My brothers already owned various guns and knives. While they

packed up their weapons, I made it clear to everyone: *I am a vegetarian and will not touch entrails of any kind.*

The ride down was endless. Dad, obviously drunk, sulked and swerved, chain-smoking until Steven got carsick. When Dad refused to pull over, Steven barfed in his gym bag, which Dad then chucked out the window.

I assumed Maryland would be ugly in November, so I was shocked as we approached the lodge. The land was soft and lovely, the Chesapeake blue and brooding.

That Dad had something beautiful he did not share with his family almost made me like him. Somehow his secret made him seem more human, more like a child. The lodge was an old barn that he'd remodeled into a warm and comfortable lair.

I brought a bag of dope with me, and after dinner snuck out for a smoke. I walked down to the bay, the smell of the water clean and bracing. The stars were very close, shuddering as the frost fell.

Not required to kill at dawn, I slept in, ate breakfast alone. In the late morning, I put on a jacket and headed out. Dad said everyone had to wear an orange hat, and I tried to do so with mannish style—though with long yellow hair, I looked, no doubt, like a confused scarecrow.

As I wandered, the day grew warm. I settled in the shade of a hedgerow and fell asleep.

Ka-boom! The first burst of buckshot missed me by only a few inches.

A second round scattered in the hedge—my tangerine hat took a direct hit.

I screamed. Screamed again. My brother Michael said, "Wha . . . ?"

"Stop shooting! I'm right here!"

"Oh."

I found him on the other side of the hedge, in boots and burlywear, sporting the same useless hat I had on myself. Behind his thick and filthy glasses, my brother's blue eyes were wild. A shotgun protruded from his waist. He tried to blame me.

"Why were you lying on the ground? Were you touching your penis again?"

"No, asshole, I was asleep. And what the fuck are you doing, shooting into the bushes?"

BACK AT THE BARN, my father had started drinking but was not yet mean. I watched him gut the geese he'd killed that morning. He meticulously cut livers from the iridescent goo, carefully placing each one in a plastic container.

He told me, "The livers are for your mother."

Maybe he still loves her, I thought. Why else would you give your wife livers?

My brothers drifted in and Dad made them pork roll sandwiches; for me, a grilled cheese on rye.

He seemed all right, in the kitchen of his secret lodge. I relaxed a little and showed him my tattered hat, mentioning the mishap with Michael's gun. Dad did not chastise my brother but rather scolded me. "It's time you learned to shoot."

After lunch, he took me outside. He nailed a dead duck to a piece of plywood, its head hung low. Leaning the crucifixion against a tree, he handed me his shotgun.

"Shoot it," he said.

I told him no.

"Shoot," he demanded.

"I prefer not to," I said, upping the literary caliber of my refusal.

"Pull the goddamned trigger." His face was a hideous rock.

I pulled the trigger.

"Shoot again!"

It was painful. I could feel the power of the gun vibrating through my entire body. I pulled the trigger three more times, watching the buckshot shred the beautiful blue wings. I put down the gun and studied the creature, clotted with blood.

What am I doing? I thought. *I love birds.*

Dad was already gone, back inside, drinking his fill. I put the shotgun down against the barn, went to the bay, and threw stones into the shallow water. Leaning down to look at my own reflection, I hated my life.

15.

For Your Own Protection

THE NIGHTMARES INCREASED. The nightmares were real.

In the hospital in New Mexico, a young neurologist had come by to check on my progress. He was nearly bald but looked no older than thirty. I asked him why I couldn't remember what happened.

"For your own protection," he said—which made no sense to me.

He used the word *shock*. He touched my arm, comforting me about a darkness neither of us could fathom.

That winter, memories of Albuquerque began to filter back. Not just in dreams but during the day.

First I saw mountains, dark peaks looming in the sun.

Then the rusted white truck, the smell of oil and sage.

There was more. I didn't want more.

There was a black bird flying too close, a tear in the picture.

These fragments, which gradually began to stitch themselves together, had an otherworldly quality. The person I saw was both me and someone else—a movie seen from the sky, a narrative disembodied by violence.

THERE IS A BOY *in the back of a pickup truck.*

The truck exits the highway.

A dirt road. It's wrong—I know this immediately.

I'm going to Tucson.

But the truck is going north, going too fast. I'm banging on the window, telling them to stop, to let me out. They won't turn around.

Blank. There's a blank.

Then I'm crying—this part makes me feel sick, even as I write it down forty years later. The man in the passenger seat turns toward me and mouths a kiss. He shows me the gun in his hand.

I know I'm going to die.

The picture wavers, then fails. Only a feeling of doom remains.

The terrible sadness of having to die, of never seeing my family again.

What could be worse? I'm not ready to say goodbye to the people I love.

16.

Sick

MOST MORNINGS, I could barely get out of bed. When my friend Sean called to say we should hang out, I told him maybe next week.

Then a request came I couldn't refuse.

"Hello?" I said, answering the phone, half-asleep at five in the afternoon.

"What—you can't even say Merry Christmas? Hallelujah, brother!"

"Valentine! Are you here?"

"Up the street at Jo's parents'. Do you deserve your Christmas present? Are you an Agent for the Forces of Good?"

"Yes—*I am*."

"Outside," he said. "Fifteen minutes."

In my army surplus jacket, I shivered, nervous about seeing St. Valentine. A big white Lincoln pulled up. Glam in faux leather and ethical syntho-fur, he and Jo wore matching coats and white cowboy hats.

In the car, Valentine lit a joint. "Jo's pregnant again. Praise God! Family is the greatest thing on this earth, Christopher. Never forget that, brother, *never.*"

Jo kissed me. "Your sister says hi."

"Is she here?"

"No, she's in Boston, working."

We drove and then parked in a deserted spot by the river.

"It's red, you know," I said.

"What is?"

"The river. Only you can't see it now 'cause of the dark."

Jo asked if I was joking, and I said no. "There's a chemical company poisoning the water."

Valentine shook his head. "Revelations: 'The second angel poured out his bowl into the sea, and it became blood like that of a dead man.'"

"Charlton Heston?" Jo said.

"Not exactly, babe—that was Exodus."

"Still, it's pretty much the same thing," I said, not wanting Jo to feel dismissed. "It's still about judgment."

"Judge this." From a satchel, Valentine removed a vial of black tar and a tiny glass pipe. He filled the pipe and passed it to me. As he carefully cooked the tar with a lighter, I took a single inhalation—and coughed so hard I could barely breathe. Hallucinations skittered around my head.

"So dude, what do you think?"

I coughed again. "*Uuuuuh* . . . yeah."

"I knew you'd like it. It's my invention. I call it 'the One'—hash oil from the Brotherhood, mixed with powdered pot. Un-fucking-real potency."

Valentine dipped the toy pipe back in.

"I made four hundred bottles. I tried to sell it to the Dead, but Garcia told me it was too strong for human beings. Who cares what he thinks? He's just a junkie. Here, do another hit."

As I inhaled the smoke, everything flashed white, then sparkled like rainbow confetti. Again, I lost my breath coughing. Through my distress, I saw Valentine's smiling face.

"That's enough," said Jo. "I tried it once and I was gone for a day. Plus, I coughed for like three hours straight."

"You get used to it," Valentine said. "So, Chris, wanna take this around to your friends?"

"Sure," I croaked.

He gave me five bottles. "I'll front them to you for a hundred each, but you can get two, at least."

I saw Jo look away, toward the black river that was really red.

"Oh, and I have this." I handed him the envelope. "For Lu. I'm sorry it took so long."

When Jo said I looked too skinny, Valentine winked at me. "I think he looks beautiful. Holy men are always skinny."

ON CHRISTMAS MORNING, my mother asked if I needed cough medicine.

I said I was fine.

The house glittered and glowed. A tinsel tree had landed in the living room, like a rocket. Above the doorways and fireplace were silver bells and daggers of ice. Staring at the metallic splendor, I coughed even more.

Mother touched my head and said I felt warm. "Maybe you should go back to bed. You can open your presents later."

I returned to the basement and took another hit of the One. At this point, I'd been experimenting with it for nearly a week. The tar was incredibly hallucinogenic, but it was also making me ill.

Somehow, dead stoned and coughing, I made it through the holidays and then back to school. Marching down the bleak hallways, I

saw the same old nonsense—boys and girls, zits and tits. There was no escape. I needed to stay high.

I FRONTED A VIAL of the One to Sean, but later he told me he wanted to return it, claiming, *This shit hurts to smoke!*

"No, man," I said. "Your body just needs to adjust."

"That's what the Inquisitor said to the guy on the rack."

I liked Sean's nerdy sense of humor.

Sometimes I hung out at his house, in his attic room. It was a sort of tent, a fantasy of tassels and tapestries. In far corners sat huge black speakers, like pagan idols. Without a word, Sean would choose a record and place it carefully on the turntable.

In that little attic, the Jefferson Airplane came in for a hard landing.

Sometimes, Sean's sister, Darla, would get stoned with us.

"Maybe you should shut the door?" I said, knowing that their father, Mr. Carney, was also the sheriff.

"It's fine," Darla said. "Dad prefers we smoke at home. So, I hear you're interested in extraterrestrials."

"Definitely," I said.

"Well, Sean and I have *a lot* of information. Do you know Gabriel Green?"

"We have all of his newsletters," said Sean.

"Gabriel's the president of the AFSCA."

I stared at them.

"Amalgamated Flying Saucer Clubs of America?" Darla said. "Gabriel goes around the country lecturing and performing past-life regressions for people."

"I'd love to try that," I said. "Sounds intense."

Sean dove under his bed. "Here, let me give you some info."

When I got home, I told Mom I had a new best friend.

"Well," she said, "I'm glad to hear it. Who is the lucky child?"

I was pleased to announce that it was Sean Carney, son of the sheriff.

"That boy you knew when you were little?"

"Yeah. He lives out by—"

"I know where he lives. I'm not sure he's the right choice for a friend, Chris."

"Why is that?"

"Well, there were problems a few years back. While you were away."

"What kind of problems?"

Mom ignored the question. "It's sad you don't see Becky anymore—the two of you used to be inseparable, playing your little games in the basement. Fainting and—"

"That was a long time ago, Mom."

"Sean Carney." Mom sighed.

MY FATHER'S TRIAL had been postponed—and his lawyer was optimistic. Despite Dad's relief, he continued to drink heavily. Without the immediate threat of prison or mob execution, Dad decided to focus on other problems.

Such as me.

One night, I heard the old familiar word, the one my father had favored before I'd left for St. John's. In the kitchen, Dad was saying something about *the queer*.

I crept to what I'd come to think of as my "listening step," the one closest to my bedroom door. My mother was in the midst of some sort of protest, but my father cut her off.

"Norma, just look at him, prancing around like the Queen of Sheba. That little faggot will cut that hair or go live with the queers in New York City."

"Charlie, don't be vulgar. He's fifteen years old. What possible difference does his hair make to you? And if, God forbid, he is a homosexual, whose fault is that? A boy needs a man to look up to, not a drunken slob."

I proceeded to smoke more of Valentine's goo, drowning out their argument with the sound of coughing.

. . .

"**READER, I TELL YOU**: the moon is inhabited, it has always been inhabited!"

Gabriel Green's essay "The Moon Is a Foreign Country" blew my mind. Reading Sean's UFO leaflets in my bedroom was a comfort. I understood that life beyond Earth was entirely plausible. Necessary, even. Why else would God have invented outer space?

Plus, Sean said: "Advanced civilizations are no doubt bisexual."

I needed to escape—to the moon, to anywhere. I was depressed—though, back then, that was a word rarely used to describe the struggles of a child. I was drugged, exhausted, ill.

Mom would let me stay home from school a few days a week. I told her over and over that I didn't feel well. She allowed me to sleep late, then she'd make me lunch. I think she was lonely and wanted company.

One afternoon, we watched TV while she ironed a basket of clothes. I sprawled on the couch, wasted, my long legs draped lewdly across the furniture.

Soon Mom was staring at my jeans instead of at Dinah Shore.

"Chris, what's that in your pocket? Is that drugs?"

"What?"

"Right there, I can see it! What is it? Is it *marijuana*?"

I had a big boner. "Calm down," I said.

She got up and started pointing at my hard-on. "I know you have drugs. Give them to me immediately!"

When she realized she was yelling at my erection, she blushed and returned to her ironing. Grabbing one of Dad's polyester shirts, she began to press very hard with the point of the iron, as if Dad were still inside. The plastic shirt began to melt. The smell was awful.

"Mom, I think you're burning that."

"I should burn everything in this goddamn house!"

I went downstairs and hid.

I'M TOO SICK to go to school became my regular line. I felt lousy.

One morning I heard my parents, upstairs, conferring on "the Chris Situation." I lost interest and went back to sleep. Around nine

or ten, Mom barked my name on the intercom. A few minutes later, my father stormed into the room and pulled me out of bed.

"Get up! You're going to the hospital."

"Why?"

"Boy your age should not be ill. Hurry up, get dressed—we're leaving in five minutes!"

In the car, I was upset. I kept asking them where they were *really* taking me.

Mother tried to minimize the situation. "You're going to like the hospital. You'll find it very relaxing. And I don't care what people say—the food is terrific!"

Over the years, Mom had disappeared for various mysterious treatments.

When we arrived, Dad said he'd wait in the car.

"Charlie," Mom said, "you come in with us. This was your idea."

But Dad refused. He didn't like hospitals.

"I don't want to go either, Mom—I'm not that sick!" Shouting, I began to cough.

FOR THREE OR FOUR DAYS, I'm trapped in the place—defeated and confused.

When the doctors come in to ask questions, I don't say much. I don't tell them I've been smoking enormous quantities of hash oil; that I'm queer; that I'd been abducted and taken to the desert to be killed.

Nurses fly in and out, listen to my heart, take my blood.

When Mom calls, I tell her to bring me a cross to wear around my neck.

She brings me a huge silver one and asks me if I'm afraid of vampires.

I say: *Aren't you?*

At night, I can't sleep with all the weird sounds. At three in the morning, I get up and walk around in my gown. I see shrunken patients disappearing into sheets and pillows. Some of them are strapped

down. I'm walking as fast as I can down the hall—but the hall is getting longer and longer.

"Is this a mental hospital?" I ask an old woman in a gown identical to mine.

"I don't think so," she says. "I think they'd tell us if it was."

An orderly finds me and leads me back to my room.

FINALLY, MOM ARRIVES to take me home. In the car I ask about my test results.

"Inconclusive. Dr. Footer has suggested it's all psychosomatic."

"Dr. Footer is an idiot."

"He's a *coroner*," Mother snapped. "He understands matters of life and death."

"Is this a matter of life and death?"

She looked me in the eye. "You know, you can't be weak, Chris. It will drive you crazy. I think it's time you talk to someone."

"Who?"

"Not me," she said. "A professional. I've already made an appointment with Dr. Hirsch. I'm told he's very good with young people."

17.

Proof

DR. J. HIRSCH, PH.D., received us in his dark, wood-paneled office. After a few polite words, Mom was dismissed and told to return in one hour.

When we were alone, the doctor began bluntly: "Your unhappiness is a given."

He said that his first responsibility was to determine if I was a danger to myself. Point-blank, he asked, "Are you suicidal?"

"No," I said. "But my parents are."

"I'm not concerned with your parents."

Dr. Hirsch was a short, swarthy man who chain-smoked Kool

100s. From a cloud of yellow smoke his face came and went, like the Great Oz.

It was a relief when he asked me to take a test in another room. Five hundred questions!

Are you sexually aroused by fire?	YES	NO
Do you like to wear clothes of the opposite sex?	YES	NO
Would you like to change your gender?	YES	NO

I boldly answered yes to everything, thrilled to admit to crimes I hadn't yet imagined. But after the test I panicked. *What if he gives those papers to my parents?*

At the next appointment, I saw my test results on his desk. Again, the doctor seemed weary, as if I was wasting his time.

"First, you need to know I'm recording this session, to help me diagnose. Do you mind?"

"Are my parents going to hear it?"

"Of course not. By law, our sessions are private, unless you are a danger to yourself or the community." He punched the buttons of a big brown tape recorder on a shelf behind his desk. We had one just like it at home.

"So, Christopher, how long have you been setting fires?"

"Doctor, that wasn't a good answer I gave. I don't really set fires."

"Are you wearing women's clothes more than once a week?"

"No."

"Just the brassiere and panties?"

"What? No! I just put on my sister's lipstick a couple of times— but just for fun."

"Okay, so can you tell me why you want to be a female?"

"I don't. Really—I don't."

"Then why would you say that on your test?" He blew smoke into my face.

"What I meant was that if I were a girl I could have sex with boys."

I was amazed to have admitted this. I felt an alarming heat move from my belly up to my head.

"So, you have homosexual fantasies?"

"I guess, yeah. I like boys. I mean: *I like girls, too.* You're not going to tell my parents about this, are you?"

"Only if you're in danger. Chris, you've indicated that you take illegal drugs. Is *that* an accurate answer?"

"Yes. I do. Sometimes."

"Mari-*juana*?"

"Yeah." I didn't mention anything else. I wished Donna were there to defend me.

"Well, that has to stop immediately. If we're going to work together, I insist that you never take any illegal drugs again, whatsoever. No drugs—unless I prescribe them. All right? In my opinion—you're a very sick young man."

"Doctor, I'm not sure I'll be able to keep seeing you."

He raised his eyebrows. "And why is that?"

"I'm hoping to go back to art school. If I can convince my mother."

"That's not going to happen. Your mother mentioned this *art* school. I think that was part of the problem. Right now, you need the support of your parents. In my opinion, leaving the safety of home would be a disaster for someone in your state."

"Less of a disaster than being killed by my father?"

"Why would you say that?"

"My father pulled a gun on me."

"Is that another one of your fantasies, Christopher?"

Oz leaned forward and gazed at me through the smoke.

"Your mother told me about your delusions."

I CONTINUED to follow the *Ten Talents* Bible cookbook, hoping to create health and order. Taking refuge in my mother's hygienic kitchen, I would bake in the evenings. When Donna called late one night in February, I was making a cashew casserole. She told me she'd just got back from "a delivery."

It was great to hear her voice. I told her about Mom and Dad's ongoing war, but she didn't want to hear it. Like Mom, Donna was an expert at changing the subject.

"I got high with Grace Slick!" she said. "I was at the Family Dog with Lu. She had on a policeman's uniform. Some guy with long fingernails kept touching me, and Grace told him to fuck off. I really liked her."

When I suggested visiting Tucson again this summer, she said, "Oh, we're not in Tucson anymore. We're in California now. With Lu and Jingle. We're working from here."

"You're in California right now?"

"Yup—and guess what? I'm pregnant!"

I wasn't sure why the news didn't make me happy. "That's great," I said.

Donna thanked me for sending her money and told me that she'd just seen Flow Bear and that he had something for me. "He said he had a great trip with you last summer. Isn't he a riot?"

When I said he drove naked, my sister exclaimed, "Such hairy balls!"

We laughed and exchanged our love. I wanted to tell her about the hospital and Dr. Hirsch. But I just hung up.

IT WAS a cold spring.

There were still patches of ice along the river, pink as stained glass.

Flow Bear called and said he needed to see me. I hadn't talked to him since we'd driven back from Tucson. I wondered if he was naked while speaking to me on the phone.

That Saturday, when he pulled up in his old Chevy, I was waiting in the driveway. Like an emissary from a barbarian planet, his beard was long, tangled as smoke. From inside the blue spaceship, he nodded. I jumped in. We shook hands.

I was excited, wondering what he had for me.

"Let's go for a drive," he said.

I guided Flow Bear out into the Pine Barrens, the land slipping slowly from township to forest. I watched for a break in the trees, for a road to the creek, to a place I knew.

"Turn here! Turn here!" I screeched, and Flow Bear turned serenely, ever mindful of his magnificent car. In a clearing, between

piles of garbage, Flow Bear parked with great care. He looked over at me, as if I could explain what we were doing there.

"This direction," I said. "If you want to hike or something."

He told me to lead the way.

I got out and found a trail into the brush—Flow Bear walking behind me in a bearish black coat. We walked along the edge of an old cranberry bog. An icy wind pushed against us.

At the broken dam, I stopped. "This is it."

The creek was very high, surging against the timbers. We sat on an ancient plank, not far above the water. I got out my vial of hash oil.

"What the fuck are you doing?" Flow Bear said.

I told him it was the One—from Valentine.

"I know what it is. That shit is poison."

I was confused. "Don't you work for him or something?"

"No. Not everybody works for that prick. I work for myself." He took the bottle from me and read from the label. "'Made by Magician Alchemists . . . smoke the divine essence.' This guy is *so* full of shit."

I wanted to defend Valentine. "Well, I believe in God. I believe in . . . hope."

Flow Bear turned to me, a huge grin on his face.

"What?"

"Nothing. You're just adorable." He laughed, putting his arm around me. He pulled closer and kissed me hard, his beard cutting my face. I coughed and spit, pushing him away.

He grabbed me harder, crushing my ribs. I screamed.

When he let me go, I felt both frightened and foolish. *Isn't sex what I wanted?*

Flow Bear was already walking back to the car. I followed the shadow of his black coat in the falling dusk. On the drive back, I said I was sorry for screaming at him. I told him I hadn't been feeling great.

"Stop smoking that crap, okay?" He patted my cheek. "If you ever feel like expanding your repertoire, you know where to find me."

I wasn't sure if he was talking about drugs or sex. I knew he did cocaine and lots of other weird drugs. In my parents' driveway Flow

pulled a bag of blue pills from his coat. "Your sister asked me to give you these. She's on a run."

I wanted to tell him again I was sorry. But before I could speak, Flow Bear licked his finger and stuck it in my mouth. I was completely freaked.

Smiling, he said, "Get out."

BY SPRING OF '72, Dad had slipped into some *very* deep sauce.

Old friends drifted away, replaced by folks who enjoyed vodka for breakfast. Dad was often found with Barton Tyson, a rich hick with orange hair and lemon leisure suits. Barton owned heavy equipment and various pinkie rings. The two of them were always blotto, a blur across the land.

I didn't understand the appeal of alcohol. To me it seemed like a bogus high, briefly pleasurable, then clumsy and dull. And for some reason it made people mean. After a drinking binge, Dad always came home angry—very angry. He'd walk in the door ready to attack. And the more vicious he was, the less he remembered the next day. *Do blackouts make him innocent?* This philosophical question troubled me to no end.

That year, Dad terrorized the whole family, but the weight of his drunken rages usually fell on me. I was an easy target, the skinny freak in the basement.

Boy or girl? was his new question. *Is he a fucking boy or girl?*

Sometimes I couldn't believe what he was saying. He called me a cunt.

One day, I remembered that we had a tape recorder like the one Dr. Hirsch had. In a flash of inspiration, I took it from the closet and put it inside a gym bag. At around six o'clock in the evening, I hid it in the corner of the kitchen—hoping that Dad would perform. He'd been ferocious for nearly a week.

Not ten minutes later, his car pulled in the driveway. From the slam of the door, I could tell he was drunk. I turned on the recorder and ran to the basement—locked my door. The moment my mother saw him, the bickering began.

Booze! Adultery! It was all on the menu.

And then the topic turned to me. My hair, my voice, the faggy way I walked. In the coarsest language, my father described various sex acts I performed—things I'd never even *heard* of.

"You know what, Norma? I ought to break his goddamn ass—that's what he needs. Why don't you come up here, you little cock-sucker? I know you're listening."

At that, he clomped down the stairs and started kicking in the door. Mom was screaming, trying to push him back. I cowered on my bed, terrified. All I could think was: *Please don't let him find the tape recorder!*

Then, as often happened, they both went silent.

I kept the lights on all night.

IN THE MORNING, Dad was nowhere to be found. I retrieved the gym bag and discovered that the recorder had captured his every word in perfect fidelity.

This frightened me, since I often doubted the reality of his rages. I'd see him the next day, sober, sipping soup at the kitchen table, quietly eating a saltine, and I'd think: *It must all be a mistake. Look, he's just a man sitting at a table eating crackers. He's okay—isn't he?*

Now his madness was recorded—and undeniably real.

When I told Mom about the tape, I was careful. I was afraid she might become furious, might destroy the tape without even listening to it. I insisted my sister Kathy be present when the tape was played. I didn't see Kathy very often, but I trusted her; she was loyal and old-fashioned—a mother and a housewife, on her second marriage. Our love for each other was neither complicated nor passionate; it was just a fact.

Kathy arrived at four, in a hot-pink pantsuit, her dark hair in a flip ten years out of style. She sat down with Mom and me out on the patio—a warm spring day. Kathy grabbed an ashtray, lit the first of seven cigarettes. Mom was so afraid Dad might suddenly show up, she could barely sit still.

"I feel like a criminal," she said, shaking her head. "Oh, Chris." I could tell she was a little mad at me.

When Kathy pressed the on button, we didn't have to wait long for my father's voice to come out of the tiny plastic speaker. The sound was brutal and clear. On a sunny afternoon by the pool, his words seemed even more outrageous than they did the night before.

Kathy began to cry. Mom, too. I refused to shed any tears, but my whole body shook.

"He sounds *insane*," Kathy said.

We listened to more. My mother covered her mouth, as if my father's words were coming from her.

Kathy clicked off the device. After a while, she said: "Divorce the prick."

Mom was crying in earnest now. "I can't. If I do, I'll have nothing."

I wanted to say, *Mom, you'll have me—you'll have me and Michael and Steven and Danny.* I thought of the day the two of us had gone to New York City, waving and laughing from the deck of a ship as confetti poured down from the sky.

"You have to leave."

I thought it was Kathy bringing up divorce again—but when I looked up, it was Mom, talking to me.

"You have to leave before he kills you."

PLANS WERE MADE quickly, without my father's involvement.

In a month, I'd be sent to California, to live with my sister. "You'll finish high school out there," my mother said. "I'll send Donna money."

I didn't argue. But I marvel now at my mother's naïveté, shipping me off to live with the ex-cheerleader turned drug smuggler.

When I went to say goodbye to Sean, I didn't mention my father. I don't know what I said—probably a lie about helping Donna or some art school out west.

Sean's sister, Darla, barged in and insisted on doing my "cards"

before I left. She lay out the tarot on Sean's bed—pictures of colorful characters and cosmic symbols.

"Interesting." She pointed to the center card. "Knight of Cups. Noble, romantic, intelligent."

Was she flirting with me? "What else?" I asked.

"Well, this card means you'll fall in love—tragically, though—but I wouldn't worry because of *this*." Her long nails clicked on the card that crowned the arrangement. "This is really the luckiest card. Number zero. The Fool."

I laughed, said, "He's walking off a cliff."

"That's true," said Darla, "but the thing is he doesn't *know* what's up ahead, he doesn't *know* there's a cliff, so when he falls he won't get hurt."

"He's sort of cute," said Sean, studying the symbolic boy in golden boots.

Darla grabbed her tarot study guide and read aloud:

"'The Fool is the vagabond, falling into the material world. Key words: *faith, folly, innocence*.'"

PART III
THE FOOL

18.

Marin

FATE IS A CRAZY BIRD, swooping down from heaven.

I'm in a helicopter—it's inconceivably loud. Out the porthole, I see a blue bay and a tiny island. It's Alcatraz, but I don't know that. I barely know where I am. Across from me sits an angelic blonde woman, her lavender gown falling to the floor. On her lap rests a black attaché case and a Bible. She keeps smiling at me.

Why am I so afraid?

That morning, I'd left my mom crying at Newark Airport and flown to San Francisco alone. Bounding across the terminal, I boarded a helicopter for Sausalito. At any moment, my new life is scheduled to begin. I feel like I'm falling in space.

Vinnie and Donna are on the tarmac, waiting to catch me, crazy-waving as the copter touches down. In tears I run to my sister, throw my arms around her.

Then the lavender angel taps me on the shoulder.

"Don't you remember me, Chris? I couldn't speak to you while we were flying—all that noise."

I recognize her now. It's Lu's wife, Jingle. She kisses me on the cheek.

"I can't believe you guys were on the same flight!" Donna embraces her.

"It's a sign," Jingle says. "Arranged On High."

She disappears into the crowd with her attaché case and Holy Bible.

It's June 1972. I'm sixteen.

AS VINNIE DROVE toward home, I took in California—giant oaks lolling across the hills, like umbrellas in the sun. The heat was fierce, the air soft, the smell of the ocean riding on the breeze.

Jingle's attaché, I learned, was full of LSD, fresh from a lab in San Francisco. Donna knew this because she'd be flying it back east. "A quick eighty thousand hits to Boston. Piece of cake."

"But can you do it—like that?" I pointed toward her bulging stomach.

"With the baby?"

Vinnie said, "Dude, it's the best disguise ever!"

I kept staring at the mound inside my sister's peasant dress, big as a planet. She was almost seven months pregnant. What a lucky kid, I thought—to have such a great mother. Donna turned toward me in the backseat and showed me the bag of asparagus she'd bought for dinner. "Look how purple it is! Everything in California is *so* psychedelic!" Donna's smile was a ray gun of love. I felt safe. I trusted her.

I trusted her asparagus.

. . .

OUR RENTAL SAT at the back of a tiny woodsy valley, a rambling maze of add-on rooms, homemade furniture, and junk.

"Wow," I said. "You've got a lot of stuff."

"Oh, most of it's not ours." Donna explained that the people they'd rented from had gone off on some adventure. "They just left everything where it was."

"We didn't need to buy *anything*," Vinnie said proudly.

My room was downstairs, and dark—the lair of the owners' teenaged son. I could smell him faintly in the blankets as I drifted off to sleep—the smell of pine and sweat. I slept well, that first night. No nightmares for once.

The next morning, Donna and I sat on a deck overlooking the friendly umbrella oaks. We drank lemonade and talked. The sun was already hot and Donna took off her top. Her breasts were huge. I was not yet comfortable seeing my sister naked—and pregnant.

She asked me how everyone was.

"Oh, fine," I said, trying not to look at her. "Danny just got his first crew cut. He looks like Mr. Magoo. And Michael and Steve are on the same soccer team—*rah*."

"And Mom and Dad—are they still on the same team?"

I shrugged. "Did Mom tell you about the tape?"

"What tape?"

I felt hurt—knowing Mom had, of course, said nothing, wanting to protect Dad more than me. I wondered what she'd told Donna about my coming out here to live.

When my sister asked again what I was referring to, I said, "Oh, it's not important." She already knew enough: that there was trouble between me and Dad. She didn't need the ugly details. I knew that Donna was like Mom; she didn't like to talk about anything sad.

It was okay. Sitting there, among those trees, drinking lemonade, I thought to myself: *California is the opposite of New Jersey.* I knew that Donna understood this, too. When I glanced at her breasts, I burst out laughing.

She laughed, too. "So, Mr. Vegetarian, what do you like to eat?"

I told her I really liked bee pollen.

"Well, we can't afford that."

"Isn't Mom sending you money to let me stay here?"

"Twenty-five dollars a month. Do you believe it? We'll get some avocados."

Vinnie came outside to stretch. He was naked, too. "We should go soon," he said. "Lu wants to see Chris."

"Why?" I asked.

"Because you're part of the team, man."

When Donna said "I guess we better get dressed, honey," I was relieved.

THE HOUSE OF LU was just up the street. To get there we walked up 237 steps (I counted). It looked like a witch's cottage. On a hillside, beneath a stand of thousand-year-old redwoods, the house stood in perpetual shadow—a shadow that smelled of mushrooms and chimney smoke.

Jingle answered the door in calico and clogs. She hugged my sister. "Darling girl, blessed with child! Come in. Come in. Vinnie and Chris!" Kisses were distributed. "Companions in Christ! You must rest after that terrible climb. In, in you go!"

Jingle guided Donna across the threshold as if my sister were crippled. In the living room Lu, the real cripple, was sitting with clients. He looked deeply drugged—though he was instantly up on his crutches.

"Chris, you're here! Come on—join the family! Sit down. Get high!"

I was embarrassed by how nice he and Jingle were, but managed a shy smile.

I'd forgotten how tiny and strange Lu was. Legs shriveled, black hair to his waist, head too big. He was dressed in white, gauzy and celestial, with beaded moccasins and a silver cross around his neck—the cross more pirate than Pope. He turned to the men in the living room and introduced Donna and Vinnie as his *dearest friends*. "Christopher, too."

I barely knew Lu. I knew that he was Valentine's partner and blood brother; that together they ran a smuggling network that

delivered pot and acid across America. I also knew that Valentine was back in New Jersey, running the East Coast business from some blanket on a beach.

As everyone chatted in the dark house, I was unsure what to do or say.

I looked at Lu's cross and took my own crucifix out of my shirt.

Jingle noticed and winked.

Lu's guests were Bob and Toby. In boots and buckles and a blousy shirt, Bob looked like Wild Bill Hickok. Toby, in braids and brocade, resembled a girly Genghis Khan. The room's décor was calm and conventional: a large couch, a teak coffee table, a clock ticking on the mantelpiece. It could have been my parents' house but for the small castle of black hash stacked on the floor. Lu filled his calabash. He said to Bob and Toby, "Let's continue with Afghanistan."

Obviously, Bob and Toby were dealers, sampling the goods. When the pipe came to me, I crossed my legs and inhaled slowly, attempting to appear professional. I knew immediately it was the strongest hash I'd ever smoked. Soon, the flames in the fireplace flickered like goldfish in an aquarium.

Lu was in command of my brain now, and I surrendered.

Donna had explained to me that the whole country was getting high on Lu and Valentine's dope. Marin was now the center of their West Coast operation. By fate, I had joined the business.

Wild Bill Hickok pulled out a knife. "We'll need a sample for our people."

"Take whatever you need, brother."

A fat slab was cut in two: black on the outside, green on the inside. The larger half went into the man's saddlebag.

Donna said, "Oooh, that smells *so* good—like Christmas!"

I relaxed. I watched the fire and spaced out, knowing my father could never find me, here among the pirates.

AS DONNA AND VINNIE'S oversized foster child, I was privy to every aspect of their naked, sunny life. I adapted quickly, though it took me a few days to finally strip. After breakfast, we all smoked reefer,

and in the afternoon, hashish. Donna made us fruit salad, guacamole, jars of sun tea.

We only had six albums and Vinnie played them over and over. The Allman Brothers, Dan Hicks, two Grateful Deads, Cat Stevens, and a solo Mama Cass.

I thought *Tea for the Tillerman* was secretly sad, especially when Cat Stevens and my sister sang at the same time: *But tell me, where do the children play?*

Donna, seeing the tears in my eyes, said, "What's wrong, baby?"

"Nothing," I said. "I'm just happy."

It was summer, and I felt safe in our tiny world, the same songs repeated day after day like prayers. I rarely thought about home or high school.

When the music faded, I'd listen to the afternoon breeze, to the wind chimes clattering like signals from space. I drew pictures, cheated at solitaire (as taught by Mom), and picked flowers in the yard. And when, in the glorious California heat, I closed my eyes, I slept deeply, without dreams. Nothing could disturb me.

I could forget.

Donna and Vinnie were my family now.

In our little house, we rested, waiting for the baby.

IT AMAZES ME to think that, at that time, Vinnie was only twenty-one, a child. In my mind, I see a bearded man, dancing with my sister in the living room, or swinging naked in the hammock, ticking off baby names. ". . . Abe. Acre. Acorn. How about Acorn, Donna? Is Acorn a good name?"

"Acorn?"

"Yeah."

"Boy or girl?"

"Could go either way."

And when we got bored, we simply followed the trail of smoke leading up the hill. At Lu and Jingle's house, someone was always getting stoned. The youngest person there, I mostly remained quiet,

listening politely to the adults. Conversation centered on one of three things: drugs, Jesus, or music. Jingle often called us to prayer, directing her special gaze toward me as she said, *Help us, guide us.*

As prayer drifted into work, Donna would often confer with Lu about plane tickets for her next run. Sometimes, I'd help Vinnie bag up buds or spoon LSD powder into capsules.

And sometimes, I'd snoop around the house. As a team member, I was allowed to wander wherever I wanted. "Take a nap on the big bed," Jingle would say. "I put lavender oil on the pillows."

One day, in the laundry room, I found a Pyrex beaker full of black fuzz, growing like the Blob—very mad scientist. I asked Lu what it was.

"The lab gave it to me. Psilocybin spores." We looked down together into the beaker. "They're *alive*," he said reverently. "We haven't figured out the dosage yet. Wanna try it?"

I carried the beaker into the kitchen. Everyone looked at the fuzz, and then Jingle handed Lu a spoon. He dipped it into the beaker and scooped up a lump of black goo covered in white hairs. "Open up," he said to me.

I took it in with a grimace—though really it wasn't so bad.

Within five minutes, my mind had disintegrated.

I ran outside, into the redwoods, and collapsed. For several hours, I was gone, my mind traveling to places my body could never follow. Endlessly odd things passed by: *the orchid homunculus, his stained-glass wings, his various trumpets . . .*

Stumbling back inside, I had sticks in my hair. Lu saw me and laughed.

"So, how was it, cowboy?"

"It was blue and violet. It had a definite sound . . . it still sort of does."

"So, it was good?"

I nodded, then asked for more.

Donna said, "Not until you've eaten dinner. Go wash your hands."

After brown rice and seaweed, Lu fed me another spoon of slime for dessert.

Soon, the elves returned, with their trumpeting trumpets—*and a net of stars*.

WHEN WE DROVE to Point Reyes, to see the ocean, I was dazzled. California was the end of America, where the continent slipped under the sea. One could go no farther. It was the place to collect one's dreams and make something of them.

The fantasy of Haight-Ashbury had collapsed into violence. But across the bay, in Marin, there was peace. People were getting back to nature. It was a good scene. At Lu's, I met yogis and junkies, trust-funders and bigamists. Rock stars lurked like lemurs in the trees.

And Lu sold to every one of them.

One evening, he had to deliver product to a nightclub and asked if I wanted to join him. I looked over at Donna, who said, "Yes, but wear shoes, in case there's broken glass."

Donna and Vinnie had Lamaze class and couldn't come.

Lu and I went off in his VW bug. He drove surprisingly well, shifting with his crutches while nursing a joint. Of course, he had no license.

At the club in San Rafael, the doorman waved us right in, the midget and the tall kid who looked eleven. Lu knew everyone. When he walked toward the green room, the bouncer stepped aside. I stayed behind Lu as he entered the backstage area and began to chat with some old guy. I could see some people in the corner passing around an oxygen mask and taking turns huffing something from a big blue tank. When I turned to ask Lu what they were doing, he was already gone. I stood against the wall, watching people laugh and drool and wobble away from the tank.

The dude next to me said, "Go ahead, man. It's laughing gas."

His eyes sparkled under a mop of brown hair. It was Jorma, the guitarist for the Jefferson Airplane. Before I could say one freaked-out word, he snagged some chick in a tube top and started making out. Over at the tank, some woman had the mask and wouldn't let go. When a man finally yanked the mask away, she collapsed onto the floor. A bouncer dragged her to a couch.

Since the mask was free, I went over for a turn. I put it on and turned the tank's valve. The gas tasted sweet, like snow, like winter.

And then I couldn't feel my face.

Someone tapped me on the shoulder. From far away, I heard a voice: *Who the hell are you?* It was a very interesting question.

Some guy pulled the mask from my face. "Get the fuck out of here, kid. *Now!*"

The bouncer pushed me out the door.

Lu eventually found me, handed me a doob. When the band came on, I danced like I'd only ever danced alone in my room. Wild dancing for the whole world to see.

The next morning, I started yapping about *the club*—announced that I had done laughing gas with Jorma. I didn't mention the unconscious woman, slobbering on the floor.

Vinnie frowned. "Nitrous oxide is not a sacrament."

He looked toward Donna for support. She frowned, too. "Chris, I'm really disappointed you would even think of taking an anesthetic to get high. Do you think that's something God wants?"

"It's just laughing gas. Jorma was doing it."

"Oh, so Jorma is *God*?"

Hell, yes! I wanted to scream.

"Chris, you're my responsibility now. And I have to ask you to respect the rules of this house."

"Amen," said Vinnie.

Donna lit a joint.

OFTEN IN LU'S LAP there'd be a large wooden crucifix. Holding it up for all to see, he would touch the nearly nude figure of Christ and then yank His head. At that, the front of the crucifix would slide off, revealing a hidden compartment.

Inside was what Lu called *the Glory.*

It was his own personal stash of pills and pot—the best of the best.

I loved Lu's crucifix. It was macabre—the hollow cross had once held unguents for the dead. I knew this because a very similar cross hung in my parents' bedroom—containing candles and vials of oil

and holy water, to be used in the ritual of extreme unction, or last rites. As a child, whenever my mother would catch me playing with the equipment, she would say, "Are you dying? If you're not dying, then put that stuff away."

Seeing Lu's cross always made me think of my parents—that they were still alive, but that one day they would die. I wondered if that would make life better or worse. The question baffled me.

Like my father, Lu was a devout Catholic. The stash-cross was not meant as sacrilege. Though his drugs were of no use to the dead, he saw them, as Valentine did, as something holy. Listening to Lu, I sensed he was the true believer, while Valentine was more of a divine salesman.

On Sunday mornings, Lu would drop acid and go to eleven o'clock mass with Jingle. He told me that he often had visions of Jesus. After church, Jingle would make a big salad and say, "He's in the room right now. *Chris, can you feel Him?*"

My answer was always yes.

I believed everything. Believing made me happy.

19.

The Barbizon School of Drug Running

EVERY WEEK OR TWO, my sister would leave on a run.

For Donna, smuggling was a performance. Her Barbizon training came in handy. She dressed as if she were preparing for a *Good Housekeeping* photo shoot. Wearing her Sunday best, she was the young mother, flying home to visit *the folks*. Seeing her in ribbons and bows, I'd gasp. She was *so* convincing in Mormon drag.

This was the early seventies, before the era of X-ray machines and increased security, when massive amounts of dope moved through the airports. The cops were clueless, harassing hippie types, while clean-cut drug runners walked on by.

A seasoned professional, Donna required a new ensemble for each run. Since money was tight, she and I would hit the thrift stores of Marin County, searching for something special, something that whispered, *Utah*. At the racks, I might shun a dung-colored maternity skirt, but not my sister—she saw the possibilities. Add low pumps, ruffled blouse, and plastic purse, and suddenly Donna was someone else. It was magic. Back at home, chemicals were applied: hair spray, makeup, perfume.

Time was obliterated. Donna looked and smelled like 1954.

In the morning, a taxi would take Donna away, with someone else's baggage, in someone else's clothes. Donna liked to begin her performance right away, starting with the driver. When asked if she was married, she'd answer, *My husband is fighting in Vietnam.*

I tried not to worry. Donna told me that people were kind to her when she traveled; someone always offered help. No one ever thought of hash or cash as they dragged her bags across the airport. They thought of a pregnant girl on the verge of widowhood.

Maybe she enjoyed being someone else for a few days, someone she might have been had she finished college, never met Vinnie or Valentine.

Of course, it wasn't just a game. Despite the fun of dressing up, Donna took her job seriously. She knew, as we all did, that a drug runner could get busted or even killed. But she refused to be *negative*. "God will protect me and my baby."

While she was gone, the house was quiet. Vinnie drank beers and moped. He hated to cook, and we ate a lot of sandwiches. Sometimes I wondered why Donna had to do what she did, why Vinnie wasn't the one doing it—or at least doing some kind of job so that my pregnant sister could stay at home.

But that seemed a small-minded question, and so I kept my mouth shut. I knew that Vinnie loved my sister, and that he was as concerned as I was.

I'd heard Lu tell Donna, "Make sure you smile a lot. And if anyone asks why your bags are so heavy, say it's books—that you're in school." He also gave my sister a special phone number to memorize should anything go wrong.

In some city, in some hotel room, my sister would sit on the edge of a big bed, waiting for the phone to ring. People would come by for her suitcases—men from Lu's crew—and then, if everything went well, they'd return a few hours later with a pile of cash. She trained herself to stay calm until everything was completed. When I asked her what she did, she said she watched TV or washed her undies in the sink.

In the morning, she'd tape the money to her body, get dressed, and fly home.

When she walked in the door, I would nearly cry with relief. She'd kiss me, then hand Vinnie the envelope with her pay before going into the bedroom to change her clothes.

Vinnie would carefully count out the money. The first time he did it, I was stunned. After flying home with fifty grand, Donna's pay was only three hundred dollars.

Both she and Vinnie thought it was *generous*.

OFTEN, WHILE MY SISTER WAS AWAY, I'd visit Jingle: simple and righteous in purple-tint granny glasses and pioneer frock. I loved going up the hill to see her, but I wonder now what she must have thought of me—this jittery, clod-hopping boy. If I knocked over my juice, which I often did, she'd stare at me, slowly saying, *What were you thinking, Chris? Was it a sinful thought? Yes, I thought so. Come on, let's say a quick prayer . . .*

After a little Jesus-mumble, she'd pour me another glass.

Secretly, I adored her—her hymns, her prayers, her praise. I felt protected by her steadiness. We all did, I think. Strangely, Jingle never took drugs, though she believed in their power to transform. Jingle was already transformed. Donna told me she'd once been a Seventh-Day Adventist, but left the church to marry Lu. Her love for him was fierce. I could feel it like a flame.

I knew that this was not the kind of love Donna and Vinnie shared, which seemed both respectful and bland. Lu and Jingle's love was more like my parents'—wild, weird, fanatical. But, unlike my parents, Lu and Jingle had no children yet—which seemed to

intensify the drama. Once, when Lu came home from a particularly dangerous mission, I watched Jingle fall to her knees and hug her husband's withered legs.

DRUGS AND LOVE and business.

I spent hours at Lu and Jingle's, learning about life.

Clients dropped by constantly, a joint endlessly circling the room—a joint I was now deputized to roll. I was the mascot, I suppose—the smooth-faced kid who made the madness seem sweet.

The dealers were often fearlessly costumed, some arriving in robes and turbans, some in overalls and ten pounds of turquoise. The mystic espionage drew me in. Often I braided my hair and rolled it into a fuzzy crown. From the sidelines, I watched, carefully studying how all manner of product was measured and sold.

But I *never* saw the money. The cash was always offstage. As with sex, there was a mysterious silence surrounding the subject of money. The real deal always took place in another room, the curtains drawn, the door locked tight.

I wondered if they were ashamed.

No, I would understand later, when I'd become a dealer myself.

The truth was that the money was dangerous, much more dangerous than the product. People were killed for cash, not so much for a bag of LSD.

Lu was a sly businessman.

He made it all seem like a party: free drugs, free food, beautiful home, beautiful wife. Everyone said, *He's a good-karma dealer.* The scene was, in some ways, similar to life at my father's table: clients sucking down his scotch, everyone talking at once.

And, like my father's, Lu's income was a mystery. At the moment of payment, Lu would drift to a back room with a client, just as Jingle brought out hot kelp nuggets for the rest of us.

The phone rang often. Sometimes it was Valentine calling about business. As Lu's partner, he was handling distribution of loads back east. I missed him, and always hoped he'd say: *How's Chris doing? Put him on the phone!* Of course, that never happened.

Anyway, Lu didn't like the phone. He was always worried his lines might be tapped and made somewhat batty attempts to speak in code. This never seemed terribly effective.

So . . . Tyrone liked the squash . . . No, not the pumpkin pie, the squash, like last time . . . Listen to me, remember the squash in the teepee, with Buffalo and the Jew?

In Marin County that summer, while listening to men in Halloween costumes talking gibberish, it was impossible to remember that drugs were illegal. Lu and his clients went boldly about their business, grinning like clowns, while Jingle sang hymns.

What I didn't realize was that these clowns—Lu and Valentine included—were becoming multimillionaires, while I packed product for free.

After the dealers were gone, Lu would shut down, go silent. I'd see him in his chair, feet not touching the floor, face in pain. "His afflictions are terrible," Jingle would tell me, cleaning his crutches with a cloth. I would think of the brace on my father's leg. But what was a drunken car wreck compared to the curse of polio?

Sometimes Lu would mumble the rosary like an old man, alone in church. He seemed to bore inside himself and disappear into sadness. Of course, I believed in Lu's sadness, as I could not believe in my father's.

And Lu was always gentle. He never leapt at his loved ones like an animal. Instead, he'd rise slowly from his chair, grimacing in pain—and to whomever was in the room he'd say, "Onward."

LIKE MY SISTER, I was expected to help the cause and pitch in.

One afternoon, Lu took me into the back room and pointed at five or six cardboard boxes. Told me to open them up. Inside were a couple of hundred pounds of hash. Lu said it all had to be unwrapped, taken out of muslin, properly weighed, and placed in Ziploc bags. I asked him where it was from.

"Kabul. Hidden in VWs, shipped by boat."

"By who?"

"The Brotherhood."

From conversations with Valentine, I knew that Lu was talking about the Brotherhood of Eternal Love, the international drug-smuggling syndicate. I adored their name, and began to imagine my own glamorous future.

I was happy to work for hours, putting hash on a triple-beam scale and recording the weight in a tiny notebook. I studied each black block, inhaling its delicious scent, trying to figure out how on earth it was made. Some of the bigger slabs were stamped in gold rectangles—tribal symbols, with swords and stars. Somewhere in the Hindu Kush, an Afghani boy had prepared this hash for sale, much as I was doing. I imagined he and I were brothers of eternal love, helping the world get high.

There was no moral confusion. I never doubted our right to get stoned and sell drugs.

At sixteen, I completely believed in the power of dope. While my brothers were in New Jersey eating candy and watching television (things forbidden in Donna's and Jingle's homes), I was eating acid three or four times a week, watching my own visions—and watching those visions blur into the visions of my companions. There was no candy, no television show that could ever compete with what these chemicals could do.

Sometimes in my room at Donna and Vinnie's, I drew for hours, and in my fantastic landscapes I often added a new figure. There, on the roiling hills, under the sea-creature skies, stood a boy—only a tiny speck, but if you looked closely you could see that he was smiling.

It was me.

IF JINGLE WAS OUT, sometimes I would help Lu get undressed for his afternoon nap. I'd seen my mother undress my father when he was drunk—but it was nothing like that. There was no drama between Lu and me. Only simple kindness.

Lu told me about the illness he had as a very young child, and how he'd spent his entire life on crutches. In his bedroom, I would

help him take off his white jeans. His legs were no wider than his wrists and would flop about meaninglessly.

Once in bed, he'd say, "Thanks, Chris, wanna smoke a J?"

I always said yes, and often in the middle of our reverie, Lu would look me in the eye and ask me how I was. This question, I could see, was real—he *really* wanted to know—and it would thrill my heart.

"There's no shame in being sad," he said.

"I'm not sad," I said. "I'm just wondering about things."

Once I asked him, "What's the greatest trip of all?"

"The greatest trip," he said, "is this, right here—*life*."

I smiled. "Then what about the greatest drug?"

"Acid, of course. *My* acid. But it's pointless, really, unless you take enough. It takes around ten hits to really break through."

"Break through what?"

"The ego, into the light."

"What light?"

"Inside the buzz is the white light. And inside the light is the void."

Lu was already falling asleep.

"Don't worry," he said, "you'll find it. You're a good kid."

JINGLE INSTRUCTED ME, TOO. Sometimes, when I brought a book to her house—*Cat's Cradle* or *Naked Lunch*—she'd put it away and say, *That's not what you need*. She would sit with me and tell me about the Bible—about the Bible and UFOs.

"Have you seen the ships?" she asked me. When I told her I hadn't, she said she felt that I would, at some point. She sensed that I was *open to them*, to what she called *angelic energies*.

I asked her if she'd seen flying saucers, and she said, "Yes, I've seen the lights."

"What do they want from us?"

She told me that was the wrong question. "What do *we* want?" she said. "What do *we* need?"

I nodded, knowing the answer had something to do with love, which according to Jingle was the mystery of the blood, the reason we were born. She was not soft about these things; there was a righteous severity to her sermons.

Whenever she said *Love is the law*, there were swords in her eyes.

Of course, conversations about UFOs and angels could easily shift to forbidden foods or footwear, especially if I was wearing my sneakers.

"What did I tell you, Chris? Rubber cuts off the Earth's emanations. Sneakers can cause serious illness. Take them off right now."

I did so, gladly—happy to be a part of the bubble-world of Lu and Jingle, Donna and Vinnie. Barefoot, by the mescaline fireplace, I forgot to be afraid.

I forgot my mother, my father, my own dreams—whatever they were.

No one asked me, *What do you want to be when you grow up?*

The future was irrelevant, we were living in the now, moved to tears by sunsets, hashish, and the miracle of asparagus.

OFTEN, IN THE SUPERMARKET, my sister would be moved to tears by the *price* of asparagus. Several times that summer, I watched her break down and sob at the checkout line when she found out she didn't have enough for our groceries.

Her payments from Lu, combined with the twenty-five bucks Mom sent every month for me, were not quite enough to keep us going in semi-chic Marin. The rental house was overpriced. It was a hot summer and the baby needed AC. "I can't believe this electricity bill!" Donna would say, just like my mother. Vinnie still wasn't working—only odd jobs for Lu, for which he was paid with product.

Donna wanted nothing more than to get away from my parents. She was against conformity and materialism. But now she had a baby on the way, and for the first time, I saw the worry in her eyes.

. . .

WE MADE THE BEST OF IT. It was too hot to eat much—and who needed new clothes when it was a hundred degrees?

Vinnie told me, "Clothing is a lie."

Donna said, "Use coconut oil, you'll get a beautiful tan."

In our backyard, past the flaming dahlias, I was encouraged to bake my nude and skinny body. The California sun darkened my flesh and turned my blond hair white as it had been when I was little; it was now so long Jingle started to call it "the waterfall."

I was proud of my tan, my flowing white waterfall.

The problem was *my penis.* Lying naked in the sun gave me an incredible boner. Embarrassed, I'd flip onto my stomach, which only made matters worse. Pressing against the towel, I'd imagine what men did with women, and what guys could do with guys. Somehow I'd always end up thinking about the surfer at Point Reyes, who I'd watched undress. Over and over, I replayed that moment, his clothes falling off in an endless loop.

Then, half-crazy, I'd take the coconut oil to my room.

WHILE MY HORMONES RAGED, so did my sister's. Her moods became unpredictable, and she looked increasingly uncomfortable as she waited for the baby to arrive. I brought her iced tea and fanned her. I felt sorry for her. Pregnancy seemed an outlandish punishment for just having sex.

Several times a day, Donna wept spontaneously. Vinnie, confused, thought Donna was mad at him, thus leading to many arguments—in which Donna genuinely became mad at him. I'd walk to Lu's to escape the shouting and pouting, trying not to think how much D and V were like my parents.

Of course, my mother had always done pregnancy in comfort and style.

On the August day my brother Danny was born, an ambulance had come to take Mom to the hospital. It all happened in the middle of a cocktail party by the pool, hundreds of people, drinking and dancing. Mom looked terrific—I remember perfectly. She had a huge

head of teased hair and a strand of amber around her neck. A black silk maternity tunic, with mustard-yellow toreador pants. Her feet were sublimely wrapped in soleless sandals—a fan of fake jewels from her ankles to her toes.

With medics on each arm, she was escorted to the ambulance through the crowd. Coolly, she waved from the stretcher as the attendants slid her into the wagon. As the door shut, I saw her toes, lacquer red against the white sheets.

The sirens wailed like a baby.

In no time, Mom had had her seventh child, alone in a hospital, while Dad partied on.

Vinnie, of course, planned to stay right by Donna's side when the baby came. "Yes, I will," he would say to my sister's belly, blowing reefer smoke into her navel.

"WE'RE POOR, but pure," Donna liked to say—though the words started to feel a bit rehearsed. In addition to having no television, we had no phone. And since Lu was always waiting for a call, he didn't like us to use his. Every couple of weeks, Vinnie would drive Donna and me to a gas station to call Mom. We called collect, of course. It was my job to talk to the operator, and I always noted how Mom hesitated—just a second—before accepting the charges.

When she asked how I was, I was always quick, giving her back the stage after a sentence or two. "What about you, Mom?"

"Well!"—and here the torrent would begin: golf, Bermuda, Dad's new building, my brother's summer camp. "We're doing well—much better," she said. "The charges against your father have been dropped. Finally some peace in this house!"

The secret message was always: *It's best you stay away.*

It made me angry how much I missed her.

"Oh, and did I tell you Steven's dating the daughter of a doctor? Do you remember Dr.—"

I had a sudden urge to cut her off—something I never did. I needed to announce my own happiness—the happiness of being far away from her.

"Marin County is *so* great!" I said. "Everyone is so nice to me. And we have these great parties on the beach!"

It was a total lie. The beaches in Marin were fog-bound and freezing.

As I hesitated, Mom burst in on my breathlessness. "You're not out there to have *fun*, buster. You're out there to finish school. Have you enrolled yet? I'm not sending checks so that you can have parties on the beach. Let me talk to your sister."

Sitting in the car with Vinnie, I watched Donna stand in the hot sun, at the edge of the highway, talking to our mother. She looked increasingly unwell. I saw her gesturing with her hands. Eventually, Vinnie honked the horn.

When Donna got in the car, she was crying.

"What's wrong?" I said.

She dried her eyes. "I've made a decision: no more runs."

"Why not?" asked Vinnie.

"I'm scared. Look at me!" she said, pointing to her stomach. "I'm getting close. What if I went into labor with a hundred pounds of hash in my suitcase?"

Vinnie didn't look happy.

"I'll talk to Lu," she said. And then a miracle—she smiled. "I have faith."

When she looked at me, I believed her.

"You'll be an uncle, Chris. And you'll go to high school in September."

Though nervous about returning to school, I was also excited. When we'd visited Tamalpais High in Mill Valley on registration day, I'd seen beautiful kids everywhere, hopping out of Mercedeses like baby rock stars. My waterfall would fit right in.

A WEEK OR SO later, I was showered and ready for my first day. I put on a simple white T-shirt and ponytailed my white hair with three purple rubber bands. Donna came into the bedroom and told me I looked amazing.

And then Vinnie came in and said the same thing.

They were both smiling too much; I was suspicious.

"What?" I said.

Vinnie said, "You don't really want to go to school with all those rich fucks—do you?"

I looked at Donna for clarification.

She sat on my bed. "We talked to Lu and he offered us another job, watching a stash house of his. He said we could stay there, rent free."

"That's great," I said.

Donna nodded, and then added: "It's in Tucson."

I felt like I couldn't breathe. I was twenty minutes away from becoming a real California kid.

"All we have to do is babysit bales of pot," Donna said. "It'll be easy and—"

"And beautiful," Vinnie added. "We'll have our little Acorn in the desert."

"We're *not* naming her that," Donna snapped.

She took a deep breath and attempted a smile. "What do you think, Chris?"

I felt my heart fluttering. I didn't really want to move again.

"Maybe I could stay here, though," I said. "With Lu and Jingle."

Silence. Donna turned away.

Vinnie finally said, "We need the checks, Chris. We need you with us."

My sister looked so tired. What could I say?

I swallowed, tried to find my voice. I took my sister's hand. "I just want to be with you guys. Wherever you are."

A wave of melancholy swept through the room. We all felt it.

In my mind, I saw all those pretty long-haired boys walking away.

California slipped into the sea.

20.

Miracle of the Dust

LU'S STASH HOUSE sat on a black rock, surrounded by saguaros. Drugs from Mexico waited there to be flipped or shipped. Lu needed someone to live at the house and keep an eye on things, and to make the place seem *normal*. The last tenant—another of Lu's crew—had fled, worried that the cops had the place under surveillance.

"The guy was paranoid," Lu assured us. "But you know what to do if anything goes down."

We did know what to do: keep our mouths shut—wait for the lawyers. For our silence, there were prayerful promises of bail and legal assistance. "We're family," Lu said.

Staying in the house involved some risk, but Donna and Vinnie couldn't pass up the offer of free rent. And Donna was glad to baby-sit product, rather than transport it.

With the feel of a beach bungalow or a motel, the place was both worn-out and never really lived in. Lacy grandma curtains, church candles, a funky lamp made from the skeleton of a cactus. Nothing in the place matched, or mattered. But the picture window in the living room was splendid: the whole valley of Tucson, spread out below. In the distance, freight trains chugged by like toys.

IT TOOK US three days to drive to Arizona. As Vinnie's old Chevy station wagon pushed on, with no AC, I wondered if my sister missed the sports car she'd given back to my parents in a huff of pride.

But she was free now, we all were—and that meant everything.

At night, we slept on blankets in the desert, the sound of the highway like the ocean. The world seemed huge and hollow. I kept hearing my mom's voice. *Why are you moving? That's absurd. Your sister is due in two weeks.*

I repeated what Donna had told me: *It's a business opportunity.*

During the drive, I had a nightmare—the first since New Jersey. I woke up screaming, but Donna and Vinnie didn't even stir. I watched the crazy stars and tried to catch my breath.

At sunrise, we were off again. As the heat grew, mirages rose from the blacktop and the mountains floated by as if on some silver sea.

When we crossed the Colorado, Donna poured us warm lemonade. We toasted with paper cups. Driving into Arizona, into the wastelands of the Gila, I thought of my brothers, drinking glasses of ice-cold milk, my father eating saltines with shaky hands.

And Mother with her checkbook and pen, writing my name in lovely loops.

Pay to the order of Christopher Scott Rush.
Twenty-five dollars and no cents.
Twenty-five dollars and no sense.

Later, I wrote both versions in my sketchbook.

Drew a starry sky full of coins like flying saucers.

A WEEK LATER. Donna handing me my lunch in a paper bag, saying: *Off you go . . .*

Strolling down the lava driveway with my avocado and alfalfa sprout sandwich, I stood in the road, a stick figure waiting for a yellow bus. Worried about yet another new school, I felt the old familiar sick. Looking down at my favorite shirt, a gauzy tunic coiled with blue embroidery, I tried to feel better. Donna had bought this shirt for me. It was my shield of flowers. Carefully, I rehearsed my lines: *Hi, I'm Chris—from California!* (New Jersey would be wiped from my résumé.)

The moment I got on the bus, my peers were transfixed. Their mouths hung open as they searched for the right word to welcome me aboard. Of course, that word was *faggot*. I took a seat at the front of the bus, alone, and stared out the window. Like in the cartoon where the coyote chases the roadrunner, the desert repeated itself, over and over.

At school, I knew the drill. *You're a robot—keep walking.*

As I'd feared, the long-haired boys of Tamalpais High had been replaced by crew cuts and cowboy hats. Many fellows sported handsome blue jackets with yellow letters: FUTURE FARMERS OF AMERICA.

Attending school assembly in the auditorium, I was unsure where to sit. A young cowhand approached. He looked me over and smiled—his teeth Halloween black. He said, "Hey, baby, want a kiss?" and then hocked chew on my shirt.

WHEN I CAME HOME from school, the house smelled of reefer and refried beans. I hid my stained shirt behind my books.

Donna said, "So—how was it?"

I said, "My teachers are nice."

I didn't want her to worry. She was nine months pregnant, in a borrowed house, with no money and a nude husband.

Most days, after school, I hiked in the hills behind the house. I explored extinct volcanoes and cliffs rotten with caves. Found geodes and blue agate, pulled quartz crystals from the ground like broken teeth. Viewed from the peaks, our little house looked like a boat stranded on a rock, waiting for a wave.

But the wave never came.

The desert was a difficult place to live. By midday, boundless light overwhelmed the valley. Barely a shadow could survive. We all looked forward to sunset—its golden rays and purple shade. After hard days, the sunsets were soft and sweet.

ON SATURDAY MORNINGS, we picked up our mail at a tiny rural post office. Only then did we see our neighbors, the ranchers who lived down long dirt driveways. These men sometimes nodded, but never smiled. I studied their slow saunter, their bright eyes, their faces wrecked by sun. As we collected our letters, their wives glared at us. Maybe we seemed too happy. Maybe it was our hair.

One day, there was a package from Lu at the PO Box—some hash, I think. The old woman behind the counter spoke kindly to pregnant Donna. "Oh, I bet it's baby clothes. What do you want, dear—a boy or a girl?"

My sister smiled. "My husband and I like both sexes."

The woman was perplexed, staring at the feathers in Vinnie's hair and my yellow pajama top. As she handed Donna the cardboard box, she frowned—her old-lady lips snapped shut.

WE LIVED IN pretend-Arizona. Vinnie and Donna thought they were pioneers, reading the Bible by candlelight, baking bread, birthing baby at home. But it was a fantasy, an attempt to live in a place as strange as the moon.

The baby, though, was no fantasy. Miles from medical care, we

waited. The Chevy was a wreck. We had no phone. I knew that Vinnie and Donna had consulted with their chiropractor, who vigorously encouraged home birth. Dr. Kelly assured them that there was nothing to worry about. Also, Vinnie had spoken to Jesus about our situation—and Jesus told Vinnie to deliver the baby himself. And that I would assist.

No way. I suggested Donna go to a hospital.

"No hospital," Vinnie said. "My child will not be traumatized by doctors."

But what about my trauma?

Vinnie and Donna didn't say much about the birth itself, but from the how-to books lying around, I'd determined that someday soon, my sister would be screaming in agony while her guts exploded.

I hoped I'd be at school.

MANY OF THE KIDS at Red Rock High were Mexican and spoke no English. I sat with them in the backs of classrooms. I did my work and, like them, said nothing at all.

One lunch, I saw a tiny boy sitting under a tree. He had on a blue *Alice in Wonderland* T-shirt. From under a mop of red hair, he smiled at me.

Too shy to go over, I walked to my next class.

Around this time, I got a homemade postcard from my friend Sean—whose sister, Darla, had given me the tarot reading. Sean, remembering the reading, had drawn the Fool on the front. On the back was written:

Chris, have you fallen off a cliff? Or are you in love?

I WOKE UP to the sound of a car in our driveway. I was scared, since no one ever came to the house. When I looked out my window I saw a pretty woman with a funny little kid—and then I realized it was Lu and Jingle.

I got dressed and ran into the kitchen, where Jingle was un-

packing groceries. She kissed me on the head. Lu shook my hand and said, "Come with me."

Vinnie was already outside with a flashlight and shovels.

Lu led us into the desert. By the beam of the torch, he looked like a fiend in a monster movie, limping past cactus claws and jagged rock.

Pointing with his crutch, Lu said, "See that stone? Dig next to it."

Fearful of scorpions and snakes, Vinnie and I cautiously picked at the dirt, but soon our shovels hit metal. We pulled a big rusted box from the ground—quite heavy.

On the porch, Jingle waited with a tiny silver key. She slid it into the lock and pried open the creaky lid. Inside was a stack of mason jars, each containing a perfect specimen of a different drug. Flowers and powders and tar.

Lu grabbed a jar of buds and then, for only an instant, I saw the money. Beneath the jars of dope sat a big block of cash. It frightened me. Finally it hit me that Lu and Jingle were criminals. And I saw the precariousness of our situation.

Lu snapped the trunk shut, shooed us inside. Jingle locked the box and put the key in her apron. Then on wicker old-lady furniture, we smoked rare herb, and soon I was asleep again.

By morning, the box had disappeared from sight.

Vinnie whispered to me, "That was serious cash, man. There's gonna be a major deal."

I skipped school to see what would happen next.

STRANGE PEOPLE dropped by the house. Unlike Lu's associates in Marin, these people were not hipsters. Up the dusty drive, men arrived in pickups—rugged men with short hair and sunglasses, cowboy hats and scuffed boots. They all carried paper sacks.

Each sack contained a kilo brick. The bricks represented different loads of pot that had recently crossed the border, from Mexico. Lu was shopping for product.

From the living room, I watched Jingle greet each guest with a

cold beer. There were no introductions—and after a moment of small talk, Lu would open the bag. He'd sniff at the brick and peel off enough for a joint. Vinnie helped him smoke it, but his opinion was never sought.

Donna stayed in her bedroom.

Lu would always walk the dealer outside to the driveway to discuss money. For days, cowboys came and went. Sample kilos piled up under the table like trash.

By then, my sister was past her due date. She was gigantic. I could tell she liked having Jingle around. At night, when the commotion died down, Jingle would sing a hymn just for Donna.

I'd listen from the doorway.

On the table next to my sister's bed, I saw the scissors and syringes, the gauze and bandages. These things worried me. I still wanted Donna to go to a hospital, especially with all these strange men coming and going.

At least Jingle kept singing.

THE NEXT NIGHT, very late, there were strange voices in the house. I opened my door and saw Lu and Vinnie standing with two mustached men—one with a holster and gun. I must have gasped.

Lu turned and scolded me. "Get back in your room. This doesn't concern you."

I locked my door and listened. I heard arguing. But I kept telling myself, Vinnie and Donna are protected by God. Nothing bad could happen.

And though I understood that Lu and Jingle were criminals—I also knew they were Christians, and that they loved me. I did the only thing that made sense. I said my prayers. *Our Father Who art in heaven* . . .

I prayed until I fell asleep.

I AWOKE to a scream.

Donna!

I jumped out of bed and ran from my room—stumbling over bricks of pot wrapped in pink plastic. There was a pyramid of product in the living room, stacked over my head. Squeezing past, I called out to my sister.

Everyone turned. Donna was lying on her bed, naked. Lu and Jingle and Vinnie, plus some people I didn't know, stood around her.

Donna's eyes met mine. "Baby's coming."

Vinnie put his arm around my shoulder and walked me back into the living room.

"There were men with guns," I said. "Last night."

"You were dreaming. Everything's fine."

"Where's our furniture?"

"On the porch—just until the buyers take the product." He whispered, "Lu promised me and Donna a nice cut."

"Who are those people?" I said, gesturing toward his and Donna's room.

"The buyers. Nice people. Donna asked them to stay for the birth, for good luck. Praise God."

Another scream from the bedroom.

Lu came out, sweating. He put some tabs of white acid in my hand.

"Take your sacrament. There's going to be a miracle."

I took five tabs, then ate a bowl of Grape-Nuts.

Twenty feet away, my sister sounded like an animal in pain.

Vinnie and Donna's bedroom had three walls of windows, with incredible views, but that morning there were only two things anyone saw: my sister's eyes, which were beautiful, and her vagina, which was mutating at a rapid pace.

The dealers, who'd come by to score pot, found themselves hypnotized by my sister's privates. I think they were relieved to look away and introduce themselves. "I'm Sherry. You're the brother? What an experience for you!"

Sherry was a short Jewish lesbian, plaid shirt to her knees. She was clearly the boss, keeping an eye on a bag in the corner of the room, which I assumed was full of cash. Buffalo, her employee, shook my

hand a little too hard. He was a burly, red-bearded guy, with a belt buckle big as a dinner plate.

"Hey," he said. "I met you when you were, like, ten. You had on a pink cape."

A memory flashed from a distant planet.

"Meet Heidi-girl!" Buffalo said.

Heidi was blonde and pretty and pale, with fluttering white lashes. She looked a bit distressed.

No star had guided these three to the manger—it was the weed.

Heidi went to the kitchen and cut up a pineapple. Jingle made iced tea. I stood around with a flyswatter. Then came a *much* more intense scream. Everyone gathered around Donna. Vinnie was at her side, coaching her breathing—telling her not to be afraid. His stopwatch categorized each wave of pain. Small talk faded away.

A mountain of pot was suddenly the most boring thing in the world.

When the crown of the baby's head appeared between my sister's legs, I could not imagine how the creature would make it out. Donna was in a trance, breathing hard, eyes available only to her husband. When she cried, Vinnie was steady, following her agony, reminding her that the baby was almost there.

Jingle wiped the sweat from my sister's brow. Heidi, terrified, held my sister's hand. Lu, Buffalo, and I stood at the foot of the bed with Sherry—all of us silent, awestruck.

Vinnie turned to me. "Get your sister a glass of water."

As I handed my sister the cup, the water glittered like diamonds. My sister drank and sighed and closed her eyes, pausing as the room slowly detached from the earth. The valley disappeared, far below.

THE SUN FOLLOWS us as we float away, bright white sheets and blood, blood, blood. I've never been more scared. My sister has changed shape again. She is wide open. The room is dizzy and dangerous.

The head emerges: ancient face, closed eyes, passive, patient, as if it had been waiting for centuries. I hear my sister's wailing, pleading

to God to help her. God, God, God. I feel my fear rise up again. But Vinnie is tender. He touches the new one's face, the child stuck between worlds.

The contractions are terrible to watch. My sister pushes and screams, pushes and screams. The baby's position is impossible. Rapt in terror, I watch the baby's head, a red rock, an orb surrounded by sheets of blood. I do not understand. *How can this dark moon be a person?*

"Oh—Oh—*Ohhhhh*," my sister screams, and out flies the baby.

Vinnie catches the slippery thing and brings it to the sunlight. The child, mysterious as stone, is covered with thick slime, maroon and yellow. But the stone breathes—it cries and punches the new air.

Instantly, it becomes a girl.

My sister weeps with joy. We all weep. The drug dealers hug. Donna holds her daughter, the umbilical cord still attached. The throbbing coil is inconceivably monstrous, a bloody purple snake.

I drop the flyswatter and go to my sister. As I look into her eyes, she smiles at me—tears and laughter. Up close, the child is covered with fine hair like a wolf-baby, a wolf with the face of an old woman.

Vinnie readies to cut the cord. I cannot look.

The child, untethered, joins the human race. Vinnie calls her *Jelissa*.

She takes my sister's breast.

I cannot remember my mother's breast.

I DON'T RECALL ever feeling the acid Lu gave me. I remember only the trip of a baby coming into this world. I remember the delirious fear that struck me soon after seeing the umbilical cord cut. *Who will protect this tiny thing?*

It takes me a few seconds to remember: *It has parents—it has a family.*

LATER IN THE AFTERNOON, Vinnie and I drove to a pay phone to call our folks. He spoke to his first, smiling and crying. My call was

more complicated. Donna had lied to Mom, claiming she was having the baby in a hospital. Mom was thrilled by the news and asked me the name of the hospital so she could send Donna flowers.

"Actually," I said, "we had the baby at home. I helped Vinnie deliver her."

"Are you insane?" my mother shouted—so loudly that Vinnie could hear.

We both started laughing.

And then Mom was laughing, too.

I told her I loved her.

AT THE HOUSE, Donna and the baby were asleep. Jingle cooked dinner while the menfolk got high. The buyers had gone to get a truck.

I recall someone helping me to bed.

In the morning, the load was gone. I helped Jingle sweep up the shake from the floor—stems and pot dust. When I saw her about to toss it out the back door, I said to her, "Don't throw it away! I can share it with my friends."

I was thinking of the shaggy-haired boy in the *Alice in Wonderland* T-shirt.

Jingle shook her head and put the shake in a paper grocery sack, and then sealed it shut like an oversized lunch bag. "God bless you and your dirty little friends."

Vinnie and I moved the furniture back into the living room. The house smelled like hay, diapers, beans.

Before nightfall, Lu and Jingle were ready to leave. Lu gave me a bottle of LSD, which he shook like a baby rattle. Jingle laid her hand silently on my head. I could feel the blessing she was giving me.

Outside, she sang a final hymn:

When I thirst, He bids me go,
To where the quiet waters flow . . .

21.

The Spoons

AFTER MY SISTER GAVE BIRTH, something came out of me, too.

Suddenly I had a voice. I'd been terrified and now I felt strong. I had a home, a new family. The relief was tremendous.

I took a joint to school and when I saw the red-haired boy sitting again under the same tree, I approached him, said hello.

His name was Owen Spoon.

When I suggested we get high, he took me to a safe spot he knew, out past the playing fields. He told me he'd just come from Idaho, where his father was a bush pilot. "My mom has arthritis, really bad, and so we spend the winters in Tucson." He said he was Mormon, which I thought meant Protestant.

I told him I was a Catholic from California. "Actually, New Jersey."

"I hear it stinks in New Jersey."

I could not disagree. When I told him about the poisoned red river, he said, "Blood cometh from every pore."

I smiled at his sudden intensity.

"It's not funny," Owen said. "It's from the Book of Mormon."

"No, no, not funny at all," I said. "It's beautiful."

We were instant buddies. He was fifteen, a year younger than me.

The next Saturday, his mom dropped him off at my house. I met her in the driveway. She had a disastrous perm and a Belair 100 dangling from her mouth.

In a husky voice she said she liked my long hair.

Owen and I were getting stoned in my room when Vinnie knocked. He told us to keep our voices down, and to stop laughing so much. "There is a child sleeping." He said our laughing was disrespectful. "Never forget—this house is a temple."

It was embarrassing. Still, I had to admire Vinnie's seriousness, his dedication to my sister and their kid.

But nothing could stop Owen and me from giggling.

VINNIE WAS IN A BETTER MOOD after dinner. He had that peculiar sway that came over him when he double budded—a joint and a couple of bottles of Budweiser. Outside, on the porch, he put his arm around me and said, "You know, Chris, there's nothing wrong with you."

I gritted my teeth, counted stars.

"We know about you, Chris. Your sister and I. But we prayed, and Jesus said it's fine. What you are."

"Okay." My cheeks were red.

"Of course," Vinnie continued, "sex between a man and a woman is the most beautiful thing in the world. I hope you get to experience that, too."

THE BABY NEVER stopped crying, and after two weeks Donna and Vinnie were worn out. Feedings, diaper duty, the mystery of

colic. Only the baby existed—a screaming sun that never let us sleep.

When Owen came over, we escaped, wandering around the desert, toking and talking. Owen discussed his dreams, even the wet ones. I listened closely, hoping I might make an appearance—but the dreams were always a little vague. "Someone's hand . . . not mine."

I was happy to have a friend. Donna and Vinnie were happy that I'd found someone my own age to take drugs with.

"DO YOU WANT to go camping?" Owen asked me one day. "Just the two of us. My dad has plenty of gear and my mom will drop us off at a trailhead."

The next Saturday, Vinnie drove me over to Owen's. His father was ex-military: square jaw, wide shoulders, steely blue eyes. He preferred to be called *Lieutenant*. Lieutenant Spoon didn't exactly smile, but he seemed pleased to help Owen and me assemble our gear. He had a hoard of Forest Service equipment in the garage and helped find me what I needed. He warned of frost.

He said, "Owen tells me you live with your sister?"

"Yes, sir. And her husband."

"What about your parents?"

When I couldn't manage a reply, Lieutenant Spoon said, "And you're a Catholic?"

I wasn't sure what I was anymore. I said, "Yes. I studied at the monastery."

After lunch, Owen's mother drove us to the top of Mt. Lemmon, an alpine peak just north of Tucson. Lily Spoon was probably ten years younger than my mom, but she was weatherworn, with jagged wrinkles, hair already thinning. She smoked nonstop and sang along to country radio.

It was obvious how much Lily adored Owen. At the trailhead, she smoothed his hair and kissed him goodbye. "You boys be careful. Don't fall off the mountain."

. . .

OWEN AND I planned to spend the night at the Wilderness of Rocks. We had identical Forest Service backpacks and mummy bags, and made our camp on a high granite cliff above the pines. Watching sunset, we ate the cheese and mustard sandwiches Lily had made—with homemade pickles. After dinner, Owen secured the food and tidied up the area. Dressed like a mountain climber, he had every possible piece of gear: flashlight, pocketknife, wool hat, down vest.

I had purple sneakers and a turtleneck.

He said I needed hiking boots. I said he needed LSD. I handed him a single white tab. I took three.

As the moon rose red, I began to shiver. It was cold. I suggested we build a fire.

But Owen said no. "If we light a fire, we won't see the moon. Let's just get in our sleeping bags."

On a big pile of pine needles, we rolled out our bedding and lay down next to each other. Though we were in separate bags, I could feel his thigh resting against mine. The acid came on nicely and we talked under the moon for hours—nonsense and real life. I told Owen about the baby, about the drug dealers, about my friend Pauly who believed in the Devil.

"Wow," he said. "You've had a really weird life."

The moon was bright. I turned away because I didn't want him to see my embarrassment.

Owen told me about Idaho, about his house up there, the horses, the rivers, the hot springs. Then, in the middle of a sentence, he fell asleep.

The sudden silence was eerie. I could sense the blue expectancy of space, between the peaks, under the stars. I tried to measure the emptiness, imagined falling through it, like a stone tumbling from a cliff. I listened to Owen's breath and studied his smooth face, the moonlight glowing in his hair.

I leaned over to smell his skin, to understand.

I touched his cheek. But the moon said: *Wait.*

. . .

WHEN I CAME BACK from the mountain, my sister and Vinnie were sitting stiffly on the couch, in a room full of blazing candles. Immediately, I knew something was wrong.

"Chris, we've got great news," Donna said, her eyes all wet.

"So why are you crying?"

"Because we're happy. Everything has been so hard lately and we've been praying and asking for guidance and . . ."

I waited. Lately, I'd become irritated by how they dragged things out, how every announcement had to have a Jesus-y prelude.

"I talked to my father," Vinnie continued, "and he offered me a job."

I was confused, wondering what kind of job Vinnie would be doing for God—and then I realized he meant his earthly father.

"We're all going back to New Jersey," Donna blurted.

I stared at them.

"Family is what's important right now," Vinnie said.

I asked him what that meant. "Our family is here."

"We need help with the baby," Donna said. "We're gonna stay for a while with Vinnie's parents."

I could see my sister was uncomfortable, but I wasn't going to let her off the hook. "And what—I'm supposed to go back to Mom and Dad's?"

Donna and Vinnie stared at me, surprised by my angry tone.

"I guess you want me to be *committed*. That's what Dad said: 'Straighten out or you're going to a facility.'"

"Chris, I promise, nothing will happen to you—okay? I'll make sure. Please don't make this difficult."

I asked them if they even cared about my camping trip.

"Of course we care. How was it?"

"Amazing," I said, marching to my room and locking the door.

When Donna knocked, I ignored her.

I was unaccustomed to rage. At first I wasn't sure what it was— like liquid silver in my veins, making my muscles taut. It felt like I was turning into an animal.

I threw a glass against the wall.

"I am not going!" I screamed.

When I think back on this time in my life, it seems like some kind

of amusement park ride I've been strapped inside—it swings back and forth, home and away, home and away.

I want it to stop, but I can't get off.

OVER THE NEXT FEW DAYS, I grew more upset.

Vinnie went on and on about the circle of life. "To grow up healthy and happy, a baby needs his grandparents. I'm Italian. Grandparents were always around."

"Well, Donna and I barely know our grandparents."

I was furious. Had they both forgotten what it was like back there? Maybe Vinnie's parents would have some interest in a screaming baby; mine certainly wouldn't. And what had happened to our noble plan to live with God in the desert? To break through into the Light?

It was hopeless, though. Donna and Vinnie were dead broke, and Mom refused to send more than her current amount. At least Vinnie's parents had offered them food and a place to stay. And a job at the chemical factory!

Unbelievable. "Why can't Vinnie get a job here?"

"We're tired," said Donna. "I just want a bath."

Our little house had only a rusted shower stall.

"What happened to being poor and pure?" I asked—but by that point Jelissa was crying. We all turned toward her, the baby who'd arrived in a house reeking of pot. Soon, she'd be in New Jersey smelling meatballs and Windex and hair spray. Maybe that wasn't so terrible.

"Are you still going to work for Lu and Valentine?" I asked my sister.

As the baby continued to wail, I knew the answer.

"So—what—you're just giving up?"

AT SCHOOL, in a state of panic, I told Owen the news. He said barely a word. We stood staring at each other, both of us refusing to speak for fear of what might come out.

We cut class and spent the day smoking weed behind a shed at the

edge of a cotton field. We took a stone and broke open the shed's lock. Inside there was nothing. Not even cotton.

AT THE STASH HOUSE, I'd stopped shouting and crying. One night, for dinner, my sister splurged and bought a dozen green corn tamales—my new favorite food. I ate four.

We were leaving in a week. Donna and Vinnie had very few things—barely enough to fill one suitcase. I had even less.

Clearing away plates, Donna stopped and said, "You know, Chris, we did love it out here. With you."

A spiteful sun was setting, filling the room with the most gorgeous light.

I went to my room and looked through my sketchbook, all my drawings of Tucson. Maybe I'll give them to Owen, I thought.

When I saw him the next day, he just blurted it out: "My parents say you can stay with us."

Whatever happiness I might have felt was weighed down by confusion—my own parents didn't want me, so why would strangers want to take me in?

"Chris, did you hear me? You don't have to leave. You can live with me."

"Your parents don't mind?"

"We've always helped people. Plus, my mom likes you."

I felt dizzy.

"We'll live in the room next to the garage. It has bunk beds. You'll share it with *me*."

It was frightening when God answered your prayers—especially when He gave you *exactly* what you'd been praying for.

"Man, you cry too much." Owen hugged me, his face on my chest, but he quickly pulled away since there were kids nearby. "You'll have to talk to your parents, of course. Make sure it's okay you can stay here."

I was pretty sure that wouldn't be a problem.

· · ·

IT WASN'T.

Efficient as ever, Mom quickly made arrangements.

"Makes sense for you to finish your junior year out there. I'll be sending your checks to Mrs. Spoon now—she seems like a very nice lady."

"She is."

Though happy about this turn of events, I felt sort of insulted by Mother's ease about my situation. Did she want me gone that much? Or was she trying to protect me from Dad?

I lingered on the phone, wanting more from her—though I'd run out of things to say.

WHEN OUR STATION WAGON pulled up to Owen's house, Donna and Vinnie said they wanted to go in and talk to the Spoons. I knew what they really wanted was to show off their baby.

Owen grabbed my suitcase from the car and took it to his room. I stood there in the driveway, not quite ready to follow him in. I didn't want my life with Donna to be over yet. She'd been my protectress for so long.

Standing in front of the Spoons' house—an army lieutenant's house—I was confused. I tried to make out the shape of the dream my sister and I had had—about peace and love and the Holy Spirit—and I wondered if I could manage it by myself.

Suddenly, the dream went sad.

I'd always imagined Donna and I would be tripping together forever. When she came out of the Spoons' house, she seemed faint in her flowered dress, as if she were already fading away. She saw my face and I could see how hard she was working not to cry. She rolled her eyes and made the tiniest gesture with her head. *Not in front of strangers.*

And then I kissed her, and it was hopeless. We broke down.

The Spoons stepped aside, as Vinnie put his arms around me and said: *Hey, bro, we love you.*

Then, in a cough of blue smoke, they drove off.

22.

I Just Like Vegetables, Sir

MOM HAD WARNED THE SPOONS that I was a vegetarian, and it was agreed that Mrs. Spoon would take me out once a week so I could buy my special food.

Lily was relieved to find out I did not need to attend Catholic mass.

I'd arrived with only a single suitcase, half-filled with clothes and books and sketchpads. The other half was filled with parting-gift pot from my sister, and the big bottle of LSD from Lu.

"Is it okay to put out my Bible?" I asked Owen.

"Sure," he said, explaining that his family were *Jack Mormons*,

which meant they didn't go to temple anymore. I remained unclear on what exactly the Mormon Church was. *Did they have priests and nuns?* I didn't want to pry.

Owen said, "My parents drink and smoke, which is strictly forbidden."

"And as you probably noticed, my mom's a little zonked from booze and pills. I think she's in a lot of pain—from the arthritis. And my dad has nightmares, on account of his killing a lot of people in Korea."

I didn't mention my own nightmares.

Owen went on. "Dad's chest is covered with scars from hand-to-hand combat. It's pretty gross. I can't even look at him when he takes off his shirt."

From the windows of our room, I could see both the front yard and the back. The front was raked gravel, but the backyard was cement block, swept clean. In a patch of dirt, there were roses and a lemon tree laden with fruit—each lemon so yellow it seemed impossible.

Owen's blonde sisters were likewise too beautiful to believe. I remember watching them run inside with their schoolbooks, laughing like an advertisement for youth and chastity: Brenda, Billie, and Barb.

Owen was the youngest child—the only boy.

AFTER SCHOOL, Owen and I would hike into the desert around his house.

Sadly, the desert was doomed. There, at the edge of town, developers were blading ten acres a day. Owen and I would come upon bulldozers scraping a hilltop we'd hiked across only a couple of days before. Giant saguaros were piled up like dead aliens, their insides slimy and green.

Luckily, reefer made everything beautiful again.

We'd sit on some other hill and get high—Owen telling me about Idaho, where he hunted and fished with his dad, and swam in the canyons of the Salmon River. It was obvious how much he loved his

life and his family. Though quiet and small (only five feet tall), Owen possessed not a trace of fear. His laugh was the surest thing I'd ever heard.

SHAPED BY BOTH military and Mormon discipline, the Spoon household was a well-run machine. Saturday morning, Lieutenant Spoon and Owen washed and waxed the Oldsmobile and the pickup. There was yard work and a trip to the dump. Mrs. Spoon and her three daughters would cook and clean house—all in matching aprons—singing to the radio.

I wanted to join the team—but when I asked what I could do, the answer was always: *You're our guest.*

At mealtimes, the Spoons never argued or raised their voices. I had grown up around a much more competitive table. The Spoons even seemed less *hungry* than my family—they took smaller bites and chewed slowly, their mouths closed.

One night, the Lieutenant asked me to explain why I was a vegetarian. With genuine interest, he listened as I described the health benefits of the New Age Diet. I simply repeated everything I'd heard Jingle say—about soy protein and the power of live enzymes.

When I finished, Lieutenant Spoon put his steak knife down and paused.

"Young man, I believe vegetarianism is a conspiracy against beef. I hope you realize that *beef* is our way of life. Owen's grandfather is a rancher, as was his great-grandfather. You're not against ranching, are you?"

"To be honest, sir, I just like vegetables."

I DIDN'T TELL Owen much about my family. I didn't want him to know how crazy they were. When he asked questions about my parents, I lied and said, *Oh, I never think about them . . .*

Of course, every week or so I'd call home—collect.

From a phone in the living room, I'd talk to Mom while staring

at photos of the Spoons. Instead of asking questions, she gave me up-
dates, as if I'd called to check in about *her*. She told me she'd made
up with Dad—that he was getting sober. "We're taking it day by day."

She sounded tired.

The next note, however, was bright and buoyant. "We bought a
penthouse in Florida—to celebrate."

I told her I'd love to visit. She said, "Someday, darling."

"Well, I'd like to see it before I'm dead."

"Don't be morbid, Chris. This is a big step for your father and I."

I picked up a cute picture of Owen, wearing a blue cowboy
shirt and bolo tie. Mom and I were both living in our fantasy worlds,
east and west. She continued to mail checks to Mrs. Spoon—to keep
me alive or keep me away, I was never sure.

I asked her if she'd seen Donna yet.

"She's coming down for dinner on Sunday."

"Maybe I should come, too?" I said, half joking.

"Chris, you just can't make up your mind, can you?"

"I have made up my mind," I said. "I was just wondering what
you thought. Forget it. How are Mike and Steve? Can I talk to them?"

"You want to talk to your brothers?"

I could tell she was getting distracted. My father was saying some-
thing in the background.

"Okay, bye," I said.

"Bye, darling." She was already talking to my father as the phone
went down.

ONE AFTERNOON, Owen and I hiked far into the desert, away from
the developments.

"*Whew*," I said, "it's really hot. I think I'd be more comfortable
without clothes."

"I agree," Owen said.

Nonchalantly, we pulled off all our clothes, keeping on only our
shoes, as protection against cactus and sharp stones. Sneakers sud-
denly seemed very sexy, increasing the sensation of being naked. Of

course, I remembered Jingle's admonition about rubber cutting off the Earth's emanations.

I was sustained, however, by other life-giving emanations. I watched Owen's splendid body, pink as a seashell, moving ahead of me across the sand. With mind control, I valiantly tried not to get a boner. Though Owen liked being nude, I still had no idea if he liked nude boys. He was a wholesome kid. He said he wanted to be a pilot, like his father. He could identify any plane that flew over us. Until the weather turned in mid-November, we regularly hiked in the nude—Owen hopping over boulders like a nimble elf while I lumbered behind, an awkward giant.

One day, in bright sun, Owen looked over at my body. I blushed. "So what happened to you?" He gestured toward my legs, where the scars from my accident were still quite visible.

"Nothing," I said.

He was leaning close, as if to better inspect the damage.

I was terribly embarrassed. I broke away and walked back toward our clothes.

"Wait up," he said. "Are you mad at me?"

DURING MY STAY at the Spoons', I never masturbated. I'd made a deal with God: *I won't come until I come with Owen.* I was a superstitious and determined child.

One Saturday, while Owen did his chores, I painted a very colorful portrait of Jesus, with art supplies I bought with Mrs. Spoon. Using poster board and Day-Glo paint, I attempted to channel the spirit of love into physical form.

Jesus's goatee was an unexpected moment of inspiration. He looked a lot like me, mixed with the Devil. In psychedelic text behind the figure wavered the words *I Love You Owen.* The *O* in *Owen* formed a halo. I felt confident that, to any innocent bystander, the picture would indicate that it was Jesus professing his love to Owen, and not me—but I hoped a clever elf might be able to decipher the truth.

When I presented the painting, Owen looked at it for a while,

nodding, and I feared the worst. He offered a noncommittal "Nice"—but later I saw my lewd messiah hanging on the wall beside Owen's bunk.

EACH NIGHT AFTER DINNER, the Spoon family gathered in front of the television set. At first, I tried to join them, but watching *The Ghost and Mrs. Muir* made me uncomfortable. I could never manage to laugh at the right moments. TV had not been allowed in my sister's house—or at Lu and Jingle's. Now I understood the wisdom of my hippie elders. Jingle always said, "Television is toxic."

I decided to stay in my bunk and read *Dune*.

There is no escape—we pay for the violence of our ancestors.

When I read that sentence to Owen, he said, "And what are the crimes of your ancestors?"

I told him I was still researching this question.

I SNUCK A CALL to Donna—not collect. Vinnie's mother answered the phone. She sounded like a truck driver. She screamed: *Donnahhh!*

When my sister came on the line, she sounded exhausted. She said she'd been meaning to call me, but that things were hectic at Vinnie's parents'. "We eat constantly."

"How's the baby?"

"She's great. Of course, Mom hates the name. She said *Jelissa* sounds *black*. So how are you?"

I told her I missed her, then admitted to feeling a little sad and weird.

"Go see Dr. Kelly," my sister suggested. "Get a spinal adjustment. It always makes me feel better."

So Lily drove me to the chiropractor. She stayed in the car, listening to the radio.

Dr. Kelly was a weight lifter, tall and handsome, glowing with good health. He always wore a white jumpsuit and white alligator

shoes, his hair a perfect pompadour. He smelled good. I liked it when he touched me. I trusted him.

After my adjustment, I reminded him I was a vegetarian like my sister.

When I asked him what else I should do to stay healthy, he said, "Perhaps you're ready for a cleanse."

He handed me a pamphlet describing a system of fasting, herbs, and colon therapy that was the apex of his clinic's healing program. "The colon," he said, "is where true health begins."

"I didn't know that."

"Yes, and I advise all my clients to participate. Supplies can be purchased at the front desk."

I was flattered by his interest in my colon. It felt so adult to even *have* a colon. I decided to follow Dr. Kelly's advice. I bought his herbs and an enema bag. The doctor had kindly explained to me how to use the contraption, cautioning me to *fight the urge—hold the nourishing fluid as long as you can.*

The next weekend, I started a two-day fast. I hung around the bedroom reading, trying to forget how hungry I was. The apple juice and slimy herbs I took every few hours were of little solace.

Owen didn't have much to say. When he went in for dinner, I waited in the bunkhouse. It was unfortunate that we had no bathroom out there. At eight o'clock, I had to go into the house *to do a very special job.*

Unfortunately, Owen had explained the Kelly Cleanse to his mom and dad. As I discreetly carried my equipment to the bathroom, the Spoons stared at me in stunned silence. Even the girls looked grave.

Taking an enema is a primitive process, something the pioneers might have done in a forest or a large field. On the pink tile floor, I lay back and surrendered to the contents of the bag, not understanding why I had an erection.

Owen's youngest sister, Billie, knocked on the door.

"Are you done yet? I need my things!"

Above me on the curtain rod were various bras and panties. Below

THE LIGHT YEARS 207

the unmentionables, I was aroused, confused. Faintly, I replied: *Soon, Billie, soon.*

OWEN ASKED ME only one question. "Does it hurt?"

And then he admitted, "Those enemas really upset my dad. I tried to defend you but my dad thinks something's wrong with you. I know there's not." He paused. "But why do you *do* stuff like that?"

I tried to explain that fasting was in the Bible and that Dr. Kelly was a well-known health expert.

"Chris, that guy's not even a real doctor. My dad says he's a quack. Why do you listen to crazy people?"

Owen was staring into my eyes.

"Don't be crazy, Chris—okay?"

And then he said: "Or just *pretend* you're normal."

I noticed the Day-Glo Jesus was no longer on the wall.

THE SPOON THANKSGIVING was traditionally held in Silver City, with the Lieutenant's parents. I was pointedly not invited.

Mrs. Spoon explained, "There'll be no food for vegetarians."

She knew this wasn't much of a reason. She put her hand on my arm. "It's not my decision. My husband has rather rigid ideas."

I told her I understood. "My dad is the same way."

"Your mother, too, I suppose."

I knew Mrs. Spoon sometimes talked to my mother on the phone.

"It sounds like she's going through a lot. I wonder if maybe she needs you at home."

Was that a joke? "I don't think so."

"Well, I left you a casserole, dear. Eat all you want."

ON THE PHONE, a week later, Mother was sour. "The Spoon family doesn't want you anymore. They think you may have medical problems."

"Medical problems?"

"Or worse."

"All I did was a fast! I'm fine."

The line was silent. I knew my fate was sealed.

"I bought your ticket," my mother said. "You'll be home for Christmas."

"What about Dad," I said.

"What about him?"

Did she not remember? "Well, for starters, he doesn't *like* me."

"He doesn't have to *like* you, Chris—he's your father."

MRS. SPOON told me to call her Lily.

Now that I was leaving, everyone seemed more relaxed.

Owen, blessedly, seemed heartbroken.

I was—I'm not sure—numb, I think.

Sitting on the couch in the living room one afternoon, Lily seemed tired, her teased hair so thin it looked like an X-ray. Her wrecked fingers wrapped around a whiskey glass, she asked if she could make me anything special. She knew how sad Owen was about my leaving. I knew she'd begged the Lieutenant to let me stay.

Lily declared my final week a holiday. Owen and I would not have to go to school. The Lieutenant was away, flying his twin prop somewhere over Oregon.

In the camper, Lily drove us to places I'd only dreamed of visiting. In Madera Canyon, she set up her lawn chair and drank Coors while Owen and I hiked up into the snowy pines. When we returned to the camper, there were piles of food, including the famous Lily Dip—avocado with Tabasco, scallions, and lots of lime.

We ate and laughed. Lily smoked her cigarettes and watched the sunset with us. As the light dipped beneath the last cloud, we were quiet. I looked over at Owen and his mom. Both had the same unguarded eyes, the same shade of candy blue.

. . .

THE LAST FEW DAYS, Owen would not let me out of his sight. He gushed about a plan to reunite the next summer, in Idaho. I tried to act excited, but I was growing more and more worried about going back to New Jersey.

"Take pictures of me," Owen said, handing me his camera.

I took a whole roll. There's one I still have: Owen lying on the bottom bunk, smoking a joint—no shirt, bare feet, the top button of his jeans undone. He's surrounded by piles of cash, maybe the proceeds of some last-minute pot deal—I can't recall. Owen's smiling, posing like a centerfold.

I think he knows what's next.

THE FOLLOWING NIGHT, in the same bedroom, conversation draws down to the inevitable. There's no time for anything but the truth. I tell him I love him.

He blushes but doesn't protest. He says, "Let's drop acid."

We walk into the freezing desert, without jackets, until we're shivering. The stars shudder and jump. As we head back toward the house, Owen suggests we go to the camper. "It'll be cozy."

Inside, he turns on the stove. We climb onto the big bed and wait for the heat to collect, to enter us. Hallucinations flash in the dark. I imagine our fathers sneaking around the yard like devils. Owen can't see them—he's taking off his clothes.

I can't stop shaking, but I manage to get my clothes off, too.

Use your fingertips like a blind person. That's what Vinnie told me—a lesson in how to touch a girl.

I put my fingers on Owen's thigh. He's breathing funny. I touch his hand. He's panting now. I grab his dick. Leaning in, I kiss him.

He stops me. "No, not on the lips."

All night we kiss—kiss everywhere but on the lips. There are other, better places.

Things pour in and out of me—transfusions. I'm greedy, taking more and more, saving it up like medicine for when I go back to the sickness of New Jersey.

Owen moans. Then a similar sound rises from me.

"He'd kill me," Owen says at one point. He's laughing.

"I know," I say.

Kill is not a metaphor.

Neither is *kiss*.

Owen says, "I love you."

I surrender. Fall from the cliff.

PART IV

SPACESHIPS

23.

Mom in Mud

MY BROTHERS AND I are in the den, watching TV. Mom and Dad, too. Walter Cronkite is calmly describing the situation in Indochina. On a screen behind his head, flames devour Saigon.

My family is eating ice cream. We each have our own bowl and our own TV tray—silver spoons clinking against ceramic. No one talks.

In Saigon, there are explosions.

But here, in the house, the war proceeds in silence.

Walter Cronkite reports on the peace talks. I, too, want peace.

I want love, laughter, conversation. But no one even asks me about the past seven months. No one says *anything*.

Between my parents, there is something new, some odd electricity in their silence. My younger brothers keep their eyes on the television. Michael and Steve are tall now, their long legs sprawled in front of them. They don't look happy. My little brother Danny is in first grade, an adorable brat, dripping ice cream onto my mother's shoes. She doesn't seem to notice.

Later, after everyone's in bed, she tells me, "Dad's going to AA."

I say, "So he's *better*?"

She says, "Who knows? He won't talk about it."

She's finally noticed the ice cream on her shoes. She starts to clean them. When I see her an hour later, she's still fussing.

ALL I REMEMBER of that Christmas was that Donna and Vinnie didn't come.

Sometime after the holidays, I called my sister to tell her that things felt really weird at home.

"What's new?" she said.

When I suggested moving out, she chided, "Chris, you're sixteen, just play along. Let Mom and Dad take care of you for once."

I told Donna I needed product.

"Just for you or to sell?"

"Both," I said. "I need to make some money so I can visit Idaho."

"What's in Idaho?"

"Owen."

I wanted to tell her more, but Jelissa was crying.

I said, "You have to go. It's okay."

But she'd already hung up.

I WAS SLEEPING in my sister's old room now. Her ruffled curtains and pink canopy bed were a little embarrassing, but they made me remember a time when Donna was all mine. Her cheerleading jacket was still in the closet, her Barbizon outfits and high heels.

I remembered how shocked I'd been to see Donna smoke a cigarette by those ruffled curtains. Now I got stoned out of my mind in

that room like it was nothing at all. Sitting at her faux French writing desk, I wrote long letters to Owen—and drew lots of silly elves. Naked ones, with red hair.

SOMEONE WAS SHOUTING.

Climbing out of my sketchbook, I opened the door. I saw my mother being dragged down the hall.

My sister Kathy yelled, "Help me, for God's sake!"

Dark streaks on the carpet. Not blood but muck. Mom was heavy, waterlogged, delirious. Her navy suit covered in mud. Her face, too. I smelled seaweed and sewage. Leaves decorated her hair.

My sister and I each took an arm and got Mom on her bed. Her shoeless feet were Easter-egg blue.

Kathy looked at me and huffed, "Your mother tried to kill herself!"

"What?"

"She jumped off the dock down by the park!"

Mom moaned. Her eyes fluttered—then shut.

Kathy told me to rub Mom's feet. "Don't worry—she's not going to die. She just took a few pills."

As I rubbed my mother's icy toes, Kathy elaborated. "It was that dock where we used to feed the ducks. Luckily, the river's not that deep there. And the tide was out. She sorta got stuck in the mud. Of course it was freezing. The guy from the gas station helped me fish her out. Dad just stood there."

"Dad was *there*?"

Kathy sighed. "Help me pull off this mess."

The Chanel was ruined. Kathy balled it up and threw it in the bathroom.

My mother's underwear was muddy, too.

Kathy said, "Why don't you wait outside, Chris, while I delouse her."

LATER, IN THE KITCHEN, Kathy poured herself a Coke and explained the situation further. "So she called Dad at the jobsite and when he

wasn't there, she went on one of her bar hunts and found him drinking at the Travelodge."

"I thought Dad was in AA."

"Yeah, right," Kathy said. "*Assholes Anonymous.* Anyway, when Mom saw him sloshed, with his face in some woman's tits, she flipped. She took a handful of Sominex she had in her purse and started running up and down Main Street, screaming. Dad called me and when Mom saw my car she started running toward the dock."

"Shouldn't we take her to a hospital?"

"Nobody dies from five Sominex. She does this shit to get even with Dad."

"Where is he?"

"Probably with Dolores."

"Dolores? The housekeeper?"

"He's always cheating. It drives Mom crazy. You know, she's pulled stuff like this before. The first time, you were away at school. It was bad—we had to get her stomach pumped. She was in the hospital for a week."

I felt ill.

"Second time was the summer you had that car accident thing. This one, though, it was a real performance."

When I asked Kathy if I should check on Mom, she said, "There's nothing you can do. She's gonna sleep. Listen—I have to go. Order a pizza if you get hungry."

WHEN MY BROTHERS came in from practice, I said Mom was sick in bed. Steven's eyes asked for more information, but I didn't offer any. We had our pizza.

Later, I went in to check on her. She was breathing, a shadow under the covers.

On her bureau there were no pictures of her children—only of my father.

. . .

THE NEXT MORNING, Mom was quiet, sipping her coffee—black, two saccharins. She had a few scrapes on her face and legs. She was in her bathrobe—her hair springing from her head in various directions like a busted clock.

She made no breakfast for my brothers. She stared out the window, far away.

Dad still hadn't come home. When Michael and Steven and Danny went off to school, I stayed home. Just in case.

Dad crept back a few days later. There was no scene. Dolores was sacked—but a few weeks later I caught my father dry-humping her replacement against the washing machine. The new woman had fat ankles and red Keds. When Dad saw me in the doorway, he curled his lips into something like a smile, as if to say, *All this can be yours.*

STRANGELY, MOM DIDN'T seem angry at all now. It was as if nothing had happened. The house went back to its routine of clean sheets, nutritious meals, and televised entertainment (all five sets on the same channel so Mom could watch her soaps as she moved from room to room).

Church, bridge games, and dinner parties—Mom managed them better than ever, with a kind of robotic precision. Every movement of hers seemed to scream: *I'm absolutely fine!*

Dad, on the other hand, had a furtive, impatient look. Sometimes, he glared at me—or offered his just-as-dangerous inscrutable smile. Never a word.

When Mom announced that she and Dad were headed to Florida, to the penthouse, I knew it was another attempt at *Love.* Only Danny would join them. Michael, Steven, and I would stay at home. My brothers were thirteen and fourteen, and used to my parents' sudden getaways.

"Does she usually get you guys a babysitter?"

Michael sneered. "We can take care of ourselves."

"We haven't had a babysitter," Steven said, "since Grandma Loey died."

. . .

THOUGH THE NEW HOUSEKEEPER in red Keds came and went, the three of us were basically alone for a week. My brothers pulled Ore-Ida French fries from the oven and made fake throw-up sounds as I boiled my brown rice. They watched *Wide World of Sports* at maximum volume. I did consider hating them but felt sorry for them, too. For a while I'd had Donna and Vinnie, Lu and Jingle; my brothers had had nothing but Mom and Dad. Now, we'd all been abandoned.

As little kids, the three of us had been inseparable. Chris-Mike-Steve: the pirate trio, stealing candy, setting the woods on fire, diving from great heights into shallow water. Best buddies in blood and mud and sugar.

My pink cape had been the end of all that. Whenever I returned from St. John's and Star Farms, my brothers had shunned me, taking their cues from Mom and Dad.

But now, even as they mocked my food and femmy hair, I found them looking at me like they needed me to explain something.

One night, Michael walked into my room and sat down on the satin duvet.

"I know what you do in here," he said.

I assumed he was going to say *jack off*, but then he added, "You take drugs."

Steven walked in the room now, too. He must have been waiting outside the door. "Did you really try to kill yourself?"

"No. Who told you that—Mom? I was almost *murdered*."

"Really?" Steven sat beside Michael on the bed.

Steven was sensitive—and, like me, suggestible, prone to nightmares. I changed the subject back to the initial line of inquiry.

"Listen, I smoke a little pot. It's not a big deal."

"I'm not talking about pot," Michael said. "A friend of mine said you sold his brother *acid*."

"A lot of people say you sell it," Steven chimed in.

"So what are you guys, narcs now?"

Fearlessly, Michael opened the closet door. At fourteen, he was

already more mannish than I'd ever be. Behind thick glasses, he was muscled and sweaty, with the first smudge of mustache.

"Get out of there," I yelled.

"Is this it?" Michael said, holding up a bottle he'd found under Donna's abandoned sweaters.

"Oh my God," Steven said.

"What are you gonna do—turn me in to the cops? Or tell Dad? Fine, I'm not planning to stay here that long anyway."

They looked at me, baffled. "We just want to try some, Chris."

"No way," I said, taking back the bottle. "Come on, you guys— just go watch TV. Or don't you have girlfriends or something?"

"Not at the moment," Michael said. "We're dry right now."

FOR DINNER I made cinnamon bread—from the *Ten Talents* cookbook.

"Not bad," Steven said. "The walnuts are good."

"Betty Crocker," Michael mumbled, replaying one of Dad's stupid nicknames for me. I watched my brothers eat—slouched in their chairs, food all over.

"It's not like a can of beer," I said.

"What's not?"

"Acid. You don't just take it for fun."

"Someone at school said it was like taking a vacation," Michael said.

"Mom and Dad are on *vacation*," Steven concurred.

I asked them if they'd ever gotten stoned.

"Of course," Michael said. "We've been stealing pot from you for years."

Steven laughed. "You never noticed?"

Michael shoved half a slice of bread into his mouth. "If you don't give us the acid, we're just gonna steal it."

MARCH 19, 1973. Full moon (I'd checked the lunar cycles in *The New York Times*).

Sunset on the roof was excellent. I gave Michael a single white tablet, then one to Steven.

Summoning Valentine, I said, "This is sacrament," but the words fell flat.

For some reason, I'd decided not to trip with my brothers. Maybe I wanted to be clearheaded to protect them, or maybe I just wanted to watch the Experiment—get some sense of what it had been like, to drop acid the first time. At least my brothers were pubescent. I'd been the *real* experiment—the grinning cherub, dosed at twelve.

I sat with my brothers on an army blanket and smoked a joint, watching the jagged pines fade to black. Not fifteen minutes later, Michael was grimacing.

Steven pointed to the east. *"Uhhh!"*

There was a spark in the trees, a flicker—then slowly a red eye rose from the earth. We were speechless—none of us daring to interrupt the moon.

My brothers looked strange, their eyes swimming. I didn't know how to guide them. All my years of tripping, and I had very little wisdom to offer.

Break through the ego—find the void. I stayed quiet.

The night was beautiful. Cirrus clouds whipped by, throwing great gobo wings across the moon. Michael stood, his figure floating above the swimming pool, the tennis court. Moonlight shimmered on his glasses; he looked mildly insane.

"Do you see them?" he said. "Do you see the animals?"

Steven started giggling. "Yes, *yes.*"

I couldn't see a thing. Without acid, I was an idiot.

"Michael," I said. "Steven."

"Yeah?"

"Listen to the animals."

I climbed down the ladder and went inside. I heard my brothers above me, laughing and walking on the moon.

I wrote a letter to Owen. *I'll be there this summer. No matter what.*

24.

Julie

A GIRL STARTED FOLLOWING ME around school, always there when I turned a corner or climbed the stairs. Then she was standing beside a tree in front of my house.

"Who's that?" Michael said.

She was pretty as a boy—white skin, black hair, Disney-red lips.

When I went outside, she adopted a hip-out stance and said, "I need to score. Emogene said talk to you." Her bold manner was undercut by a rather tremulous voice—like a cartoon bunny rabbit.

We went to my room and got stoned. "Good stuff, right?"

"Yeah—but I want acid."

I guess word was getting around.

I sold her a few hits. She came back for more.

Though beautiful, the girl was odd. One day, she seemed rather distracted. When I asked her what was wrong, she sighed. "I have a head cold with none of the symptoms."

She didn't smile—but her hands moved constantly, nervous as birds.

WE STARTED TRIPPING together—skipping school.

One day, we ended up back in my room, door locked.

"Love your décor," she said, stroking Donna's pink phone. Then she leaned back on the canopy bed and opened her blouse.

Her breasts were perfection.

She kept talking. She asked if I was a virgin.

"I'm not really sure." I didn't know how to explain Owen. "Are you?"

She blushed. "God, no. Why don't you kiss me?"

As the weeks went on, we became more like playmates than lovers. We went about town, holding hands, laughing. We were both sixteen, but at six foot two I towered above her.

Julie lived in a huge Victorian—immaculate, but without a trace of color. Walking into her house was like traveling from Oz back to Kansas. In the gloom, Julie could only whisper.

Her mother had died when Julie was eight or nine. She now lived with her little sister and her father, who'd been married and divorced numerous times since her mom's death.

The day I first went there, the house was empty. The living room was very dark. I said, "Why don't you open the curtains?"

"I can't. The sun hurts my father's eyes."

"But he's not here."

"I'm not allowed—okay? Would you like a glass of juice?"

I walked with her into the kitchen.

"I'll probably move out after my dad gets married again. He'll marry someone new. He always does."

The juice was warm and I asked for some ice.

"We don't have ice."

I said, "Everyone has ice," and reached for the freezer door.

Julie screamed, "No!"

I pulled back my hand.

"It's just . . ." She sat down at the table and covered her face.

"What?"

"It's just so embarrassing."

I told her it couldn't be any worse than the stuff that happened at my house.

"I bet your father doesn't keep his underwear in the freezer."

She had me there. I sat down beside her, while Julie explained about her father's recent speeding ticket. "He told the cop he was having a 'bathroom emergency,' but he still got a ticket. So he's keeping the underwear—as evidence."

She stood and opened the freezer. In a large plastic bag was a stiff pair of white briefs, stained and bulging with what appeared to be—

"Oh my God, is that . . . ?"

"Yes, Chris—it's shit. My father said that because the cop pulled him over, he didn't make it home in time."

She slammed the freezer door shut.

I asked her how long the "evidence" had been there.

"Two weeks—and the court date isn't until next month. I'll never be able to eat ice cream again."

AROUND THIS TIME, I also started to hang out with Sean again. His hair was as wild as ever, and I was happy to see him in his harem pants, to see the stack of UFO pamphlets piled up on his desk.

"So you're still into this stuff?"

"Definitely. Gabriel Green's a genius."

"He's the president of that flying saucer club, right?"

"Chris—he's not just president of *one* club. He's president of *all* of them. The Amalgamated Flying Saucer *Clubs* of America." Sean was

getting very excited. He sat up and grabbed my arm. "I think I might be an Xian."

I wondered if it was another word for homosexual.

"What is that?" I asked.

"Xians are the people who are able to see the ships. You might be an Xian, too."

"Maybe," I said, handing Sean his package.

Sean was buying a fair amount of weed. I had an excellent supply of Colombian from Lu and Valentine, through my sister and Vinnie.

Sean put the package under his bed and said, "Let's go swimming."

It was March. It was raining. I said, "Uh, maybe not the best weather."

"I *need* to swim! Are you coming or not?"

We hitched over to the beach. I sat on the sand as Sean, a Viking in boxer shorts, fought the dark Atlantic and swam out into the freezing waves. When he emerged from the depths, he was blue—and limping. He'd cut his foot on something. I bandaged the wound with kelp, then put a few strands in his hair. He lay there shivering, a merman washed up from the depths.

I put my coat around him. It couldn't have been more than forty-five degrees.

"You better get dressed. And we should take care of your foot," I said.

"Let's just sit here a little longer, okay?" He stared at the waves, nodding his head, as if to music I couldn't hear.

My mom had told me that something had happened to Sean while I was away. Instead of asking him questions, I stayed next to him, tried to keep him warm.

MY PARENTS and Danny arrived one night with their luggage—back from another getaway. Dad and Danny went straight to bed. Mom stayed up, silent, sorting the mail and emptying the dishwasher.

She broke a bowl and cursed.

When she saw me standing in the doorway, she jumped. "You scared me! How long have you been standing there?"

I asked her how her trip was and she said, "Why can't you and your brothers rinse things before you put them in the dishwasher?"

I sat at the table, reading one of Gabriel Green's newsletters as my mother sighed and scraped at plates with her fingernails. Gabriel's message was reassuring—interplanetary peace. He'd been personally contacted by the aliens and asked to spread the word. He reported back to the Alliance of Planets telepathically.

"What are you reading?"

"Gabriel Green."

"Who in the world is that?" my mother said.

I recited the bio at the back of the pamphlet, citing the most impressive bits—about Mr. Green's runs for U.S. president in 1960 and 1972, and his run for the U.S. Senate, in which he'd received nearly two hundred thousand votes.

"Really? I don't remember him. But, you know, your father and I saw a UFO."

"You did?"

"Yes. We were sailing on the bay one night and this thing just zoomed out of nowhere with glowing red lights. Then it stopped over the boat as if to watch us. It was quite remarkable. We weren't scared a bit."

My mother and father—Xians? I was confused—and jealous. I was the one who needed to see a saucer! I went to my room and penned a fan letter to Gabriel Green.

And then I wrote one to Owen.

It had been almost four months since I'd left Tucson. At first, Owen and I wrote each other constantly—then the letters trailed off. When I called the Spoon residence, Lily was of no help. "I'm afraid Owen is outside with his father."

I kept photos of Owen on my bureau, like holy cards, but made sure to hide them whenever Julie was around.

. . .

SPRING CAME, at last.

On Easter Sunday, my three brothers were dressed like Motown singers in powder-blue suits. Mom permitted me to clash: I wore a striped shirt, striped tie, and striped pants, of various persuasions. Mom was classic in a lavender dress, amethyst jewelry, floppy sunbonnet, and high heels. With her handsome boys, she promenaded down the central aisle of St. Ignatius, removing her praying mantis sunglasses only when we took our front-row seats.

Dad was an usher at our mass. In gray silk, he passed the basket. I saw him smile at Mom as she dropped in the envelope. (For many years, the Rushes were the number one contributors to St. Ignatius Church.)

At home, after mass, Mom put on her Italian records—music that let us know that happiness might be risked. She babied the ham and cha-cha'd about the kitchen. There was legal chocolate everywhere, in plastic baskets and crystal bowls.

I took off my suit, put on tight jeans and a flowered blouson. Dad strolled in, saying nothing as he walked by. *We're cool*, I thought, as I wandered into the dining room to fuss with the table settings and daffodils.

Finally, at four—late as usual—Donna called out from the back door: "We're here!"

I ran to her and the baby. We hugged like long-lost friends. My mother, an only child, could never understand why I loved Donna so much. "You just saw each other two weeks ago. What's the big deal?"

On Vinnie's shoulder was a tremendous diaper bag. With a nod, he asked if he could put it in my room.

"Sure, man, go ahead."

I followed him and locked the door behind us.

Vinnie plopped down the heavy bag and unzipped it. "It's all here," he said. "The hash and the Colombian, same as last time. There's acid, too, but only about five hundred hits."

"Okay." I put the various packages in my closet.

"So total of three thousand," Vinnie said. "And you still owe us a thousand from last month. You're sure you're okay with this?"

I nodded and handed him an envelope full of cash.

"God bless you, man. Your sister and I really appreciate you selling this. It makes a difference."

I nodded, pleased that I could help.

When someone knocked at the door, I quickly shut the closet.

But it was only Donna and the baby. "I need a quick toke. Mom is trying to convince me I should golf."

When Vinnie tried to take Jelissa, my sister snapped. *"Just leave her*—she's fine. Why are you always grabbing her?" She lit a joint and took a deep, life-saving drag.

AT DINNER, Mom asked me to say grace, like in the old days.

I was stoned and felt inspired.

"Bless us, O Lord, for these Thy gifts," I began. "For these yams and the ham. For the milk and the mushed potatoes."

Steven giggled.

I looked at him and smiled. "And I would also thank God for giving me the opportunity to share sacrament with my brothers."

Now I directed my beatific gaze to my mother. "Lastly, I would like to thank Jesus for sending the UFOs who bring a message of—"

"What did you say?" my father interrupted. "Did you take the Lord's name in vain?"

"Charlie," my mother said, "I don't think that's what—"

"Norma, shut up."

"Dad," I ventured calmly. "I'm just trying to celebrate the relationship between Jesus and other spiritual forces." I looked at Donna for support, but she shook her head: *Don't.*

"I want you to leave this table," Dad said. He picked up the electric carving knife, his hands trembling.

"Dad—"

"No. You have been a pain in my ass for years, little woman."

"Both of you, stop!" Mother hissed. "We are *not* doing this again! Everyone is hungry and waiting. Charlie—*carve*."

My father's face was purple as he sliced the ham.

．　．　．

I FUCKED JULIE for the first time on my parents' bed.

It was fun and when I came, I felt weirdly proud—perversely wishing that everyone I knew could have watched, including my father. My brothers knew what was going on and were a bit confused.

Mom had met Julie a few times—and eventually asked if the two of us were dating.

"I think so."

Mom had on her good apron, the serious one: white canvas, no pockets, no stains. She was stirring some sort of crucial sauce for dinner.

"I like Julie very much," she said. "She reminds me of myself at that age."

Uh-oh, I could feel a monologue coming. I knew the signs: the tilted head, the faraway eyes.

"I used to have so much fun, Chris. You know, I was *never* going to get married. I was actually dating another boy when I met your father, and one night he waited on my doorstep until I came home. It was three in the morning. Your father proposed to me in the dark. I couldn't even see his face! I said, 'Is that really you—Charlie Rush?' It might have been the Devil for all I knew. He grabbed me and he just wouldn't let me go. I was sixteen! Now he's mine forever . . . good God."

She stared into the saucepan, lost. There was only the sound of her spoon, moving in circles—the cookbook open beside her.

When I approached, I saw that she'd underlined the words:

Do not be tempted to turn the heat up. The sauce will thicken.
Be patient. Do not leave your post.

Owen called the next day. He said he loved me.
Love. I sighed. I knew it was complicated.

25.

A Better Man

IN APRIL, there's a late snowstorm. I take one of Dad's cars and drive over to Julie's house. She's outside, waiting—somehow knowing I was on my way. We're like that now—telepathic.

We sit in the T-bird with the heat on, perplexed. When we were children, snow required an immediate response: running, throwing, flapping like fallen angels. But now that we're adults—almost seventeen—snow is an abstraction.

Julie and I drive out to the Pine Barrens. The snow is dazzling, useless. The last time I was in the Pine Barrens was with Flow Bear— who kissed me and put his finger in my mouth. Now I'm with a girl

I love and don't love. We listen to the radio and watch the white-shouldered pines.

After a while Julie says, "Let's go back to your house."

When we walk in, we hear yelling. There's a sheet over the doorway to the dining room. Julie pulls it aside. The crystal chandelier—my mother's prize possession, bought in Ireland—is gone.

My brothers are mad with laughter.

The chandelier has been disassembled—its many crystals now hanging in the living room window, attached to strips of elastic cord. Sunlight passing through the crystals throws prisms about the room—a room in which my brothers have draped dozens of white sheets over everything to capture each rainbow flash.

Obviously, they're tripping.

When I ask what they're doing, Michael answers, "Destroying the universe!"

Both boys are barefoot in long underwear and hats.

"Hi, Julie," Steven says shyly. "Do you wanna play?"

The light swims about the room like tropical fish through an aquarium. Julie's face flickers purple, then pink.

Michael strums the hanging crystals as if playing an instrument. The colored bullets fly. My brothers jump right in their path—demented soldiers in a psychedelic war zone. They are yelling: *Uh—Uh—Uh!*

Julie says, "Take me home."

In the car, she asks me if I gave them acid.

"No," I lie. "It's probably some crap they got at school."

She shakes her head. "Everything is so fucked up."

We sit for quite a while in front of her house—and then I ask her if her father's had his court date.

"It was postponed," she says. "The shit's still in the freezer."

We know this is somehow funny—but we can no longer laugh.

ONE SATURDAY MORNING, I'm sitting at my desk. I light a beautiful fat joint—my first of the day—when my door flies open.

"What the fuck are you doing?" It's my father. He's already drunk; his eyes are red ruins.

I look right at him. I do not put out the dope. Instead, I take a long pull on the joint, sucking the smoke into my heart; what's left floats from my nose. I'm a dragon. I feel victorious—my father frozen in place.

Then he flies across the room and socks me squarely in the jaw. I fall off my chair, bleeding; his hands are now around my neck, choking me. My brothers appear, try to pull him off. He takes one hand from my neck and swings at them. Steven is thrown against the wall.

"I'll kill all of you," he cries. "You're not my brothers!"

He seems to hear his own mistake, and stops. He lets go of me. We're all stunned by the ugliness, the pileup, the blood.

He leaves the room, the house. I listen to his car screeching away.

LATER, MY MOTHER has only three things to say. She's crying, of course.

I'm so sorry, Chris.

He was once a better man.

I told you not to come back.

26.

What I Didn't Know Then

A COLD FAMILY. VERY POOR, very religious.

There's a daughter, maybe two—but in this story, it's the boys who concern us, the sons: Burton, Charlie, and John. The Rush Brothers. Charlie, the middle one, wants to be a priest—but when he comes to school in threadbare clothing, everyone says he's the student *most likely to become a janitor*. Just like his father—janitor of St. Ignatius Church.

Fuck that. The Rush boys would beat the dust, march until they found gold. Teenagers now, the three of them are hell-raisers; they steal cars, rob houses—but Charlie manages to stay focused at

school, graduates top of his class. At seventeen, he joins the navy—chases subs in the North Atlantic. He leaves behind his pregnant sweetheart, Norma.

When he gets home there's some trouble. Burton's in Chillicothe prison. And John, just out of the marines, is always getting into brawls. He never loses, though. He fights for money in the parking lots of taverns.

When Burton gets out of prison, he drives demolition derby.

It's not an easy life. They all have wives now, and kids. Charlie says let's build things. Let's make some real money.

It happens, just like he says. *Rush Brothers Construction*.

Hard work—but they're hard workers.

One rainy night, Johnny, the youngest, is driving a borrowed dump truck. He's blinded by someone's high beams and swerves. The truck turns over; Johnny's ejected into a field. He's alive, but he can't get up.

In the dark, he hears a speeding car crash into the dump truck lying across the road. Some fucking drunk.

Johnny passes out.

When he wakes up at the hospital, Charlie's there.

"I'm all right," he tells his brother. "What happened to the drunk?"

"He's dead," my father says.

And then: "It was Burton."

BURTON HAS JUST PICKED UP the first big check for Rush Brothers Construction. He can't wait to show it to Charlie and John.

But first he cashes it, gets drunk, plays some poker.

He bets all of it—*and goddammit*, he wins. Triples their money. To celebrate, he drinks even more before flying down the dark road toward his brothers—the cash in a bag beside him.

By the time he's wheeled into the hospital and pronounced dead, the money is gone.

John says *the police*.

Charlie says *the ambulance drivers*.

"How can you talk about money?" Charlie's wife, Norma, says. "Oh, Burton." She can't stop crying, thinking of his curly hair. "Beautiful Burton is dead."

TEN YEARS LATER—I'm three years old—my father gets a call and runs out the door. There's been an accident, not five blocks from the house. Watching television, we'd all heard the crash.

His brother John has hit a dump truck with his new car. Another fucking dump truck! Dad wonders if he's dreaming. And then he sees it, he sees the blood, more blood than he's ever imagined. Johnny's car has gone under the truck. There is only a body. There is no head. My father runs screaming: *Where is it? Where is it?*

AT THE FUNERAL, the casket is closed. John's wife, Linda, becomes hysterical. She insists the coffin be opened: *How can I know it's really him?* She cannot be dissuaded. The undertaker opens the box while my father holds her up.

For weeks my father is inconsolable, weeping, saying over and over, "He looked like a monster. My brother is a monster now . . ."

Apparently, no one in the house sleeps for days—not my mother or father—not my brother Chuck, not my sisters, Kathy or Donna. Especially not me, the baby. I wake up screaming at all hours.

"Please, Norma," my father cries. "Please make that child stop."

27.

The Invitation

DEAR CHRIS,

I am so pleased by your interest in Amalgamated Flying Saucer Clubs of America and will be sending your back issues of the newsletter as soon as I can pack them up!

I have always believed the future of the UFO movement lies in today's young people.

If ever you are in the Los Angeles area, please drop by.

My phone number (unlisted) is given below.

Sincerely,

Gabriel Green

President AFSCA

I felt like I'd just received a message from God. That night I barely slept. Outside, I walked in circles around our property, memorizing the roses, the dark lawn, the grim pines. Could I keep my childhood alive for a little bit longer? My face was still black-and-blue from my father's punch. I was seventeen and ready to leave.

Above the yard, the light turned violet, the first blush of dawn. I knew my father would soon be up.

Ten minutes later, his face appeared in the kitchen window, smoking. He seemed to waver, out of focus, already fading like an old photograph.

Back in my room, I read Gabriel Green's letter over and over, telling myself: *Everything is falling into place.* I'll visit Owen in Idaho, and then hitch to L.A. to see Mr. Green. Maybe Owen could come with me. That morning anything seemed possible.

I knew Sean would freak when he saw the letter. When I showed up at his house, he was still sleeping. I didn't care, I woke him up, screaming, "Sean, Sean, you gotta see this! I'm going to L.A."

He grabbed the letter and sat up. Once he read it, he said, "I'm coming with you." He must have seen the hesitation in my face.

"Dude, Gabriel was *my* idea. You wouldn't even have known who he was without me."

"I know," I said. "But I have to go to Idaho first. To see a friend."

"What friend?"

"Someone I know from Tucson. I'm not sure I can bring company."

"Chris, *I'm going*—I have to get out of here. I can't stay in this shit town all summer."

"Okay," I said. "Let me talk to my buddy"—though I had no intention of bringing Sean to the Spoons'.

Or, even worse, a girl.

When Sean told Julie I was leaving, she showed up at my house with tears in her eyes. "Where are you going?"

I told her about Gabriel—not Owen.

"Then take me with you."

I told her not to worry, that I'd be back in a few weeks.

"No. You don't understand what it's like in my house—it's not just the stupid freezer." She was crying now. "My father is not a good person."

Seeing her tears, I realized that I loved her. I couldn't leave her. I loved her—and Owen and Sean. Suddenly the idea of saving my friends made me giddy. Saving them was like saving myself.

A plan was made: Sean knew some people in Boulder. We'd all head to Colorado and I'd leave Sean and Julie there—while I went to visit Owen. Then, when I got back, we'd all go to see Gabriel Green.

I pictured myself on some mauve mountain, embracing my friends in a storm of passion—a teen orgy by Maxfield Parrish.

I said yes—to Julie and Sean. *Of course you can come.*

IN THE POOL, my baby brother, Danny, is splashing about, a pink porpoise in a blue suit. He's swimming with his friend Jamie, the mailman's son. No adults in sight. The boys are seven. My parents must think they're too old to drown.

I want to talk to Danny, to tell him I'm leaving, but both boys are underwater, wearing masks, struggling to complete some vital task. Choking and cheering, they emerge from the deep, each holding up a toy truck.

"I won!"

"No way, asshole, I won!"

Jamie demands a rematch. The boys swim to the shallow end and carefully release their vehicles one more time. In slow motion, the trucks roll down toward the bottom, monitored by aquatic seven-year-olds, hovering above. They drown their toys over and over again—never even noticing I'm there.

My brothers will be fine, I think. They're stronger than I am.

MOM'S IN HER ROBE, sewing something on her Singer. I can see the satin trailing down like a mermaid's tail. She hasn't used the sewing

room since 1962. The way she leans on the pedal and sighs, it's as if she's a concert pianist attempting her big comeback. Clearly, she's in a fit of nostalgia. Me, too.

I tell her I'm leaving for the summer. As always, I'm sad to leave—to leave her.

She asks, "Where are you going?"

"Out west to see Owen."

"What about Julie?" she asks with a touch of concern.

"I'm taking her with me."

"Have you asked Julie's father for his permission?"

"Yes," I lie. Julie is planning to tell her father at the very last minute.

Mom is silent for a bit and then says, "I'm not sure I'd let my daughter go with you."

"You let Donna go with Vinnie."

"No," Mom corrects. "Vinnie *stole* your sister."

I don't want to have this conversation. "Sean's coming, too."

"Sean Carney? Really? That sounds a bit complicated." Mom's drifting, losing interest. She adds, "You know, Chris, we had such high hopes for you once."

She shakes her head and turns back to her sewing, never asking how long I'll be gone for or when I'm coming back. Watching her hunched over the rumbling machine, I know she's making a new evening gown—something bright enough to catch my father's wandering eye.

I guess we both want to shine. We both want someone to love us.

THE BUS from New York City to Denver was endless—three days of sleeping in our seats surrounded by a shifting cast of suspicious characters. I have a pocket full of cash from dealing—and a box of hashish and LSD. I can't wait to share everything with my friends.

While Julie and I chatted, Sean sat across from us, reading from random signs as if they were omens of great import: YOU ARE NOW LEAVING ILLINOIS! PANCAKE DINNER AT ST. ALOYSIUS!

Neither Julie nor Sean had ever left home before.

From Denver, we took a cab to Boulder. At a pay phone, Sean called his friend Tina—who was actually a friend of his sister's; Sean had never even met her. Tina was a biker chick with a crew cut and a four-year-old. Sean hadn't informed her he'd be arriving with company.

Tina split to her boyfriend's and just gave us the house.

The place was filthy: dead houseplants, crappy old furniture the color of meat loaf. Sean took the guest bedroom—an empty, small-windowed cubicle with nothing but stained carpeting and the smell of cat pee. Julie and I set up camp in a weedy backyard.

In spite of my pristine camping equipment, Julie refused to have sex in a tent. She whispered: *Too many people are listening*.

"Who?"

"Everyone."

"I'll be quiet."

"You don't know how."

So we got stoned and fell asleep before sunset.

The next day, I took Sean and Julie to the park in Boulder, where I'd met Peter, the runaway. I mentioned that I'd done cocaine with him.

When Julie said, "I'd like some cocaine," I took her hand and, channeling Donna, replied, "We need to protect our souls. Cocaine is a lie. I think the three of us should only take acid."

"I agree," said Sean. "Give me some."

I told him to wait until we got up the mountain.

THE NEXT DAY, we hitched into the Rockies and ceremoniously took our acid. Soon we were tripping, running madly up a trail until a wall of snowcaps loomed before us like icebergs in the summer sky. We'd run so far we were actually *standing* in snow. Around the peaks, clouds flew by at dazzling speed—the storm light changing from second to second.

"It's so beautiful," Julie said. She put on her movie-star sunglasses and extended an arm into the glorious sky.

I, too, was in alpine ecstasy.

Not Sean.

Sean kept turning in circles, like a dog chasing his tail. At first, Julie and I laughed, thinking it was a joke—but then Sean took off his beads and bangles and threw everything into a stream. Even the new watch his father had given him.

Then he started screaming, tearing off his clothing. Julie and I tried to calm him. We managed to get him dressed again and lead him back down the trail toward the road. It was dark now and starting to pour.

At the highway, we tried to hitch back to Tina's house—but Sean kept running away. When we finally got him into a car, he was an incoherent mess. At the house, he locked himself in the bathroom and wouldn't come out.

In the morning, Julie and I found Sean sleeping beside our tent.

I called Darla, Sean's sister, and explained that he was acting strangely. "We took some acid and—"

"Chris, don't let him take LSD. Please. He can't handle it."

"Why?"

"You don't know?"

All these years later, I can still hear Darla's voice coming through the black telephone, as I stood in some stranger's filthy living room.

"Chris, Sean was raped in the woods near our house."

I was sure I hadn't heard her correctly.

"When he was eleven. I thought you knew."

"I guess I was away at school." I thought of my mother's warning to stay away from Sean.

"He was beaten up pretty badly." Darla paused, but I could hear her breathing. "Dad found the guy just as he was about to kill Sean. The man's in prison now. Sean just pretends to be okay. But he's not, Chris. Did you hear me?"

I felt sick, thinking of the scars I'd seen on Sean's neck.

"I won't give him any more acid," I said quietly.

When I hung up the phone, Julie asked me what was wrong. "Nothing," I said.

If I told her about Sean, I might end up telling her about what

had happened to me in New Mexico. That Sean and I were the kind of boys people wanted to kill.

I VOWED TO be kind to Sean, but only a few days later I told him and Julie that I was leaving for Idaho and that I'd meet them back in Boulder in a couple of weeks. I left the address and number, in case there was an emergency.

Though my friends knew this was the plan, they were sullen.

Selfishly, all I could think about was Owen.

When I think back on this, I marvel at how effectively I emulated my parents: turning my back on heartbroken children to satisfy my heart. It's the flaw of love—it makes you perfectly selfish.

THE NIGHT BEFORE I left, the three of us decided to walk downtown to get some ice cream. It was an irresistibly beautiful evening, the world washed in gold.

No acid, only the gentle hum of pot.

Sean seemed much better. At one point, he stopped and looked up at the sky, pointed.

"What? The plane?" Julie asked.

"It's not a plane," Sean told her. "Look at how it's moving."

It *was* moving oddly—a bright orb jittering about, as if trying to get our attention. It turned at a right angle. Stopped. And then, streaking away at great speed, the light vanished.

At the ice cream parlor, Sean couldn't stop talking—excited as a five-year-old. "We saw a ship, man. *Wow.* We actually saw a fucking spaceship." He had chocolate all over his chin.

Julie, dabbing Sean's face, said, "It definitely wasn't a plane."

I remember feeling so happy that night—as if the universe were reaching out to us, giving us a sign that we were safe and watched over, that love would prevail over everything.

A flying saucer!

Sean kept saying, "It was real, it was real."

28.

The Flood

I TOOK A GREYHOUND to Randall, Idaho. Population 551.

Out the bus window: a gallery of canyons. As I watched the world go by, I knew it was wrong to leave Julie with Sean. I felt guilty. But when the bus pulled into the tiny town of Randall, Owen was standing on the platform, and my heart raced with joy. I'd forgotten how small he was, how beautiful. He had on his blue *Alice in Wonderland* T-shirt—the one he'd been wearing the first day I'd seen him.

We hugged for a long time as his sisters watched. Then I kissed each girl to make up for hugging Owen so much.

When we arrived at the house, Lily wrapped me in a cigarette-

scented embrace and said it was good to see me. She asked me what I'd been doing in Colorado.

I told her: "Hiking Rocky National Park with my girlfriend."

"Oh, really. Where is she now?"

"She's house-sitting in Boulder."

Owen looked at me and smiled, like I was doing a good job. Maybe he thought I'd been making up this girl all along, I'm not sure.

Lieutenant Spoon shook my hand. "We're happy to have you back, son, for the *two weeks*." He seemed to emphasize that last part.

After dinner, Owen escorted me out to our accommodations— the camper in the driveway. We both understood the erotic significance of that silver ship. Once my backpack was inside, Owen decisively locked the bolt. We sat on the bed, nervously smoking a little hash and chatting. We seemed to be waiting for dark to fall, but this was Idaho in summer—the days were long. Finally, with light still in the sky, we couldn't wait. We undressed and had frantic sex—a jumble of limbs. I can still see the pink sex-rash blooming on Owen's chest and face. Both of us seemed stunned by desire.

"You look better," Owen said, touching my cheek. "The cuts have healed."

I thought of Sean and his scars. Wanting to block out the image, I leaned in toward Owen for a kiss. He let me do it this time—on the lips.

Afterward, we slept together, naked, touching the whole night. Even with Owen wrapped in my arms, I was afraid he'd disappear.

IN THE MORNING, Lily made us pancakes and then drove Owen and me to a backcountry trailhead, where the two of us would spend a few days under lonely snowcaps, hiking and camping and unabashedly devouring each other.

We dropped acid, floated like clouds in the aquarium-blue sky.

It was freezing at night, so we built a tent inside the tent. Hiding under blankets, we were buck naked, laughing and talking and

tripping. Owen pissed out the tent flap and then jumped right back in, so I could "warm him up."

Back in Randall, we were inseparable. Every night, in the silver camper, we held on to each other—goofy smiles stretching our faces. At dinner, though, with his family, we adopted flat expressions, masks to hide the light that would give us away.

Then, early one morning, someone knocked on the door of our camper.

I knew this was the end: Lily or the Lieutenant finding their son in my arms.

Owen jumped up, terrified. "Who is it?"

The answer was "Julie!" A jiggle on the door handle.

Then banging. "Hey, it's Sean. Open up!"

Owen and I flew into our pants. We swung open the metal door and jumped outside, forgetting to close the door. Julie looked in at the single messed-up bed and I could tell she knew immediately. I saw her eyes go cold.

But after a pause she kissed me *on the lips*.

And then it was Owen's eyes that went cold.

"Your mom told me you guys were out here," Julie said to him.

Sean was oblivious to the betrayals. He reached out to shake Owen's hand, then said, "Boy, am I starving!"

LATER, WHEN I ASKED Julie what she and Sean were doing here, she said she missed me. They'd decided to hitchhike eight hundred miles to find me. *Surprise!*

The Spoons fell instantly in love with Julie—her beauty, her little-girl voice, the balance of boldness and tremor. Lieutenant Spoon suggested new living arrangements: Julie and I were given the camper; Sean would stay in Owen's room—*with Owen*. I was amazed that long-haired Sean in sandals and beads didn't bother Lily and the Lieutenant one bit. Sean fit right in with the family; he had a healthy appetite, ate meat, and was happy to watch TV with everyone. And he got along quite well with Owen—which drove me crazy. It was as

if stepping inside a normal household had made Sean normal again. If anyone seemed inappropriate now, it was me—trying too hard to hide my disappointment.

My eyes traveled between Owen and Julie—the twin statuettes of my confusion.

Lily hummed and made cookies and her famous avocado dip. The Lieutenant, too, seemed happy with a house full of children. On a clear Saturday morning, he took all of us up in his prop plane to see the sights. He had Julie sit next to him in the copilot's seat, trying to impress her. He tipped the wings, flew low around jagged peaks, and squeezed through canyons. When we landed, he winked at me and said, "She's a lovely girl. You take good care of her."

At night, Julie and I kissed and hugged in the camper, though we didn't have sex. She seemed adrift and I didn't know how to reach her. As soon as she stopped performing for the Spoons and was alone with me, she let her face fall.

"I thought you'd be the one," she said.

"I am," I said. "I want to be."

She told me that I was the only boy she'd ever really been able to talk to about all that "stuff." I knew she meant her fear, her father.

When I put my hands on her breasts, she said I didn't need to do that.

THE LIEUTENANT, a great champion of western wilderness, decided that Owen and his new friends should camp out in the Salmon River Primitive Area. "Something you kids will remember the rest of your lives."

We piled into the back of his pickup truck and he drove us up dirt roads, far into the mountains. The land was rugged, vertical, cataclysmic. Late in the day, we arrived at a remote campground. From the truck we unloaded a huge canvas tent and enough food for a ten-day stay.

The Lieutenant said "Be careful" and left. I listened to his car

radio fading into the forest. When I looked at my three friends, I felt like an actor thrust into a role I hadn't rehearsed.

That night, the stars were brighter than any I'd ever seen. Owen was proud of them, acting as if he owned each one. "That's Vega, in the constellation Lyra. In the summer, it's cobalt blue." He pointed out satellites moving steadily across the sky. They were like red cars driving by, no lane changes—orderly and reassuring.

I looked for UFOs.

IN THE WILD, mornings came early.

At four, birds discussed their plans for the day.

At five, it was still freezing but the sun was up, demanding the same of us.

One bright afternoon, Owen and Julie were sitting near the river on a bed of moss, chatting about their grandmothers and all the delicious food they made. I knew that Julie was close to her grandmother—her dead mother's mother, who lived in North Jersey. She spent long weekends up there and hung out with her cousins.

I knew my father's dead brothers had had children—but I'd never met them; I'd never even seen pictures of them.

Like Julie, Owen was close to his grandparents and cousins and now he was talking about "this amazing cake" his grandma Greer had made him for his birthday.

I said, "My grandma made gin and tonics."

"Don't be rude," Julie said. "Why don't you go and find Sean?"

I stood and peered down the trail. Sean had wandered off to look for a waterfall. When he finally showed up again at midnight, we were all worried. We could see by the campfire that he was a wreck, covered with mud and blood and bug bites. He grumbled away our questions and went straight to bed.

THEN THE DELUGE began: *seven days of rain.*

The mosquitoes were so thick we didn't dare leave the tent. Naps

replaced hikes. Using the blowtorch Owen had brought to start camp-
fires, we smoked hash with bleak efficiency. We sat around with our
mouths hanging open, saying nothing.

The Maxfield Parrish fantasy grew dim.

Though we still had food, we'd run out of the good stuff. Julie
tried to make meals with what remained. Over wet wood, she boiled
oatmeal and carrots for dinner. Sean and Owen added soy sauce; I
tried it with grape jelly. Julie just spit it out.

Then there was the horror of our excrement. In torrential rain, no
one wanted to walk very far, and soon a ring of shit encircled the tent.

Our canvas lodging became increasingly claustrophobic. It smelled
like unwashed humans in a moldy basement. Of course, at night, I
could hear Sean masturbating. Owen and I did it, too—though not
together. Eventually, Julie moved her sleeping bag to one corner to
get away from the self-abusers—where she attempted to read *The Last
of the Mohicans* by flashlight. In the daytime, she tried to clean the
tent. She scrubbed with such intensity, it was clear how unhappy
she was.

On day eight, when the sun returned, Julie announced, "I'm
leaving."

"What?"

"I can't live this way, all the dirt and smoke, the *smell*."

I took her aside and said, "Please, Julie—stay."

"Chris, I need to go home."

I reminded her of our plan—to see Gabriel Green in Los Angeles.
"And then we can just stay out here," I added. "Why do we have to
go back home? We can get our GEDs in Tucson."

"Stop being an idiot," she said. "I'm hitching back to town."

I took her hand. "Julie—"

Again, she told me to stop. "I have to go home. I'm worried about
my little sister. I should have never left."

When I said her sister would be fine, she said, "You don't know
anything. If I'm not there, I don't know what will happen." She pulled
her hand from mine. "I have to protect her."

I told her that I needed her, too.

"You'll be fine, Chris. You have *Owen*."

"I want you."

"No, *you don't*. Let's just enjoy our last hour. Okay?"

She said goodbye to Sean and Owen, who were stunned. Later, walking Julie to the road, I, too, was in shock. I waited with her in silence. When I tried to hold her, she pushed me away. "Stand back or no one will pick me up."

Soon, an old fisherman in a truck stopped for the beautiful girl standing in the forest. He had a feathered hat, a sloppy dog. I studied him long and hard—sad eyes, an honest smile; he wouldn't hurt a fly. I put Julie's stuff in the back. Our parting was a single, sad kiss.

WHEN MRS. SPOON came out to retrieve the three survivors, she was sour.

"Chris, we were a bit surprised to see Julie show up alone on our doorstep. Luckily, the Lieutenant was able to fly her to Boise so she could get a flight home to her family." She glared at me, as if I'd left Julie alone to die. "And when are you headed home, Chris?"

"Sean and I are going to the West Coast."

"Well, perhaps you should be moving on."

The next morning, Owen drove us in his dad's big pickup. He dropped us off on the side of some desolate road. Like his mom, he seemed ready for us to go. He gave me the same faint hug he gave to Sean. This meaningless gesture destroyed me.

His truck took off in a cloud of dust.

Sean said, "To the ocean," and put out his thumb.

I DON'T RECALL the drive, the getting in and out of cars—but my memory wakes again in Oregon: Sean and I on some drizzly beach, eating peanut butter on wet bread, listening to invisible waves. The Zen fog was impenetrable.

In tide pools, I studied weird sea creatures, displayed as if under glass. Giant starfish rested with their arms around each other, like

sleeping children in orange pajamas. Sean and I were not nearly so content. Without Julie and Owen, we became sullen, silent. I could feel some part of us communicating, though—some secret pain passing between us.

We stayed in our separate tents as it rained, writing moist postcards. I was lonely. I wanted Sean to be my brother, but at the same time I kept thinking: *I'm nothing like him.*

Soaked through, we left the beach and began the slow hitch down the coast. Often, we'd end up waiting on a patch of pavement outside some town, already piled up with hitchhikers. I studied my peer group: young runaways and their jailbait girlfriends, jittery loner kids—a tribe of lost children. And always the bearded men with army duffel bags and worn-through shoes. Our wise men—the veterans of inner wars. I saw the bad teeth, the eyes that swam.

A few times, Sean and I camped in the woods with other kids. Cheap wine, reefer, and rain. Guitars in garbage bags, a puppy on a length of rope. Ragtag youngsters talking loud enough to block out the real story. It was clear we'd all been abducted or attacked or run out of town. You could see and feel the shame in their eyes. None of us really cared what happened next.

One night, Sean drank too much. He looked unhappy. Maybe the rain was bothering him, the hitchhiking.

I said, "Things will get better once we see Gabriel."

"What *things*?" He sounded pissed. He said he wasn't going to see Gabriel. "I have better things to do."

"Like what?"

"Like making something of my life. Like not pretending: *Oh, I'm from fucking Venus.*" Sean said that when we got to San Francisco, he was flying home, to get ready for high school. "This vacation is *over.*"

The word *vacation* stunned me. Is that what this was for Sean—and for Owen and Julie? A vacation? I studied Sean's backpack—a small thing, just as Julie's had been. A few things needed for a few weeks.

It frightened me now to look at my own pack—a triple-story

monstrosity, filled to the brim; there were even wool socks and winter sweaters. Why had I packed these things for summer? I had books, a Bible, family photos. An ashtray I'd made at school.

Hadn't I realized? *This was no vacation.*

Maybe I wasn't going home.

29.

Do You Remember Your Past Lives?

I CALLED MR. GREEN from the bus station, shaking in a phone booth, even though it was warm.

He remembered me, remembered my letter, said, *Come right over.*

In front of the station, I put out my thumb. I'd never been to Los Angeles; the traffic was frantic and I was suddenly afraid. What if Gabriel Green, head of the Amalgamated Flying Saucer Clubs of America, was a psycho? I reminded myself that the man had twice run for president, and once for the U.S. Senate—but I understood that was no assurance of sanity.

My ride dropped me off in front of a mod suburban home. In the yard, all the bushes had been trimmed into leafy balls, like little planets floating on the branches.

I rang the buzzer, which was the greenish color of glow-in-the-dark toys. It was very sci-fi.

The man who came to the door was not sci-fi, at all. He looked absurdly normal, in a sweater-vest buttoned over a starched white shirt.

"Are you Chris?"

I nodded and followed him in with my grubby backpack. He was very polite, showing me to a guest bedroom, asking me if I'd like a snack.

I'd imagined that Mr. Green's house might look like the ship in *2001: A Space Odyssey*—circular hallways with chrome accents—but it was more like the cottage of an old lady, with ceramic figurines, rubber plants, scratchy furniture. My host sat me down at the kitchen table and made me a grilled cheese sandwich. There was even a pickle.

"Mr. Green, I'm sorry that I'm a mess. It was a long trip."

"I'm honored that you made such an effort. You're welcome to take a shower after lunch."

"Thanks. So, where is everyone else?" I asked. I had assumed the Amalgamated Flying Saucer Clubs of America would be a bustling beehive of offices. "Don't you have, like, employees and secretaries?"

Mr. Green laughed. "No, it's just me—and, *yes*, I should have a secretary. It's a lot of work."

He was a good-looking man, swarthy, with slicked-back dark hair and black glasses. The same age as my father, but he was very calm, very *California*. He told me to call him *Gabe*.

After my shower, I felt even more nervous, as if the dirt washed from my face exposed me: a clueless kid.

But Gabe was pleasant and attentive, as we sat on the fifties sectional. He asked about my life, my home, my parents. I disclosed the bare minimum, trying not to lie. "Have you seen a UFO up close?" I asked him.

"Of course," he said. "You know, Chris, I've rarely read more

passionate letters—I'm speaking of yours, of course. Which is why I felt comfortable inviting you to my home."

Had I sent him more than one letter? I recall writing one just before my father had flipped out—but maybe I'd sent a few more afterward. It was a blur.

"Are you okay, young man?"

"The AC is a little cold," I told him.

He got up to adjust the thermostat—and the rush of cool air ceased. In the hush, he said, "So you know how my work began, yes?"

I knew a little from the newsletters.

"My wife," he said, "was a gifted clairvoyant. It was she who began to receive messages from an unknown entity regarding the future of our planet."

"Your wife?"

"Yes, but she's no longer on this plane."

"Oh, I'm sorry."

"Nothing to be sorry about. I still communicate with her every day. But it was through her that I first came to know the entity Korendor, from the star system Alpha Centauri. After she'd been in contact with him for a while, he instructed her to go to a remote location in the Mohave Desert and await further instruction. I went with her—and it was there that we first met Korendor in person. My wife died shortly after this—and the entity then began to communicate directly with me."

"Your wife died in the desert?"

"No, at home. In peace."

"So do you still meet with Coriander?" I asked.

"*Korendor*," he corrected me. "No, my communications with him now are entirely telepathic. Do you understand, Chris?" Mr. Green leaned in, making serious eye contact. "I am now the one whose job it is to announce the arrival of the Centaurians and share with the world their message of peace. This is my purpose!"

THE NEXT MORNING, Gabe made us a big breakfast—eggs, potatoes, toast with orange marmalade. He sat beside me, drinking coffee and

reading the *Los Angeles Times*. Afterward, he asked if I'd like to see *the library*. In one of the back bedrooms, he'd assembled thousands of books on metaphysical science. It looked and smelled like the rare-book room at St. John's—books the boys were forbidden to touch. But here, Gabe said, I was welcome to read whatever I wanted. Books had always made me happy—or at least had been a kind of solace. Life reduced to fact or rearranged into myth.

"You are here to study, Chris—to learn. Take advantage of these volumes. *Profitez!* as they say in France."

While Gabe went off to watch daytime television, I scanned the high wooden shelves. His collection was quite varied—antique volumes with crackled leather spines, pages without covers wrapped in twine, mimeographed pamphlets, books bound in metal. Over the next few days, between meals, I sat at a wooden desk, under an old office lamp, speed-reading everything I could. It felt good to use my brain again, to study. I read about the crystal ray guns of Atlantis, about telekinesis and levitating yogis. I read histories of extinct tribes and the channeled wisdom of long-dead prophets.

I tried to drink it in, like a potion in a fairy tale—something to make me strong and wise. Though the truth was, I began to feel more and more confused. I had no plan. As the theme to *Days of Our Lives* drifted under the door, I wondered: *What am I doing here, exactly?* I thought of Julie and Sean back home, Owen with his family in Idaho. Had I abandoned them? Had they abandoned me? I couldn't recall. Now that I was alone, it seemed incredibly important to know if the magical universe was real—if a world of love and spaceships could be *proved*.

Once the soaps ended, Gabriel would bring in a tray of iced tea. He wanted to see what I was reading, ask me what I'd learned.

"And what do you wish to know from me?" he said.

I asked him about extraterrestrials, of course, and life on other planets—about the possibility of survival there, for humans. I told him that I'd seen a saucer, and he said, "I sensed that. I feel I know you, Chris."

I felt the same.

He said, "What you are, my friend, is a seeker. It can be a lonely business."

When I asked him if he had any children, he turned away.

"Not in this lifetime."

AFTER A FEW DAYS, our conversations grew odder. I remember Gabriel discussing his affection for popular Venusian fashion: one-piece jumpsuits in translucent fabric. When I asked if he owned one, he laughed. "I'm not quite a sexy Venusian."

"What do they look like—the Venusians?"

"Well, you know, there are extraterrestrials walking around beside us every day, and you might not recognize them. The ones I've met have been quite attractive. They have beautiful skin. Of course, they don't all look the same. The Venusians are blond, like you, and the Martians darker, like me."

At night, in the spare bedroom, my mind raced with excitement. Before bed, I snuck tokes of hash to help me sleep. In the morning, I was always ravenous.

"Eggs, my boy? Or would you prefer French toast?"

DURING MY STAY, there was a heat wave in Los Angeles. After a few days of deep air-conditioning, Gabriel's house started to make me feel claustrophobic. I'd been in the woods all summer, sleeping outdoors, and I needed some fresh air. One morning, I put a towel down on the backyard lawn and sunbathed modestly in cutoffs. The heat was intense but soothing. Gabriel kept glancing at me through the sliding glass door. Finally he stepped outside and asked me why I wanted to be out in the "godforsaken heat" when I could be inside "cool and cozy" with him.

I told him my doctor had advised me to get plenty of vitamin D.

A little later, Gabriel came outside again, this time with a plastic bottle of Coppertone. It was old and crusty—maybe it had belonged to his dead wife. Perhaps, like me, she'd been a pale Venusian. I

applied the lotion to my bony arms and legs and resumed baking. Gabriel continued watching from the sliding glass door, holding up various beverages and treats to tempt me inside.

After three or four days, I started to feel self-conscious and thought I should probably be moving on—though I had no idea where I was headed. "I better go," I said to Gabriel. "You probably have a lot to do."

"I do most of my work at night," he said. "And besides, I enjoy making dinner for two. You're welcome to stay."

After being evicted so many times by my own family, I was both complimented and distraught by Gabriel's kindness.

"Plus," he said, "I'd like to take some pictures of you." Suddenly he began to rave about his new camera equipment, pulling a bunch of it from a closet. He set up a tripod in the living room. He asked if I'd ever shaved.

"Not yet."

"I'm jealous. If I don't shave twice a day—I'm the Wolf Man." He growled at me. "Let's do a photo with your shirt off."

"I'm really skinny," I said as I took off my purple T-shirt.

Click. Click. Click.

The air-conditioning was cold. I stood there straight as a soldier. "So the Venusians are, like, here in Los Angeles?"

"Oh yes—they're everywhere."

Click. Click. Click.

"I'd like to meet one."

"You will, I'm sure," he said. "Your energy is very compatible."

Click.

GABRIEL TALKED CONSTANTLY. Other than my mother, I'd never been around someone so loquacious. I was rapt, nervous, grateful—as Gabriel shared his story, bared his heart.

His ideas went far beyond UFOs. He believed souls migrated from planet to planet as they evolved, through the process of reincarnation. The universe was a vast school, he said, with students

migrating through countless lives and experiences toward enlightenment.

I found his ideas inspiring.

"Do you remember your past lives?" he asked me.

"No," I said. "How could I?"

"There is a way, if you want. I have the ability to take people back to memories of their former lives. It's called regression. Would you like to try it?"

"I'm not sure." I thought, *What if my past lives were worse than this one?*

"Chris," he said, leaning in, patting my knee. "I think you need to."

SITTING ACROSS FROM ME on the couch, he asked if I was ready to begin. I nodded, and he told me to close my eyes and breathe deeply. I heard him turn on his reel-to-reel, across the room.

The following is an excerpt from the transcript Gabriel made of that recording:

> *It's ten thirty p.m., Saturday, August 18, 1973. Gabriel Green regressing Christopher Rush, age seventeen. All right, Chris, now, guided by your higher self go back to a former life you would like to bring to your conscious awareness at this time, and tell me what you see.*
> CHRIS: *[No response.]*
> GABE: *All right, let's try looking at other planets. I want you to project your consciousness into outer space. Tell me what you see.*
> CHRIS: *I see just a few stars and a small planet in the distance.*
> GABE: *All right, are you looking at the planet Earth?*
> CHRIS: *No.*
> GABE: *Can you get the name of it?*
> CHRIS: *Neptune, maybe. I'm in a building, walking down a hall.*
> GABE: *Is this a past life you are regressing to?*
> CHRIS: *Yes. I think so.*

GABE: *What is your name?*
CHRIS: *I don't know. I don't have a name.*

I recall the feeling of floating—similar to how I'd felt when Pauly had put me in his magic circle in the woods at St. John's. In Gabriel's transcript, I go on to describe a barren planet, frozen solid, and how, eons ago, my civilization had been driven underground.

GABE: *Are you married?*
CHRIS: *No.*
GABE: *Do you have any romantic interests?*
CHRIS: *Yes. Blonde hair, a small face, gray eyes.*
GABE: *Can you see yourself?*
CHRIS: *Short brown hair. I have a square head.*
GABE: *Is there hair on your face?*
CHRIS: *No.*
GABE: *Was your lover selected for you scientifically?*
CHRIS: *No. Our relationship was spontaneous.*
GABE: *Do you engage in sexual activity?*
CHRIS: *Yes. We met on a public transportation tube and knew we wanted to copulate. She got off on my stop instead of hers.*
GABE: *It's a woman?*
CHRIS: *I think so.*

After a long series of questions about Neptunian sex practices and politics, Gabriel, sensing I was tired, brought me back to the present by touching my hand. He clicked off the tape recorder.

"I didn't make that up," I said. "It was all frozen where I came from. Everything was ice." There was a strange sadness in all I'd seen.

"But you found a way to live," Gabriel said. He helped me into the kitchen and made us some peppermint tea. "Not only did you live, but you passed through many other lives to be here now, with me."

· · ·

I **WOKE** to a pile of clean clothes—everything I owned, even my obscene underwear, washed and folded and lying in three neat piles on a chest at the foot of my bed. After breakfast, Gabriel said, "Do you want to go to the mall with me today? I have some shopping to do."

I hadn't been in fancy department stores since shopping trips with my mother. I enjoyed walking around the mall with Gabriel. I wondered if people thought he was my father.

"I don't know what I'm looking for," Gabriel said. "I just like browsing."

Finally, at Sears, he bought a meat thermometer.

He turned to me. "If you need anything, get it."

I was running out of money. "No, thank you. I'm okay."

"Please. I'll pay for it."

I looked around and tried to come up with something cool. I found a little pillow, gold and green, with goofy tassels. I thought it would look nice in my tent.

Gabriel seemed perplexed. "Anything else? A new pair of jeans?"

I shook my head and we left—with a meat thermometer and a pillow.

GABRIEL SUGGESTED we try another regression.

It was different from the first session—no tape recorder. Gabriel said he didn't want me to be self-conscious. He sat closer than he had the first time.

He took me back slowly, telling me not to be afraid.

A story begins to play in my mind—a flickering shadow, a scratchy movie of a boy moving through a dark landscape. I see the life of this child; see him playing in winter woods, going to school in a red jacket.

It's Earth.

Gabriel asks where.

I say, "Germany, World War Two."

He asks what I see.

The boy in the red jacket is twelve or thirteen, with blond hair, blue eyes. He is me. He's walking on a road bordered by trees. There's

shouting from the forest, then men. The boy is shot—he's murdered. I can feel the pain of the bullets piercing my body. "I'm dying," I say.

Gabriel takes my hand, "No—not you. Come back now, Chris. Come back."

Fear and blackness overcome me. There is no way back.

But then I'm sitting on the scratchy couch, weeping in Gabriel's arms.

THE FOLLOWING DAY, I told Gabriel that I had to go—some lie about meeting a friend.

"I'm sorry to hear this," he said. "I feel like we've just begun."

For some reason, my hands wouldn't stop shaking.

Gabriel asked me to sit with him for a moment at the kitchen table. "It was good you came to me." He reminded me that as I headed back into the world, I must take with me a message. "The Space People are here, among us."

I nodded.

"And why are they here?" he asked.

My hands were out of control. "Love?"

"And why are you here?"

"Love?" I ventured again.

"Do you see?" said Gabriel. "You are not who you were when you came here."

I wasn't sure if he meant Earth or Los Angeles.

"Chris, those bad things . . . they all happened a long time ago."

He told me how glad he was to meet me, and then he kissed my forehead.

It went deep. I can still feel that kiss.

"You can always come back," he said.

But I never did.

30.

By the Grace of God

AFTER THREE DAYS OF HITCHING, I arrived in Tucson. Late August, 110 degrees.

Scorched and hungry, I found it hard to think straight. I knew that classes would be starting soon in New Jersey—my last year of high school. At the side of a road, I stuck out my thumb. But instead of heading east, toward home, I headed north, toward the high mountains. I needed shade and shelter.

A few miles from the base of Mt. Lemmon, I ducked into a tiny grocery store to buy a gallon of water, some bread and jelly. On a staticky radio, someone was talking about Vietnam—about how the

war had finally ended. When I heard a crash of thunder, I ran back outside.

The sky was half-black, a wall of monsoon rain sweeping across the valley. Bolts of lightning struck ahead of the downpour. I waited until the first icy raindrops stung my face. Soon I was soaked, shivering in a soggy T-shirt, dancing in the mud. *The war is over!*

As the storm passed by, the smell of chaparral rose from the ground, overpowering and familiar. Even without Donna at my side, the desert filled me with a feeling of home. Back inside the store, I reclaimed my meager supplies. The woman behind the counter chided me. "Are you crazy, running into the lightning like that? You wanna get killed?"

I smiled, set my things before her.

"That's all you're getting? Buy some jerky, you're too skinny." She held out a small plastic bag of shriveled meat—no label, closed with a twist tie. "We make it here."

I hesitated.

"Just take it," the woman said. "My treat."

"I don't eat meat," I told her. "But maybe I could take an orange?" She gave me a dozen.

WITHIN FIFTEEN MINUTES, it was dry again, the temperature creeping up. Patiently, I sat on my pack, waiting for a ride up the mountain. Finally, an old station wagon with Sonoran plates pulled over. A family on vacation.

The father jumped out and vigorously shook my hand, showing me his perfect white teeth. *"No inglés."* He hoisted my stuff onto the roof rack, tying it down with rope. I climbed into the crowded backseat, full of dark-haired kids all giggling at the blond boy in their midst. The girls pulled my ponytail. The mother, in the front seat with a baby, tried to communicate but I understood nothing. She handed me a big paper bag full of peanuts.

"Gracias," I said.

I took a handful and passed the bag to the kids. I was hungry but carefully dismantled the shells, eating each nut with slow pleasure.

Following the children's lead, I threw the shells out the window. For some reason, everyone was laughing, as if throwing peanut shells out a car window was the funniest thing in the world.

Then we all fell into a lull, watching the scenery, the cactus changing to forest as we climbed the mountain. I could smell pine and moss and water—the cool air. A short way from the top, I signaled the father to pull over.

As he untied my stuff from the roof, the whole family got out to say goodbye. The mother handed me a tortilla wrapped in wax paper. I put it in my pack for later, and then lifted the nylon monolith onto my back. Watching me stumble away, the children waved and cheered, like I was going on some great adventure.

AUTOMATICALLY, I HIKED to the Wilderness of Rocks, where Owen and I had spent our first night together. The view of the valley—seven thousand feet below—was astonishing. Tucson looked like a game board, shuddering in the afternoon heat. Soon Owen would be down there in the dust, back with his family from Idaho and starting the school year. I'd call him after I got settled, when I had a plan.

But I needed to be alone now, to think about all that had happened.

Though I was running out of dope, I wasn't ready to visit Valentine, to explain myself.

On the mountain, days were heaven. In the mornings, I went to the cliff and peed on the world. Then I ate an orange or two, a slice of bread and purple jelly. I hiked trails, jacked off in a dozen new places. In the afternoon, I'd sleep, draw in my sketchbook, or make up songs.

Olden golden, hat of piss
No one sees me doing this

On the ledge outside my tent, I built a vulture from broken branches and bits of string. Socks and dirty underwear, plastic and

tinfoil—everything became part of its wings. I added scraps each time I came back from a hike, until the bird was a scarecrow, looming over the valley. Something to protect me at night, when the wind would roll down the slopes and stir the forest. There were strange sounds, creaks and cracks, as if the mountain itself were waking.

In the vastness, I kept my fire small, feeding it carefully, twig by twig. On the hearthstones I placed quartz crystals, sheets of mica, the deer skull I'd found in the crook of a tree. The light of the fire charged each object with ancient meaning. I was falling backward in time as the city lights shuddered below, a separate fire, distant and cold.

It was only here, on Mt. Lemmon, that I realized how profoundly tired I was. Crawling into my blue tent, my mummy bag, I would feel the cold on my nose, the electricity of alpine air, and instantly I'd be asleep.

Without drugs, I dreamt vividly—not of clouds or crystals, but of my father. I could not escape him. He had followed me across the country, howling with hate. Waking in terror, I could feel him there—more real than the mountain.

I HITCHED INTO the valley once a week for supplies—always saying a prayer that God would keep me safe. I imagined He heard me, because I got to town and back easily, often in a single day. I kept postponing a visit to Valentine and a call to Owen. Regularly I forgot to call home.

The morning I woke to frost, I realized I'd been on the mountain for almost two months. Like Robinson Crusoe, I'd become a capable man, able to take care of myself. I built a hearth, dug latrines, set up an altar. I lounged on my Gabriel green pillow, writing poetry and brewing sun tea. Studied *Black Elk Speaks* and *The Essene Gospel*. Fasted and chanted (in a language only I knew). I watched the sky for saucers and when they didn't come wondered: *Could a person live alone? Live alone forever?*

Nature was indifferent, but not unkind. Autumn was beautiful. The aspens yellow-topped like me.

Down to maybe thirty or forty dollars—I was a backpacker slipping into homelessness. Back then I would never have said such a thing. The mountain was my home.

The Wilderness of Rocks was a labyrinth of towers and caves below the high peaks. My favorite spot was a ledge I called Sky Island. Small animals sometimes appeared there and watched me as I drew in my sketchbook—a coatimundi or a fox. They seemed unreal, like humans taking animal form.

Bears and panthers, I knew, were also near. I'd seen the stacks of bones, claw marks outside of lairs. Some nights I could smell the cats—not kittens, but cougars—a rancid musk. But I knew that if I let myself become afraid, all would be lost.

In the night sky, planets made shocking appearances, hanging in the void—rocks moving through massive time. I considered their reality, considered the cities of the universe.

Lonely, I waited on the moon, longing for her company.

I DIDN'T THINK about school.

I had other concerns, other studies. I made elaborate lists in my notebooks. All the people I'd ever met. All the places I'd been. So many things passed through my mind and traveled with me on the trails. A white-haired kid from third grade emerged like a hologram from the trees. When I said his name, he disappeared like smoke.

I wandered a hundred thousand acres of wilderness. The trees shuddered and the hoodoos swayed. I was an animal walking the earth, a feather-headed boy.

FOR MONTHS, there was no water in the canyons, no people. In the empty places I hung my hammock, swinging in silence, basking in the blinding light—no sunglasses, no sunscreen, no hat.

I did have a mirror, though—a small compact—and some eyeliner that Julie had left behind. I talked to the mirror, wore makeup by the campfire. I was slowly becoming someone else. *But who?* Not a man or a woman, maybe not even a human being.

Notebooks full, I sketched on any paper I could find—scraps and wrappers collected on the side of the road. I drew birds and trees with scientific precision. The drawings didn't survive. I burned everything for warmth. In town, I scavenged for books—read them twice before they went into the fire.

Not my Bible, though. Not yet.

CERTAIN DAYS I could feel electric currents sweeping across the mountain. The wind was tremendous. The sky was a bell, ringing. I begged God to show himself. But in the vastness, He remained carefully hidden.

I kept praying. Praying enabled me to make a story out of my predicament. I was lost but called it a quest. I called loneliness a search for God.

At the Tucson food co-op, I met a girl with a boy's haircut and overalls, burn marks on both her arms. We both had backpacks waiting by the register. I invited her up the mountain. She camped with me for a single night. She was mostly silent. I couldn't stop talking, though. She asked me to tell her more about the UFOs. No one else ever had.

We shared a chocolate bar by Power Line Trail. We slept together in an aspen grove, under fluttering leaves. In the morning she was gone. Said her name was Moonshine, *Moon* something.

SOMETIMES SADNESS GRABBED hold of me like the flu. I wouldn't even make a fire, just sleep, lose a week or two.

I missed Pauly, Owen, my brothers Michael and Steve.

Jingle had once explained to me that our bodies could meet on the astral plane—*bodies of light*. Out in space, I imagined Owen—saw him like a flame on a map. Sent my astral body out to find him. In some luminous picture, I kissed him, held him, mixed my ghost inside of him.

Deep in the night, I stirred the spheres, sent Owen a burning ray.

The moon roared above my hallucination. A bitter wind swept down the mountain.

The trees vibrated like metal wands. Angels hissed.

I don't know how I lasted up on the mountain for so long. I froze. Sometimes I hardly ate. I never cooked, never made a warm meal. Maybe I was capable of photosynthesis. There was strange blood in my veins.

I did not plan to be so alone. I just fell out of the habit of being with other people. But the moon—my spangled goddess—was always near.

DELIRIOUS, I WROTE long, loopy letters—to Julie, to Sean, to my mother. My head was full of saucers, Venusians, past lives, past deaths. Some letters I was brave enough to mail.

Years later, I tried to hunt down those letters, to understand my state of mind. It turned out my mom had saved everything I sent her. At first, she was reluctant to give them back. Maybe she wanted to protect me from myself—from knowing how undone I really was, how close to madness. Recently, though, she sent me an envelope dated *Tucson, 1973*. I don't remember the letter at all—eight pages of meticulous penmanship, addressed to *The Rush Family*. Mom told me that she shared it with no one.

The letter begins with an apology for my poor writing skills. Then I dive in.

There are no words to describe all the wonderful things that have happened to me. They're all inside me now.

I explain that I'd met a man named Gabriel Green and describe his contact with extraterrestrials, his beautiful home and library. I claim he is a genius.

At present, he is in telepathic contact with the Master Souls of the Great White Brotherhood. He has been appointed to unify the Forces of Light.

He has shown me how to pierce the veil between the conscious and super-conscious mind, allowing me to tap the soul records.

I explain my regressions, every florid detail.

The Allies had bombed my home and killed my family and then I, myself, was shot in the back. I could feel the bullets going in. Remembering that made me cry.

There are dark forces all around, but we are entering a New Age.

I tell my family not to worry.

In the next few years, the ships will land. Gabriel has promised me it won't be long. He has become like a father to me.

On the top of the page I've drawn a picture of myself signaling a saucer, beckoning it to land.

The future is promising. Gabriel is forming the United World Church, a consolidation of all religions. He will soon ordain me as a minister and I will travel America to spread the Truth.

We are entering a time of great opportunity. When the time is right, I will return and answer all your questions. By the Grace of God, I will take you back to your past lives. You will understand everything.

31.

The Valley

I'M SOBER, FILTHY: my mind's been blasted clean.

I'll go down from the mountain, call Owen. I need to see him. I need to tell him things. Maybe I'll stay in the valley for a while, get a job at the library, filing books—quiet days in cool, musty rooms. I'll meet Owen after work and we'll . . .

My stomach growls. I'm squinting in the too-true sun. Since I've lost Julie's compact, I comb my hair blindly with my hands. I really have no idea what I look like—or how I reek of smoke and sweat.

When I approach the pay phone, I feel confident Owen has received my ray of light—that he's expecting my call.

When Lily answers, she's polite—and, as ordained by On High, she hands the phone to Owen.

"Chris?"

His voice unmasks me. I feel like a fool. I apologize for everything that happened last summer, for Julie and Sean. I tell him I'm here in Tucson, that I have to—

Owen interrupts me. "Let's not talk on the phone. Why don't we meet?" He's whispering—maybe the Lieutenant is listening.

I ask him if I should come to his house.

"Are you nuts? No." He asks if I'm going to watch Kohoutek. "Maybe this weekend, we can camp or something?"

"Yes," I say, flushed from the miracle. How could I have forgotten about Comet Kohoutek? Timothy Leary said it was the harbinger of the New Age.

"So Owen, let's meet at the gas station at the base of Mt. Lemmon. Okay?"

And then I asked him if he knew what day it was.

THE MIRACLES did not cease.

A few days later, I was on Speedway, hitching back from the co-op, when a little black Mazda swerved over. The driver flew from the car, grinning like a crazy person. His embrace nearly knocked me down.

"Chris!"

For a few seconds I didn't recognize the handsome short-haired man in slacks and shiny shirt.

"Flow Bear?"

"How are you, man?"

It was shocking to see the big hairy hippie who'd driven me home from Tucson—transformed into a clean-shaven businessman. From the passenger seat, a slender girl my own age waved up at me.

"That's Laney, my new wife."

I waved back at the girl, blushing, remembering how pervy Flow Bear had been during our cross-country drive—and later in the Pine Barrens, his finger in my mouth.

"Dude, you look terrible," he said. "You're a fucking bag of bones."

"What happened to your car?" I asked. "The big blue—"

"The Chevy? Oh, she finally died. But nothing wrong with this number, huh?" He stood beside the sleek import, beaming like a movie star. Clearly, love had remade the bear.

Laney said, "Maybe we should give your friend a ride?"

She had long blonde hair like me—with silk scarf, safari jacket, diamond ring. A flower child fallen on good times.

"Of course he's coming with us! Hop in, buddy." Shook his head. "I think you need some dinner."

THEY WERE STAYING at a swank 1930s hotel—pink, with swaying palms and a croquet lawn. They let me take a shower in their room. Laney gave me a clean T-shirt.

"Out here for a bit of work," Flow Bear told me.

"And our *honeymoon*," added Laney.

I asked about my sister.

"She's worried about you, dude. She says she hasn't heard from you in a while."

"How is she?" I gushed.

"Fine. Still living with Our Savior."

I knew he meant Vinnie. Flow Bear had never been religious. He sold drugs to make money, not to enlighten.

When he asked if I was going to Valentine and Jo's for Thanksgiving, I felt embarrassed. I'd been meaning to get in touch with Valentine but kept putting it off.

"I wasn't invited," I said.

"Fuck that," said Flow Bear. "You'll come with us. Where you staying?"

"I'm camping right now. Kind of a retreat."

Flow Bear rolled his eyes. "You're like the last holdout. Well, no camping tonight—we've got the suite. You can have the couch."

. . .

AFTER A LONG DINNER—Flow Bear and Laney eating steaks and drinking wine, while I had lemonade and lasagna—the three of us went back to the room. I settled on the couch (too short for me) and Flow Bear followed Laney into the bedroom. He shut the door only halfway. For the next hour, I could hear them having sex—and, from my position on the couch, could even see Flow Bear's hairy ass moving up and down. I tried not to look. I looked.

In the middle of the night, I woke to the smell of pot. Flow Bear was sitting naked on the armchair beside the couch, smoking a joint. He said I was making noises in my sleep. Each inhale lit up his face like a taillight braking.

"I just wanted to check on you, kiddo."

THE NEXT SATURDAY afternoon, I stood in front of the gas station in my denim shirt, stream-washed and wrinkled. I was half an hour early, and Owen was half an hour late. He arrived in a new blue pickup.

After a hug-less hello, we headed out to the desert, high speed on dirt roads, barely saying a single word to each other. I tried to communicate telepathically.

Then Owen said, "So are you and Julie still a thing?"

"Nah," I said, "she can't deal with my lifestyle."

I sounded like an idiot.

Owen kept driving, deep into the desert, far from anyone. That was a good sign. Together we put up my blue tent and spread out our sleeping bags side by side.

"Thank you for coming," I said.

"My dad says the comet should be brightest just after sunset," Owen replied.

He had plastic containers of food from Lily, which he shared with me. When I tried to take his hand, he pushed it away. "Later."

For an hour, we watched the sky. We saw nothing—only pollution and contrails.

"Fucking joke," said Owen. He went into the tent and undressed. My heart was racing, my dick so hard it hurt. Owen's looked the same.

"This is the last time," he said.

I hoped he meant that this was *like* the last time—the two of us naked together in a tent.

"Why are you smiling, Chris?—I mean it. This is the last time *ever.*"

I knew boys had to say things like this.

We fell on top of each other—and it didn't even matter if this was the last time, because it went on forever. All night, we made up for the comet's failure—coming across each other's face and back and chest. The final orgasm sending me into a dreamless cavern of sleep.

In the morning, Owen was beside me, still naked, still hard—but when I tried to touch him, he said, "What did I tell you? No more. Don't ever touch me again."

"What's wrong?"

"Nothing's wrong. I have a girlfriend now."

"So why did we come here?"

His face went red. "I just felt sorry for you."

I reached toward his ridiculous erection.

"Get away from me."

"Please, Owen."

"Stop begging. You're disgusting."

He kicked me away, threw on his clothes, and dragged his sleeping bag outside. A moment later, I heard the truck take off.

I stayed in the tent all day, like a bug hiding from the sun.

When I finally went outside, I saw that Owen had left me some food, but an animal had found it first—a trail of Lily Dip across the dirt.

BACK ON MT. LEMMON, I wrote a letter to Gabriel. In great gushy gasps, I begged. *Please teach me how to use telepathy and contact the aliens.* I crumpled up the page and threw it from the edge of Sky Island, certain it would reach him.

· · ·

THANKSGIVING DAY.

Valentine and Jo's new stash house was a rambling adobe near Cat Mountain, far south of the rock I called home.

Flow Bear and Laney led me down the hallway. "Look who we brought!"

"Christopher!" Jo hugged me. "What are you doing out here?"

It was hard for me to talk around so many people—but hunger, it seemed, was a kind of truth serum. "I don't know. My parents don't really want me at home."

"Don't be silly. They adore you."

"My dad pointed a gun at me. And a knife."

Jo looked confused. Everyone else went quiet.

I was out of practice being a human.

In the living room, I could see some older guys smoking reefer with Valentine.

When I walked in, he stood and handed me the joint.

"Hawaiian," he said. "Some of the new sinsemilla."

I hadn't smoked in a while, and as I puffed, Valentine smiled. "Good, right?"

"Excellent," I said. "How much?"

When he whispered the price, I was shocked—a single joint would be as expensive as a bag of groceries.

Immediately, I was stoned. I stumbled, nearly knocking over a lamp.

Jo rushed in and said, "Come with me. Let me fix you something."

Valentine went back to the men—customers, I suppose.

In the kitchen, women were chatting and cooking—all of them in peasant dresses from which milk-laden breasts kept flopping out. Babies in all directions.

"I wish Donna was here."

"We all do, Chris. Are you okay? Here, have some salad."

BEFORE DINNER, the men wanted to play football—a dumb idea in the desert, where every plant was needle-sharp. It was a blustery

afternoon, everyone in sunglasses to keep sand from blowing in their eyes. Having no shades, I squinted against the wind.

Flow Bear kindly picked me for his team.

I knew nothing about football and could barely understand the men's gestures and grunts. At one point, Valentine ran over and knocked me to the ground. As I brushed the dirt from my legs, I saw that my jeans were ripped, and that my knee was bleeding.

Flow Bear helped me up.

Valentine, who'd just made a touchdown, was grinning.

I went inside to clean up and stayed in the bathroom until I heard Jo's voice: "Dinner!"

I took a seat across from Valentine, but he didn't look at me. After he gave his ridiculous grace—more bragging than gratitude—he delivered a sermon to the assorted men, who were no doubt there to buy heaps of Hawaiian.

"God bless the smuggler and his load."

Most of the men laughed, but Flow Bear shook his head and winked at me.

I couldn't understand why Valentine refused to catch my eye. I wanted him to recognize me, to give me his approval. This was the man who'd given me my first tab of acid. Didn't he see that I was still on the path—*still searching for God*?

All through the meal, I was silent as Valentine performed for the dealers. "Without us, no one gets high. It's our dharma to offer up this service."

Warm and full of food and dope, I began to relax. I remembered my mission. I remembered Gabriel. When I spoke up, my voice sounded thin and high.

"I saw a flying saucer this summer. They're all over the place now. I think maybe this is also part of the story, you know—the Space People and how they want us to change. I'm confident they'll be here soon."

Everyone was silent.

I continued: "I hear that if we all visualize the ships, that'll encourage them to come even sooner."

Valentine looked at me, finally. He was glaring.

The dealers took their cue from him. One of them, a short-haired guy with a Brillo mustache, said, "That is such bullshit. Why don't you give it a rest, kid?"

Valentine reclaimed his power. "Jo, bring out the coffee. Gentlemen, let me show you something in the living room."

As he stood and walked away, I felt like I might barf. Maybe I wasn't used to eating so much.

And I kept thinking of Judas. Had I somehow betrayed Valentine?

Sitting alone at the table, I sensed that I'd failed some kind of test. Valentine had allowed me a place at his table, and I'd fucked it up.

I waited quietly, until all the deals were finished. Then, when the coast was clear, I asked Valentine if I could speak to him alone. I asked him if he could front me some product.

"I'm not a charity—maybe you should pay me sometime."

I was confused. I always paid him—though it was true, sometimes it took me a while.

"And you never move any weight," he added.

I told him I wanted to enlighten people, but that it was just difficult to sell right now in my situation.

He frowned. "What happened? I had such high hopes for you once."

Hadn't I heard those words before?

"But you're family, so . . ." He led me to his stash and assembled a bag of fine product: Kona, Afghani, blue microdot. Then he shook my hand and reminded me how much I owed him.

THAT NIGHT, Flow Bear and Laney drove me up the mountain. I was relieved they didn't want to see my crazy camp with its altars and shrines. Parked in a dirt pull-off, we sat in the car, talking.

Flow Bear said, "Chris, let me give you a little advice. You don't have to say everything that crosses your mind. It's okay to have secrets."

I blushed.

"Don't take it to heart, kiddo. It was a business dinner, you gotta play by the rules."

Flow Bear had bought some product from Valentine, too.

"Let's have a toast before you go."

I expected a joint of Hawaiian, but instead he signaled to Laney—who opened her purse and took out a bag of powder.

"Oh, no thank you," I said.

"What? You don't approve? I know Valentine hates this shit, but everything's changed, man. It's a new world."

Flow Bear applied a delicate line to the soft spot on the top of Laney's hand and snorted some up. Laney took what was left.

They both beamed.

Flow Bear poured some more and Laney held out her hand toward me.

Since Valentine wasn't watching—since maybe *no one* was watching, not even God—I accepted their generosity.

"Call me when you get back to New Jersey," Flow Bear said. "Will you call me?"

When I nodded, he kissed me on the lips.

Laney smiled.

32.

The Biggest Trees on Earth

AT MY CAMP, THERE WAS no sleep. After partying with Flow and Laney, my mind was doing some ferocious math, most of it beyond my comprehension. It was a cold night. I built my fire a little larger than usual, but I could barely sit still in front of it.

Flow Bear had told me that Lu was selling coke now, too—and that Jingle had left him. This was upsetting to me. In my head, I tried to put the two of them back together, make them fall in love again. Wasn't I capable of such things?

I was confused, sad, angry, horny.

Fuck Valentine! became *Fuck Flow Bear—Fuck Laney*—but they

were different kinds of fucks. My thoughts were deranged. Cocaine was like some mad star I had to race to keep up with.

And then I crashed, crawling into my tent with a sense of digging myself into the center of the earth, as far from the stars as I'd ever been.

THE BIRDS WOKE me up.

I put on my shoes and stepped outside into hazy light—rays of smoke like God in a painting. The ground was simmering—*and red. Shit!* The campfire had spread. The ground, covered with pine needles, had ignited. I tried unsuccessfully to stamp it out with my boots. Then, digging with a flat rock, I attempted to get under the flames, before the whole forest went up. Screaming, I scooped up the burning needles and sticks and consolidated them into a smoking mound, four feet tall. It was a glowing volcano, dangerously alive. I ran back and forth to the spring twenty or thirty times, and after a couple of hours, the fire was finally under control.

I was a wreck with blistered hands, staring at the destruction. My tent mostly survived but my vulture-sculpture was ruined. Laundry and sketchbooks burned, crystal altars scattered. The deer skull was black and smoking like a demon. I was filthy, out of breath.

Die. Die.

The voice of my father.

But the mountain was silent. I stared at the ground. I did not pray. I did not ask for anything. Just let the emptiness of the mountain overtake me.

IT WAS GETTING much colder. At night my jug of water froze.

During the day, I kept moving. I climbed the hoodoos—no ropes, no fear. I was becoming strong. This surprised me, having always assumed I was a weakling. I began to push myself, leaping across crevasses hundreds of feet above canyon floors. I tested my limits, plunging into pools of snowmelt.

I did not die.

I just got lost sometimes. Without a map, I stumbled upon the famous places before I'd ever heard their names. *Devil's Bathtub, Seven Cataracts, La Milagrosa.*

I walked for miles, sometimes with my pack, so that I could collect specimens—quartz and agate, jasper and fossil—carrying it all back to my camp, moving it with me wherever I went. There were always more rocks in my pack than food.

Occasionally, on some lonely trail, I would run into a stray hiker, usually a man wearing too much gear—German camera, multiflapped hat—who might offer half a sandwich to the hungry-looking kid. Then I'd fly back up the mountain like a mad goat—long legs, purple sneakers, a blond blur.

WINTER.

A foot of snow.

Dressed in three sweaters, I put cayenne in my socks.

But my food was frozen and, despite the pepper, so was I. I had to leave the mountain—had to go down into the world. The valley was still warm, a world of palm trees and swimming pools. Cautiously, I set up camp on the edge of town, on private land—a rat in the desert.

My money was pretty much gone, but I refused to worry. I called home a few times—collect—but then hung up after someone accepted the charges. I just wanted them to know I was alive.

I'd survive, somehow. I still had some of Valentine's product to sell.

Besides Owen, there'd been another boy at Red Rock whom I'd become friends with—a stoner named Walter. When I called his house, his mom told me he was now at the University of Arizona. She told me how to find his dorm room.

It was good to see Walter again. We looked like brothers, both of us long-haired Irish mutts. Walter was happy to help me move product.

Every week, I'd drop by his dorm to sell drugs to whomever was around. Walter would let me crash in his room and take a shower. Hanging around the dorm, watching students head off to class, tennis, dinner, I began to realize what a true weirdo I'd become.

All of Walter's friends had clean clothes, new cars, and cash from home. They were dorks with bad haircuts and bright futures, carrying around books instead of rocks.

Was there another version of myself headed to Yale?

If so, I'd lost track of him by then.

Valentine had always taught me that it was better to deal dope than to be *part of the machine*. These college students perplexed me. The machine did not seem to be tearing them apart. They looked like they were having a splendid time.

A FEW DAYS before Christmas, I called home from an outdoor pay phone. It was cold, even in the valley. I stood there shivering, listening to the phone ring. My brother Michael answered, accepted the charges. I did not hang up. I quickly asked him how he was before he could ask me.

He rattled on about wrestling, his girlfriend, his driver's license. Then he told me I should mail him some LSD.

I said, "Maybe I'll visit instead."

"*Who are you talking to?*" I heard someone say to Michael. I knew it was Mom.

"No one," he called out, before whispering into the phone, "I won't tell them you called."

"Why not?"

"They're being pretty cool right now. You'll just get them mad."

THERE WERE VOICES in my head, but I knew I wasn't crazy. Because they were the voices of real people—my father and mother, Owen, Valentine. Sometimes they were so present that I would turn, certain one of them was behind me.

Alone, I was skittish. Smoking weed with Walter, I felt better. Walter was kind. He watched out for me.

After the holidays, he dropped out of college and moved in with a wealthy divorcée. He was having the time of his life. His lover was a gorgeous bottle blonde, maybe thirty-five, who'd just escaped a bad marriage. She was beginning a new life, in a big new house. On her front porch, she brushed Walter's long hair like he was a prize pony.

Her name was Susan—and she loved not only Walter's long hair; she loved good weed, too. She was happy to pay a premium for better product. Often, she let me sleep in the spare bedroom after a delivery. Walter was already very comfortable in the master suite.

One night Susan said to me, "I envy you. You won't have to get married—you should thank God for that."

I told her that, actually, I had a girlfriend.

"Oh honey, *you're gay*. And luckily you're very sweet and very handsome. So, can you bring me more Hawaiian next week?"

Despite the standing offer of a room, I sometimes chose to sleep in the desert. Susan's house reminded me too much of childhood— the fresh towels, the folded clothes, the panoply of televisions. In the guest-room bathroom was a skylight, a sunken tub, a huge mirror. My hair was a shipwreck, my clothes dirty—I didn't belong there.

IF I DISAPPEARED for too long, though, Walter would come by my camp and try to coax me into town. "Come on, you might make a sale." Sometimes, I went with him.

One night, Walter dragged me to a kegger—a bonfire ten feet high surrounded by bored teenagers. After a while, he went off to get his girlfriend, who lived nearby. I stood there feeling lost when two drunken cowboys showed up, looking for a fight. I knew them both from Red Rock High. Handsome Bo and a badass named Jimmy Lynn. Both were short—and mean.

They strutted about, all boots and chew. Their cowboy drag was

laughable. They looked like fourth graders dressed for a birthday party.

Jimmy caught my eye and I looked away, fast as I could.

Not fast enough. The boy snickered.

As I walked away, his voice followed me: "So, Chrisss . . . are you a *queeeer*?"

I kept walking toward the desert.

Bo yelled, "Hey, my friend asked you a question!"

Jimmy blocked my path—and in a single gesture threw me to the ground, his knees against my shoulders. "We *all* want to know if you're a queer." This time, the question came with a flash of metal— the barrel of Jimmy's pistol pressed against my forehead.

Terrified, I said, "No."

"Are you sure?"

"No. *Yes*."

"I think you're a faggot. Are you a faggot?"

I was quiet.

"There's one bullet left in this gun."

I looked into his crazy, radiant eyes. It was too dangerous for me to be scared.

"Are you a lucky faggot?"

"No, Jim. I am not."

He spun the cylinder, pulled the trigger.

Only after the hollow click, the hammer back in its place, did I become aware of all the other people gathered around, watching and laughing.

Jimmy dismounted me, then lifted the gun to the sky and pulled. Girls screamed as a bullet blasted into the clouds.

THAT SPRING, I hitched north. Went to the Grand Canyon, the San Juans, the Sierras. I had no plan, just a couple of twenties in my pocket. Sometimes I'd waste money on postcards and send them out in every direction: a thank-you to Gabriel Green, a note to Sean and Julie, to my sister. *Thinking of you. I'm by myself, standing next to the*

most amazing waterfall. Wish I had a camera. I told them they could write back to me, if they wanted, at the Tucson Post Office, Main Branch, General Delivery.

Back in Tucson, I bought product from Valentine, sold what I could, and used the rest myself. By this point, Valentine was no longer much of a mentor. It was just business now. Whenever I picked up product, he still gave his sermonettes. But I didn't listen.

I CONTINUED TO move around. Sometimes I'd drift into California and back, always hitching, always waiting for someone interesting to pick me up.

Hitchhiking is a kind of blind date. A car pulls over and you look for clues, hope for hope. It's true—in the back of my mind the white pickup always waited, the memory of being abducted and left for dead. But who can live in fear forever?

At one point, I ended up in the Mohave.

In the hours waiting for a ride, I'd always force myself to relax. On some unnamed patch of sand, I would sip water and watch the sky. Sitting there on my pack, eating single sunflower seeds, I did not think of the future or the comforts of home.

In the inexhaustible light, I was changing. My hair had turned white and wild, my blue eyes eerie against a dark tan. More than once a driver told me, "I had to pick you up—you looked like an angel." I'd bow my head and get in.

That day in the Mohave, west of Needles, a small pickup finally pulled over. An older guy with rough hands and worn-out boots. He said he had a house near Barstow with his wife.

"Do you need a place to sleep?"

I tried to read his face. I'd gotten pretty good at it. "Okay," I said, with a fake deep voice.

The house was small but very neat, on a scrappy hill above town. With my backpack, I could barely fit in the door. The man's wife showed no surprise to see a blond giant standing there. Her name was June. She said dinner was in fifteen. She showed me to my room.

I had not slept indoors in weeks, maybe months. Putting down my pack, I sat on the bed, on the blue plaid cover. Around me: model cars, schoolbooks, the *World Book Encyclopedia*. Everything in perfect order.

When we all sat down to dinner, the husband seemed tired, but his wife was all smiles.

"Tom says you're from New Jersey."

"Yes, ma'am."

"Are you a runaway?"

"No, ma'am. I call home every week."

"Well, I hope you're hungry."

I was. As I ate seconds, Tom asked me, "So where you headed?"

"I'm going to Sequoia. To camp out."

"Then?"

"Oh, I never know."

After dessert, I watched TV with them. Looking away from the screen, I saw the picture of their son on the mantel, a blond boy around ten years old, in a cowboy shirt. Between a younger version of June and Tom, the boy smiled.

He was dead. I knew instantly. I excused myself.

June said, "I put fresh towels in the bathroom for you."

"Thank you for dinner, ma'am. It was really good."

After a shower, I ducked back into the boy's room, wrapped in a towel, my long hair dripping on the floor. It felt strange to be standing there naked, looking at some kid's toys and teddy bears. Inside a notebook, I found his name: *Stanley, Sixth Grade.*

I leafed through the pages. The writing stopped in May of 1968.

The boy's bed was too small for me. I slept a bit and then left the house before dawn, without making a sound.

For a few days, I couldn't stop thinking about Stanley. Said his name like he was there with me in Sequoia National Park.

Stanley, look, man—the biggest trees on Earth!

· · ·

I'D BEEN WANDERING for months. On return trips to Tucson, sometimes there'd be a letter from Julie or my sister at the post office. Never any from Sean. In one of Julie's she wrote, *I wish it had worked out.* My sister wrote something similar.

I received a measured reply from Gabriel Green, typed on Amalgamated Flying Saucer Clubs of America stationery, suggesting that I find a spiritual teacher more qualified than himself. Until then, he encouraged me to "watch the skies and ask for God's help." It was a nice way of telling me to get lost. I was crestfallen. Somewhere in the back of my mind, I had always been ready to hitch back to L.A. and offer my services to Gabriel.

I'm not sure what those services could have been. After so much time alone, I was barely equipped to have a conversation. I'd lost hold of normal life. I could take drugs, and on a good day sell a bag or two. But I was in a kind of mystic haze, wandering the worn-out hills. And I knew what I was becoming.

Sometimes, like shadows, other drifters would pass by. Men with only the clothes on their backs, maybe a bedroll across their shoulders. They moved lightly across the land, always flickering just out of frame. Like me, they waited for rides on the on-ramps.

One rainy day, a truck picked me up, and then a drifter just down the road—an old man in a ragged dinner jacket. The geezer sat up front with the driver and me, saying nothing, just rolling cigarettes and smoking. His face was a worn wooden mask, like nothing I'd ever seen. It frightened me. I could feel the cold on him, the tremor. It was like he'd been outside forever. After an hour or so the rain stopped and he asked the driver to pull over.

The old man got out and stood on the shoulder of the road. Facing me, he bowed deeply, reverently—storm light flashing in the distance. The image was burned into my heart, and the message that came with it: *Once a boy, now a beggar.*

33.

Brief Landings on the Earth's Surface

THERE WERE GLORIOUS MORNINGS in Tucson—the sky washed to absolute crystal, the valley new with sun. Still, the sadness would hit me now and then, and I would fly back up the mountain. I would lose weeks. Sometimes Walter would come to find me. He always smelled good, like a box of crayons.

"You should come down," he often said. I knew he meant from the mountain—that I should get a place in town. But I felt that God was with me on the mountain—and I was afraid to abandon Him.

I looked for signs, searched the caves and canyons.

In my notebooks, I wrote phrases I do not understand now: *Into the keyhole, a yellow bird.*

ONE DAY, I came back from an early morning hike to find my tent shredded by a bear—my remaining food splattered like a crime scene.

Maybe it was time to live among humans again.

In Tucson, I found a rental.

After so long without a roof, the Covered Wagon Trailer Park didn't seem so bad. Strategically placed between a sewage treatment plant and a cemetery, some days it smelled like flowers, other days like poo. But the trailer I rented was cheap—thirty bucks a month, no deposit, no lease.

The other residents of Covered Wagon were working-class retirees, warming their bones in the desert heat. I was the only kid on the premises. My landlady, Geraldine, lived in one of the better trailers, with a patch of Astroturf and a birdbath filled with pebbles. She had African violets on her windowsills and photos of delicate grandkids—but Geraldine was all brass. Husband dead, muumuu slipping, she was a midday fright. Rouge, red lips, eyebrows painted in like big black frowns, she stayed close to her afternoon soaps, beer in hand. She reminded me of Loey.

Right off, Geraldine asked me if I was *some kind of he-she*, adding that I should take no offense to her question. "You pay your rent on time—don't matter to me if you kiss a cow."

After the mountain, the trailer was disorienting. With each step, the capsule rocked from side to side. The toilet was in the shower. The windows were portholes. The view was nil. It was a crashed spaceship.

UNEXPECTEDLY, I RECEIVED a letter from Sean. He'd graduated from high school; was thinking of moving to San Francisco—but maybe he could stop in Tucson first? He apologized for his "tardy reply" to my letters, and said more than once how much he missed me. But

what moved me most of all was that he'd begun the letter *Dear Poopinita*—a nickname he'd given me years before in New Jersey. I read the letter and wrote him back in a rush of emotion: *You are welcome here. Whatever I have is yours.*

As if I had anything to offer.

A MONTH LATER, when Sean arrived at the trailer, he was shocked. "Is this how you've been living?"

I gave him the bed-sized bedroom. I crashed on the kitchen floor.

During the day, I dragged Sean to my favorite spots in the mountains, though I think he would have preferred to drink beer in the trailer. We walked and talked—and though it was good to see him, we seemed to bring out a weird mania in each other. Often we had long conversations, the two of us talking about completely different things—Sean about music in San Francisco, me the mountain and the road.

At the trailer, sometimes it was hard to talk at all because of the racket from next door: an old couple howling in torment. For weeks, I'd assumed they were in pain—but when Sean informed me that Grandma and Grandpa were having sex, I realized he was right. The old woman's orgasms were particularly disturbing, not unlike the screech of tires before a crash. Sean would turn up his transistor radio as loud as he could. "We need to get laid, man. And *not* like that!"

Sadly, Sean and I could never sleep with each other. We were too similar—both of us on the edge, barely hanging on. No matter how much we tried to hide it, we could see each other's madness.

ONE WEEKEND we decided to camp in one of the canyons. We found a deep pool and swam. The water was freezing, but the sun was glorious. We ate tangerines and smoked hashish.

Then, in the afternoon light, I saw something glitter in the scrub.

I said, "Sean, look. What is it?"

Walking over, we found a kid's bicycle, chained to a tree. It had obviously been there a long time—tires shredded, padlock corroded into an awful red fist.

Why would someone carry a bicycle into the mountains and just leave it there? And where was the kid? We were miles from a trail, miles from civilization.

Sean shook his head and laughed. We went back to the stream and lay naked together on a rock. The rest of the day, we were completely silent. Drowsing in the sun, I listened to Sean breathe. It was the law between us that we would never talk about the terrible things that had happened to us—about the men who'd carried us away.

The scars on Sean's neck like crossed-out words.

SEAN TOOK PICTURES with his Instamatic.

I still have a few from that time, the two of us smiling as best we can, sunburned kids with big square mountains behind us. In one picture—taken by whom?—we're naked in a mountain stream, standing side by side, like soldiers. Sean is handsome as the Sphinx. The water is icy, but we are stoic. I remember perfectly the clear water, the golden pebbles shimmering beneath our feet. When I look at this image, forty years later, I wish I could move my arm and put it around Sean's shoulders.

SOMETIMES HE WENT BLANK. A fog would overtake him and he'd stare off, distant and unhappy. I'd see his mind working, his mouth moving in some secret conversation. I knew that, soon, he'd start screaming.

One night, the two of us were sitting beside a small fire pit outside our trailer, and Sean began to rant. I could only understand some of it: "This isn't what I want. This is *shit*!" He took the sunglasses from the top of his head and threw them in the fire.

I said, "Okay, Sean, calm down—whatever you need. I promise, I'll help you."

I pulled his sunglasses from the flames, but they were already shattered.

The next morning, Geraldine came by to say, "I can't have the two of you making a ruckus."

"*Us?*" screamed Sean. "What about the fucking howler monkeys next door?"

I told Geraldine I was sorry, we'd keep it down.

Sean glared at me. "Why are you apologizing to *her?*"

IT WASN'T JUST Sean who was losing it. I, too, had trouble living with another person. The trailer was stifling; without the sky overhead, I was growing anxious. When Sean fell asleep, I'd leave the trailer and walk the dry riverbed of the Rillito, talking to the stars.

Not long after Sean's outburst, he informed me that he'd gotten a job as a waiter, and that he'd found another place to rent. He said he wanted to give Tucson a go. And then he told me I should call my family—ask for help. He was probably right, but all I said to him was: "You owe me ten dollars for the pot."

After he left, I got wasted for days.

I DIDN'T CALL home, but I decided to try for a job. I filled out a few applications, made up answers about experience and the length of time at past residences.

Finally, I got work not far from the trailer, as a dishwasher at the Miracle Motel.

There was no miracle. The neon sputtered. The plants were plastic. The manager's office smelled like Ben-Gay and BO.

On the way home, past hookers and bums, I'd buy a quart of Coors—sixty-nine cents. Sitting on the steps of the trailer, I thought of my father and raised a toast to him.

Thanks for nothing.

As I lay on my lumpy mattress, I knew I should find someone to share it with. I longed for Owen and hated myself for missing him.

Every day, I trudged home from work with a cold beer—my reward for being an adult.

SOON I STARTED to stray, started to miss work.

After a few months, I finally quit my job and left the trailer. I went back to the perfect pleasure of owning only a backpack. I could feel my mind expanding. This was not always good, as I slipped easily into mania. One day, returning from a ragged trip north, I wrote to my sister.

> *How can I find the words for all the things I'm feeling? I've experienced such beautiful places: the Badlands, Devils Tower, and the Bighorns. In Yellowstone, I woke up to an inch of snow and a giant moose! I was in Tucson with Sean Carney but we're not together now. I want to get a job and a house. I worry about stuff but try to trust in God. I'd rather believe in too much than in nothing at all. I think Sean has problems, though. I think he's brain damaged. Did you know that when he was little he was abducted?*

As I wrote, Sean morphed into me. I recounted what had happened in Albuquerque. Putting it down in words was frightening. Still, I kept writing.

> *I escaped before they could do anything. Mom doesn't like me to talk about it, but it wasn't my fault. Probably Mom and Dad think something did happen, like what happened to Sean. Is that why Dad hates me? I know you tried to protect me, Donna.*
>
> *I don't mean to be negative, but why do people want to kill us?*

I kept the letter for a long time and read it often. Even now, I can pretty much recite it by heart. When the cold came, I burned it along

with lots of other things, including, finally, the Gospel—a gray paper-back of the New Testament ridiculously titled *Good News!* I watched the flames turn the pages.

DURING THE WORST of winter, I crashed at a hippie hideout on the edge of town. The place was a jumble of apartments—lots of stoners sitting around, getting wasted. At first, it was all very friendly, but then I noticed people watching me. I didn't realize how feral I'd become. I tore through everyone's food and smoked all their dope—the whole time going on and on about the sacred mountain and the Holy Spirit.

Eventually, they asked me to leave.

IN THE BACKCOUNTRY of Sabino Canyon, I set up camp on the edge of a cliff.

Lost and lonely, I wrote letters to my brothers Michael and Steven. The prose was maniacally cheerful—I called them *my little bunnies*. On all borders, there were drawings of the desert, spaceships, and oversized stars. Pretty much every word was a breathless exaggeration: *I swim every day under huge snowcaps, there are rainbows every-where. Please come visit me. I'm carving a hobbit-hole in a cliff!*

Instead of selling my drugs in Tucson, I began mailing packages to my brothers, as Donna had once done for me. In return, they sent me enough money to live.

There are UFOs, I wrote, *like crowns in the sky.*

ONE DAY, when I was thumbing to the co-op, a yellow Camaro pulled over—red pinstriping, chrome hubs. It was Dino, a friend of Walter's who'd scored from me a couple of times. Dino was a rich kid, a lawyer's son. Dressed like a greaser, in short hair and tight pants, he rolled down his window and smiled. "Small town, small town, get in, get in"—he liked to repeat things at least two or three times.

I told him I was headed to the co-op, but he said, "No, no, no. Come with me."

Dino was cute and I wondered if this was a sex thing. But then he said, "My buddy and I are moving a fair amount of product—speed mostly, mostly speed—but we'd like to branch out. I know you've got good connections. Really good connections. Maybe you could set us up?"

He said he'd be *very appreciative.* Twice.

He shook my hand, sealing the deal before I'd said a single word.

Dino's partner was a kid named C. Carl Duclane, who came from a rich ranching family. He was bald and pudgy—the first person I ever met who shaved his head. When I walked in the door he shook my hand—way too hard. Like Dino, he spoke so fast it was almost a foreign language. *Sowhatarewedoing?*

Everything in their apartment was big—big stereo, big bong, big pistol on the table. While I sat on the couch, Dino and Carl conferred in the next room. I could hear them chattering like chipmunks. When they returned, Dino said, "Okay, okay, so we decided that you should stay here—you wana stay here? You could sleep in the dining room. There's room under the table. That could be, like, your *spot.*"

Was I their new pet?

I didn't care—I was ready for air-conditioning and a cold beer.

The next morning, still in my sleeping bag, I woke to C. Carl sitting in a chair—staring at me. Obviously, he'd been up all night speeding. He was now cleaning his nails with a very large knife. "Don't forget," he said. "The only reason you are here is to score drugs for me, cheap."

I was silent.

"So get up and get out," he barked. "Find me something tasty."

He was an asshole. But if I knew anything, it was how to do a drug deal.

Within two days, I brokered the sale of five thousand hits of white acid from Valentine to Carl and Dino. Sensing shade, Valentine had refused to meet the partners, so the deal was done with only me, in Valentine's van in a parking lot.

He was curious, though. "How much cash do your guys have on hand?"

"Maybe twenty, thirty grand."

"Then we should move more product."

I may have looked less than thrilled.

"Is there a problem?"

"They're sort of rednecks."

"Do they have guns?"

I nodded.

"Well, there's no reason I have to meet them. We'll do it like this—just you and me. Chris—it's good to see you working. I'm proud of you."

The acid sold well, and I was able to score from Valentine several more times. The partners were pleased. They said I could keep my spot under the table.

The apartment was always busy. People came by, day and night, to score. Dino answered the door, brought out cold beers, sat and chatted with everyone, but it was always Carl who did the actual deal. All product, all monies, were managed with extreme precision. Carl was obsessed with his scales—it was the math of meth. All conversations at high speed—a revolver within reach.

One night, after everyone had split, Carl stripped to a thong and begin lifting weights in a bizarre frenzy. I hid in my sleeping bag as he thumped and moaned like he was going to come. "Quick, spot me!" he screamed.

I didn't move. The weights crashed, missing his bald head but shattering the coffee table. A bag of speed flew onto the carpet, mixed with beer and broken glass.

As he yelled, blaming me for the mess, I pulled the mummy bag over my head.

Sometimes, when the partners went out, I'd snoop around. Dino's bedroom was a hopeless wreck, but Carl's was always disturbingly neat. Lit only by a bubbling aquarium, the room glowed an evil green. In the tank was a baby octopus stuck to the glass and a sleepy eel. Carl's immense waterbed was covered with a mink bedspread, reeking of sperm.

Dino told me Carl would be worth millions the day he turned twenty-one.

CARLTON, AS HE LIKED TO BE CALLED, handed me a Coors. It had been a long night, with a lot of traffic in the apartment. I wanted to sleep, but Carl insisted, "Drink up, man!"

"Okay, okay." I guzzled it and went to bed.

A couple of hours later, Carl was on the floor, touching my butt with his fat hand.

"How do you feel, Chris? Any interesting dreams?"

"No."

Carl was right next to me. I could smell him, hear him breathing in the dark.

"So, Chris, do you like being our dog? Does it excite you?" And then he laughed and told me he'd put fifteen hits of acid in my beer.

I started to panic. Was the asshole trying to poison me?

"You're a lowlife," I said—and when he tried to touch me again, I started screaming, "Fuck you. *Fuck you!*"

I packed my stuff and split. Greeted dawn, on fire.

SUMMER WAS ON its way. I wandered in the heat.

One morning, I went into a gas station to ask the old man at the register what day it was. It was just a few days before my birthday. I stared at him, confused. When he asked if I needed anything else, I said, "Nah. Just enjoying the AC."

"There's a chair in the corner."

He let me sit there for an hour or so, gave me a bag of chips.

I kept thinking, *Soon I'll be eighteen*. It wasn't until that night, just before I fell asleep, that I realized I was wrong—that I'd lost a year. I was about to turn nineteen.

. . .

THE NEXT MORNING, before sunrise, I stood at the base of Mica Mountain—a great blue whale rising from the valley.

It seemed impossible. There was no road—the trail to the summit less than a scratch.

Slowly I climbed up the steep canyons, past waterfalls, moving from thorn to pine. I entered a miraculous green world concealed from humans, a garden on the back of a whale.

Near the summit, I rested for the night, smoked hashish. No campfire. The mountain was too vast and I was not yet brave enough to announce my arrival. I hid under dark pines, quietly watching the sky fade from violet to galactic black.

In the morning, there was ice along the streambed. I filled my canteen and walked on. Not too far away, I saw the weathered wooden signpost: HELEN'S DOME—8364 FEET. I climbed up the granite tower, weak with hunger, strong with other intentions. Rocks fell into the void as I ascended, the mountain crumbling in my hands. It was crazy.

Am I going to die today? Is that what's next?

At the top, the wind was full of swallows, cutting the air—*cashuuu! shuuu! shuuu!* Tucson was no more than a blur of smoke. It was no longer real. Nothing was.

And then, on a stone ledge, a panther appeared, *a shadow.*

I can remember his voice—or my starved translation of it.

He says that he's the Devil, that he's known me forever—that he's always been my friend. He has so many things he still wants me to do.

I think of Pauly, from St. John's, and how he'd once fed me to the demons. I wondered if Pauly is famous yet, if all his dreams have come true. Maybe he's playing at Carnegie Hall.

Where is everyone I love?

The panther disappears.

I'm nineteen.

FOR FIVE DAYS I wander, wrapped in a blanket, sneaking past panther shit and broken bones. On the other side of the mountain, I find

my way to Chivo Falls. Water hisses from a hundred-foot cliff, steady as a machine.

At the top is a stone pool, six feet around, jutting precariously over the gorge. For a whole day, I soak in its green waters.

On morning six, I look back and see a cloud resting on Helen's Dome, dark as blood. Thunder rolls down from the high peaks. As I hike out, a storm erupts. Later, I slip off my pack by some empty corrals near the road to town. I eat rain. Stick out my fool thumb.

The old cowboy who stops is concerned. "Son, are you all right?" I nod.

"What happened to you? You look like you're in shock."

In the truck's rearview mirror, my hair is tangled and wet, the whiskers on my chin white as snow. My skin has turned dark. My eyes are buggy, blue as glass.

I try to answer. "It was the mountain, sir. It was very bright."

IN THE CITY, I was a foreigner, a time traveler. People stared at me on the bus. When I tried to buy an apple, in the Safeway, I could barely remember how. Pulling the money from my pocket, I didn't understand: hundred-dollar bills appeared, one after another, like some kind of magic trick.

NOT THINKING CLEARLY, I started walking toward Dino's apartment, hoping to crash for a night or two. When I got there, I saw the front door broken off its hinges. I walked in, still wearing my backpack. The place was hollow. I called out, but there was no reply. In the hall, ash and broken glass. All the rooms were stripped—only a single pointy boot remained, on the bathroom floor—ostrich skin.

I saw bullet holes in the living room.

Are they dead?

Outside, in the parking lot, I spotted a neighbor, an old lady with a bouffant and somebody else's baby in her arms. She looked at me suspiciously.

"Ma'am, do you know what happened here? Everyone's gone."

"Oh." She paused. "The police came."

When I asked her if anyone died, she didn't answer, only covered the baby's head.

I could feel my heart racing. "He saved me," I said.

She looked right at me. "Jesus?"

Not Jesus, no. I was thinking of the panther.

34.

Rush Brothers Construction

SOMEHOW I ENDED UP IN the derelict pool house of the Rancho del Rey, where Sean was now living—a rambling 1920s dude ranch that had been converted into apartments. The pool house was at the edge of the property; beyond it, hundreds of acres of desert. Tumbleweeds flew by and saguaros leaned like drunks. In any western, this would be where the bad guys would be.

Months had passed since I'd seen Sean and I didn't recognize him at first, with a goatee and a crew cut. His explosion of curly black hair gone, he no longer looked like a dopey lion. He was handsome now, even with his big ears. Of course, his shorn hair exposed scars I'd

never noticed before. He'd traded his harem pants for tight slacks and a shiny button-down shirt. *Very disco.*

When I said "Wow, you look great," he replied, "Wish I could say the same about you. What the fuck, Chris?"

He looked me in the eye. Sean seemed strong and steady. I was jealous.

He said he was working at an expensive restaurant, had saved some money, was still considering San Francisco. He made me a sandwich. Egg salad. He apologized for the pickles. "I know some people hate them."

"I love pickles," I said, wolfing down the sandwich while he watched.

He told the other tenants that I'd just be staying temporarily. In my gratitude I said, "I have a plan, too, Sean. I'm going to go into business for myself." And then I quoted a line from *Dune*: *He who controls the spice controls the universe.*

In reply, Sean slapped me—not hard, but with enough energy to make me gasp.

"Chris, wake up—it's 1975!"

HE OFFERED ME his couch, but I knew better. We were not good roommates. I stayed in the pool house.

But sleeping on the concrete floor, in the pitch black, I barely knew where I was. In the mornings, I'd wake up covered in sweat, breathless from the heat. Where was my dream of Tucson? Lying there naked and lost, I realized that everything had failed: Friends, family. Even Jesus.

What was wrong with me? Boys don't spend years in the desert, looking for God. They get jobs, get married, live in lovely homes. They do not hide in crumbling buildings. They do not masturbate with suntan lotion found in the trash.

How did I get there? I tried to play the movie backward.

Since I was eleven, I'd been ready to believe such terrific nonsense, believe it with all my heart, certain that I'd become enlightened

from little pink pills and rare herb. I'd abandoned everything for sacrament. It suddenly seemed ridiculous.

Still, my heart wasn't quite ready to give it up. *Jingle*, I kept thinking—*if only I could talk to Jingle*. Listen to her hymns. I wondered if she still believed.

Sometimes, outside the pool house, I'd see a little girl playing in a field of dust—a child of one of the tenants. The girl was always alone, chewing on something—a scrap of bread or, one day, a piece of rubber, maybe a toy snake. I saw it hanging from her mouth, like the tongue of a demon.

I OFFERED SEAN some of my stash, but he no longer partook. He only liked to drink—and often he'd come back to the Rancho, shit-faced, dropped off by strange men in big cars. He put on a performance of happiness, but sometimes he came into the pool house and sat quietly, leaving some of his sadness beside my own.

At night, my dreams returned, the same old horrible repertoire—men with mustaches, black bears, white pickup trucks. One morning, an apparition was so real I jumped up, thinking I could hear wheels on gravel outside the pool house.

It was no dream. My father's truck appeared in a cloud of dust. I could see the red words on the door: CHARLES RUSH CONSTRUCTION.

I ran inside, but he followed me.

"Chris!"

Not my father, but my brother Michael. And behind him my brother Steven. The two of them, teen giants—sixteen and seventeen.

They looked at me, shocked.

I tried to tame my hair as they stared. They stepped forward to shake my hand—polite, too polite.

Finally, Steven said "Shit" and hugged me.

Mike refused. "You smell terrible."

When I asked how they found me, Steven said, "Sean. He called us."

. . .

THAT FIRST NIGHT, I slept outside with my brothers, a row of Rushes under mad stars. I didn't ask why they were here; they didn't ask why I'd been gone so long. We smoked hash, of course.

"Are they still fighting?"—my words quiet in the dark.

Michael said, "Not exactly. They're always bickering and shit, but they're never together for long. Mom's in Florida a lot, with Danny. Dad just works and drinks. Then he goes down to the hunting camp."

"He has a woman down there," Steven added.

"That's what Mom says—but who knows if it's true." Michael shook his head. "He's an asshole, either way."

I could hear the tremble in his voice. "Doesn't matter," I said. "In a year, you'll be at some fancy college."

Michael laughed. "Yeah, with what money? Dad told me if I want to go to college, I better start saving now."

"Well, at least he gave you the truck."

"We kind of stole it."

IT TURNED OUT my brothers had only forty bucks between them— they'd spent the rest of their money on the trip out. They told me that our parents wouldn't give them a penny when they found out they were coming to see me.

"Dad said we could get jobs as migrant workers."

"Well, I have some cash and—" I pulled out a bag of acid, skimmed off Carl and Dino before things went south.

"Let's just drive," Michael said. "Show us shit."

I CAME TO LIFE.

My brothers and I got in Dad's truck and took off. *My little bunnies.*

We'd helped one another through the rip-off of childhood. Michael and Steven were copies of me, improved versions, with flesh on their bones and clean clothes on their backs—hands in their pockets, not

flailing through the air. They were already men—Mike in a beige bucket hat, Steve with a rock-star mustache.

Strangely, my brothers were experimenting in vagrancy, too.

How was it possible that the three of us had come to this? The summer before, when I'd been living on the mountain, my brothers had taken a bus to Maine, picked blueberries, and lived in the woods—a daring escape from my parents' craziness. This trip, though, was bigger and better than anything we'd done before. We were together, driving north across a thousand miles of desert, to where the land lifted and the great forests began.

Idaho.

In the Sawtooths, over every rise, another peak floated up, another waterfall came down. Tripping, we ran through all of it, trying to comprehend the savage splendor of the place. In a pool of melting ice I saw a shining stone. When I picked it up, it was too heavy, a yellow nugget, big as a bent nickel.

"Gold," Michael said.

Just then, a bolt of lightning struck the mountain. We were above the tree line, exposed. Another flash—too close. My brothers screamed and ran. I followed, the metal clenched in my hand. Torrential rain took the valley just as we reached the truck and climbed into the camper. We passed around the gold, marveling how something so small could be so bright. We talked about going back for more, getting rich.

Once we'd sobered and the rain slackened, Steven said, "We should go into business for ourselves. Dad doesn't want us."

Michael added, "We know how to build things. We could compete with him."

"Rush Brothers Construction," I said—none of us aware then that such a company had once existed. We'd always assumed my father had done it alone.

Embarrassed by the swell of fraternity, we agreed we were starving. Steven sliced open some avocados and we ate like animals, green goo on our fingers and faces.

. . .

TOGETHER WE DRIFTED away. Some nights, staring at the embers of our campfire, no one said a thing. I was glad to be with my brothers, flickering young men with dirt on their faces. My father was there, too. I could see him in Steven—the square jaw, the ocean-blue eyes. All of us straight-backed, with that soldier stare.

In my backpack, I had a yard of velvet. It was deep blue-purple, iridescent. I'd stolen it from my mother's sewing room years ago, and had been carrying it around since I left home. Just as I did every night, I put it under my head while I slept, sometimes rubbing the fabric across my cheek.

When Michael saw it, he pulled it away from me. "What are you doing with that shit? Put that fucking thing away or I'll throw it in the fire!"

Maybe it reminded him of my pink cape.

IN WYOMING, the Grand Tetons were impossible. Peaks so violent, so vertical, they opposed reason. They were monsters, shredding the clouds with their fangs.

We asked a ranger how to get to the high peaks.

"Take Avalanche Canyon Trail," he said. "You boys have ropes?"

We didn't, but headed toward a crystal blade rising above all others. The peak was entirely beyond us, a celestial tower. With every step, it receded farther into the distance. After a couple of hours, the trail rose up and disappeared. Pulling our way up the face of a cliff, we began to shrink in the immensity. The wind was fierce; communication was difficult.

Michael yelled, "*Noooo—we need to head doooowwwn!*"

But down was worse than up, our backpacks unruly, ready to throw us into the abyss. Steve took his off and let it slide down a chute of snow. It crashed onto the rocks, sending boots and frying pans into the air.

At the base of the cliff was a field of talus. In caves below the broken rock, we could hear the roar of an underground river. We followed the sound to where the waters emerged into a tremendous pool, deep and utterly clear.

Solemnly, Michael said, "We should come back here, the rest of our lives."

We stared into the water like it was a window to another world—a snowmelt aquarium.

There, we made our camp—and the next morning, we dropped acid.

"What are you doing?" Steven asked as I pulled off my shirt, and then my pants.

"No!" Michael cried, but it was too late.

I dove into the pool. It was shocking, the most complete cold I'd ever felt.

Beneath me I saw underwater passages, caves of sapphire blue. I wanted to enter the underworld, but in a kind of mortal panic my body saved itself. When I flew out of the frigid water, my brothers were yelling. They pulled me onto the rock. Everything went white . . .

"Your leg! Your leg!"

I looked down and saw the outrage of red. Blood was pouring from my shin—a deep, vivid slash from heel to calf. Peaking on LSD, we all gaped at the magnificent wound—and then Michael tore off his shirt and dressed my leg as best he could.

Steven was ready to cry. "Chris, why do you always do this?"

THE SKY WENT black. Hailstones rattled on rock—then came sleet. Through an opera of rain and clouds, my brothers helped me down the mountain. Slipping back into the forest, I could hear them breathing, one on either side.

At the truck, I pulled off my boot and poured out a cup of blood. Steven barfed.

Michael said, "We better get going, it's late."

At Jackson Lake, we stopped the truck, just as the setting sun passed under the storm. For an instant, the clouds were as transparent as paper, fluttering in the sky like a book of gold. When I asked my brothers if they could see it, they ignored me. They were whispering in the front seat.

I started to sweat; maybe I had a fever.

"We're going home," Michael finally announced. "We're taking you home."

I stared at the metal roof of the camper as the miles passed beneath us.

I remember Steven touching my forehead, singing to me.

She wore blue velvet
Bluer than velvet was the night . . .

When I saw the sign, WELCOME TO NEW JERSEY, I could feel the pain in my leg for the first time and started to cry.

I couldn't stop.

PART V

THE REAL DEAL

35.

New Religion

WHAT DID I WANT? Did I want to die? Or did I want to try to live among the humanoids again? My parents seemed to have no preference as to my decision, but my brothers had shown some interest. They'd dragged me home, dressed my wounds, led me down to the cool and dark basement. I was tired, jangled. My mother brought me milk, made minimal eye contact.

It was a new version of Mom, sporty and bronzed. Her hair was short, boyish, the color somewhere between ash and blush. She wore a pale pastel sweater and stretch pants—a new diamond ring the only sign of excess. I commented on her tan.

"We've been down in Florida a lot, Danny and I. I'm on the courts every day." Her gaze fell on my bare arms. "You've got quite a tan yourself."

We avoided the difficult question of my long absence, turning it into a story of separate vacations.

I knew that, in many ways, I was still camping out—that everything was provisional here, this comfortable house simply the edge of another cliff. I could be blown off or pushed at any moment. I barely unpacked.

When my baby brother first saw me, he smiled but didn't say a word. Danny was my mother's late child, her last child, and now—in a way—her only child. At nine, he was lashed to her; the two of them went everywhere together. Having once been in a similar position, I didn't envy the kid's complicated luck. When, finally, he was comfortable enough to talk to me, he asked if I liked Tucson.

"Yes," I said. "Do you like Florida?"

"It's okay. I have a tutor. But I miss Jamie and my other friends. Florida is mostly old people. Chris, did you run away because Dad hates you?"

We were in the backyard. I could see the clothes on the line, flapping like flags.

"I moved to Tucson to be in the mountains," I said. "Nature is important to me."

"Mom says the most important thing is money. I already have around three thousand."

When I picked up a fallen blossom and tried to put it behind his ear, he said, "Please don't do that."

MY FIRST CONVERSATION with my father happened by the pool, where I was sitting on a chair, trying to get warm after a swim. It was morning, and when Dad came outside he had a scotch, the first of the day—his *happy drink*, as Michael called it.

"So you're back," he said. "What are your plans?"

I found myself stuttering. "I-I've been thinking maybe art school or—"

With a flick of his hand, he dismissed the notion. "No more school. I meant, what do you plan to do for money? If you have no prospects, you'll work for me."

An attempt at kindness?

He finished his drink, threw the ice onto the lawn, and walked off—his limp worse than I'd ever seen it.

SIX THIRTY in the morning—a slate-gray sky, unbroken. Every day that fall seemed the same—my brothers heading off to school, and me to work, all of us on our ten-speeds, even in the rain. I liked listening to my wheels hissing against the wet blacktop. After a few weeks of cold, Dad invited me to drive with him.

We didn't chat. When the air got too thick, he turned on the radio.

Strangely, as soon as we arrived at the jobsite, my father became cheerful. To hear him laughing with his men at 6:45 a.m. seemed bizarre. When had I last heard him laugh at home? I must have been eleven or twelve.

Early, the ground was often covered with frost. Retrieving a worn red shovel from the bed of the truck, I carried it on my shoulder like a gun. I tried to walk squarely, tried to mimic the rest of the crew, who were rough and sun-wrecked. Many had worked for my father since the fifties, and they knew who I was—the boss's sissy son. I hid my ponytail like a shameful pet inside my shirt.

My job was to help my father build a church.

I was often cold, my teeth chattering. My tasks were simple: dig holes, make mud, fetch coffee and Danish.

Most mornings, my father simply inspected the site, gave orders, and then left—sometimes returning after lunch with an architect, or some mincing priest afraid to get his shoes wet. He rarely talked to me. I assumed his silence was anger or embarrassment—never imagining that, like my own, it might have been the result of sadness.

But his face was so hard, I never knew.

I wanted to hate him—I did hate him—but the real problem was far worse: I wanted him to love me. In the early part of the day,

before he was drunk, he seemed so knowledgeable, so capable. Even when the building was no more than a scratch in the dirt, I'd see him pointing upward, directing the workers' gaze. He could see a church in the empty air.

That year, humbled, I was almost ready to listen to him, to learn something. There were clearly things he knew, things he could teach me. I wanted him to reveal himself—show me his world.

But nothing.

AS THE CHURCH ROSE, I was given another menial assignment, though one of the most dangerous—a job the foreman called *walking the plank*. On a scaffold thirty feet in the air, I had the unpleasant task of distributing block and concrete to masons. There were no guard-rails and I worked in a constant state of fear. It was nothing like the mountain.

One blustery day, my father showed up in a beautiful blue suit. The wind caught his thinning hair, now more gray than blond. From high above, I noticed, as if for the first time, how much smaller he was than the other men. My father was almost as slender as I was— nothing like the pictures I'd seen of his mysterious, athletic-looking brothers. I almost felt sympathy for him.

I wanted to study him longer, but he walked under the scaffold. Three stories up, I had to be very careful. I was carrying shovels of gray goo back and forth across a wet scaffold, trying not to slip on what I'd already spilled. Suddenly, a great gob slid off my shovel, missing the tub and splashing down directly onto my father's head.

Dad cursed, blobs of concrete dripping down his face. The men were in hysterics. One of them yelled, "Hey, Charlie, don't think your son likes you so much."

DURING THE TIME I was away, my mother remained very involved with my father's business—and his money. If she could not have his love, then she would control his assets. And even if my father

continued to have mistresses, my mother could at least starve those women of gifts and travel.

Mom did the books, the banking, put her name on everything she could manage. Despite my parents' antagonisms, the company hummed. At home, the adding machine clicked under her red nails. This arrangement had become central to their marriage.

Cash had replaced romance. It was the new religion.

ON FRIDAY MORNINGS, when the crew was paid, Dad was usually nowhere to be found. The cash was delivered by Mom—fresh like pizza. Just before lunch, her Cadillac, gleaming like a white boat, rolled through the jobsite mud. When the front door swung open, everything stopped, as we all waited for my mother's heels to reach the precarious earth. Standing next to the car, she played the damsel in distress, looking around as if trapped on a mountain ledge. Before she could hazard a single step, the foreman always rushed over to take her hand.

Then she smiled—and it was dazzling.

Everyone stared, even me. She often wore a tight skirt and tailored blouse—fresh lipstick, coat unbuttoned in the breeze. After whispering a few words into the foreman's ear, she placed the yellow payroll envelopes in his hand. From the scaffold, I could smell her perfume, but Mom never gave me a glance. In two minutes, the hand-off was complete—and after a vague wave to the cheap seats, she slipped into her white barge and sailed away.

The pay envelope for my forty-hour week was always the same, penned in Mother's loopy script: *Christopher Rush, laborer: $52.50.* The two quarters were always ice cold, as if they'd been stored in a freezer.

IT WASN'T ENOUGH. I'd never be able to save money for art school, or to get my own place. I didn't understand if my parents were trying to protect me or humiliate me.

I decided to call Flow Bear, acquire some product. It wasn't just

about making money. Like my father, I knew there was no reason to remain sober.

My first impulse, of course, was to work with Valentine—he was often in New Jersey, but I couldn't stomach his sermons about *sacrament, enlightenment*. Something about watching my father's church being constructed—how brick by brick it had become something brutal and prisonlike, a warehouse for souls—I realized that I needed to be a pragmatist, like my mom.

I knew how to sell drugs. Other than art, it was my only skill—a trade taught to me since the age of twelve. And if drugs were merely product and not some dance with God, then I could finally get serious, become a real dealer and make my way.

On a Saturday morning, in one of my father's fast cars, I drove a couple of hours to Flow Bear's new place in Philadelphia. Somehow, he was living in a mansion on the Main Line. He came to the door barefoot, in paisley pajama bottoms, no underwear. He blinked for a few seconds, as if I'd just woken him up. Then he said, "We have to stop meeting like this." He smiled and pulled me into an embrace. His skin smelled sharp, like metal.

When he asked where I'd disappeared to, I said I'd recently returned from the Grand Tetons—trying to adopt the same measured tone I used with my mother, in an attempt to turn homelessness into some kind of grand tour.

But Flow Bear didn't buy it.

"Cut the bullshit, Chris. They fucked you up, man." Strange, how his terrible assessment made me feel a kind of relief—the honesty of it.

Flow Bear looked good. He hadn't reverted back into the hairy beast he'd once been. His curly locks were short and his body as fit as when I'd last seen him in Tucson, though perhaps a bit thinner. I asked about Laney, the pretty hippie girl he'd married.

He lowered his eyes. "Long gone."

I asked no more as I followed him through various empty rooms, past fireplaces and mad chandeliers. There was no art on the walls, no carpets, not a stick of furniture, only a phone on the parquet, beside a pencil and pad. Another stash house.

We ascended a wide staircase to a bedroom stacked with suit-
cases. On a table stood a triple beam scale and the ubiquitous box of
Ziplocs. Flow Bear opened a satchel and pulled out a bag of enor-
mous green buds, each spear a foot long.

"Just got back from Hawaii," he said. "Take a whiff, man. Maui
Wowie."

He held the bag to my nose. Sweet and jungly, with something
rank about it—shit and flowers. I'd bought something similar once
from Valentine—though I sensed this was much better. And after
Flow Bear offered me a hit, I knew it for a fact.

"So what does it cost?"

"Three thousand a pound."

Ten times the going rate for normal weed—and ten times stron-
ger. I wasn't sure I could sell it. I tried to be a businessman. "Valentine
sells it for cheaper."

"Not this stuff."

I nodded thoughtfully, wondering what I was getting into.

"Chris, you'll make a killing on this. I'll front it to you. And,
listen"—he reached back into the trunk—"I have product Valentine
will *never* have. Take a look at this." He pulled out a rock of palest
pink, the size of a small plum.

It was beautiful. It looked like a jewel, sparkling as Flow Bear
turned it in his hand. "The finest cocaine you'll ever see. Peruvian rock.
Pharmaceutically pure." On a tray, he shaved it with a razor blade
and pulled the powder into a line. "Here, taste it."

Handing me the straw, he leaned in close enough to kiss me—
and as the first burst unclouded my brain, Flow Bear whispered, "This
is the future."

36.

St. Granola

IN A SMALL TOWN, Maui Wowie was big news. Soon, no one wanted to smoke anything else. In the corner of the basement sat my mother's long-unused sewing room. I set up shop there—bought a scale and a decent stereo.

Weekends and after work, I sold Hawaiian from where my mother had once made dresses. My brothers' friends, rich kids from St. Ignatius, bought everything I had. My brothers became a crucial part of the business. Michael reminded me of the plans we'd made around a campfire in Idaho: Rush Brothers Construction.

For luck, I kept the gold nugget we'd found next to the scale.

A shoebox quickly filled with twenties. In just under a month, I moved three pounds of Hawaiian—fifty ounces, fifty Ziploc bags, all of them stuck in the shirts and underwear of kids who would not be doing their homework anytime soon. My customers were polite young men who said good night to my mother as they ran out the door.

My profit was nearly nine thousand dollars. Staring at the money, I recalled a day when I was eight years old and drove with my father to his bank, to deposit fifty grand in cash. In the car, he'd opened the bag and shown me the loot, a big grin on his face. I was in awe of him. Now I wanted to show him my own loot and say, *Look, Dad—I am your son.*

I paid Flow Bear and bought three more pounds of Maui. I bought cocaine, too.

The coke was slow to catch on; I sold some to one of Dad's younger masons, but mostly I just did it myself, or shared it with Julie. The mess in Idaho forgotten, Julie and I became friends again—no romance.

After high school, she'd moved to the Poconos and waited tables, but now she was back in New Jersey at her dad's. Both of us were vaguely embarrassed to be living with our tormentors again. The cocaine helped.

ONE AFTERNOON, after snorting for hours, I drove to visit Donna. She was living on a dairy farm now, where Vinnie milked cows. They stayed in one of the old outbuildings, at the edge of a swamp.

When I arrived, my sister hugged me, but I could tell she was distracted—both kids pulling at her dress. After Jelissa had come Claire. I raspberry-kissed the girls, making them giggle, and then immediately started a rant about the old days in Tucson. I couldn't stop talking. Donna eyed me suspiciously. "What's wrong with you?"

"Nothing. *Hey*," I said, "I brought you a present." I handed her an ounce of Hawaiian. She opened the bag and sniffed.

She smiled. "Thanks." She didn't ask where I got it.

We smoked a doob. Maybe it was the weed or the housework, but Donna had become strangely incurious, not unlike our mother. We sat there in silence, watching the girls play.

Finally: "Listen, Chris, maybe you can do us a favor?"

From the fridge, she brought out ten plastic vials in a Ziploc bag. They looked just like the bottles of Lourdes water sold in the St. Ignatius gift shop.

"Holy water?" I said.

"What? Don't be stupid. It's liquid LSD. From Valentine. We thought we could move it, but we don't get out that much, and the people who live around here aren't really ready for this. Do you want to take some and sell it for us?"

The room was dark and cold. A votive candle flickered before an old portrait of Jesus. He looked sadder than I remembered. Suddenly his misery seemed to be infecting me—or maybe I was crashing.

"Sure," I said. "I'll take it off your hands."

We settled on a price. Donna was a little surprised I had the cash in my pocket.

"Thank God," she said. "I'm buying heating oil with this."

I asked her if she missed Tennessee. During the time I was home-less, Donna and Vinnie had made one last attempt at hippie life—living on a big Christian commune in the South.

"Are you kidding me?" Donna said. "The food was gross and we had to use a latrine in the woods. Every morning, there'd be a pack of dogs waiting."

"Waiting for what?"

"Shit—they wanted our shit. *To eat it.*" My sister was suddenly red-faced and practically shouting. "How was I supposed to toilet train a child in a situation like that?"

I looked at my sister, in pigtails and a Mennonite dress. How had our glorious experiment failed so miserably?

She put the money I'd given her in a little bowl at the back of a cupboard. Still agitated, she said, "You know, Chris, I heard what's going on. I know you're working with Flow."

"I thought you liked him."

"I do. But he's not family. I'm just saying, lay off the powder. That's not what we taught you."

I could feel my face turning red, too—not with shame but with anger. But there was no place for it to materialize in this sad little house, my sister in pigtails, her crazy joy used up.

"Where's Vinnie?" I asked.

"In the barn, I guess. Why don't you say hi on the way out?"

Was she suggesting it was time I leave?

"And don't tell Mom you were here. She'll think something weird is going on."

I DID TELL MOM. I thought she should be aware of Donna's situation. "They can't even pay their heating bill."

Mom was dusting the kitchen ceiling with something that resembled a robotic arm. "I don't know what on earth has happened to your sister. She was the best of the bunch. Now she lives up some godforsaken road with a farmer."

"Why don't you help her then? Give her some money."

"I'm sure Vinnie would just spend it on dirt."

"Dirt?"

"You know what I mean."

I poured myself a bowl of granola and added some milk Donna had given me at the farm.

"I don't want that in the house. You would think your sister would have heard of Louis Pasteur. Oh, that's right, your sister dropped out of college! You know, my parents didn't offer me that opportunity. I had to stuff dead animals." Mom was now scouring the immaculate countertop.

I went to sit in the backyard, leaving my mother alone in the house. After a while, I could hear the piano. While I was away in Tucson, a baby grand had appeared in the living room. Sometimes, Mother would play old Methodist hymns, belting them out like demented show tunes.

Pass me not, O gentle Savior.
Whom have I on Earth but thee?

Under the apple tree, I snorted more coke, knowing my brothers were probably somewhere in deeper woods, getting wasted. And surely Vinnie and Donna were deep in the Hawaiian by now—and my father deep inside a mistress, drooling drunk.

Mom was the only sober adult in the house, though she often seemed the one in the most altered state. Sometimes we laughed at her madness, but, one way or another, we were all infected with it.

MY OLD GIRLFRIEND Julie went a bit mad, too, that winter. Like my mother, she was a maniacal house cleaner, and this tendency was exacerbated by cocaine—cocaine she got from me. I assumed her passion for hygiene and cleanliness had to do with her father's dirty underpants in the freezer, but she said that the evidence was gone—the case settled. Her father had lost. When I asked her why, then, she was always cleaning, she said it made her feel better, that it was her *art*.

There was a deep unhappiness in Julie, but she never fessed up to it and I never wanted to pry. I knew her father had done some terrible magic on her, too. I never forgot what she said to me in Idaho—that she needed to go home to protect her sister.

Julie seemed to have a new boyfriend every few weeks, and though they didn't treat her particularly well, some of them bought her a fair amount of coke. It gave me pleasure to overcharge them.

Slowly, cocaine began to turn a profit—enough that when Julie was between boyfriends, I could simply give it to her. Flow Bear had warned me against such behavior, telling me, "In this business, there are no friends." But when I saw Julie attacking her kitchen in a pair of rubber gloves, I wanted to be kind. And coke was the ultimate kindness.

If Julie's house was empty, we'd partake in her gleaming bedroom. On the coldest days, she liked to turn up the heat and put on a

bikini—her favorite was scarlet with black polka dots. She'd snort and dance around, her feet touching the ground with no more effect than that of a tiny bird. She was as skinny as I was and, like me, a vegetarian. She never ate much, and it didn't help that she made herself vomit. "Don't worry," she'd say, heading into the bathroom, "I'm good at it." Once, after a long line, she suggested writing a cookbook for girls like herself—girls who liked to purge.

"They need to know what food comes up easily and what doesn't. Pizza is easy, but ice cream, that's a bit of a problem."

I never knew what she'd say next.

"You know, Chris, I've killed a baby."

For a moment, I thought she was delusional, but then she said, "Right before I met you," and I realized she was talking about an abortion. Her eyes flashed and met mine, begging for sympathy or judgment—I couldn't tell. I just gave her more coke.

And then I told her I still loved her.

Eyes closed, she smiled the faintest smile. "I know. But you're a fag."

She was not without a mean streak.

"You have to go now, St. Granola. I've got a date with a man."

THERE WERE NIGHTS I was so lonely I was almost tempted to stand in the yard and call out to my old friends, the flying saucers. I thought about Gabriel Green and my past lives, about sexy Venusians in see-through jumpsuits.

Around me, people were falling in love. Michael and Steven both had steady girlfriends. They talked of the future, of marriage. Every night, the couples disappeared into bedrooms and got stoned. For them, the drugs were just dessert. For me, though, they were the entire meal.

At six in the morning, I smoked the most expensive pot in the U.S.A. For lunch, I had cocaine with one of Dad's masons. Dinner required something closer to oblivion. Knowing my brothers were fucking in their bedrooms (my parents, too), I needed something

more, and I sometimes found my way to a needle. Shooting coke was, I convinced myself, superior to sex.

But I knew there was an even better high.

At the mansion in Philly, sometimes I'd catch a small glimpse of Flow Bear's private life. On my way to the bathroom one day, I saw where he slept: huge mahogany bed, barbells on the floor, steel syringe on the night table. It was the only room with real furniture.

Flow Bear, I discovered, did not live alone. Now and then his lover would appear in a pale negligee, lavender or blue. She was a limp blonde, tiny, zonked out, floating by like a bit of ectoplasm in the dark. In a whisper, she'd ask Flow Bear a question, and he would always nod. Once she sipped a glass of water and watched us from the doorway as we conducted our business. Her dressing gown was open, and I stared at her breasts.

Flow Bear was counting my cash. When he saw me watching her, he laughed. "So, what's up with you? You like boys or girls?"

The woman in the doorway began to mumble or sing. She was spectacularly high. That night, Flow Bear sold me a gram of heroin— China white. After he warned me how strong it was, how dangerous it was if I did too much, he suggested I shoot up with him.

When I said "I just wanna watch," he smiled, as if I were flirting with him.

After he injected, he began to tell me about a big new deal he was planning—but then, in the middle of a sentence, he nodded off, slipping from his chair onto the floor.

Somehow I got him to his bedroom, where his lover was lying on the bed, reading, naked. I put Flow beside her.

She whispered, "Don't leave. Please."

BUSINESS WAS BOOMING. I continued to sell my wares from Mom's old sewing room, which I'd turned into a sort of haunted house. Bolts of blue velvet draped my childhood statue of Mary. Phrenology heads sat on nineteenth-century medical texts. There was driftwood,

turquoise, a jeweled candy box. Beneath a Tiffany lamp, quartz crystals were laid out like daggers.

Everyone called my office the Dungeon.

Mom thought it was my art studio, though she never asked to see my work. As my customers came and went, she said, "I'm glad you have so many friends. Why don't you ever introduce me to anyone?"

When I didn't answer her, she snapped, "Am I too old? Your father thinks I'm too old. He won't even *look* at me."

ONE MIDNIGHT, I found her in a satin nightgown, polishing silver. A pirate's hoard was stacked on the kitchen table—knives and forks, platters and bowls, coffee urn and butter dish. With pink goo, each piece was polished, then rinsed and laid out to dry. The results were outrageous—an explosion of white light.

Mom was finishing the demitasse spoons. I asked if she needed help.

"No. I like the work. It gives me time to think."

"About what?"

"About why on earth we need all this silver. I should just sell it and take off. You were smart to run away, Chris."

When I explained that I hadn't ever run away, that I'd been sent away, she nodded and handed me a spoon. Maybe it was a bid for forgiveness.

I put the spoon in my pocket.

37.

Mysterious Substance

IT TURNED OUT THAT MONEY wasn't enough. My mother still wanted the same old thing, the thing she knew was impossible—my father's love. That was the precious, ineluctable prize. Though, for a while, she'd resigned herself to go without it, suddenly she was mad again for his attention.

That spring, her hair became increasingly troubled. Michael called it *the UFO*. In the morning, her frazzled locks were vaguely paranormal, a creeping presence. Later, she'd go in her bedroom and whip it up, emerging with something like a chocolate sundae on her head. She seemed to think it looked fine.

Then one afternoon, she came home with a shock of orange curls. "I'm going away for a bit," she told me.

"How long?" I asked.

"Maybe a week. Danny's going to stay with Kathy."

When I asked her what had happened to her hair, she said, "Doctor's orders."

I was stoned and my mouth hung open, uncomprehendingly.

"I guess I can tell you. I'm getting a face-lift."

"What does that have to do with your . . ." I gestured toward her orange head.

She huffed impatiently. "Dr. Susskind told me to dye it. He said when I get home from the hospital and people mention I look different, I can just say I changed my hair. It's a diversion!"

When Mom returned, five days later, she was horrifying: a woman in a yellow turban, fat-faced, with purple bruises and mummy bandages. She looked like she'd been assaulted.

When my little brother saw her, he started to cry. She tried to hug him but he pushed her away. She said, "Don't you want Mommy to look pretty?"

That same week, she hired a private investigator to follow my father around—though I couldn't understand why she couldn't just follow him herself. She was completely unrecognizable.

ONE LATE AFTERNOON, at the jobsite, my father showed up and said he'd drive me home. This was *very* odd. I told him I had my bike, and he said, "Throw it in the back." He was clearly drunk, and as he drove he drifted from lane to lane; I tried not to worry.

The radio was off and when I went to turn it on he said, "Leave it."

"Where are we going?" We were headed in the opposite direction from home, toward the woods.

Dad lit a Winston and shrugged, said nothing. Now I was frightened.

After a while, he finally said, "*Your mother,*" slurring like someone talking in his sleep. He took two pulls on his cigarette. "There's

a few things you should know about that woman. She's no saint. *Shut up*," he barked—though I hadn't said a word. "I know you take her side on everything. I'm the villain, right? Is that what you think?"

I wished I weren't high, so that I could have known what to say.

"You mother's done her share of shit."

He turned to look at me. The car swerved.

"Watch the road!" I said.

"I see the goddamn road. I'm asking you, what kind of woman sleeps with her husband's brother?"

At first I assumed he was so drunk that he'd forgotten his brothers were dead—but then he said, "We'd been married two years—two kids at home."

Why was he telling me this?

"Dad, can we just—"

"I said, shut up! I come home early from a hunting trip, and Burton's car is in the driveway, three a.m., your mother in the back-seat. I parked on the street, turned off my lights. Saw my brother get out and take a leak. Your mother was in that car *all night*—two babies in the house! When Burton drove off in the morning, he didn't even see me with a goddamn buck strapped to my car."

I didn't understand. Why would my father just watch such a thing and not try to stop it? And then I remembered the photographs I'd seen of Burton—how big he was.

"That morning, I had it out with your mother." Dad's voice was wavering now. "She tells me she loves him—can you believe that? *Oh, but she's sorry, she wants to stay*, she tells me. 'I want to stay with you, Charlie.'"

I knew that Burton had died around this time.

"All started there," my father mumbled. "Beginning of the end. Long fucking end."

He seemed on the verge of tears, and I asked him to take me home. I felt as if he were putting something into my body—some sort of poison, a mysterious substance from the past that had nothing to do with me but that tainted my every breath.

"By the way," my father said. "I'm laying you off."

When I asked him why, he said, "The church is finished. Your services are no longer needed."

AT HOME, I went into the basement. I had thirty or forty thousand dollars hidden down there, and nothing to spend it on but more drugs. When I snorted coke with Julie, I was fine, but when I did it alone, I did too much and often descended into paranoia.

I was sure my parents knew what was going on. Without work, I suddenly had too much free time, and more customers than ever. People came and went constantly, and I wasn't being careful. Money went missing, and then a couple of my father's antique guns. My parents were furious, certain the culprit was one of my *new friends.*

"I bought those guns in the forties, after the war," my father growled.

My mother joined forces with him, happy to share a common enemy. "Chris, you don't care about anything. Guns are memories!"

Guns are memories?

I went to the dungeon and locked the door, worried about guns and money and the mound of cocaine piled on my desk.

When, early on Sunday morning, my father called a "family meeting," I knew, by the very civility of the term, that something was seriously amiss.

Dad got right to the point. "Judge Thompson phoned me last night. It was a courtesy call. There was a search warrant on his desk, which luckily he decided not to sign. He didn't want detectives getting your mother and I out of bed."

"A search warrant for what?" I said stupidly, my pockets filled with drugs.

"Shut up, Chris." My father shook his head. "Selling LSD to a narcotics agent! Really, how stupid are you?"

I went red. When I tried to open my mouth, my father cut me off: "I do not want to know the details! But the judge did mention it was you, Michael, who managed this moronic stunt. No more of this nonsense or your asses go to jail! Do you hear me?"

I looked at my brothers, incredulous they were doing deals on their own.

Mom was frantic. "Luckily, no one knows about this besides the judge. Thank God he's a friend of ours. Can you imagine if people heard about this?"

"Disgusting," my father said.

DISGUSTING. THE WORD seemed familiar.

Walks like he has a cunt. Why don't you come up here?—I know you can hear me, you little cocksucker! I thought of the recording I'd made of my father.

One Sunday afternoon, when everyone was outside, I went into my parents' bedroom and shuffled through my mother's drawers, and then her closet, slipping my hand in coat pockets, emptying hatboxes onto the floor. I was out of control.

When Mom found me, I was looking under the mattress.

"What on God's earth are you doing?"

"Where is it?" I said. *"Where is it?"*

"Chris—stop it! What's wrong with you?"

When I told her I wanted the tape, I could see by her face she immediately knew what I was referring to.

"It's gone," she said.

"What do you mean, *gone*?"

"Your father found it. He destroyed it."

Suddenly I felt defeated, like I'd lost some vital part of my past.

"What does it matter?" She picked up a hat from the floor and put it back neatly in its box. "Sometimes I think it's your own fault you have nightmares. You have to forget things, Chris. It's the only way to survive."

ERASURE.

Mom was right. I had to forget.

I cooked my China white in a silver spoon. Sometimes I'd shoot

up with friends—not friends, but whatever they were, the customers who craved a speechless high, who wanted to grow dim with me, become sputtering candles in the dark.

I never admitted it, but needles scared me. I hated the feeling of the spike slipping, without resistance, an inch into my arm. I worked so hard to believe I existed, that I was a solid being, and the needle always undid me—the ease of its entry, like a hand passing through a ghost.

But the high was irresistible—the dark bliss, the low note, the sleep cure. In heroin, I found absolution—all my sins were erased. Suddenly, a warm ocean was rolling out to meet me.

I preferred to smoke or snort it, but there was a beauty to the needle—the ritual and the rush. For a while, there was a pale young man I shot up with. He was a silent, charmless creature, a blond shadow. I thought he was beautiful. We had an unspoken agreement that he would sit there and I would feed him drugs, just for letting me look at him.

One night after we shot up, he got out his dick and let me blow him. It happened a few times. The last time we did it, I nodded off at his feet. When I woke, drugs were missing, and my precious piece of gold was gone. And, of course, my pale thief never returned.

WHENEVER I CAME back from Flow Bear's mansion, my brothers would rush to the basement like it was Christmas morning. *What do you have? What do you have?* I never told them about the heroin. I want to remember this as nobility—that I was trying to protect them from the worst of it. In truth, I just didn't want to share.

I'M STONED, WAVERING.

I watch her from the bathroom window. Mom's in bicentennial red, white, and blue, smiling like some sort of nutty cheerleader. It's her fiftieth birthday, and she's surrounded by family and friends. I can see the mad glitter in her eyes, the look everyone interprets as

pep!—but which I know to be something else. It's the same light I see in her eyes when she's shouting at my father or vacuuming the carpet like she's digging for gold.

Mom's animation seems superhuman to me, since I'm nodding out on junk. But watching her, I want to go outside and wish her well. Thinking it's a pool party, I put on my flowered bathing suit. I have no idea what I look like—I'm thin as a beggar boy, a wreck with red eyes and hair tangled to my waist. Six foot two and I weigh only 125 pounds.

I see my mother's face change as I approach her—the sparkle freezes. It's a deflector shield—no possibility of getting through. So, instead, I wade into the pool, only to find myself alone in the water. The guests stand above, on the concrete—not one in a bathing suit. They're all watching me. Conversation falters—falls to whispers.

Is Chris unwell?

I hear my mother then—her voice loud, directing people toward the food table. Everyone moves across the lawn, away from the pool. There are piles of presents, screaming babies, birthday candles. I see my mother lift her arms, as if she's trying to fly—and then the crowd begins to sing.

JULIE WAS THE ONLY ONE who said, *Chris, you look a little green. Chris, I'm worried about you.* Lightly touching my face—*Chris, are you listening?* She would say, *You have to stop*—and in the next breath, *Do you have any more coke?*

Coke was not a problem for Julie. She managed it fine—managed to do it while holding down a waitress job and taking care of her dad's house and little sister. Even during her worst binges, Julie was always impeccably groomed and desirable. She told me she'd been on a date with some musician I'd never heard of, named Bruce Springsteen. "He's nice," she said, "but way too short."

One night, Julie and I drove to a Hot Tuna concert at a Long Island roller rink. Once the band came on, I got out a big bag of coke. Julie said, *I love you.* As the audience tore the place up, my heart

swelled with compassion. I felt tenderness for everyone, especially the young men stomping on the bleachers.

That night with Julie was by far the most coke I'd ever done. I felt expansive, brilliant—the blood Julie wiped from my nose a badge of courage. Flow Bear had been right: *this was the future.*

But after six or seven hours of snorting, I began to feel quite ill. The drive home was awful; neither one of us could even talk. The bag was finished—and as its effect wore off, I felt as if my skull were collapsing. There was no place left to exist.

The next morning, my arms and legs were numb and swollen. I tried to ignore the feeling of doom. Smoking weed only made me feel worse. It took me a week to feel like a human again.

When I think back on this time, it amazes me that such awfulness was happening in my parents' immaculate house, and not in some filthy cave. Everything happened among my mother's collection of happy turtles, under the gaze of my father's glass-eyed deer. I waited for someone in my family to say *stop*; they waited for me to say *help*.

But no one said a thing.

38.

Cottonmouth

WHEN I ARRIVED AT FLOW'S house with a bag of cash, he was on edge. He didn't count the money or offer me a sample of new product. He got up to take a call in another room. My bag of money lay untouched on the table. I considered taking it back.

When Flow returned, I began to rattle off my grocery list—but he cut me off.

"Chris, I can't sell to you anymore."

"What?" My mind flashed on Judge Thompson. "Is there a problem?"

"No, baby, I'm just moving serious weight right now. Too busy for this small-time shit."

I told him I could buy more, but he shook his head, claimed he had to put his attention elsewhere.

I couldn't understand why he was being cold. Had I done something to offend him? The last time I'd been here, I helped carry him to bed. And then I remembered how his girlfriend had asked me to stay and how I'd refused her.

"What do you want me to do?" I said. I was freaking out, begging him to reconsider. When I asked if he wanted a blow job, he laughed.

"You are such a sweet kid." He shook his head and gave a look of pity. "Here—" He wrote down an address. "Go see Kenny. He's one of mine. He'll take care of you. Do not show up before Monday, though. We're doing some business out there this weekend."

When I tried to take his hand to thank him, he waved me off.

"I've got clients coming. You gotta go."

THE ADDRESS was a trailer.

Up a long driveway, past a concrete gnome and a wheelbarrow full of pansies, stood a tiny dark-haired man, waving a cane at me, screaming.

"Get the fuck off my property!"

I rolled down my window. "I'm Chris. Flow Bear's friend."

He put down the cane, but his scowl remained. He pointed to a flattened trail of grass. "Pull around back."

Kenny was young, midtwenties maybe, but he walked with an old man's shuffle. Short hair, mustache, bedroom slippers, boxer shorts. As soon as we were in the house, he handed me a sweating can of Coors. We sat down at the kitchen table, looking out on an acre of rolling lawn, the middle of nowhere. Kenny chain-smoked Camels and interviewed me about Flow—making sure my story checked out. Once he was satisfied, cocaine appeared on a silver tray. We both partook.

Then Kenny's voluptuous wife, who also had a mustache, swept in. She was wearing short-shorts and a tube top, bare feet.

"I am Carmelita."

She gave me an outlandish kiss. I blushed.

Kenny winked. "Carm's from Colombia. She kisses everyone."

"You look like a wee-zard," she said to me. "Kenny—don't he look like, you know, with the pointy hat?"

"Wizards have beards, honey."

"I know—but look at his *clothes*."

I had on a brocade tunic and velveteen pants.

Kenny told her to get him another beer, and when she was gone, he said, "Don't worry, I'll take care of you, Chris." He said he could give me better prices than what I was used to.

I was confused. "Don't you work for Flow Bear?"

"Sure, sure. He's a great guy, I love him, but he's a greedy ma-ma-motherfucker. I do my own bi-bi-business on the side."

Kenny, I realized, was not well. In addition to the cane, he had trouble speaking. With each line of coke, his stutter got worse. Before long, he was skipping indefinitely on single syllables. As he snorted more, his neck twitched and his hands trembled. I acted like nothing was strange. Like Mom, I just put on a fake smile.

On a trip to the bathroom, I saw into an empty room stacked with cellophane-wrapped blocks of white powder. Immediately, I understood. This was one of Flow's stash houses. I felt honored to be there—and a little frightened.

I drank more Coors, snorted more coke. Bought a few ounces and left.

AS SUMMER WORE ON, I came to think of Kenny and Carmelita as friends—though, really, I knew almost nothing about them. It was better not to ask questions. They lived in the woods, in a borrowed trailer full of someone else's cocaine. Their job was to stay there at all times, and, I think, they were bored out of their minds. They never wanted me to leave. Carmelita showed me pictures of her family in a moldy photo album, while Kenny played jacks at the table—his spastic motions often swiping the pieces onto the floor.

I never saw Flow Bear at the trailer, though I did a lot of business

there with Kenny—Thai sticks, opium, a little heroin, and increasing amounts of cocaine.

One day—it must have been the very beginning of September—Kenny and I were standing at the edge of the pond on the property, with our pants rolled up. We were there because Kenny said his feet hurt and he needed to soak them. As we talked business, Carmelita—who was picking flowers nearby—started to shout. She pointed toward something, and when Kenny and I turned, we saw a huge cottonmouth swimming toward us, its awful mouth wide open, white as death.

Before we could move, the snake swam right between Kenny and me, onto the shore. Carmelita dropped her flowers and fled, screaming all the way to the trailer.

WHEN I GOT HOME, Mom was screaming, too, something about her *poor mother.* Dad got her into the bedroom and tried to calm her down. It was Steven who explained to me that there'd been a theft at the cemetery, that Mom's family mausoleum had been broken into. All the skulls had been stolen.

"Dad says Satanists. They broke in and took all the heads."

AT OUR HOUSE, everything seemed to be tilting. At least once a day, someone broke a plate or a glass. Outside, there were shady characters waiting in cars—new customers there for cocaine. None of them were hippies, no teenyboppers either. My coke clients were usually older, and always a little too intense. I was in uncharted territory, and I knew I was being reckless. Some customers showed up two or three times a day. My parents, worn out, chose to ignore the traffic.

I owed Kenny tens of thousands. I needed to pay him, but I dreaded the long drive to his trailer. I asked my brother Steven to come with me, for company, for sanity.

Before the trip, I snuck to the boiler room, grabbed a stepladder, reached up to a gap in the rafters, and slipped down a cardboard

box. I was quiet; no one knew where I kept my cash, not even my brothers. I'd learned from Lu that drugs are the easy part; it's the money that'll get you killed.

We took my mom's Cadillac. The trip up to Kenny's trailer was always long, and I was glad Steven agreed to come. He rambled on about soccer, his girlfriend—a glamorous brunette who looked like a movie star. I knew I should be glad for his happiness, but his joy felt like a stone in my chest.

We had miles of mountain road—windows open, music loud. The headlights slashed through black and buggy air. But summer was ending; the leaves were tattered, the flowers fading. I let my brother off in a patch of woods not far from the trailer—he knew he couldn't come in. I handed him a joint, promised I wouldn't be long.

Kenny and Carmelita were sitting on their couch, exactly where I'd left them two weeks before. The same show blasting on the TV, the same reek of pot and pizza and beer. Carmelita went to one of the bedrooms while Kenny and I counted cash on the kitchen table.

He offered the ubiquitous silver tray. I declined.

"What? Why not?"

"My nose is fried. I just can't do it."

"Then let's shoot up. I've got works in the other room."

"Nah. Not tonight."

Kenny looked insulted, and when I apologized he said, "If your nose is fried, why don't you just put a chunk in your mouth and swallow it. That works."

He put a rock in front of me, a tainted pearl, the color of wax.

I hesitated, but habit kicked in. I popped the far-too-large chunk into my mouth. It dissolved instantly—and instantly I knew I'd made a terrible mistake.

My face went numb, then an awful freezing sensation overtook my whole body. I could taste my blood—ice and metal. My flesh began to tingle and various parts of me began to disappear. I fell into a desperate panic. Seeing my reflection in the dark window behind the table, I told myself: *I exist. I'm alive.* I tried to hang on to the tiny

bubble of consciousness that the poison couldn't reach, but it was hopeless.

"Hey, ma-man, what's wrong?" Kenny's voice, impossibly loud.

"I feel . . ." I couldn't breathe. "Really bad."

"It's just the coke. It'll wear off soon."

I saw my reflection again, tried to believe it was me: *blue eyes, yellow hair*. But the reflection was failing, fading like an old photo. My heart was racing, and then it vanished. I felt nothing. I knew I was dying. Everything went white, white—no breath, nothing.

I was gone.

39.

Black World

MY NIGHTMARES BEGAN when I was four, the year after my uncle John was decapitated. I'd be in bed, my real bed, but everything was terribly wrong. All around me was chaos, screaming, wind, and voices. As my bed shook, I kept my eyes desperately shut, knowing monsters were in the room with me. Demons. My bed was about to be thrown into space, into an endlessly black world.

The only hope was to keep my eyes closed; if I kept them closed I might survive.

But even the next day, I knew I wasn't safe. The demons were still waiting and could take me whenever they wished.

• • •

I COME TO on the floor, in front of a screaming television. Sharp pain, a knife in my gut. I can feel my body again, but it's terrible. I'm trembling, disoriented. I struggle to get up, but the pain is too much.

A man with a mustache leans over me. He's bizarre, a monster, his face too small, a rodent or a mouse. Then he disappears. Whispering from another room. A woman's voice: *Get him out of here. He's going to die.*

When finally I manage to get to my knees, the man says, "No-no-no, stay on the floor." He's stuttering. "Stay ca-ca-calm."

I barf green on the rug, double over in agony. A crazy woman appears and frantically tries to clean up the carpet. The man is drinking a beer now and pacing.

I can't stop shaking.

The two people have left, or I'm blind. I try to call out. *I need to go to a hospital. Please take me to a hospital.* I can't tell if I'm speaking.

But then the man says, "No. No hospital. No-no-no can do."

I understand where I am now—at Kenny and Carmelita's. I know why they won't help me. They're protecting the twenty kilos of coke in the back room. "You have to take me!" I scream.

But I don't persist. I'm too weak. I'm going to die on a filthy carpet, watching *The Tonight Show.*

ANOTHER MAN IS in the room now. He takes me in his arms. He's thin but strong. *My father?* I smell his sweat; feel the bristles on his face. I whimper as he scoops me up and carries me like a child to the bathroom. In the light, I see it's Flow Bear.

"Take your clothes off," he says. He runs a bath.

"Hospital," I say again—but he ignores me, pulls off my shoes, my shirt, my pants.

When he places me in the hot tub, I scream. He forces me to drink glass after glass of water.

"Steven," I say. I remember that he's been hiding in the woods for hours, or days—I don't know. "The car," I say. "My brother."

Flow Bear tells me they know, they've sent him home.

I don't believe him, I think they're going to hurt him. I want to get up, run into the woods, but the pain shuts me off again.

I WAKE UP in cold water. Out the window, it's morning. The trees flutter in golden light. But the sickness has not faded. I stumble out of the tub, knowing they've left me here to die. I start to cry.

In the kitchen, Flow Bear and Kenny are sifting rocks from a huge mound of powder. For a second I think they're baking bread. When I realize it's coke, I feel faint, ready to fall over.

The men stare at me.

Kenny says, "He's alive."

Flow Bear says nothing.

When Carmelita appears with a blanket, I realize I'm still naked. She wraps me and tells the men, "Take him away."

WE'RE DRIVING. To a hospital, I think.

Leaning against the door, I look out at the trees, a stream, the indecipherable patterns of black birds. Flow Bear, jangled on coke, switches the radio station a hundred times. *I have a lot to do*, he keeps saying. He drives fast. I can tell he wants me out of his car.

And then I see where we are—not at the hospital but at Donna's house. My sister. Again, I start to cry.

"Get out," he says. But I can't move. The ground seems to be speeding by, even though we've stopped. Am I supposed to jump? Is that what he wants?

I remember I've done this before—jumped from a speeding car.

I open the door but still can't risk it.

"Chris, come on—get out."

Flow Bear pushes me, and I fall onto the lawn.

40.

Waves

DONNA AND I ARE SITTING, *watching the waves. She is seventeen. I am eleven. We're in our bathing suits, on the white sand of Island Beach. Out to sea, a storm blows past, washing the sky clean. Everything becomes sharp and ultra-real, every breath is a thrill of cool air. In my child's mind, I think: Donna is amazing. On cue, she says, "You're the coolest kid ever, I'm so happy you're my brother." We get up and run into the waves. The water is perfect, warm and rough, and we swim out too far, bobbing up and down, laughing so hard we should have drowned. But that August afternoon, we float in the blue like angels. Below us, a school of fish flashes—a million lucky coins.*

. . .

BEFORE I COULD even knock, Donna was at the door. She grabbed on to me and we immediately started to sob. I could hardly stand, and my weight dragged both of us to the floor. I tried to explain what had happened, but words fell from my mouth in senseless jumbles. Her babies were crying, too—actually screaming—tiny beasts in the shadow of a doorway. She gave them cheese and crackers, and then put them in some kind of cage.

Playpen. The word came to me, and, strangely, it hurt. How can a word do that?

Later, Donna told me I babbled about the Devil, and Jesus.

What I remember, most clearly, is my sister telling me, with a look that will haunt me forever: *I did this to you.*

41.

How Can You Say That?

I REMEMBER A BRIGHT ROOM, a man examining me—a young doctor in a crew cut. He was beautiful, a deep cigarette-commercial voice. Every single touch from him, though, was excruciating. I clenched my fists—remembering Gabriel Green saying that when the ships took me away, there might be tests; the extraterrestrials would want to understand my body.

Between the bursts of pain, the doctor's huge hands made me tremble with shame. No one had touched me in a long time. When he gently pressed on my lower back, I screamed.

Later, he said, "No doubt, your kidneys failed last night. It's

amazing you didn't die." He told me to drink as much water as I could. Looking me in the eye, he added, "If you take drugs again, they'll probably kill you."

NEITHER DONNA NOR I phoned our parents.

Back at the farmhouse, I slept a bit. When I got up, sweat was pouring down my face. Donna wanted to take my temperature, but I was shaking, my teeth chattering so hard my sister was afraid I'd break the thermometer.

I tried to make a joke. "Well, remember what Mom always said about taking our temperature?"

"What's that?"

"Only the anus is accurate."

We laughed. We laughed because I wasn't dead.

Donna turned away, and I could see her back shaking, but she wasn't laughing anymore.

When Vinnie came in and saw her crying, he sat down next to us and suggested we pray. The three of us held hands but said nothing, nodding our heads over a rosary of tears.

EVENTUALLY, I ASKED my sister to take me home.

When we arrived, she said she wouldn't go inside. We sat in the car for a few minutes, full of words we were too inept to say.

"Don't worry," I told her. "I'll be fine."

We both knew it was the end of a story we'd started a long time ago.

I kissed her, said goodbye.

WHEN I WALKED through the back door, I was disoriented. My body was still wrong, still numb. When Mom saw me, her face went pale. She told me to come to her bedroom, and then quietly closed the door.

"Are you all right?" she whispered.

"No."

"Where on earth have you been?"

I shook my head.

"Tell me, Chris. I found my Cadillac in the bushes the other morning. Who drove it home?"

I felt sick again, like I might fall over, but I refused to collapse in front of my mother. Refused to cry.

"Mom, I'm not well. I almost died." Leaning against her vanity, trembling, I told her I'd overdosed. She was silent for a while, and then I saw her face appear in the mirror.

"How could you let this happen? So—what—you're an addict now?"

I looked up, told her I needed to rest. "I have nothing," I said.

"How can you say that? You have me. I'm your mother."

She was crying now, still facing the mirror. I nodded at her reflection and walked away.

FOR DAYS I could barely sleep—certain I was dying. Anxiety annihilated rational thought. Only walking made me feel better. Hours at a time, I walked in circles, trying to find relief.

Steven brought me a glass of water—and I apologized for abandoning him in the woods.

"Who were those people?"

"You don't want to know."

My mother mostly stayed away. She didn't suggest another visit to the doctor, or rehab. No one used the word OD. I stayed in the basement, like a punished child.

"Chris, do you want some soup?" It was my father, strangely, who exhibited inexplicable flashes of kindness. No conversation—just soup. My dad had once been a short-order cook and he knew the best meals for a hangover. But I could manage no more than a sip before I felt sick. Often, my father had been in the same boat.

He would hand me a box of crackers, telling me they went down easy.

42.

We Are Gathered
Here Today

I HAD ONLY THE FAINTEST hold on Earth. I couldn't sleep or eat. My legs were numb. I was always shaking and afraid, always close to tears. Donna's doctor had warned me that my kidneys were barely functioning. He said, darkly, that cocaine had *burned* my internal organs. My digestion was shot. My father's crackers did not go down easy. If I ate after three in the afternoon, I couldn't sleep a wink, tossing all night, moving between pain and panic. It was as if all the smoke and chemicals were still trapped inside me. How many years of poison? I was too exhausted to look back.

. . .

WHEN MY MOTHER announced there was to be a wedding, she did not look happy. It was October, a few weeks after my OD. My brother Michael was going to marry his pregnant girlfriend.

"I can't go," I said.

"You'll go," my friend Julie said to me later. "I'll be your date."

Julie knew what had happened to me, but we never really discussed it. She was still snorting coke—which she was now getting from someone else. During my two days away at Kenny's trailer, the Dungeon was robbed. All my product was gone. Luckily, the thieves hadn't found what was left of my cash in the boiler room—maybe ten grand.

IN A TORRENTIAL DOWNPOUR, my brother and his tiny blonde bride ran from the church, dodging rain and rice. The garden reception at her parents' house was forced onto a big screened-in deck, where her large Catholic family mingled uncomfortably with mine. The girl's parents were not at all pleased that Michael had knocked up their daughter.

I couldn't eat anything, of course. I felt rotten. I sipped Perrier while I watched Donna and Vinnie run through the rain to their car with my brother Steven. I knew what they were doing out there. I had no wish to join them.

Dad, of course, got wasted, too—as if to confirm all the stories his new in-laws had no doubt heard about him. Things were not good with my father's business; recently, there'd been several public, drunken incidents. The church I'd helped him build turned out to be his last project for the Diocese of Trenton. He was deemed unfit for church contracts.

Mom was ashamed. Like me—but unlike herself—she was very quiet at the reception. She wore a purple gown with a green orchid pinned to her chest like some terrible insect. She looked defeated. Maybe she was thinking about her mother's missing skull. Was it now sitting on someone's stereo? Recently, she'd had her family's mausoleum sealed with concrete, so that no thieves could ever get in again. Of course, that meant that it would forever be closed to her, as well.

The bride's family was more pious than our own—the older brother had recently been ordained, and it was he who'd performed the wedding. At one point, he walked up to me to say he'd heard I'd attended St. John's School.

"Yes," I said. "It was the happiest time of my life."

"Why was that?"

"I was a child. God still existed."

When the priest asked me if I no longer believed, he looked genuinely concerned. He was only a few years older than me, dapper in black—another version of myself.

I told him, "I'm trying."

JULIE, MY DATE, mostly ignored me. I watched her dance with all the cute guys.

But later, as she ate a crumb of wedding cake, she leaned into me and said, "Wow, it's getting chilly already."

The rain had cleared and frigid air rose invisibly from the lawn. It was only October, but winter was already on its way. I shivered.

The music got louder.

Play that funky music, white boy . . . play that funky music till you die.

Michael danced with his pregnant wife and Steven with his girlfriend, who would be pregnant before the year was out. In the end, Mike would have six children. Steve would have three.

My parents, the cause of all of us, chose not to dance. I saw them standing by the wedding cake, looking tired.

Julie and I drifted outside. Donna and Vinnie were in the yard, stoned, staring at the trees as if looking for something. Their marriage would hang on for another decade.

"We should go to Tucson," Julie said. "It's warm out there, right?"

I tried to smile. The desert had been the testing ground for so much. The Great Experiment.

As I stood beside Julie on the wet lawn, I was stranded in 1976, having no idea what to do next.

"I mean it," Julie said. "We should go."

When I asked about her little sister, Julie said her father was getting married again, that her sister would be fine.

"I have some money saved," she said.

"Me, too."

"Sunshine." Julie sighed. "I miss it."

PART VI

ONE HUNDRED PIES

43.

I Wish I Had a River

ONLY MOM AND DANNY CAME to the airport. The day was cold and windy.

Mom kissed Julie goodbye, and then whispered in my ear.

"Take me with you."

When I searched her face, she smiled, as if joking, but I could see the glimmer of longing. *Your father and I used to take such lovely trips.*

When I didn't answer her, she grabbed Danny's hand and together they headed back to the car. I blew my baby brother a kiss he didn't catch.

Julie put her arm around me. "We're fine," she said. "We'll be fine."

A FEW DAYS before I left, on one of my walks, I went down to the river. It was still the wrong color. At the shore, by some ragged trees, there was trash and discarded clothing. As I approached one of the broken-down docks, I saw two boys huddled by a concrete pillar—twelve or thirteen, skipping school. Each held a plastic bag to his face. They were sniffing glue.

Once, I would have told them, *Throw that shit away.* I would have offered them sacrament—or some prime Hawaiian bud. I would have been kind to them, generous. I would have done unto them as others had done unto me.

Now I just drifted by, a skinny guy in a black hoodie—son of the grim reaper. I continued along the river, crossed the bridge, walked toward my sister Kathy's house. When I got there, I didn't knock, just looked in the window and watched everyone eating dinner. In the late light, I thought they were all so beautiful. In a few years, my sister's neighborhood would be a Superfund site, a particularly heinous one, requiring long-term vigilance. The report will say, *It may be a thousand years before all the poison is gone.*

IN TUCSON, Julie and I rented a small red ranch house not far from the air force base. Walking in, our voices echoed, the place all but empty. The owners had left behind two army cots, a beanbag chair, an old black-and-white TV.

Julie said, "This is not a house. It's a hut."

Taking the bus, we bought groceries, cleaning supplies, a vacuum, and a mop. A few days later, a thrift-store truck delivered a couch and a dinette set with four mismatched chairs. This was all Julie's doing. I watched, amazed, to see someone make a home from nothing. I realized I had no idea how to take care of myself. Julie, for all her struggles, never allowed herself despair. I tried to follow

her example. I cleaned the windows with newspaper and vinegar, while Julie, in rubber gloves, scrubbed out the refrigerator, singing as she worked.

Why do birds suddenly appear
Every time you act queer?

I knew she was trying to make me laugh, but I couldn't quite manage it.

My insides hurt, and I still wasn't sleeping well. I went to see Dr. Kelly, my sister's old chiropractor. Having lived among hippies for so long, I never considered seeing an MD. Dr. Kelly agreed I was in bad shape. His advice: distilled water, fresh juice, vitamins, protein powder. I followed all his excellent suggestions, but improvement was slow.

Julie bought me new socks, claiming she'd had a lot of success with them. Sometimes a fresh pair, she said, was all you needed to set you straight.

LYING AWAKE on my cot, I tried to imagine a life, a future. All my fantasies had vanished. I thought of beautiful Owen Spoon, lying naked in his arms, but even that could not arouse me. Everything felt wrong. Pleasure wasn't an option.

I had my silver cross, and I wore it, tried to pray again. The words came back effortlessly, but some part of me seemed to have forgotten what it all meant.

The Virgin, the Devil in the glen.

Some days, the sunshine defeated me. I just wanted to hide. On the bus or at the market, I'd see lots of people living without drugs. Geezers and grannies, fathers and sons—what did they do all day? What did they think about? How did they not just run, screaming?

I never thought of getting help or counseling. I could barely talk about what had happened, even to Julie.

She got a lunch shift at a restaurant, and during the day I was

often at home by myself. In the neighborhood, I walked in circles, as I'd done the first few weeks right after my OD. Somehow walking was important—but often my circles would turn into a road, and I'd end up in some scene from my childhood. Memory itself seemed a kind of sickness.

I'M FIFTEEN, on the living room floor, reading a book.

You look like a woman, with your goddamn legs spread, he says.

For the first time, I don't get up and run. I've had enough. I say, *Fuck you.*

And fuck you, my father replies.

I stand. We stare into each other's eyes.

I'm stronger than he is, I realize. I consider smashing his face.

Coolly, he says, *You hate me, don't you?*

Yeah, and you hate me.

That's right. I do.

We walk in opposite directions, like cowboys in some heart-smashing western.

THE FACTS as they existed astounded me, terrified me. Without chemicals, I was unequipped to process everything that had happened. The past was too hard to look at. Sober, one could only see things as they were. A person's face was a person's face. You could see it immediately for what it was. My father's was terrible. Even worse was my own in the bathroom mirror. I had lost two more pounds, weighed an impossible 118 now. I did not want to recognize myself.

WHEN I RAN into Valentine one day, he was not sympathetic. He scolded me for giving up what he called *the Life*—something he would never do. He mocked my bad judgment, my use of heroin. He offered me LSD.

As I walked away, I started shaking—a rage so potent it stayed with me for weeks, the anger somehow emptying me out, leaving me exhausted but strangely peaceful.

This emptiness, which previously I would have filled with visions and lies, I simply faced, waiting to see if it had its own message.

ONE DAY, Julie came home with another waitress. She told me to stay in the kitchen until she called me. I heard the two girls groaning, dragging something across the floor. A few minutes later, Julie led me into a small room we weren't using at the back of the house. She'd put an old wooden desk in there. On top of it were sketchpads, pens, colored pencils. "Your art studio!" she chirped.

I sat at the desk, thanking her.

After the other waitress was gone, Julie said, "Come on—draw something."

I considered the blank paper and got up. I had nothing to draw.

EARLY THE NEXT MORNING, I crept into the studio and shut the door. Sat down and carefully sharpened a pencil, a decisive 3B. I slid it across the paper and stopped. The mark had no message, no pulse. I tried again and again. Nothing. Without dope, I could not find a face, a cloud, a scrap of light.

On the first few pages of the sketchbook, in lieu of art, I wrote a list of all the different drugs I'd taken—at least the ones I could remember.

Two hundred and fifty entries.

I'd once been so proud of my extravagant drug use, my cunning, my crime. Now it was sickening to even consider. I'd been stoned for half my life. Since the age of twelve, drugs had been the only song playing in my head.

Why?

There was never a good answer. It was as pointless as asking why my father drank. There's a shadow. Maybe it's God, maybe it's the

Devil or something in the human heart. What does it matter? There is a shadow.

I STARTED TO wonder about Sean, who I heard was still in Tucson. According to his sister, Darla, Sean had had a rough couple of years. Darla said that when he moved out of Rancho del Rey, where I'd holed up in the pool house, Sean had lived in a trailer with an older guy—a man he'd eventually stabbed.

I wasn't shocked. Kill yourself. Or kill someone else. Sean's story was just a mirror version of my own. Strangely, the man who Sean stabbed hadn't pressed charges and had even invited Sean to live with him again. "But he's on his own now," Darla said. "I'm sure he'd love to see you." She gave me his address.

"I don't know if you should visit him," Julie said. "After all that stuff."

But I went anyway.

When he answered the door, he was holding a papaya. He had very short hair; looked tan and strong. "Poopinita," he said. "What are you doing here?"

We hugged. I told him I was off drugs. I asked why he was still in Tucson—wasn't his plan to move to San Francisco? He ignored my questions, asked if I was hungry. As we ate the papaya in his kitchen, I asked if he was feeling better.

Sean looked confused. "I wasn't sick."

"I know, I just . . ." I wasn't sure what to say.

I said, "It's really great to see you."

THAT FRIDAY, we went to the Graduate, Sean's favorite bar. I was nervous, having no idea what to expect. I had on a clown-red Guatemalan shirt, jeans, and Birkenstocks. Sean, a bellhop at a resort, was still in his work clothes and already half-drunk. An old jukebox played country swing. Sean introduced me around. Even in a fag bar, I was a weirdo. I hadn't cut my hair in seven years. My shirt was handwoven

by Mayan spinsters. When a handsome man tried to buy me a drink, I said: *I'm sorry—I only drink spring water.*

While Sean talked to his buddies, I leaned against a wall, astonished by everything I saw. From a tiny stage against one wall, a black drag queen appeared. "Hello, boys," she shouted. "I'm Honey Jerky, your hostess. Tonight, the Graduate Lounge presents for your unnatural pleasure . . . *the beautiful baby contest!*"

The crowd clapped and yelled as five guys walked onto the stage. The men were naked, except for bonnets and diapers. They paraded and twirled. One snuck down his nappies to show off his hairy butt.

As I watched the grown-up babies prance around, gooing and gahing, I found myself laughing for the first time in a while. But soon I felt sad again. And though I was glad Sean had found his circus, I wasn't yet ready to join. I still needed quiet. With what remained of my drug profits, I could hide out a little longer.

JULIE TOLD ME I needed to have some fun, to meet someone. Every few weeks, she sent me back to the clubs. Sean watched out for me, even if he sometimes wandered off with some guy—to the bathroom or the parking lot. After last call, he'd always let me stay at his apartment.

One warm night, as I lay on his couch, I was restless. All my various worries came and went. I knew that drugs were finished—and there was a kind of crazy grief in my heart, as great as any grief I'd ever known. My old life was over and I was empty, with no idea what would happen next.

At first light, Sean's apartment materialized before my eyes, as if to suggest: *What about this?* Sean was living on the upper floor of the aging Hotel Geronimo, near the university. His room floated above a sea of palm trees fluttering in the morning breeze.

How does one live, I wondered. I admired Sean's place—the new camera on his desk, the stereo stacked with albums, the poster of Tina Turner. His bathroom was particularly swank, tiled in black and white, a puzzle perfectly solved.

I washed, gave up on sleep, faced another formless day.

Sean did not stir. I watched the sun catch on empty beer bottles in his kitchen, whiskey bottles, too, all glittering like gold. For a moment, I was jealous that he could drink, but I knew I couldn't join him on that raft.

Sean called from the bedroom, *Dude, are you awake?*

I saw him maybe once a month. I might have seen him more, had I known the sickness that would come and take him away.

The last time we met was thirty years ago, in a Chinese restaurant in San Francisco, where Sean had finally moved. He was rail-thin and looked like I had during my recovery in Tucson. Before we said goodbye, he touched my short hair, told me I was beautiful. And then he told me to be careful.

I was.

JULIE CHECKED our mailbox every day. Usually there was nothing. But two or three times I got a postcard from Donna. The notes were always too short. *We put up pickles this year, you'd love them.* She'd tell me her daughters were fine, that she missed the desert. As I read her cheerful handwriting, my heart would sink. Our worlds were drifting apart.

ONE NIGHT, after months in Tucson, I went out to a nightclub alone. Shy as usual, I was standing at the edge of the dance floor when I saw my twin, a boy with long blond hair and velvet bell-bottoms. He saw me staring and smiled.

I walked over, my heart pounding. "Hey, man, do you wanna dance?"

He said, "Yes."

We both danced oddly, hips locked, arms akimbo. Like me, the boy was nervous, unable to make eye contact—and when we tried to talk after the song, his voice was so soft that I could barely hear him. He said he was from Delaware, on vacation with his mother.

He took my hand. "I'm Todd. Maybe we should get together?"

"Tomorrow?" I suggested, and he said, "Sure."

The next day, during Julie's work shift, he appeared at my door. In his incredibly high voice he said, "You don't mind if my mother waits in the driveway, do you? It's the only way she'll let me do this."

I peeked outside. In a large beige Pontiac sat an old woman with a copper bouffant. She appeared to be holding knitting needles. She waved at me. I waved back. "Todd, does your mom want to come in?"

"No, no, no. She prefers to wait and give me my privacy."

"Do you do this a lot?"

He looked down, seemed to be counting with his fingers. "You're the fourth."

For our date, I'd put on a silk shirt with an embroidered dragon. Todd's outfit was far wilder: yellow granny glasses and a matching, knee-length crocheted vest. Though he was tiny—much shorter than me—his hair had been teased into a huge, unearthly nimbus.

In my room, sitting at the edge of my bed, he told me about himself. He said he was a pinball champion, and that he'd been touring the country with his mother since he was twelve. "I've won a lot of prizes. The trophies are in Mom's trunk. I can show you later."

He stopped talking and kissed me.

I kissed him back, trembling. It took me a long time to come that afternoon, but Todd didn't seem to mind. When it finally happened, my whole body shook from head to toe. I hadn't come in months. As I lay there, something like a sob came out of me, which I tried to turn into a cough. Todd held me and closed his eyes.

I studied his face, young and smooth, but sad—too tired for a boy of nineteen. I saw the mascara on his eyelashes. His skin was nearly transparent, exposing tiny trails of blue blood. I told him I wanted to see him again.

"Definitely," he said. "But I should go now." His mother had been in the driveway for over two hours.

For the next week, we met every afternoon in my bedroom, while his mom knitted in her car. We kissed, slumbered, and fumbled behind the curtains, trying to save ourselves.

It was the first time I understood that one's sadness could be touched—another person could actually touch it. Todd never seemed troubled when I cried after coming. He said sometimes it happened to him, too.

AT TWENTY, in my little art studio in Tucson, I forced myself to draw again. Sitting in the sunny room, five blocks from an air force base stacked with nuclear bombs, I sat before each blank piece of paper, as if before God. On pot and acid, I had always drawn fantasies, strange creatures in strange trees. But now I wanted to draw what was in front of me. First I sketched my left hand with my right—and then my right with my left.

I still have hands, I thought.

Next I drew a rock from the yard, then a hiking boot, then an empty cardboard box. I took up again with the real.

ONE MORNING, I wandered the aisles of Safeway, trying to feel hungry. In the produce department, I confronted a pyramid of red apples. Apples meant health and happiness. I decided to bake a pie. I'd never baked a proper one before, but on a bag of flour I found a recipe. Making a pie from scratch took all afternoon. From a disaster of flour, butter, and cored apples, I constructed an accidental masterpiece. The house was filled with the smell of home. Coming out of the oven, the pie was golden, a miracle.

Julie and I ate it for dinner, ate almost the whole thing, sitting on the kitchen floor. It was absurdly delicious and that night I slept like a baby.

After that, I made a pie from scratch every few days. The effort of preparing the fruit, rolling the crust, shaping the pie—it kept me busy. Apple to blueberry to peach, as the seasons turned. I started to feel human again.

I baked about a hundred pies. I suppose it was on one of these days, eating pie with Julie, that I decided I wanted to live.

AFTER NINE MONTHS in Tucson, my body began to feel better. I'd stayed clean since leaving New Jersey. My body's memory of swallowing that pearl of cocaine—the pain, the sickness, the fear—had banished all craving. I never used again.

I don't know why I was saved and others were lost. My father would never stop drinking. Flow Bear would OD in jail. Maybe it was Tucson that saved me. I found tremendous solace in the desert, in its generous warmth and light. Had I stayed in New Jersey at that time of my life, I don't think I would have survived.

AS MY STRENGTH returned, I spent more and more time in the mountains, visiting the places I'd camped when I was living rough. One breezy spring day, I borrowed a car and drove to some hot springs east of Tucson. From the highway, I had to hike a ways to get there. The springs were in the wilderness, pools I'd once visited with Owen and his family. The canyon smelled of sulfur and flowers.

Sitting alone in the steaming water, I watched the clouds, hoping a cute guy might show up. Instead, an old man appeared, out of breath. He leaned on a wooden staff, a leather patch hanging over his left eye. "Is it warm?" he asked.

"Perfection," I said.

"Then I must get raw."

I'd never seen a geezer naked. Though decorated with marvelous beads and amulets, his fat body was a wreck. Lowering his hairy flesh into the pool, he sighed orgasmically. *Ah! Ah! Ahhhhhhhhhhh!*

"My friend," he said, "we are in hot water."

I laughed.

The pool seemed too small, our bodies too close. I looked down, certain I was blushing. "Where are you from?" I asked.

"Here and there. Spain and Spokane. And you, my child?"

"New Jersey and maybe here. Arizona."

"And are you in mad love?"

"What? I don't know. Sort of."

"Hmm—*sort of*? Don't be shy."

"Honestly, I really don't know." I was ready to get out of the pool.

"I do know," the old man said. "I can see it. Love is your true flag."

He was calm as a king, talking to me as if he knew me better than anyone on Earth. I was transfixed. He said his name was Pluto.

He asked for my name—and then he told me a story.

"There was a boy like you who had a dog, a dog named Girl. He loved Girl but as he grew strong, Girl grew old. One morning, the two of them walked to the mailbox and Girl saw a squirrel dart across the road. She went to investigate and didn't see the truck. The driver was carrying a load of canaries." He paused. "What does a canary weigh in flight? Do you know?"

I shook my head.

"Of course you don't. No one knows. The driver was looking back at the canaries when poor Girl went under the wheel. And at the moment Girl died, her spirit merged with the boy."

The old man lifted the leather eye patch, revealing a hole in his face. I was afraid, imagining his brain working back there in the dark cavity. The other eye glowed like a faraway planet.

"You can love anyone, Christopher, even the dead. Will you be here tomorrow?"

"I'm not sure."

"None of us are."

He told me to take care. He shook my hand like a man.

Epilogue

The Portrait

A LIFE SHAPES A FACE, makes it what it is. In the old, you can see the roads and reckonings. The shocks of childhood rise to the surface. What was hidden becomes visible.

It was so with my father.

He disappeared for a few years, not long after I left for Tucson. When he showed up again, my mother was still waiting for him. I think it stunned him that he had not lost everything. Shaky, mistress and money gone, he was defeated. But my mother took his arm and led him back to life.

I made my way to New York, became an artist. Julie tagged along for a while, encouraged me, then met a man and drifted away.

I saw Donna now and again. By then she'd married a rich Republican, played a lot of tennis. Of course, she'd always remind me, "I'm still that girl tripping in the park. That's the real me." But now she got stoned in a big Mercedes.

My life changed, as well—my face, too. A short-haired man in a sharkskin suit.

For a long time I avoided my parents—but I missed them too much, even my father.

In my forties, I decided to paint Dad's portrait. At first I attempted to paint him from memory, but memory is a tricky thing. Then I thought to use a photograph—which, as I looked at a few, did not seem right, did not seem to capture the man I knew.

In the photos, he's often with my mother. Mom, in pearls and a dark silk dress, a tangerine jacket with big black buttons. Dad wears a silver trench coat, very slim and sexy. As I look at these photos, many snapped right before they're about to leave on a trip, I see that these people are not my parents; they are lovers, going someplace I'll never completely understand. It's between them. It's their story.

This is not the father I want to paint. I want to paint the man I know.

And so I don't use photos. I ask my father to sit for me.

At this point, he's old, can barely speak—the ravages of cancer.

And at this point, I know about his past. I know about the awful tragedy of his brothers.

In my studio, my father is already beginning to shrink, to become the figurine I'd find in his coffin just a few months later.

I paint him quickly, a face daubed with ash and violet. I keep saying, "Great, Dad, really great!"

He grimaces, using all his strength to produce a smile. And somehow, he manages.

"Is he smiling?" my mother asks when she looks at the portrait. She can't see it. She says the face frightens her.

It doesn't frighten me at all. I recognize him. He is my father.

Acknowledgments

I want to thank:

Victor Lodato, for his love, support, and guidance. His editorial insights were a marvel—he sent me to the heart of my own book.

Daniel Mahar, who first heard these stories on a train ride across India. He encouraged me to write—and then read each and every draft. He never didn't get it, not for a second.

My agent, Bill Clegg, for his wild enthusiasm and total faith.

My editor, Colin Dickerman, for his cool brilliance and style.

Everyone at FSG, including Alex Merto, Abby Kagan, Jeff Seroy, Daniel del Valle, and Dominique Lear.

My mother, for answering a thousand questions, and for wisely saving all my letters, drawings, and photos. Her memory is uncanny, her mind extraordinary.

My six siblings, for suffering years of interrogations about that crazy time—a time that we all agree was like no other. Donna, for her courage and kindness. My cousin Caroline, for the long interview she gave me after not seeing me for thirty-five years.

My early readers, who were all too kind: Larry Kallenberg, Liza Porter, Mary Reynolds, Peter Groff, Shawn Garrett, Wynn and Sally Chamberlain, Bob Deluca.

My later readers, who I leaned on heavily: Jeff Westerman, Adam Geary, Ken Van Houten, Mayo Roe, and Michele Conway.

My cheerful comrades: Richard Davis, John Wells, and Steve Johnstone.

My soul support: Norah Pierson, Austin Brayfield, and Karson Leigh.

For divine accommodations: Pietro Torrigiani-Malaspina and Maddalena Fossombroni at Castello in Movimento, Italy; the Chamberlain family, for spring at Sierra Giri; and Henning Bartsch, for Heaven 11 in Akumal.

Lastly and perhaps most of all, I want to thank the friends who lived through this story with me—who were everything I needed.